LEGACY

THE ART OF TRANSFORMERS PACKAGING

By Bill Forster
& Jim Sorenson

Additional Restoration
by Jillian Wilschke

Editor: Justin Eisinger
Assistant Editor: Alonzo Simon
Copy Editor: Adam Morris
Production: Chris Mowry

Special thanks to Hasbro's Clint Chapman, Joe Furfaro, Heather Hopkins, Jerry Jivoin, Joshua Lamb, Ed Lane, Mark Weber, and Michael Kelly for their invaluable assistance.

ISBN: 978-1-61377-943-9

17 16 15 14 1 2 3 4

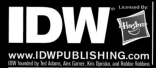

www.IDWPUBLISHING.com
IDW founded by Ted Adams, Alex Garner, Kris Oprisko, and Robbie Robbins

Ted Adams, CEO & Publisher
Greg Goldstein, President & COO
Robbie Robbins, EVP/Sr. Graphic Artist
Chris Ryall, Chief Creative Officer/Editor-in-Chief
Matthew Ruzicka, CPA, Chief Financial Officer
Alan Payne, VP of Sales
Dirk Wood, VP of Marketing
Lorelei Bunjes, VP of Digital Services
Jeff Webber, VP of Digital Publishing & Business Development

Facebook: facebook.com/idwpublishing
Twitter: @idwpublishing
YouTube: youtube.com/idwpublishing
Instagram: instagram.com/idwpublishing
deviantART: idwpublishing.deviantart.com
Pinterest: pinterest.com/idwpublishing/idw-staff-faves

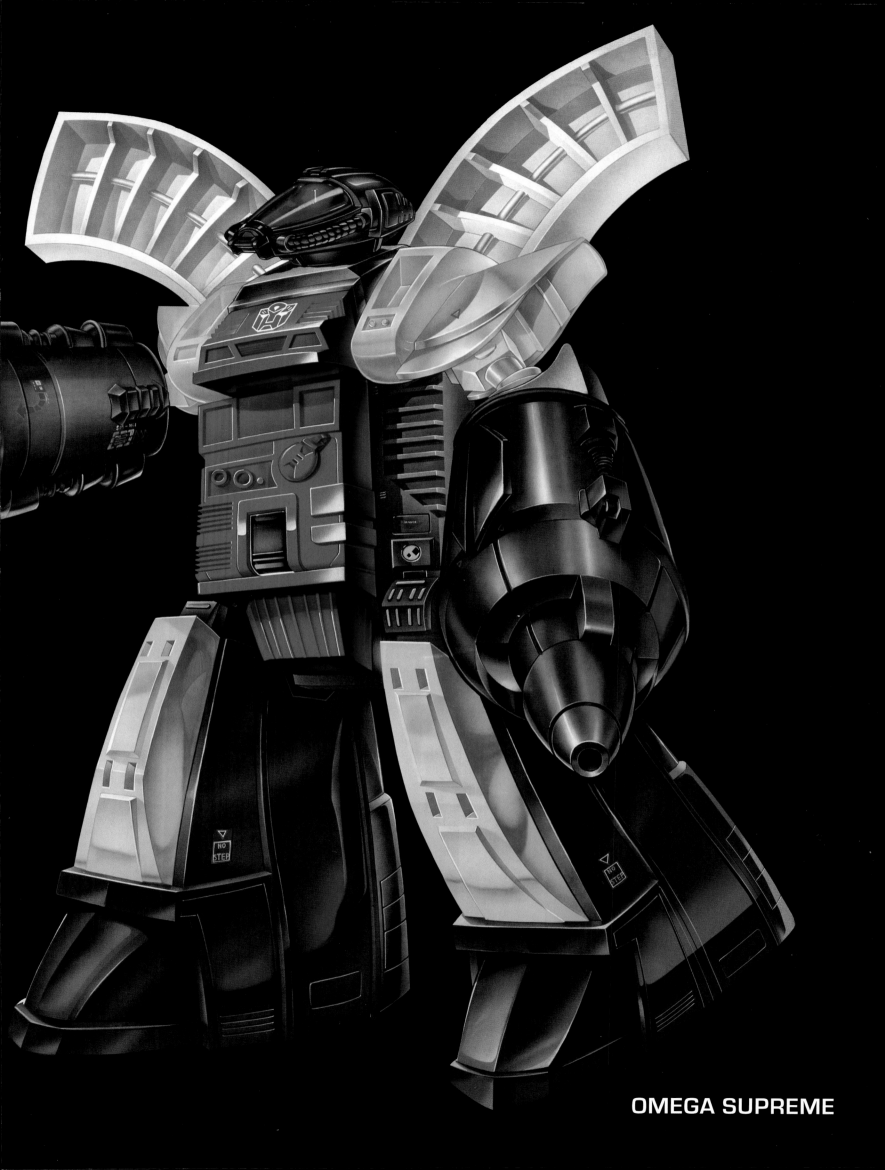

OMEGA SUPREME

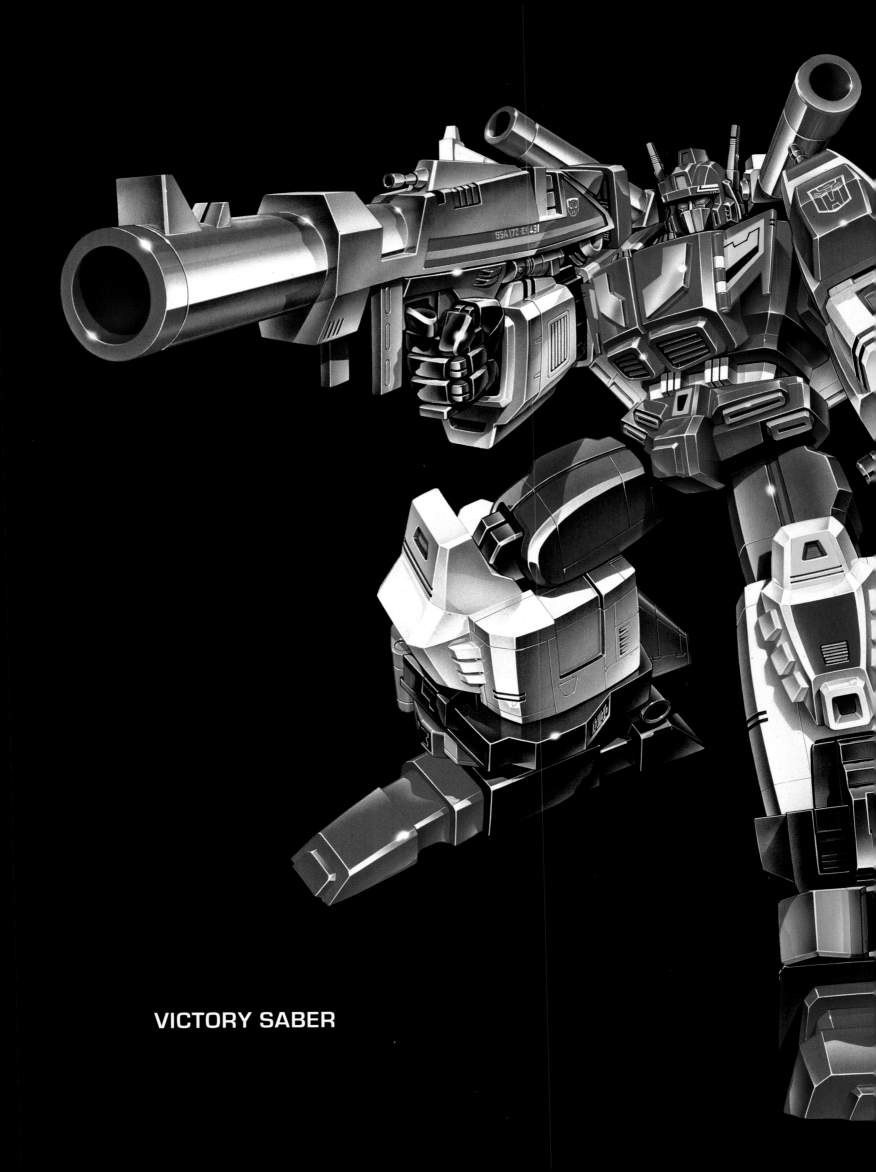

VICTORY SABER

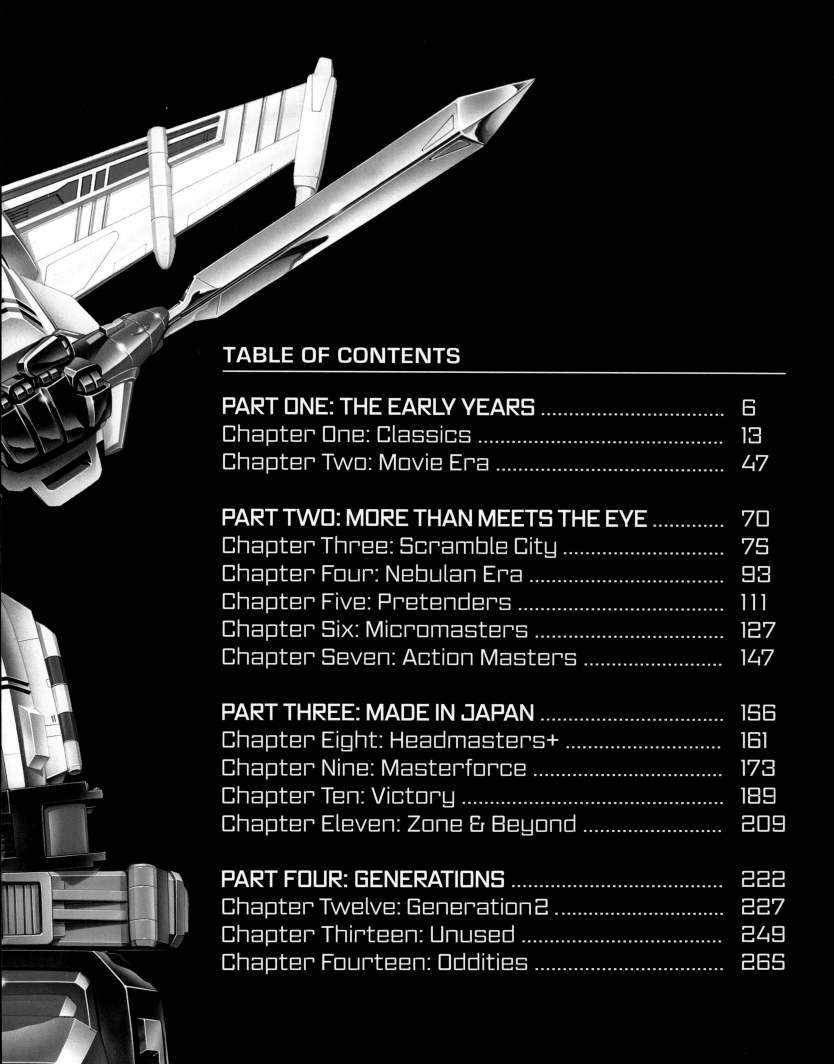

TABLE OF CONTENTS

Part One: The Early Years

There's something truly magical about the package art of Generation 1 Transformers. There is perhaps no other element of the brand that is quite as iconic, as resonant, as beautiful as the airbrushed paintings adorning each and every box and card, lining toy stores and promising endless science fiction adventure.

But what, exactly, are we talking about here? Well, back in the early '80s, the folks at Hasbro faced a conundrum. How do you best use the packaging to let kids know that this really cool jet it contains can, in fact, turn into an even cooler robot? Certainly, photographs of the toys were one answer, but it was a bit dry. Fortunately for Hasbro, this problem already had a solution ready-made. Takara, the Japanese company who had developed most of the molds that Hasbro would license to become the first two years of The Transformers, used incredibly slick airbrushed paintings of the robot modes of their toys to convey the core feature, the ability to change form.

Hasbro embraced this strategy—with a vengeance! Whereas only some of the Diaclone and Micro Change toys licensed by Hasbro had artwork associated with them, every Transformers toy would feature artwork to showcase the transformation. Generally this was the robot form, as most toys were packaged in vehicle or animal mode. On occasions where this format was broken, such as the Jumpstarters or Clones, the vehicle mode would be illustrated. Even when Japanese art existed for a given toy, it was often redrawn to account for branding elements and color variations between the markets. Another difference in strategy was the standardization of backgrounds, with color variations separating the good guys from the bad guys. In contrast, each subline in Diaclone and Micro Change had a different background style.

The results were amazing. The unique aesthetic of the package art of The Transformers became closely identified with the brand. It would prove one of the more popular licensing elements, appearing on lunchboxes, bedsheets, puzzles, backpacks, pajamas, pencil sharpeners, games, cereal, towels, calendars, sunglasses, stickers, trading cards, and just about anything else you can imagine. The artistic style remained essentially unchanged for more than a decade, through all seven years of Generation 1, three years of Generation 2, and overseas with the Transformers produced in Japan and the United Kingdom.

With the what covered, that brings us to the hows and the whys. How exactly was this volume put together, and why did we choose to do it the way we did? One may naively think that we simply called up Hasbro and requested a copy of their archives, with the results in your hand after a few weeks of fiddling with layouts. Nothing could be further from the truth. You see, back in the early '80s, no one at Hasbro realized that, in addition to creating THE hot toys of the day, they were building incredibly valuable intellectual property. They can be forgiven, few of their competitors realized it either. After the work was done, the work was done. Art was often lost, thrown out, refurbished, or just misfiled. One Hasbro executive wistfully told us how the artwork for a prominent G.I. Joe hero was literally painted over to give him a new costume.

So, where DID the art in this tome come from? Well, Hasbro has managed to save a few pieces, 'round about 30, mostly original paintings. Additionally, Takara (through their graphics design firm, Part One) had an extensive archive of several hundred characters that were released in their markets. For the math inclined, there are about 750 pieces of art in this book, which means that official sources got us only halfway. There were serious gaps in coverage from where the US and Japanese markets diverged, largely late Generation 1, all of Generation 2, and early non-Takara licensed pieces like the Deluxe Insecticons. That gap was largely filled by fans. Some had original artwork. A few had original photo negatives. Many more had transparencies (called chrome positives) that were used for licensing and production purposes. Style guides made up the rest.

One source which we did not turn to was actual scans of the packages. Oh, sure, we gave it a shot, but the sad reality was that the quality just wasn't there. The print on the original boxes was too poor, resulting in images that had to be much too small to use, and that was assuming that the image was unobstructed, which was generally not the case. Thus, there

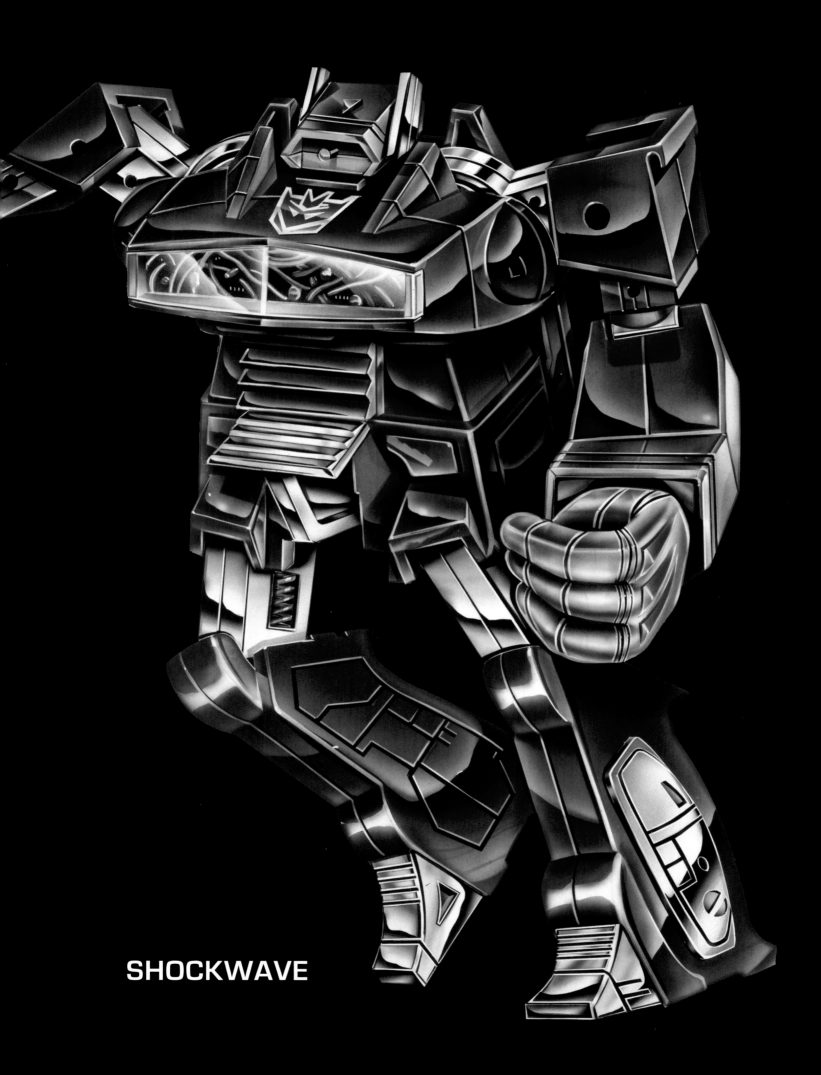

SHOCKWAVE

Micro Cassette Robo
Jaguar (Ravage) Illustration

are the occasional gaps. This book isn't QUITE 100% complete for our scope (US G1 and G2, Japan G1) but it comes close. By our count, we're missing just over a dozen unique illustrations, not counting repainted art and regional variations. We trust you'll forgive us these omissions.

Which brings us to this book, a true celebration of this artistic style. To make things digestible, we've organized things into four parts and fourteen chapters. Part One covers the early years, when the concept was fresh and new and kids were still getting used to the basic idea that a sentient alien robot could come from the planet Cybertron and disguise himself as a fighter jet or a Lamborghini or a space shuttle.

Things kick off in Chapter One with the Classic Era, toy concepts introduced in 1984 and 1985. Even today, these characters have a special resonance. The name Optimus Prime has truly transcended its origins to become a part of the pop culture landscape. There were a few sublines here but gimmicks were few and far between; most toys simply relied on the core concept of a robot that could change into another form.

Chapter Two covers the Movie Era, toys introduced in 1986-1988 excluding some specific sublines. In this timeframe, Hasbro transitioned from toys licensed from Japanese companies to toys they were producing themselves. Due to story and design considerations, many of the alternate modes took on a futuristic feel. The use of gimmicks expanded, to the point where most toys featured in Chapter Two can do something beyond a simple conversion.

But why wait? Adventure beckons!

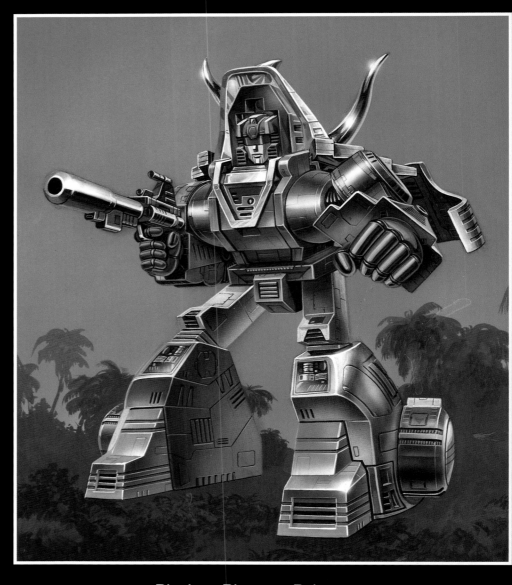

Diaclone Dinosaur Robo
Triceratops (Slag) Illustration

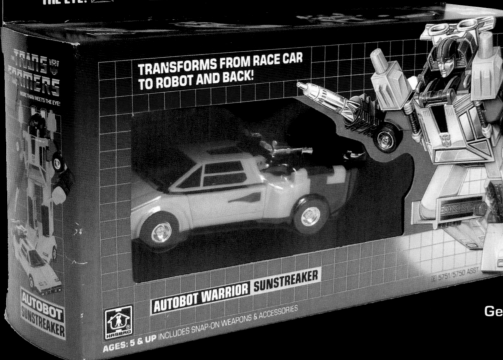

Generation 1 Sunstreaker
MIB (Mint In Box)

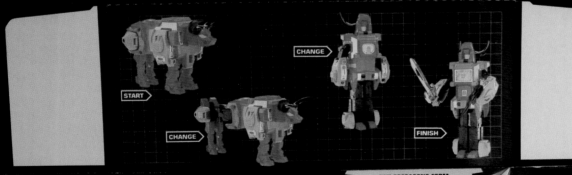

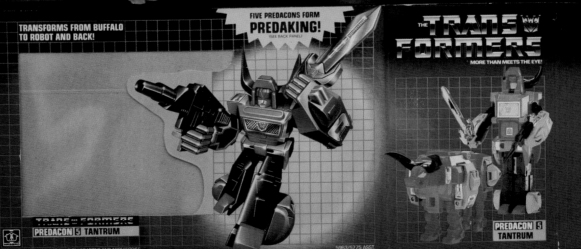

Tantrum Pre-Production Package

9

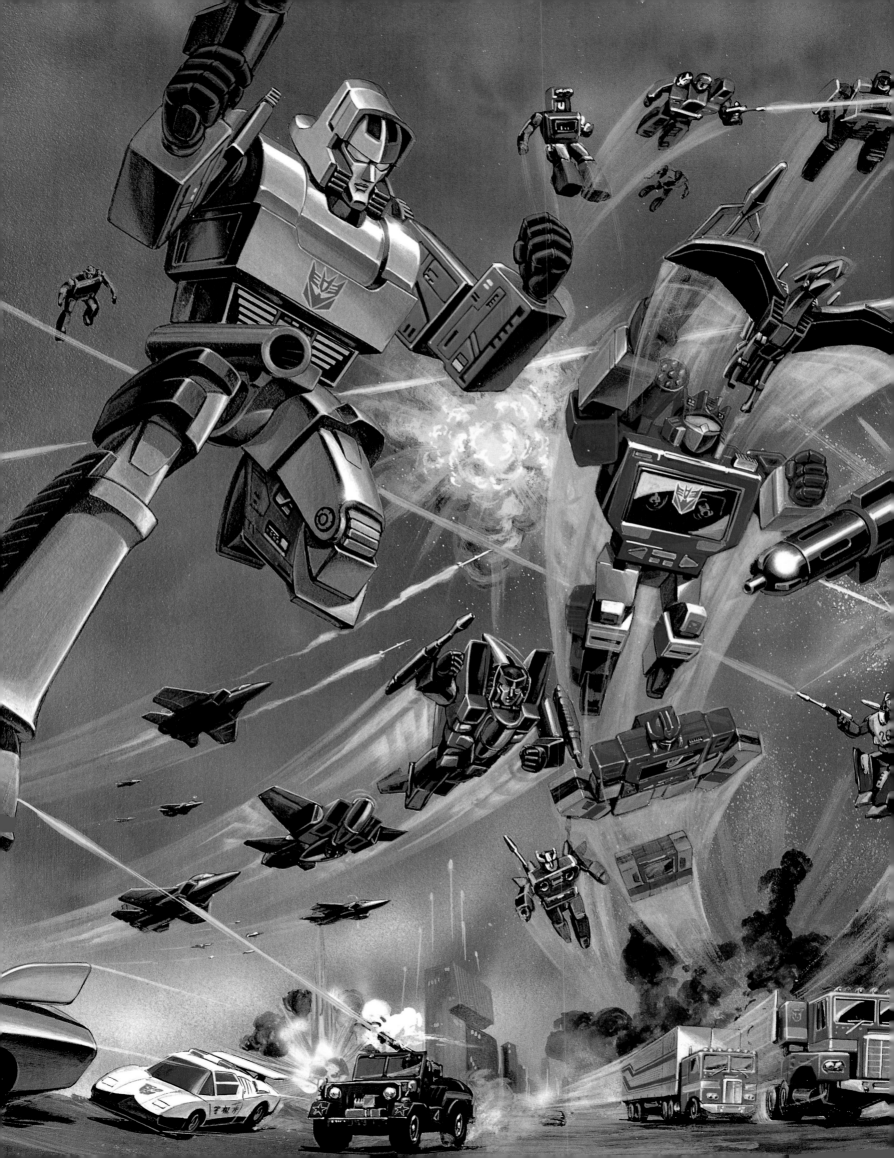

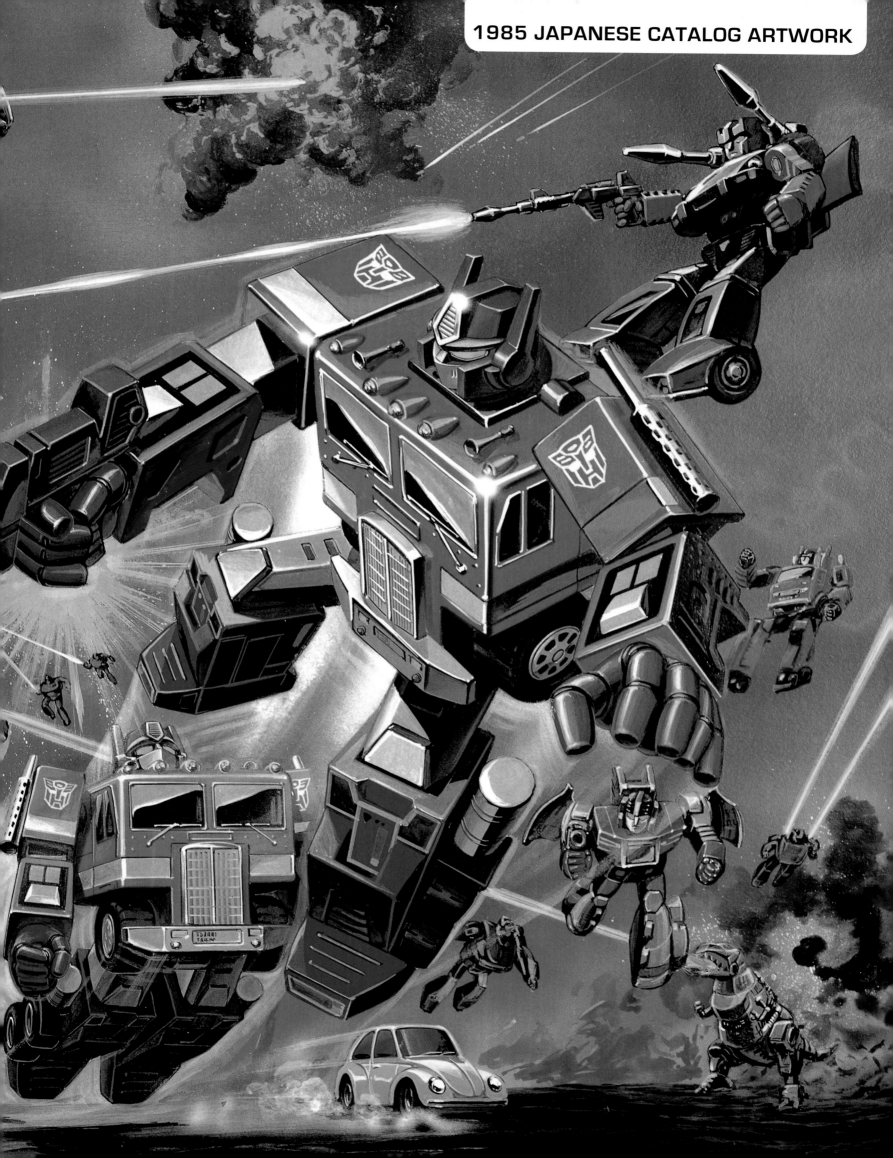

illustrators WANTED

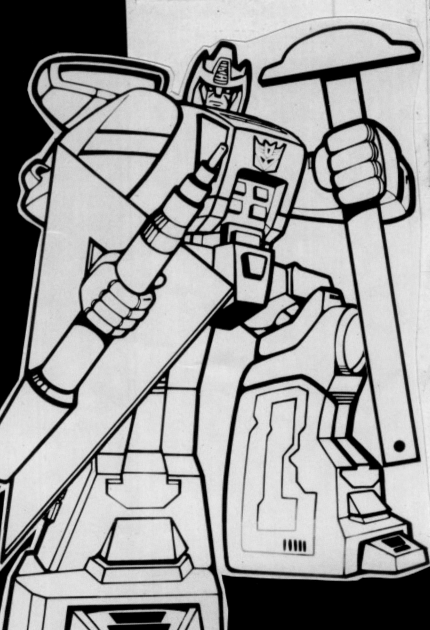

Hasbro, Inc., the world's leading toy and game manufacturer, is seeking freelance, line art and full color illustrators for exciting product lines like G.I. Joe®, My Little Pony® and products from our Playskool®-Preschool divisions. Qualified candidates and design studios should have experience with:

- Technical line art illustrations for consumer assembly instruction sheets.

 Ability to do accurate perspective drawings and exploded views.

- Full color illustrations.

 Excellent drawing and rendering skills.

 Interaction within a dynamic, fast paced environment.

If you meet these requirements, please respond with sample to:

HASBRO

"It is a world transformed, where things are not what they seem." 1984 saw the debut of The Transformers, with the heroic Autobots battling the evil Decepticons.

OPTIMUS PRIME

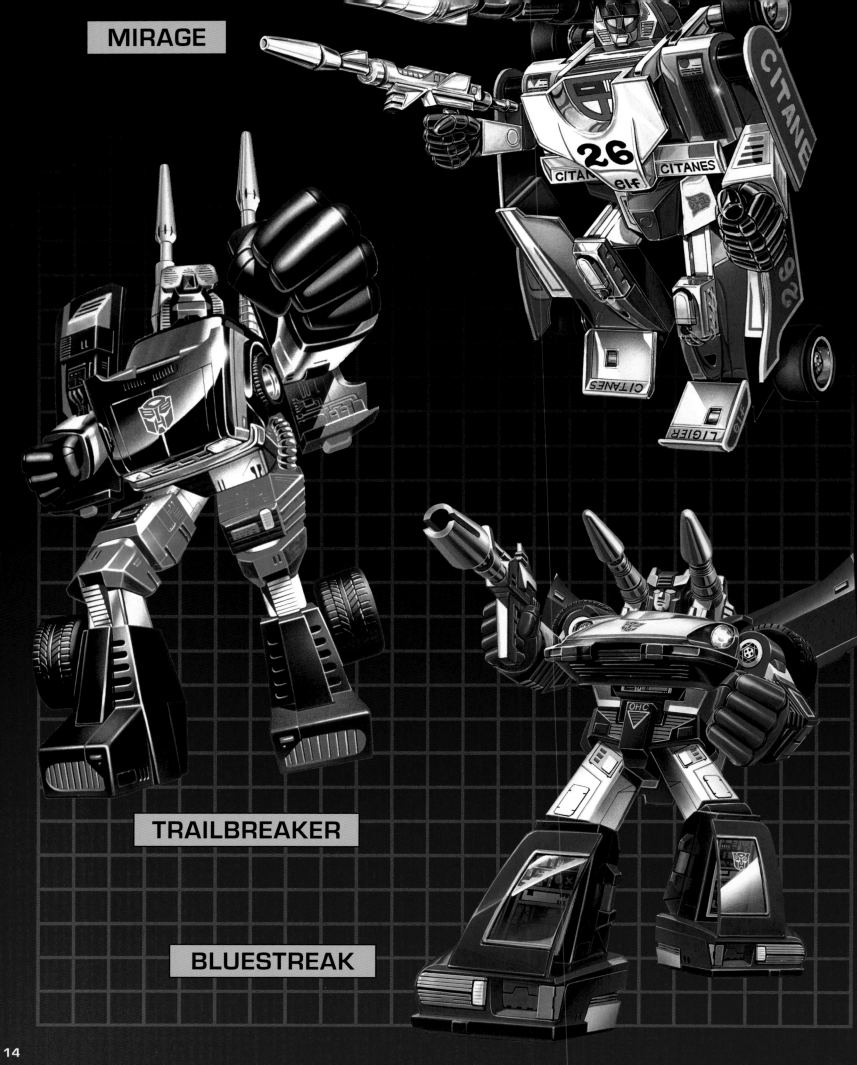

MIRAGE

TRAILBREAKER

BLUESTREAK

14

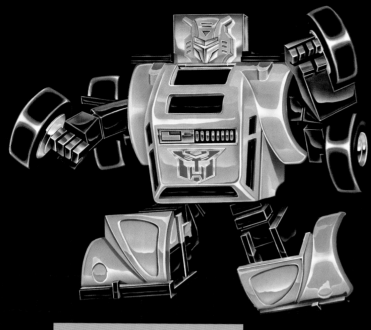

BUMBLEBEE

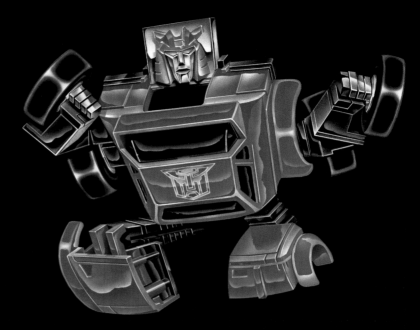

CLIFFJUMPER

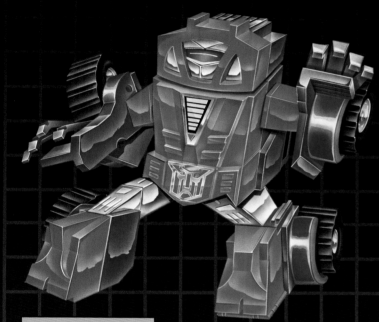

GEARS

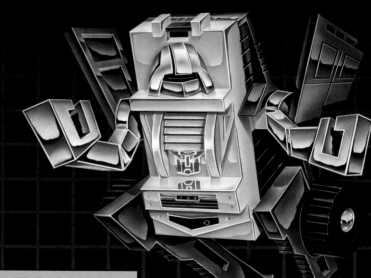

BRAWN

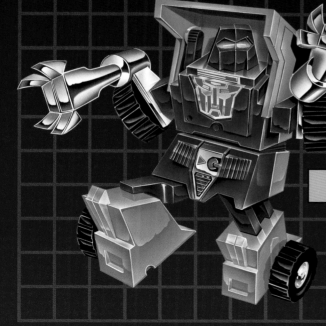

HUFFER

WINDCHARGER

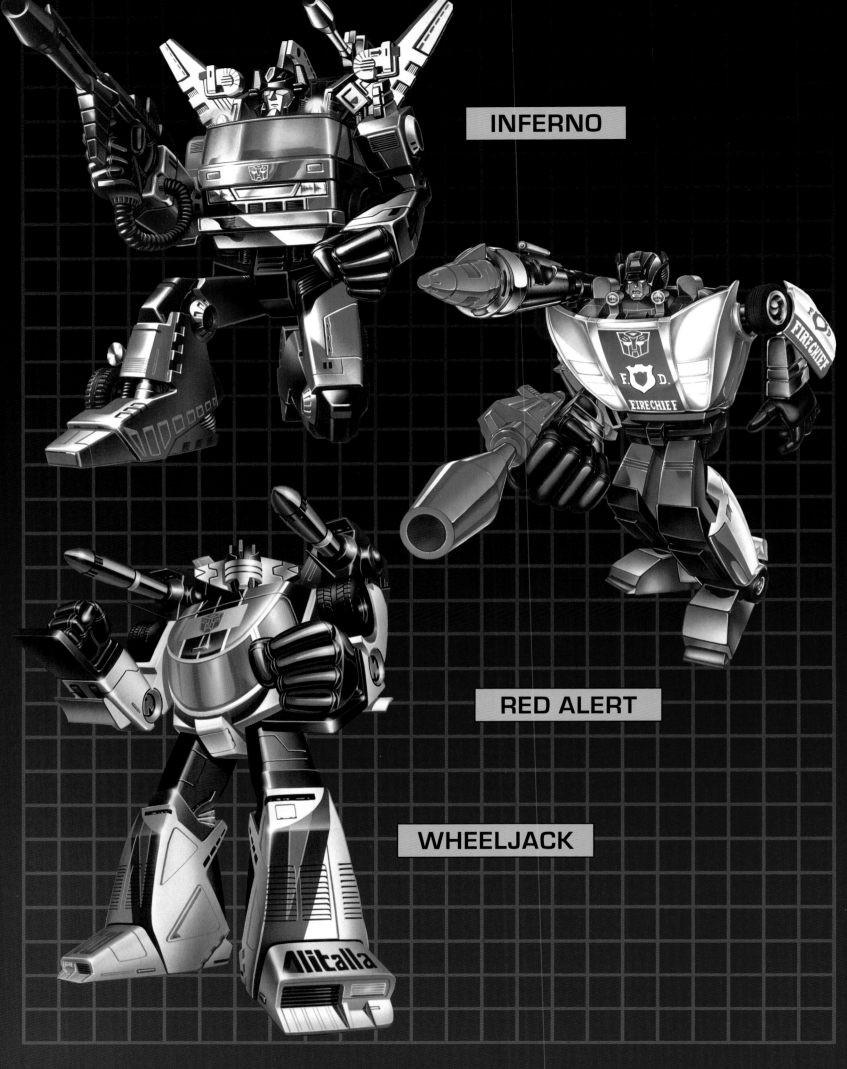

INFERNO

RED ALERT

WHEELJACK

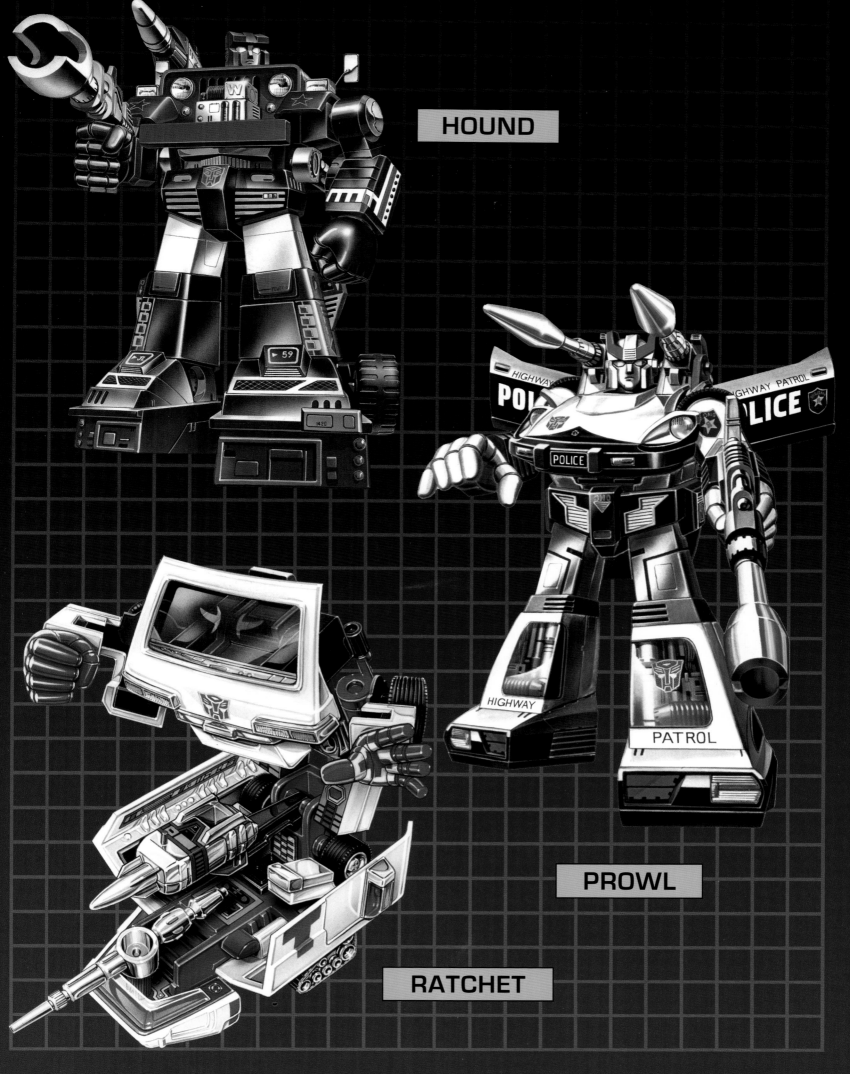

HOUND

PROWL

RATCHET

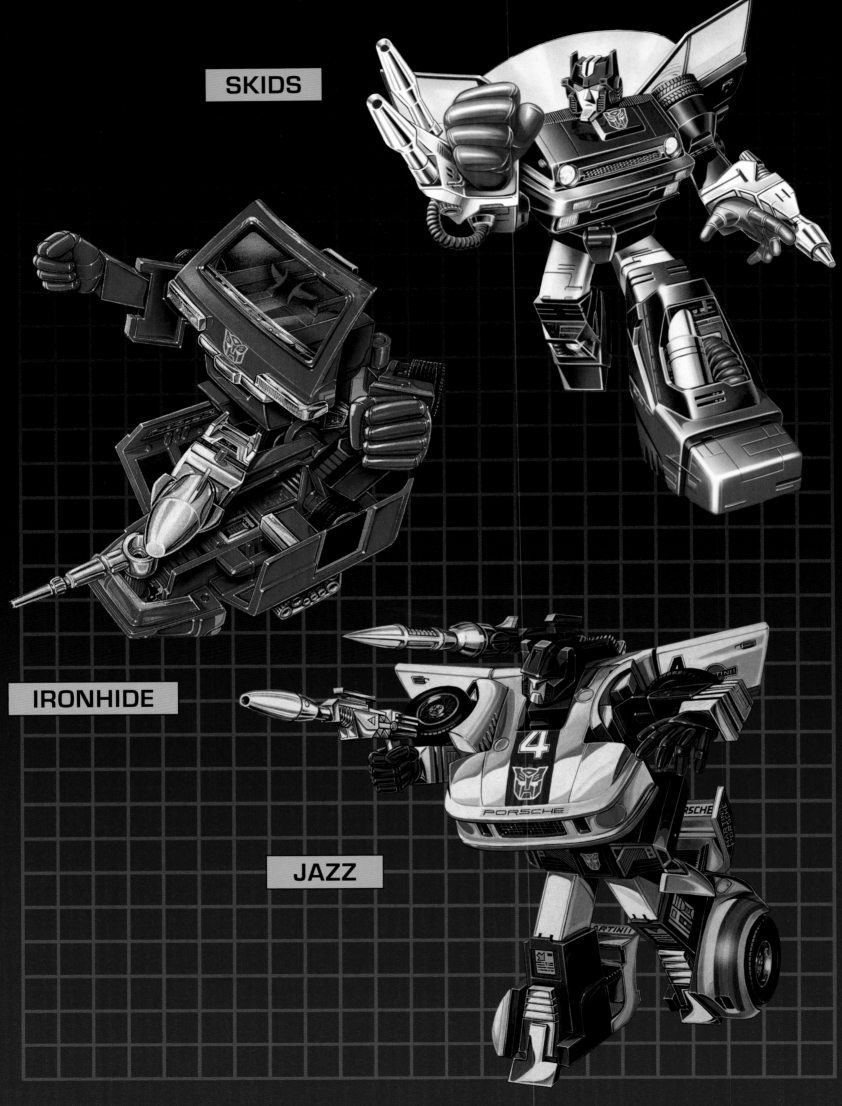

SKIDS

IRONHIDE

JAZZ

18

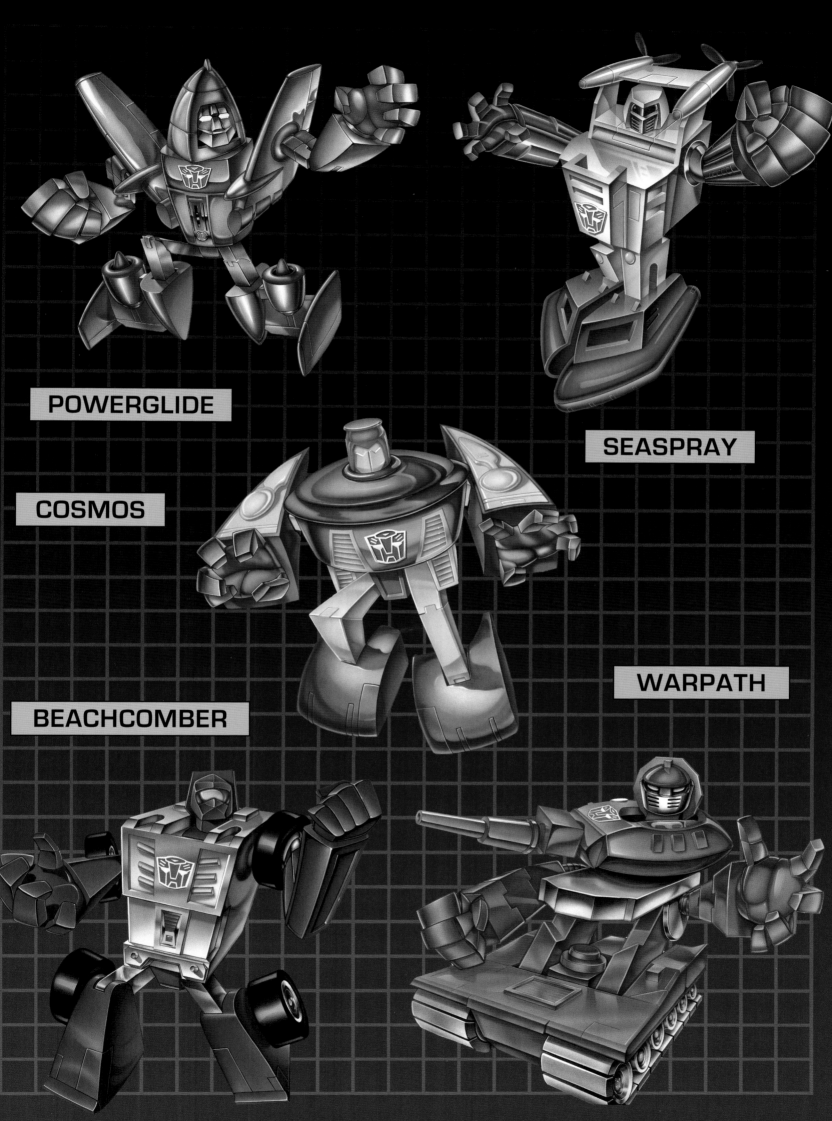

POWERGLIDE

SEASPRAY

COSMOS

WARPATH

BEACHCOMBER

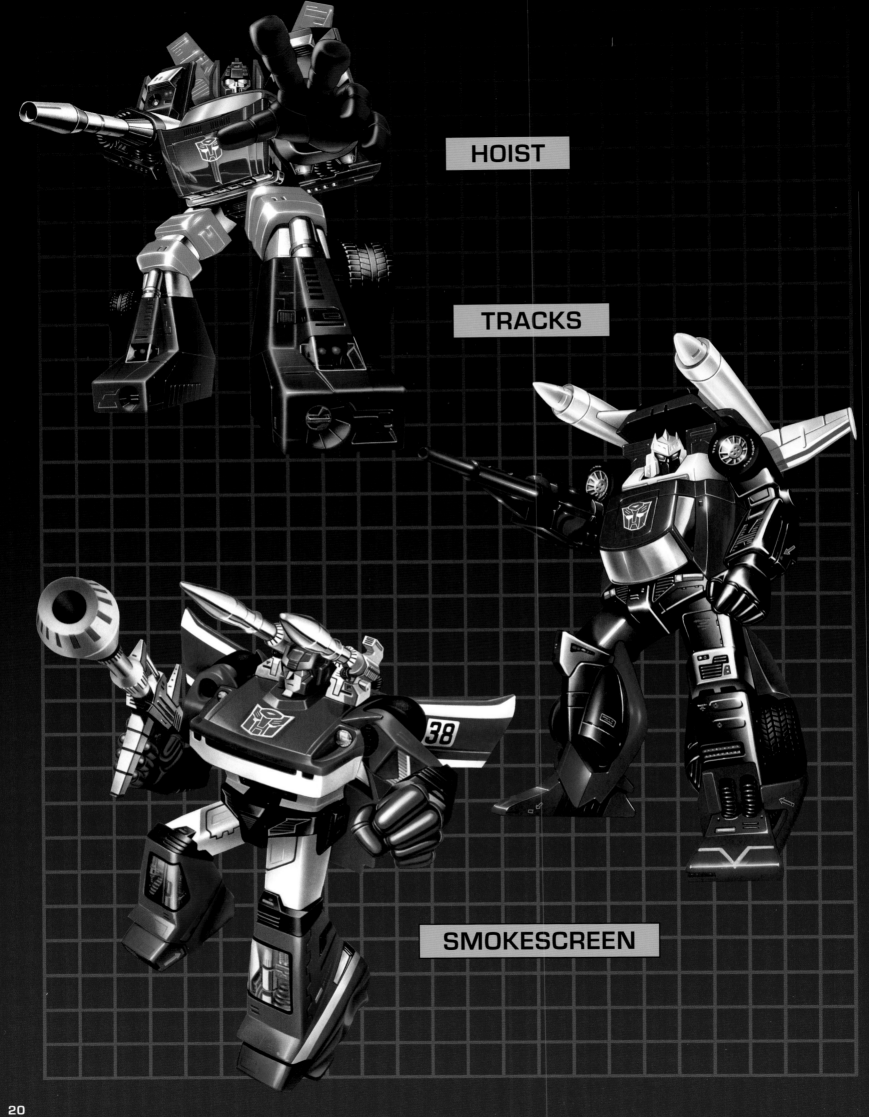

HOIST

TRACKS

SMOKESCREEN

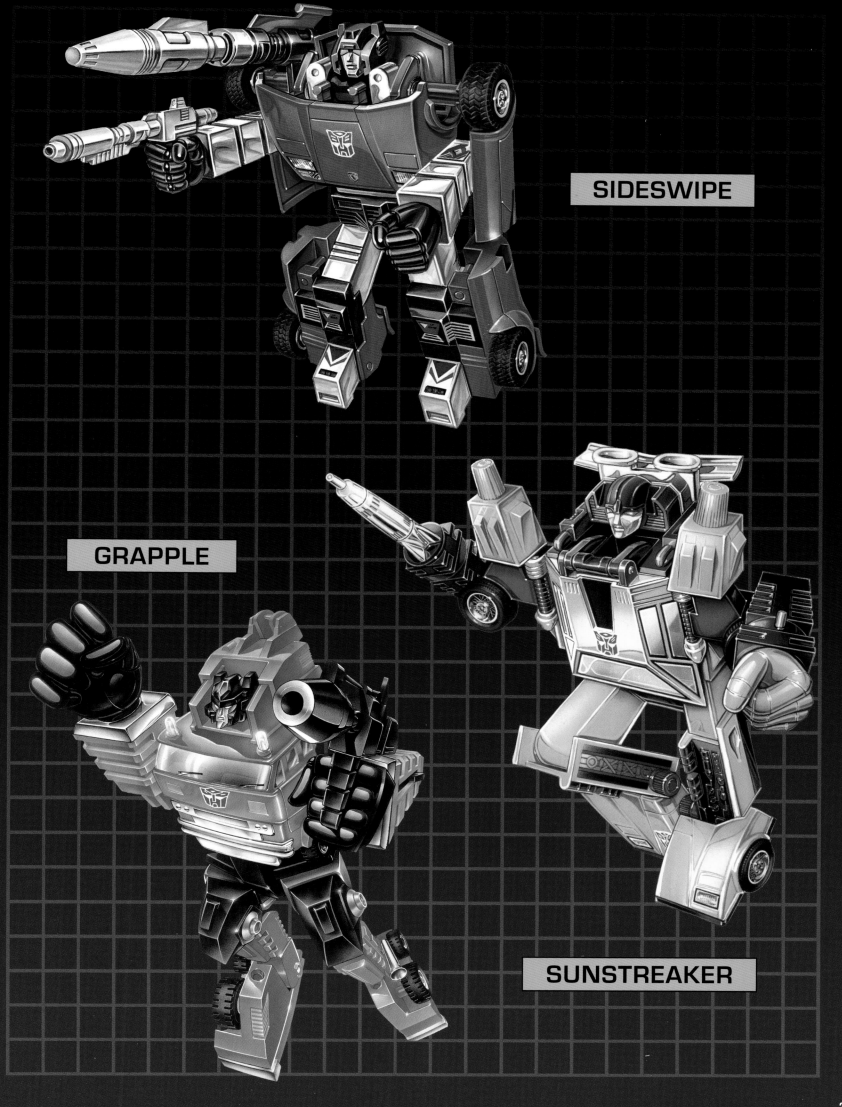

SIDESWIPE

GRAPPLE

SUNSTREAKER

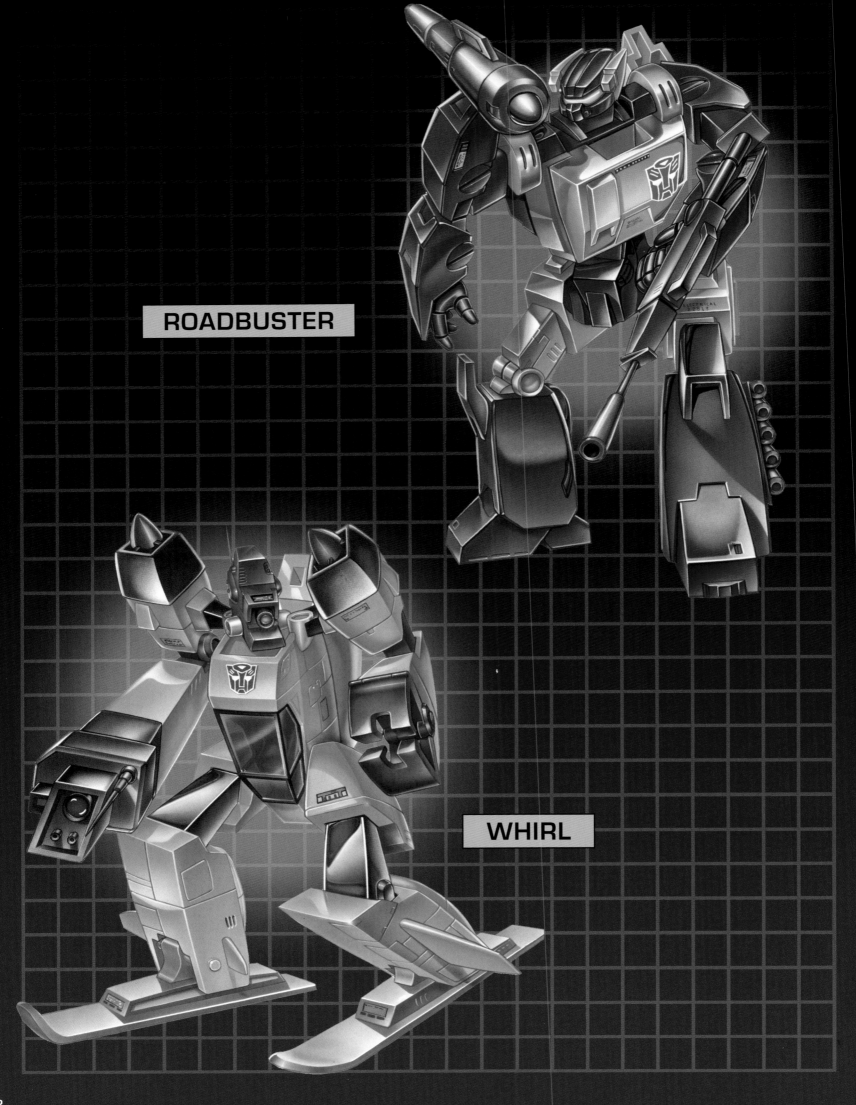

ROADBUSTER

WHIRL

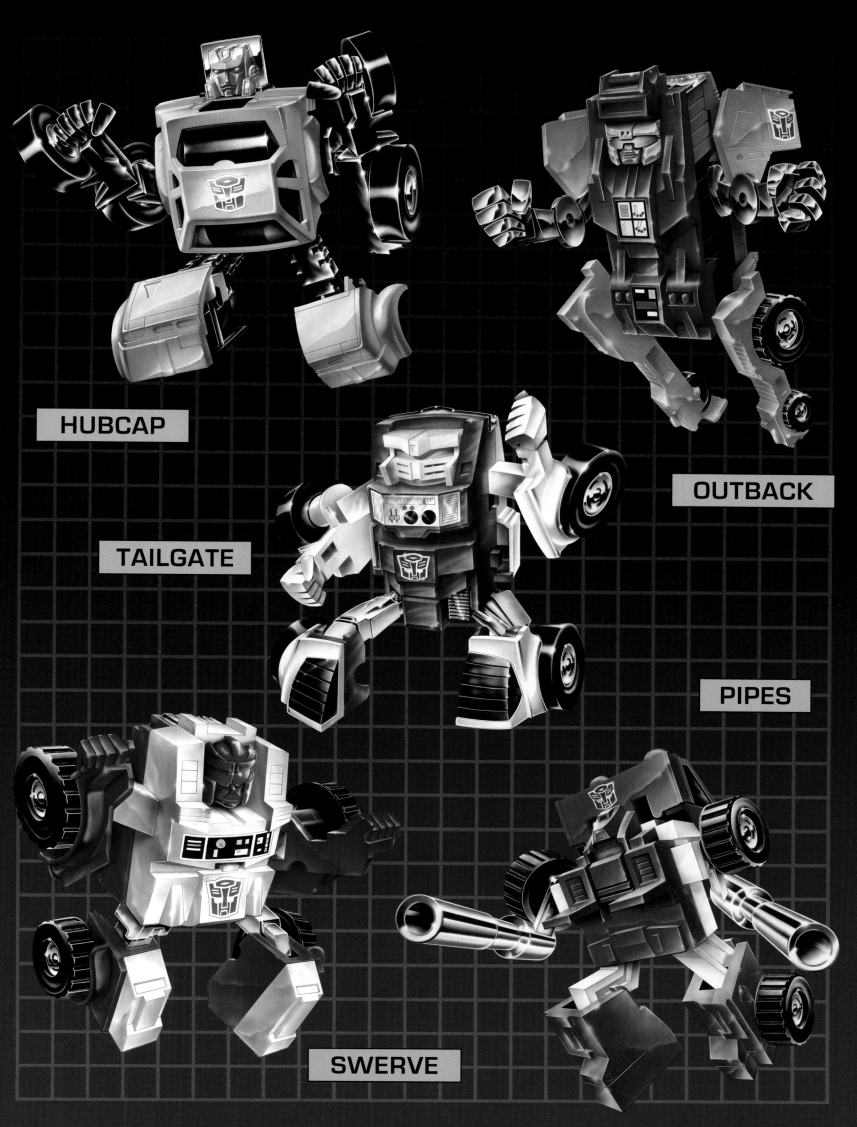

HUBCAP

OUTBACK

TAILGATE

PIPES

SWERVE

23

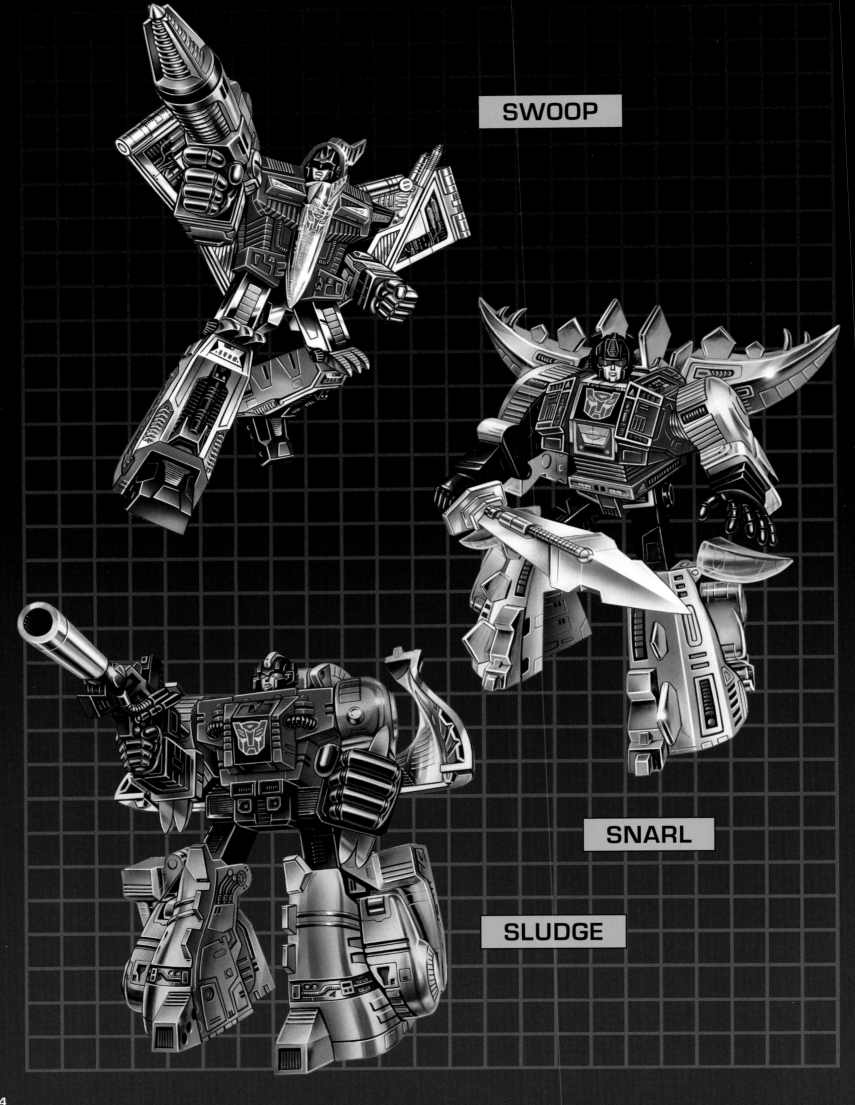

SWOOP

SNARL

SLUDGE

24

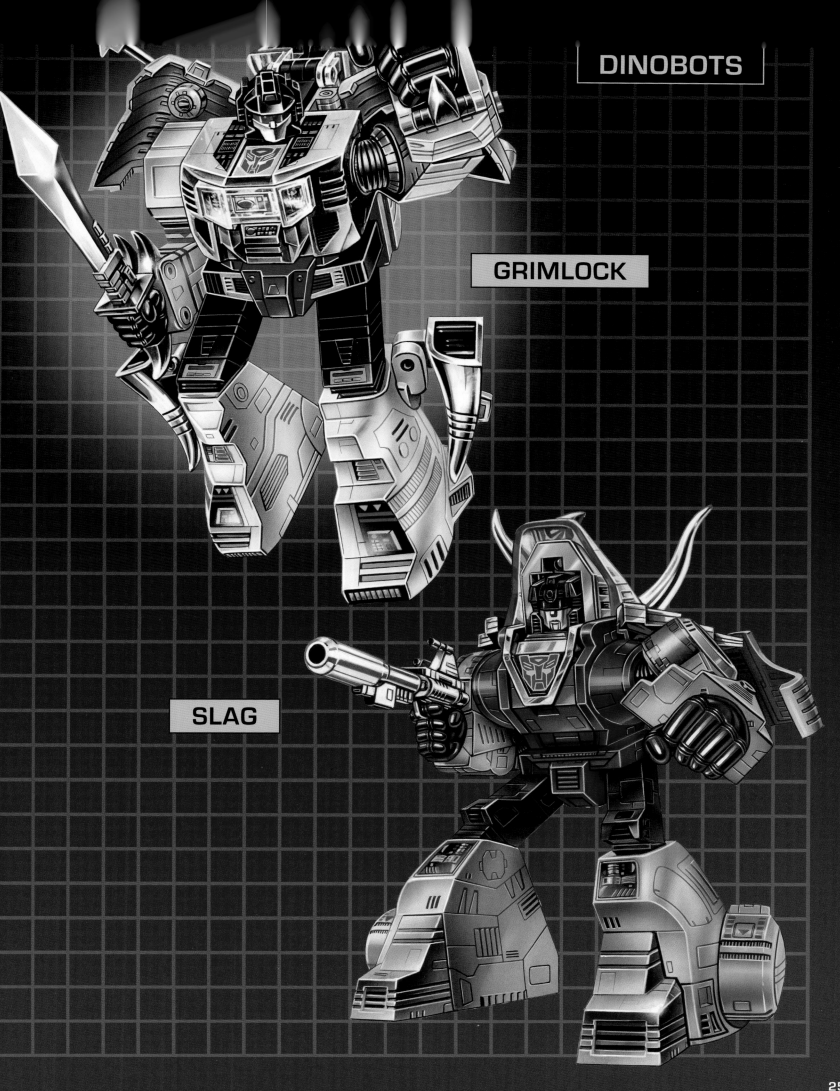

DINOBOTS

GRIMLOCK

SLAG

25

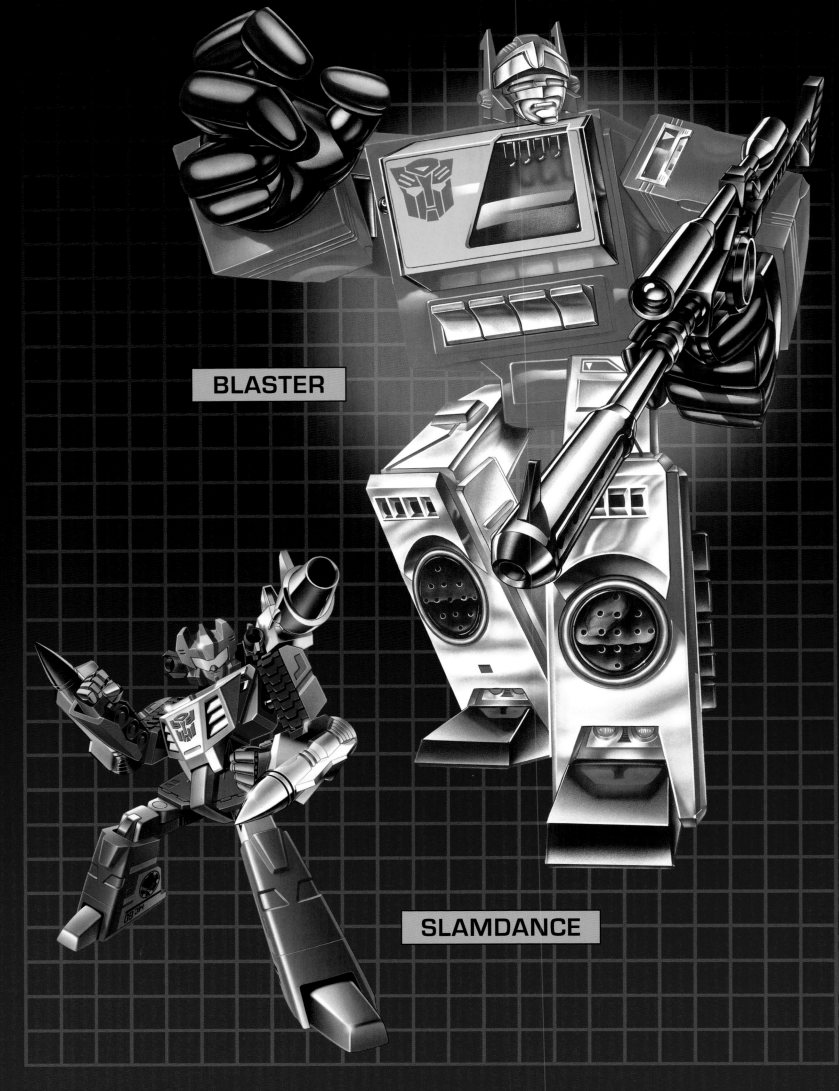

BLASTER

SLAMDANCE

26

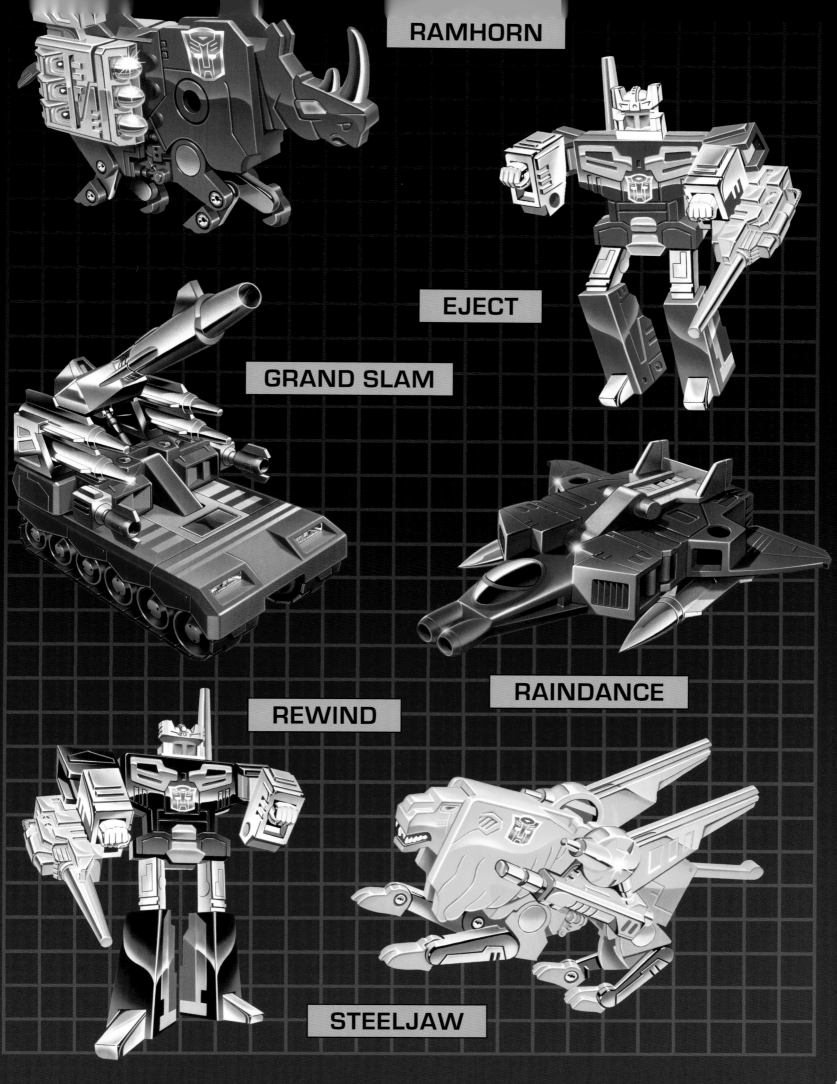

RAMHORN

EJECT

GRAND SLAM

RAINDANCE

REWIND

STEELJAW

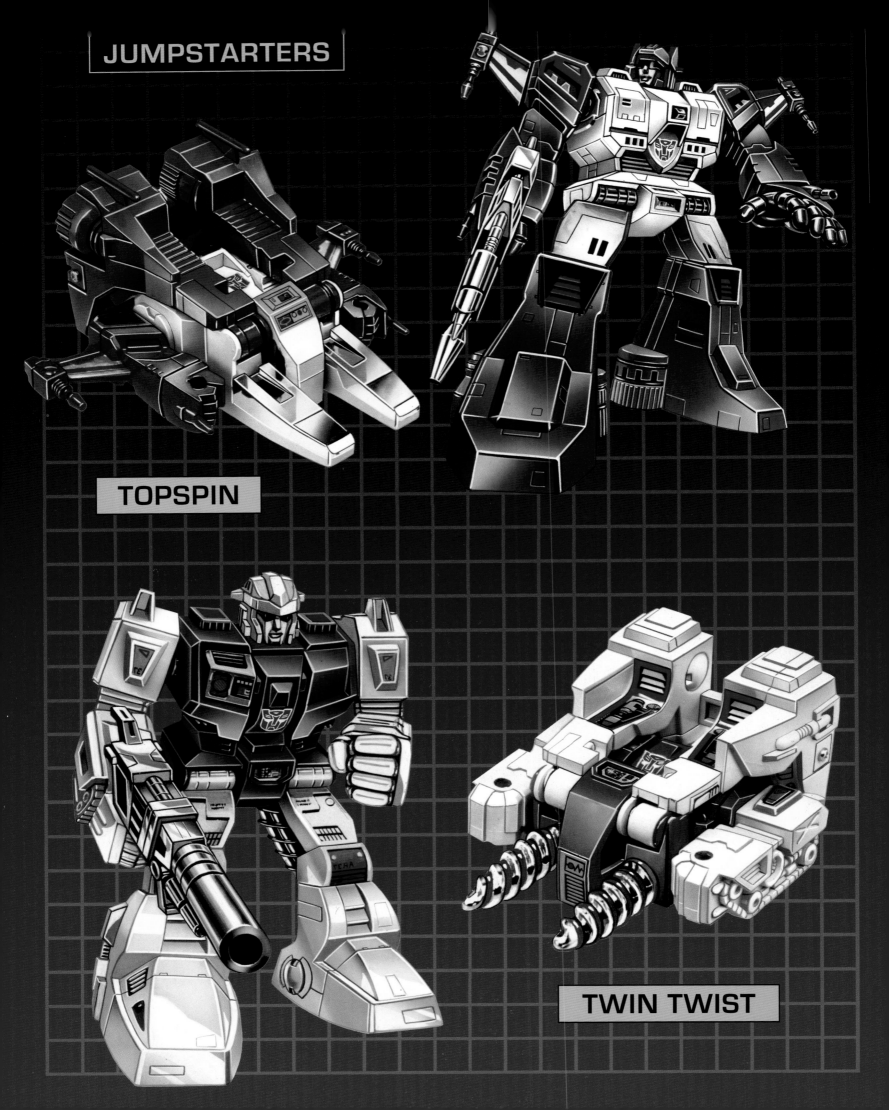

JUMPSTARTERS

TOPSPIN

TWIN TWIST

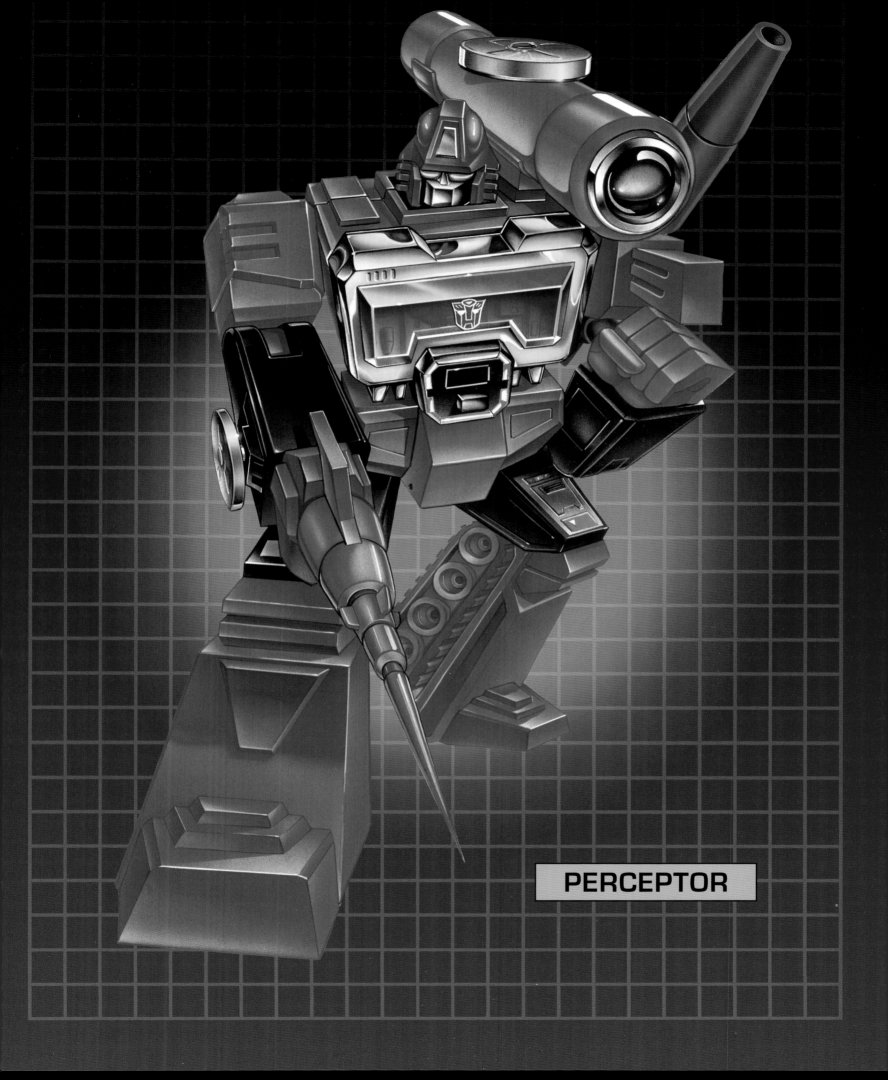

PERCEPTOR

OMNIBOTS

OVERDRIVE

DOWNSHIFT

CAMSHAFT

SAVE FOR SPECIAL
TRANSFORMER
PREMIUMS!

2

ROBOT PTS.

SAVE FOR SPECIAL
TRANSFORMER
PREMIUMS!

2

ROBOT PTS
PTS DE ROBOT

CONSERVEZ POUR
PRIMES SPÉCIALES
TRANSFORMATEURS!

C-108 ターゲットマスター
スナイパー
アートファイアー

2

ROBOT PTS

The Omnibots had no box art of their own in their US release, as they were only sold as mail order exclusives for fans who clipped the "Robot Points" from the back of their packages and sent them in. This artwork was created for a toy pack-in catalog.

MEGATRON

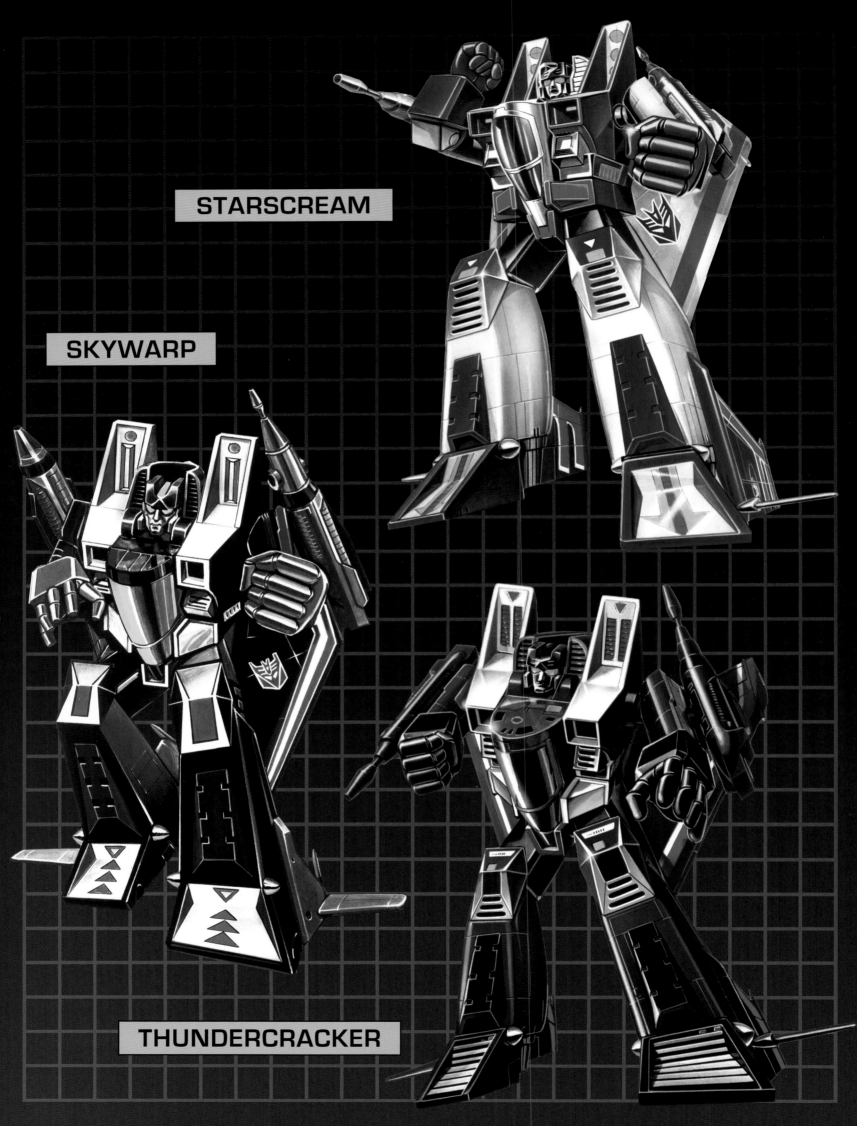

STARSCREAM

SKYWARP

THUNDERCRACKER

32

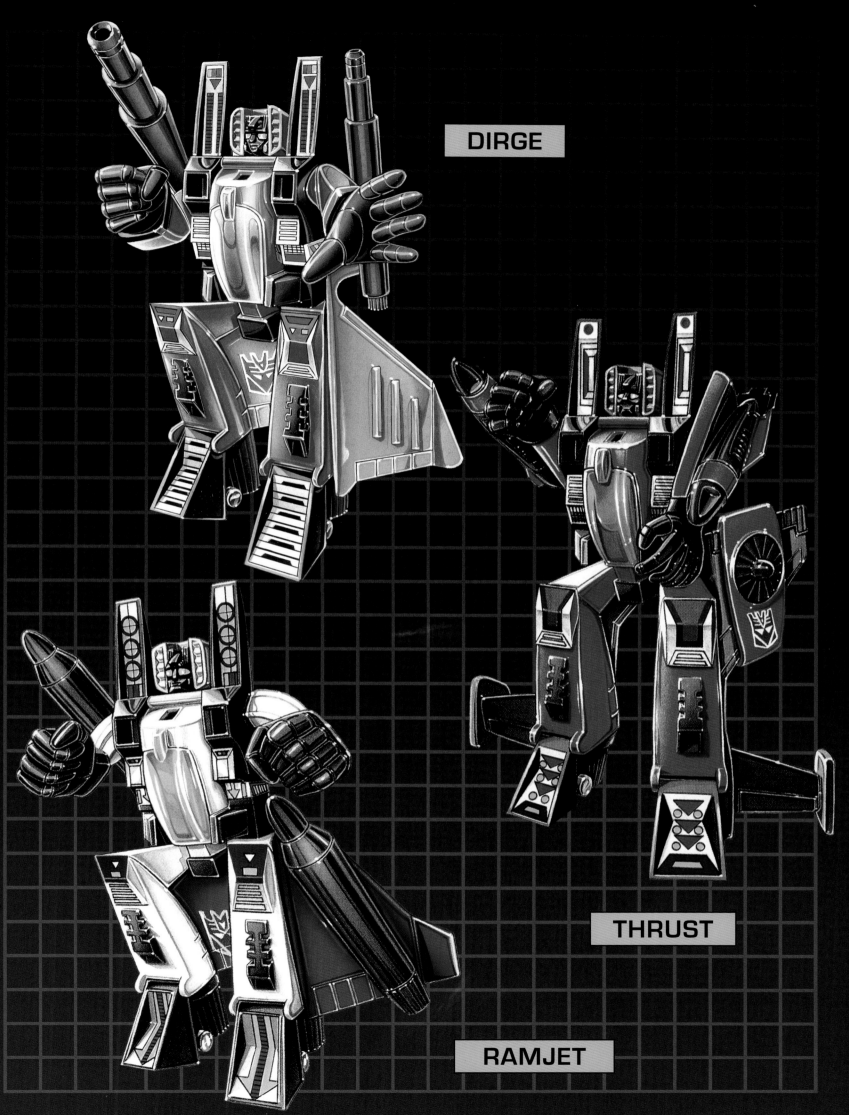

DIRGE

THRUST

RAMJET

33

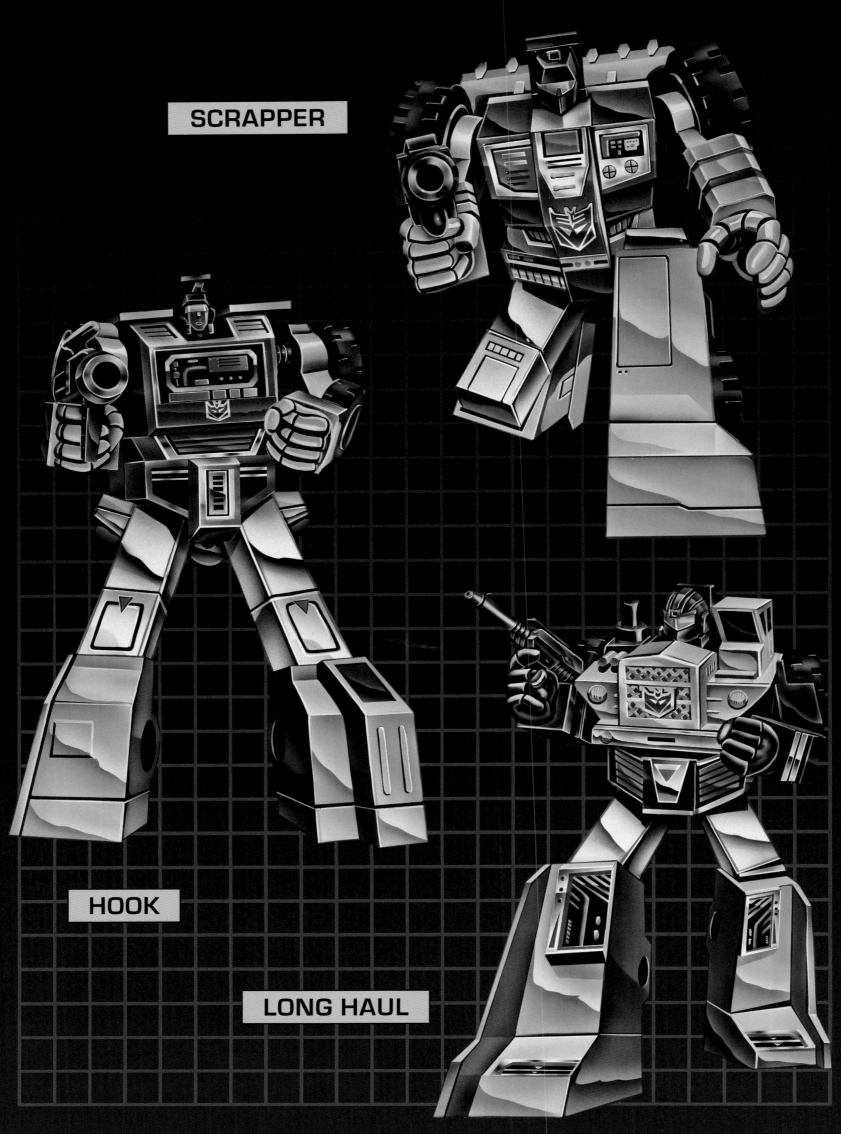

SCRAPPER

HOOK

LONG HAUL

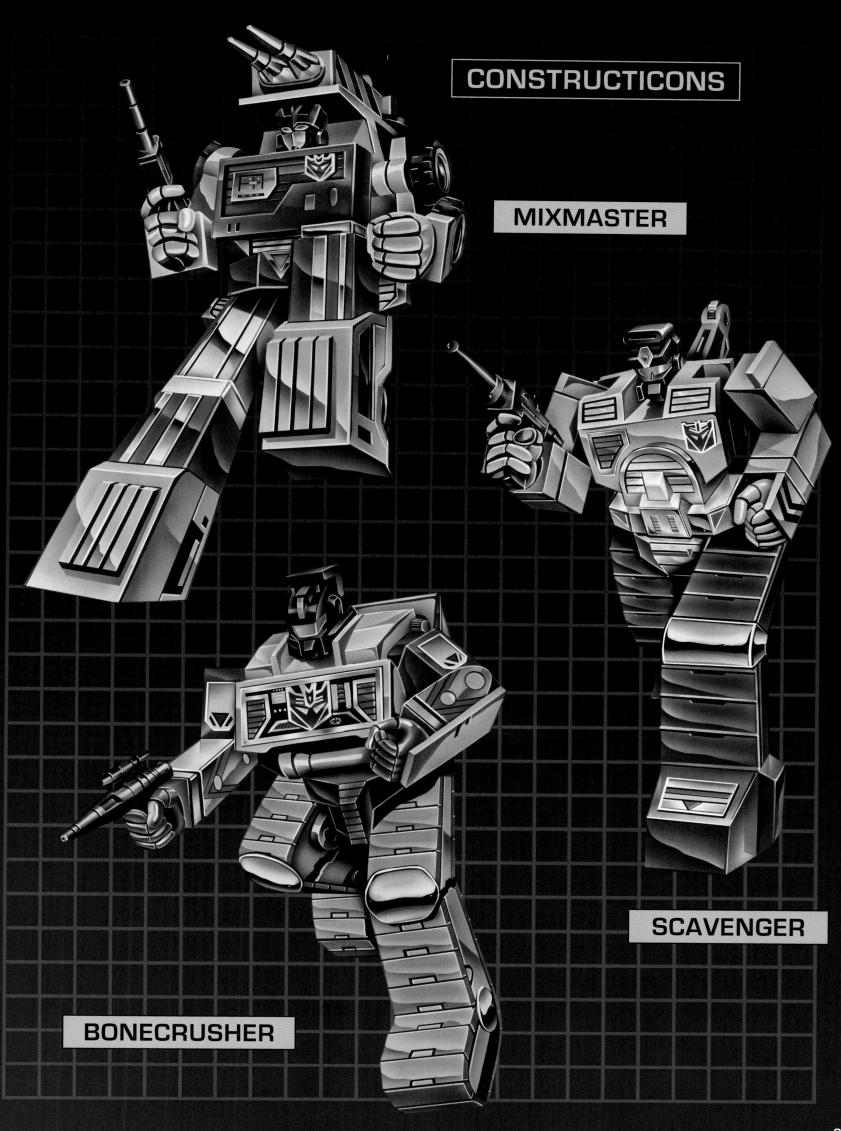

CONSTRUCTICONS

MIXMASTER

SCAVENGER

BONECRUSHER

35

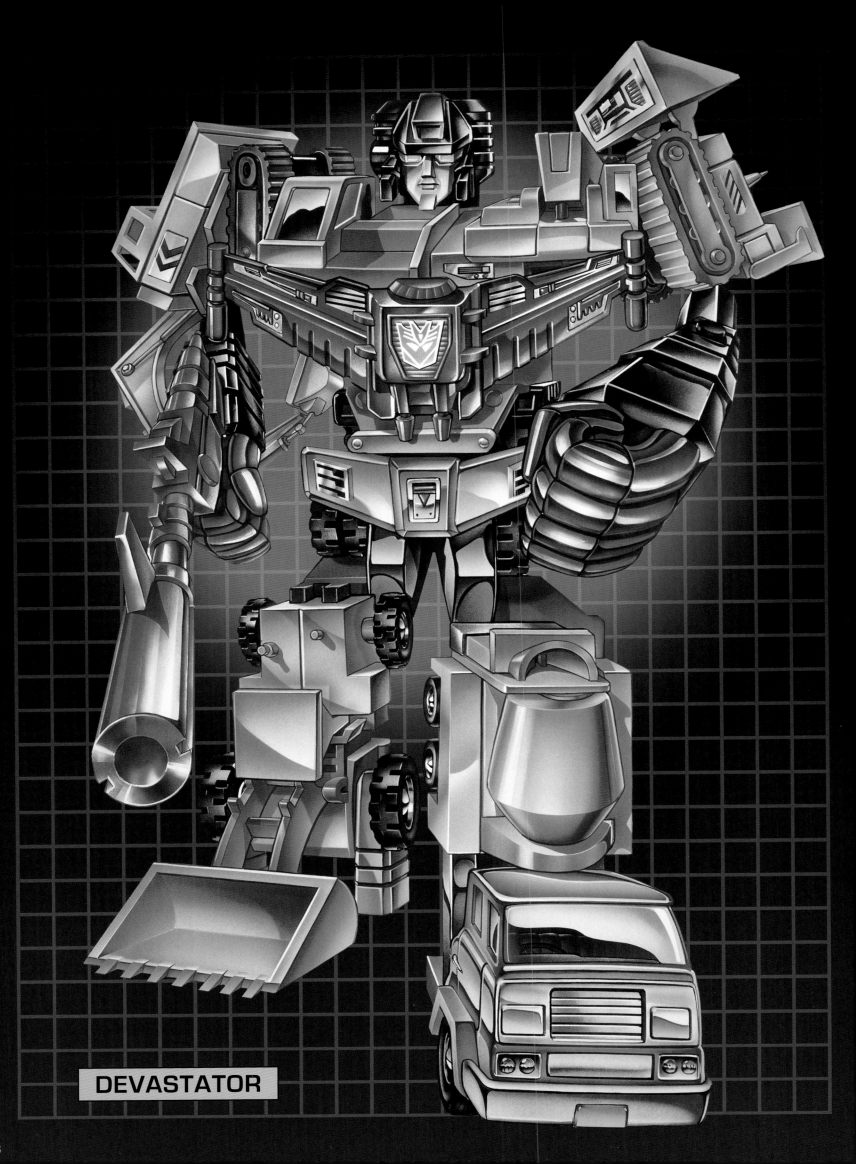

DEVASTATOR

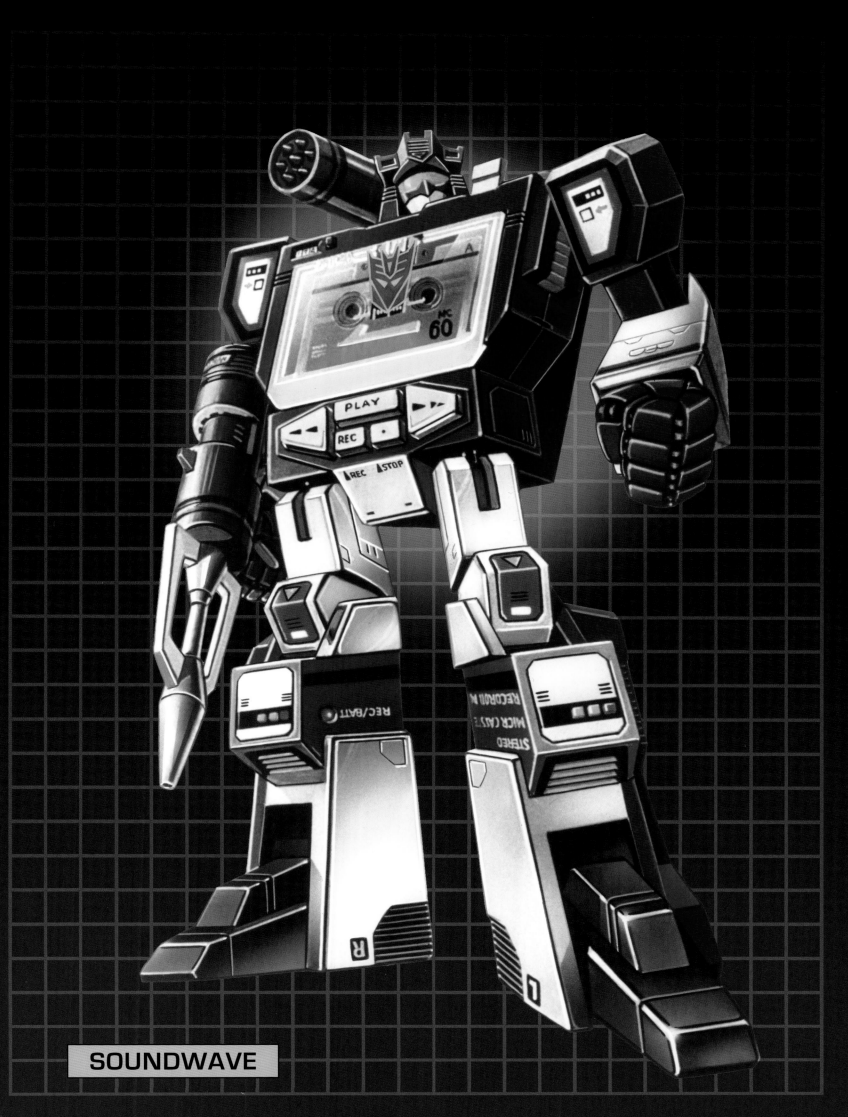

SOUNDWAVE

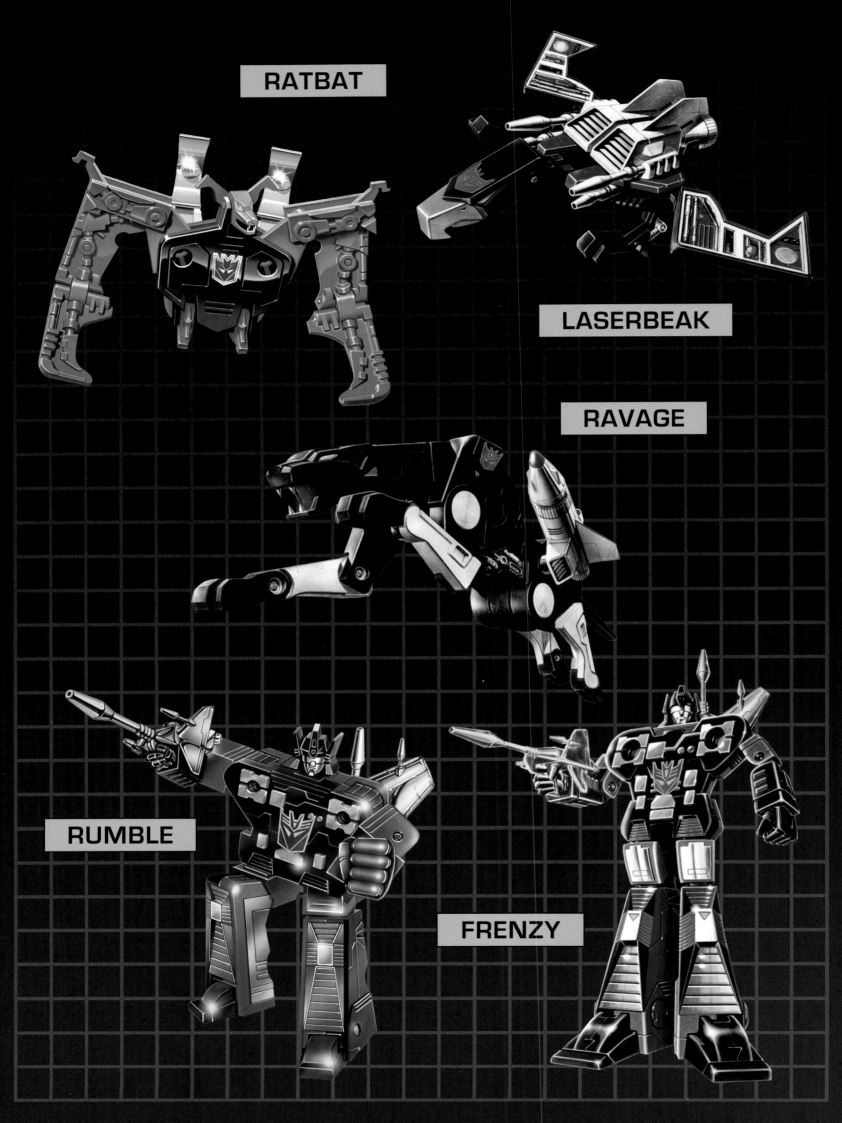

RATBAT

LASERBEAK

RAVAGE

RUMBLE

FRENZY

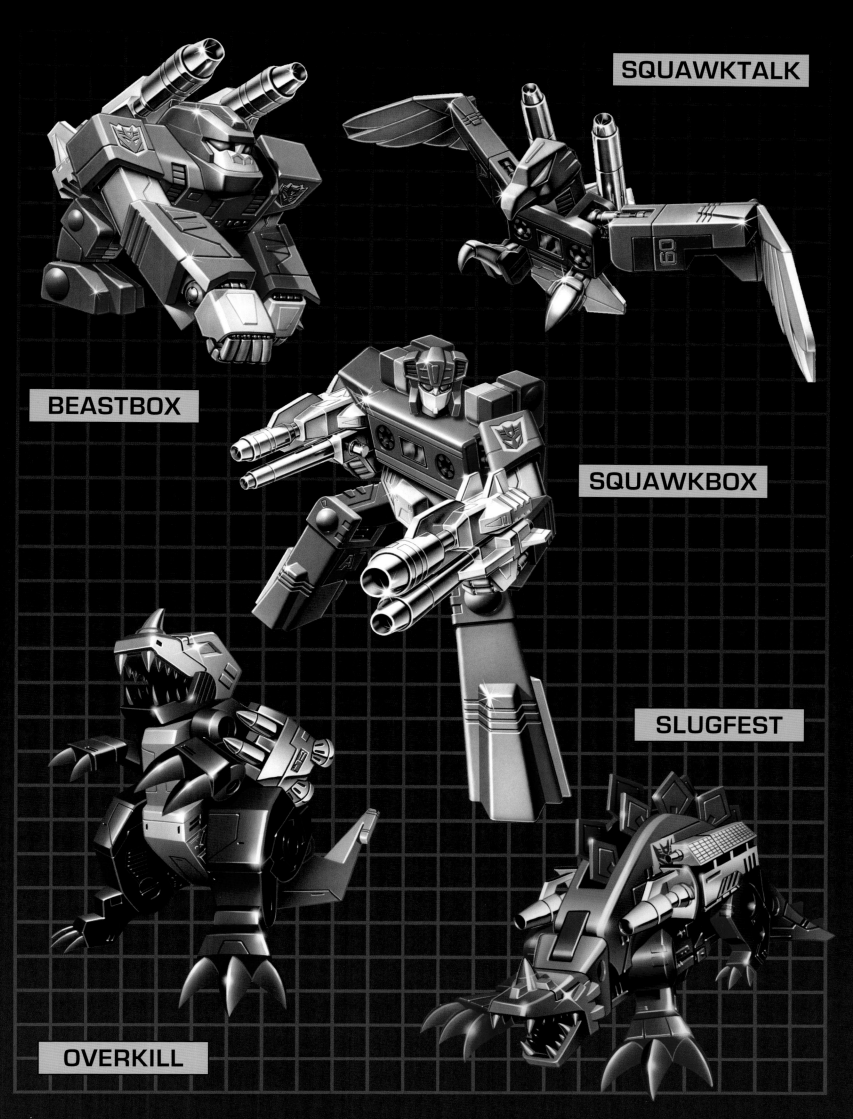

SQUAWKTALK

BEASTBOX

SQUAWKBOX

SLUGFEST

OVERKILL

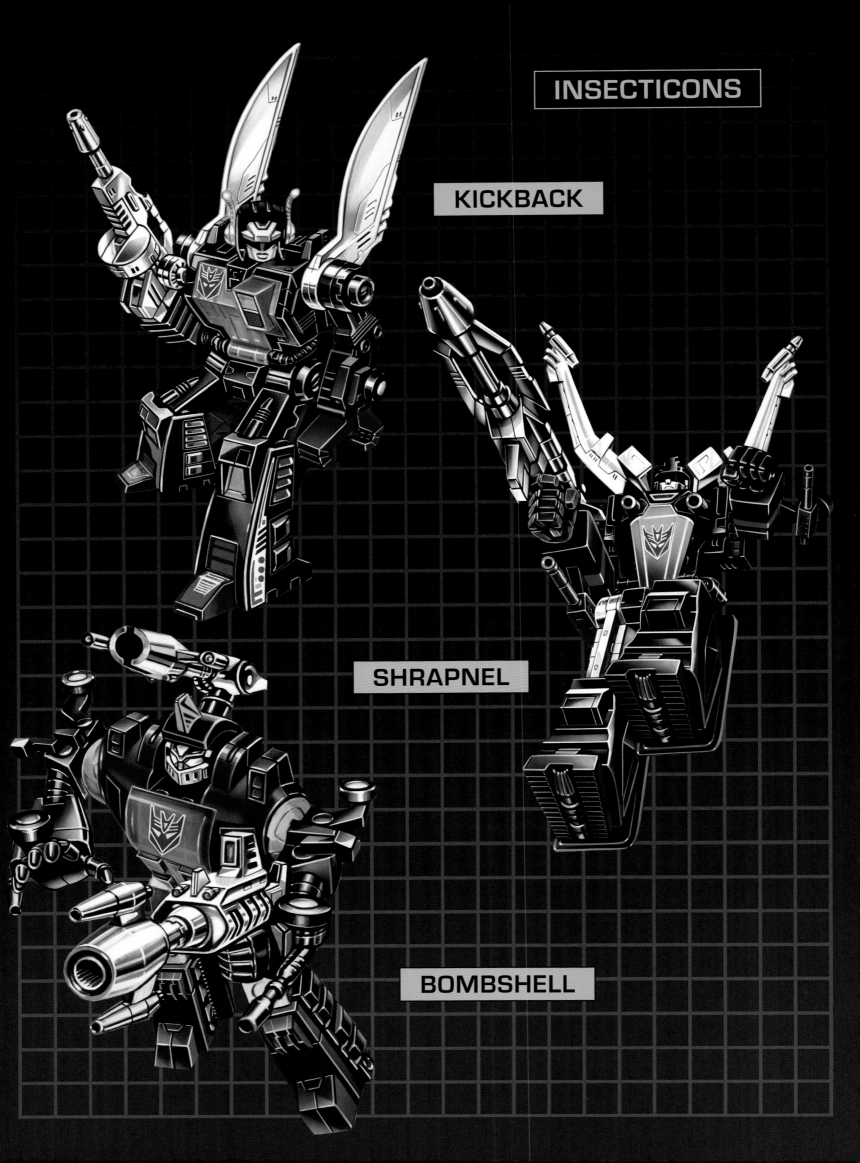

INSECTICONS

KICKBACK

SHRAPNEL

BOMBSHELL

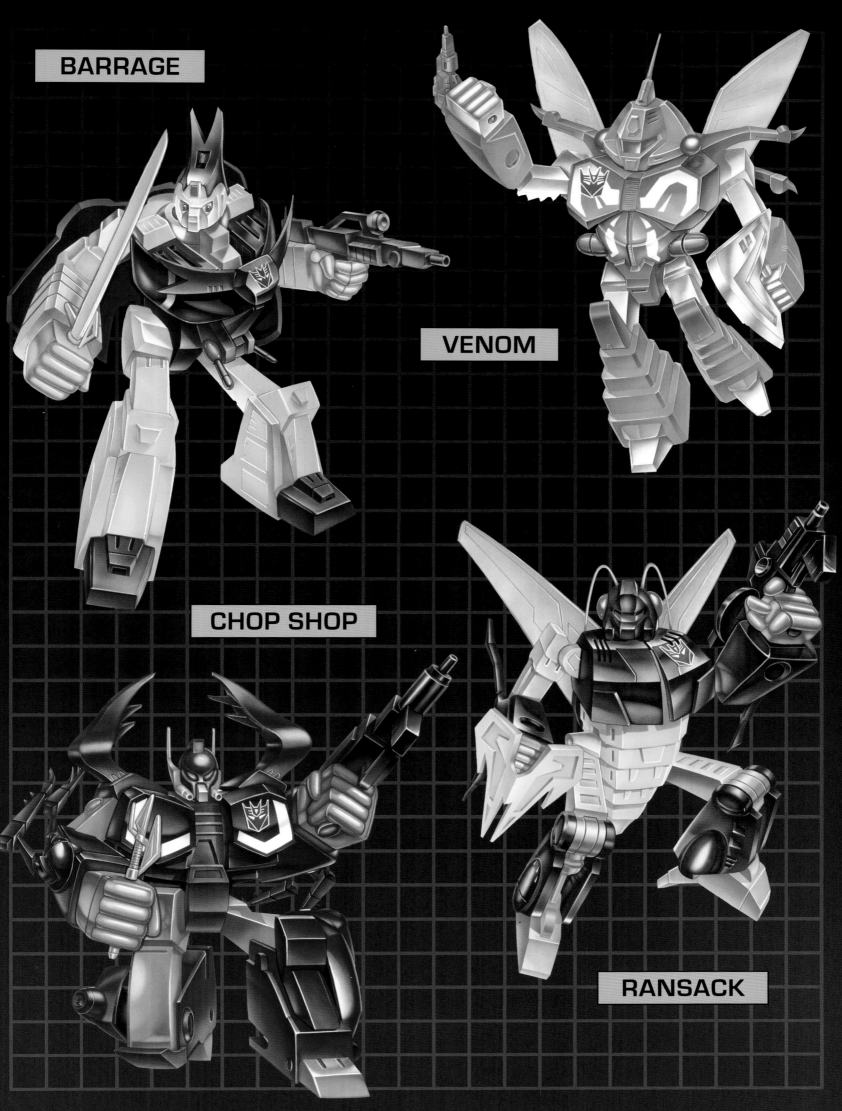

BARRAGE

VENOM

CHOP SHOP

RANSACK

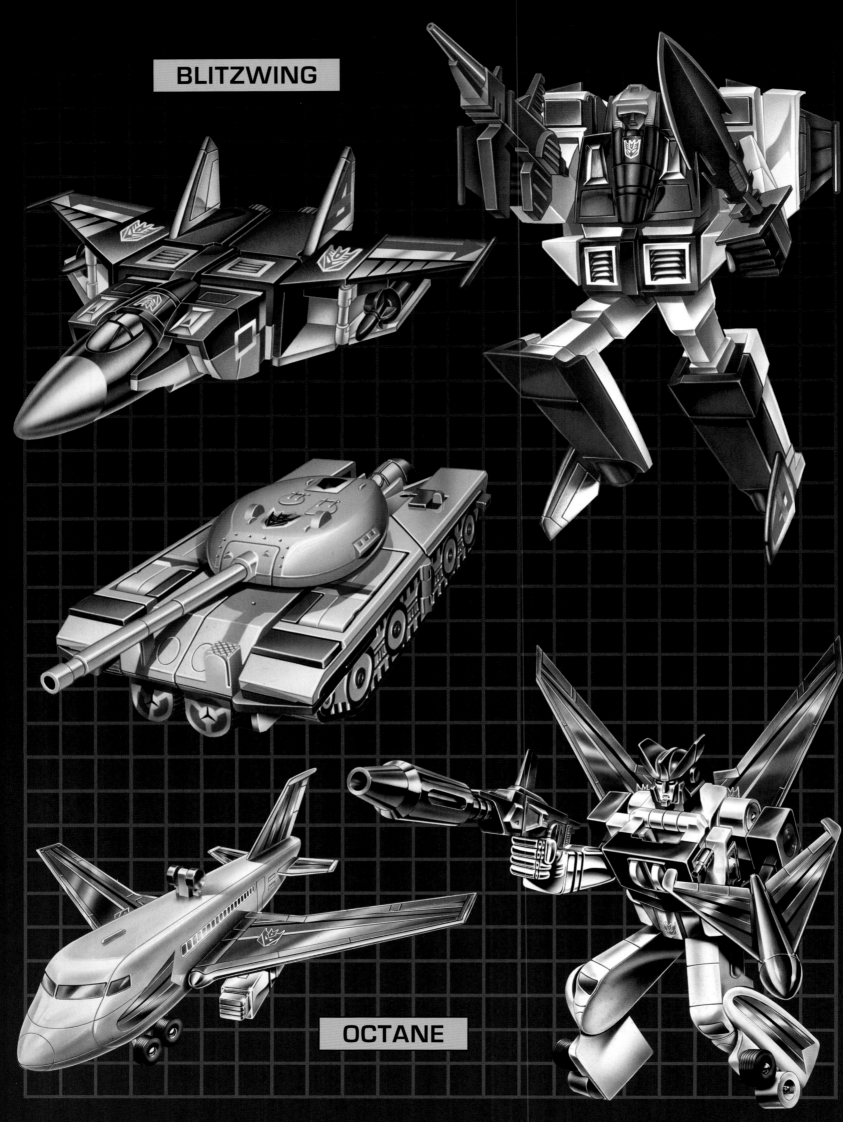

BLITZWING

OCTANE

42

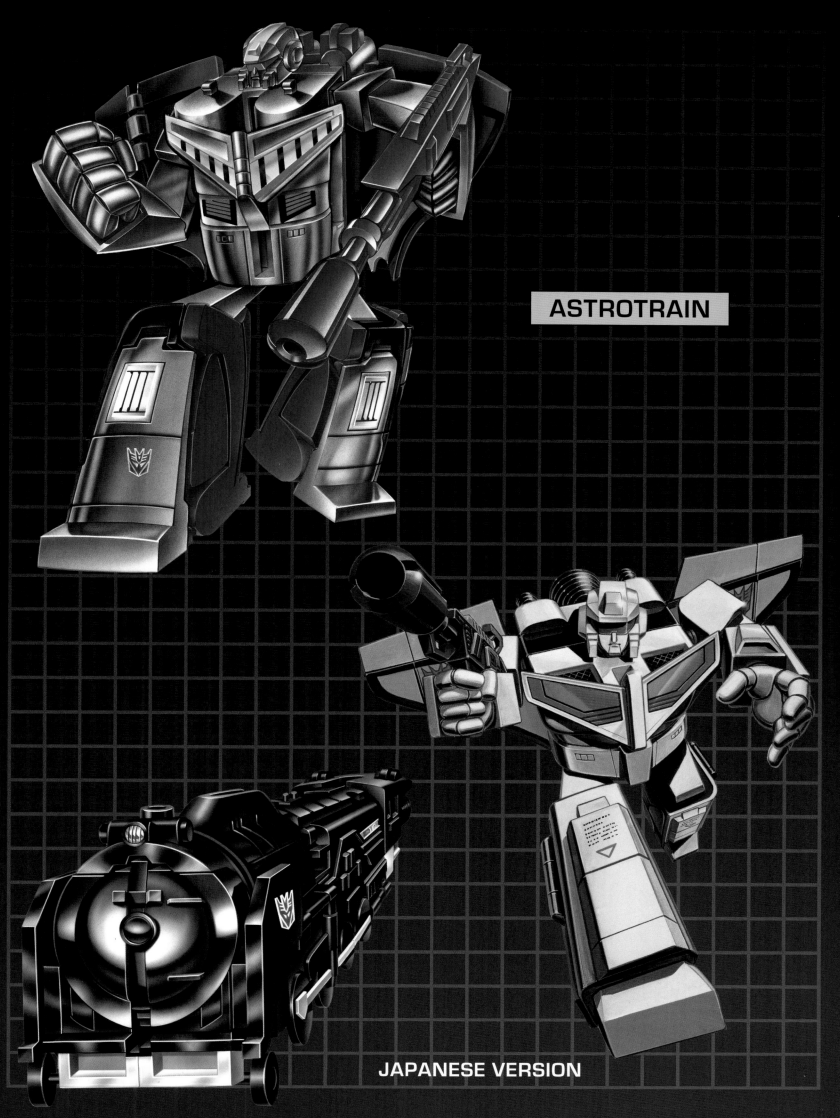

ASTROTRAIN

JAPANESE VERSION

43

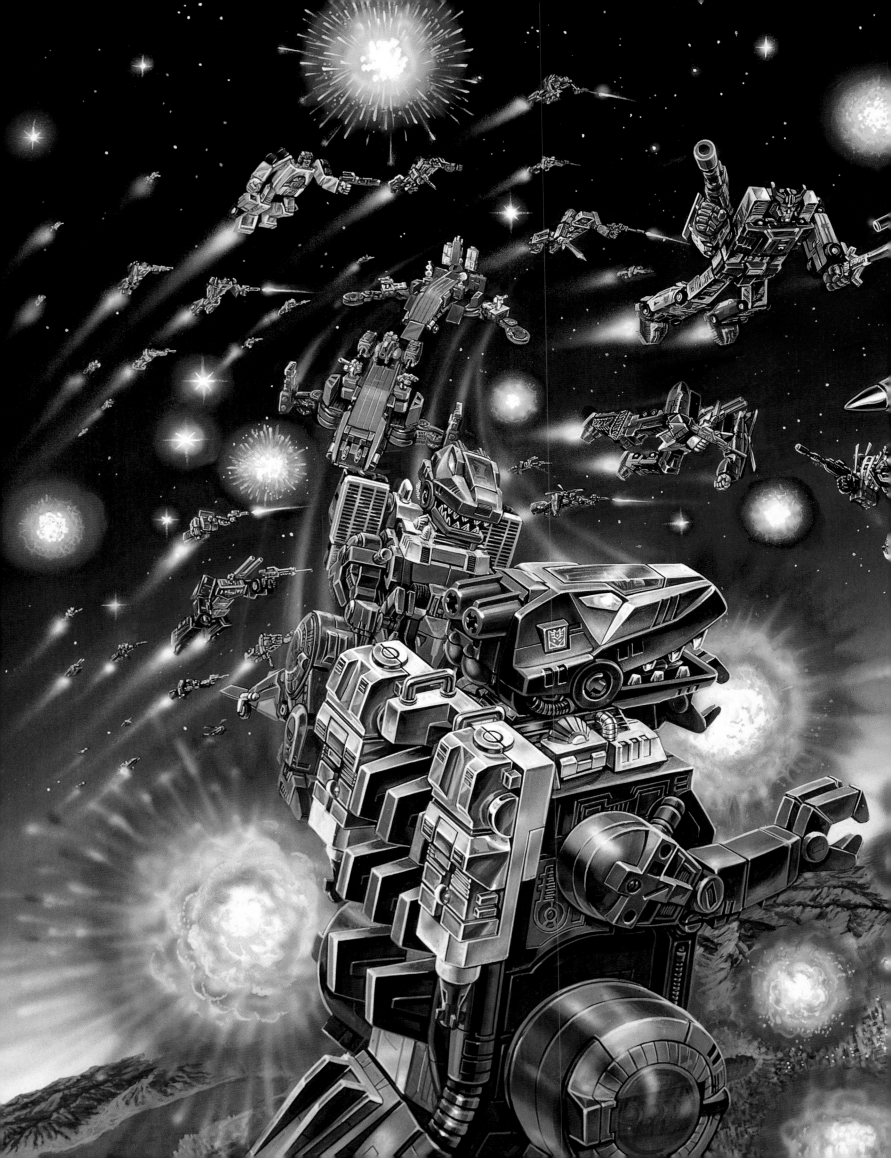

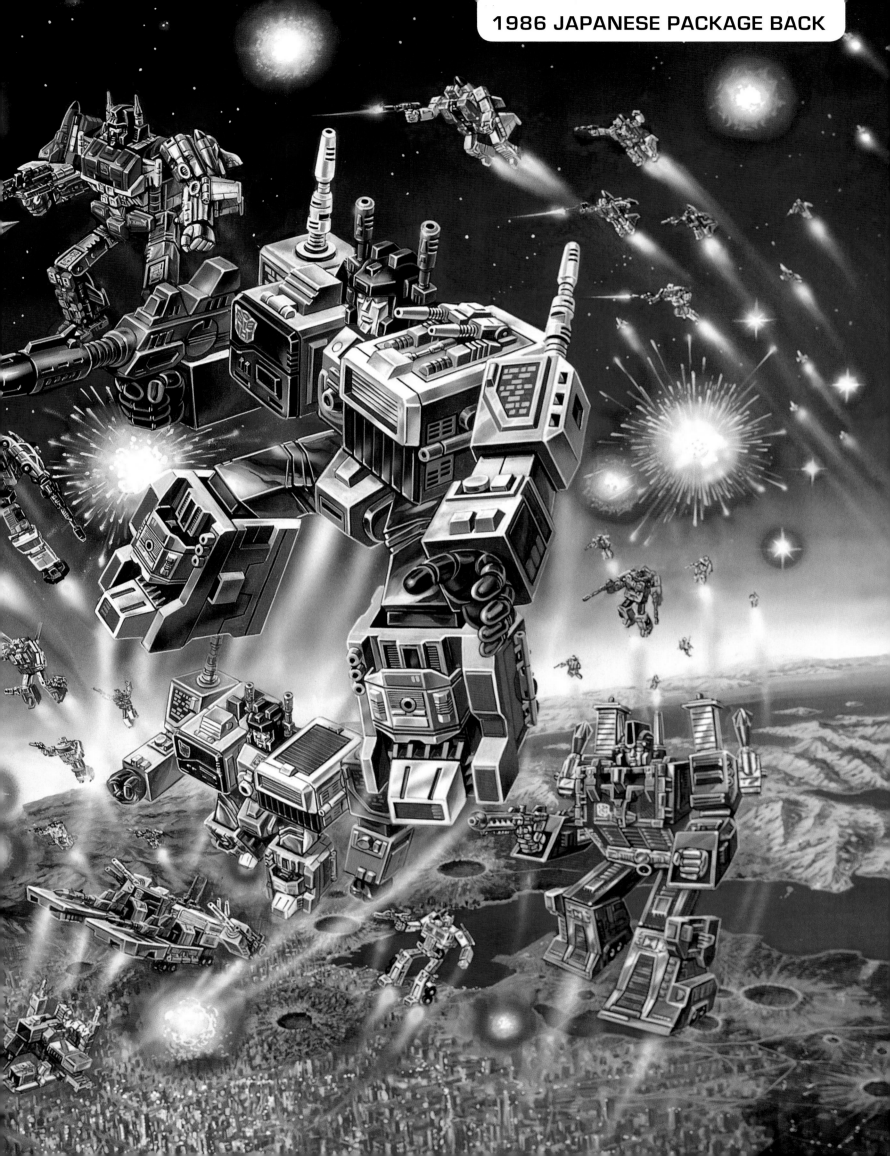

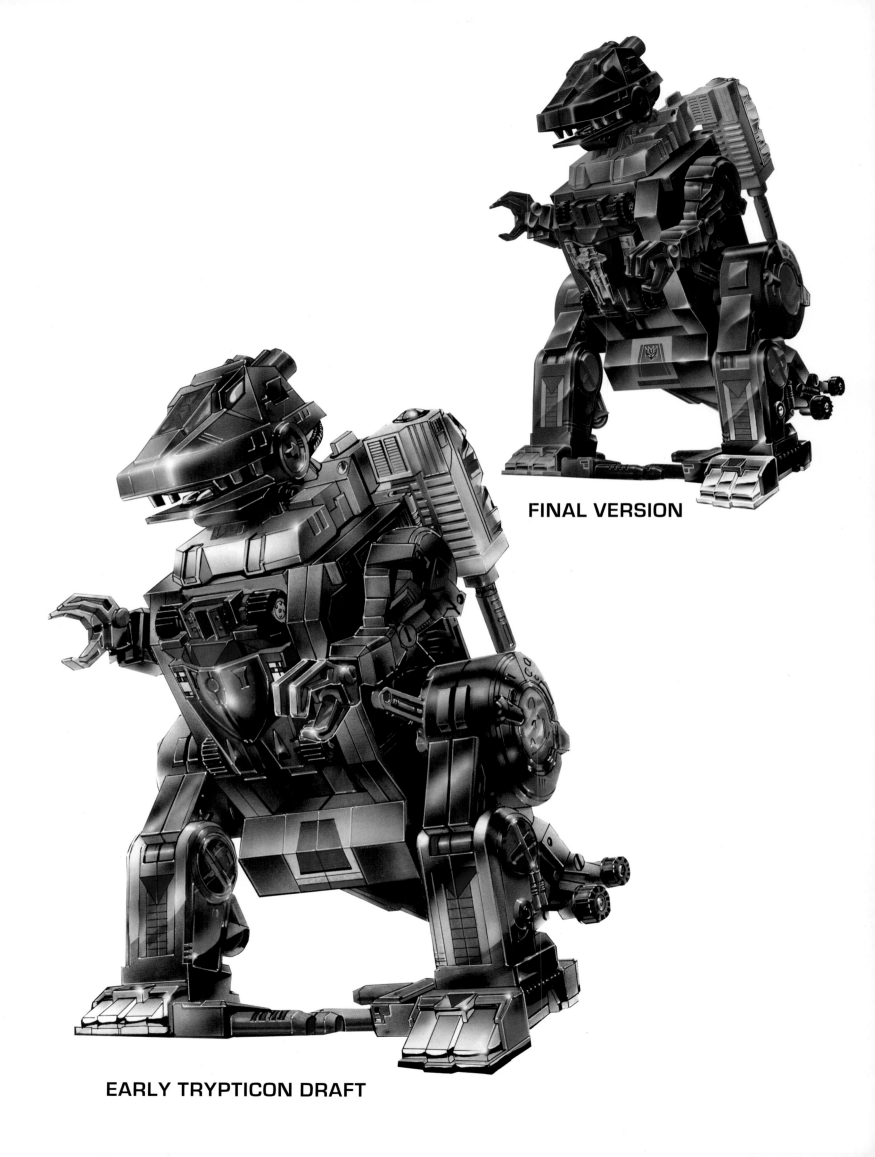

FINAL VERSION

EARLY TRYPTICON DRAFT

MOVIE ERA AUTOBOTS

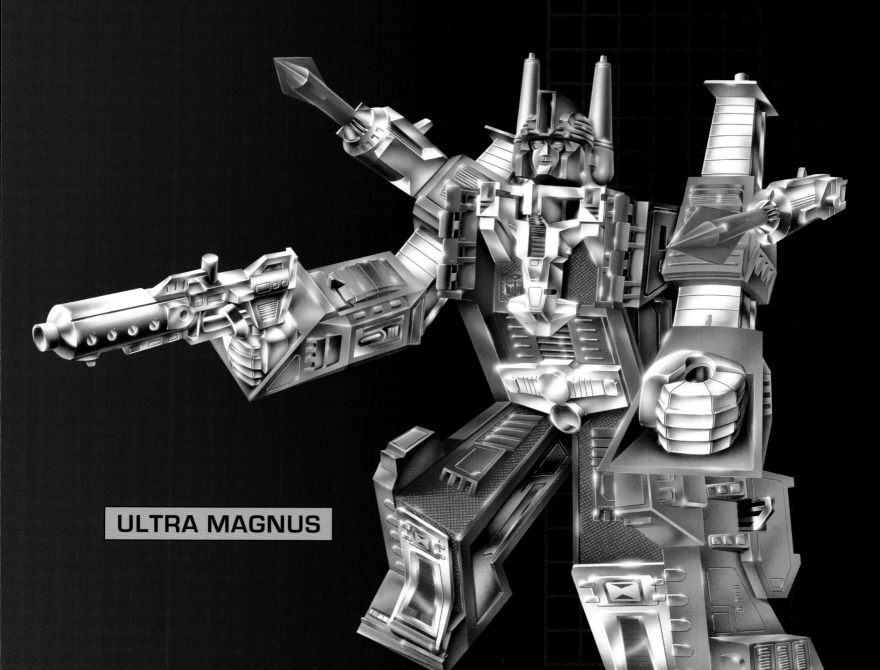

ULTRA MAGNUS

"It is the year 2005." In 1986, The Transformers exploded onto the big screen and into the future with new gimmicks and science-fiction inspired transformations. Sub-teams proliferated; most new characters introduced had some affiliation beyond just being Autobots or Decepticons.

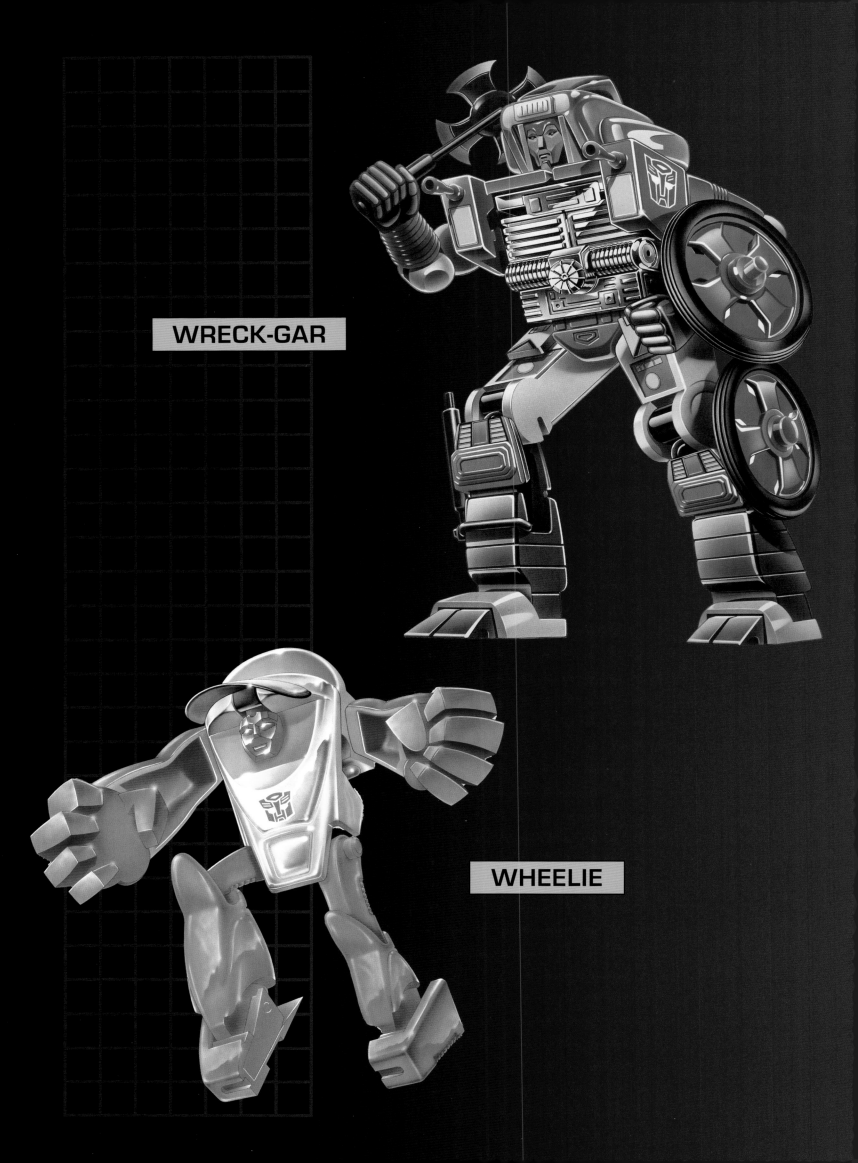

WRECK-GAR

WHEELIE

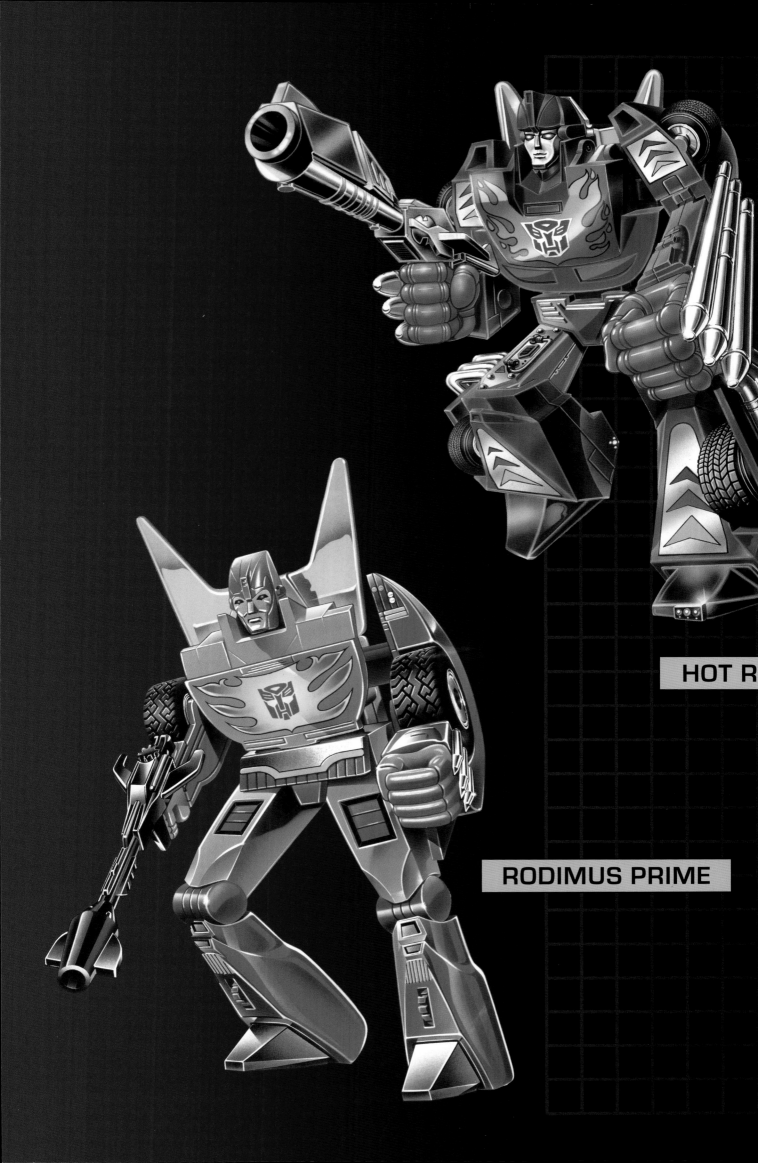

HOT R

RODIMUS PRIME

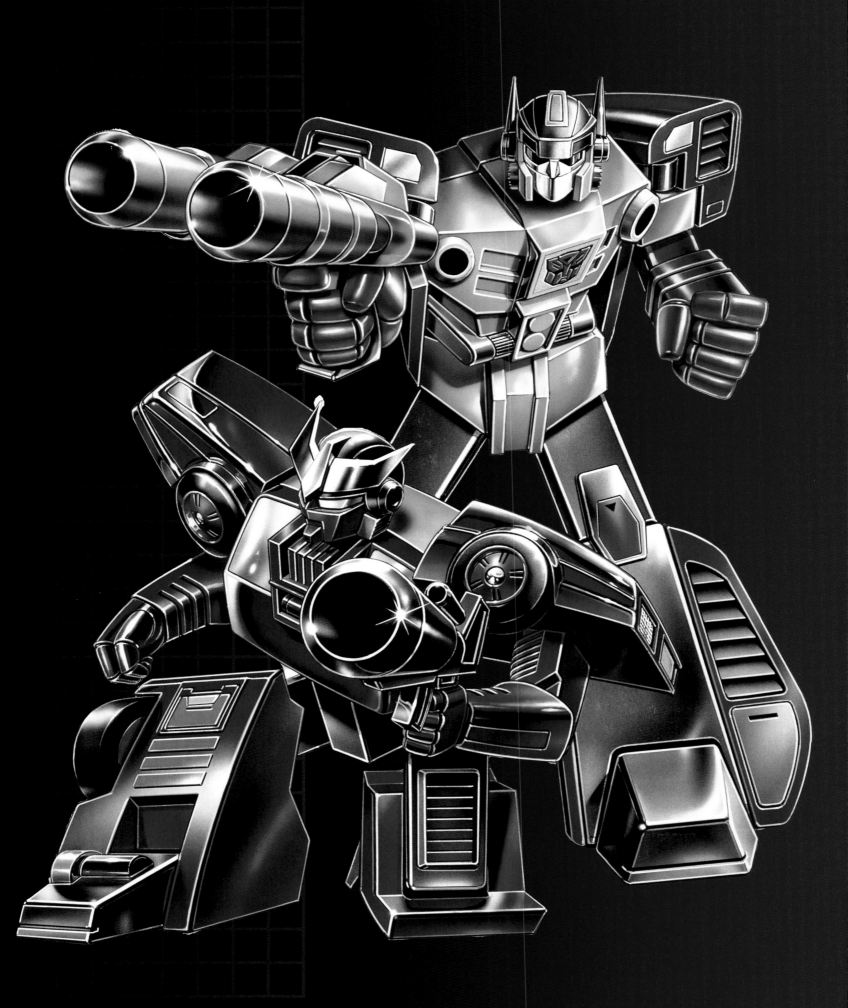

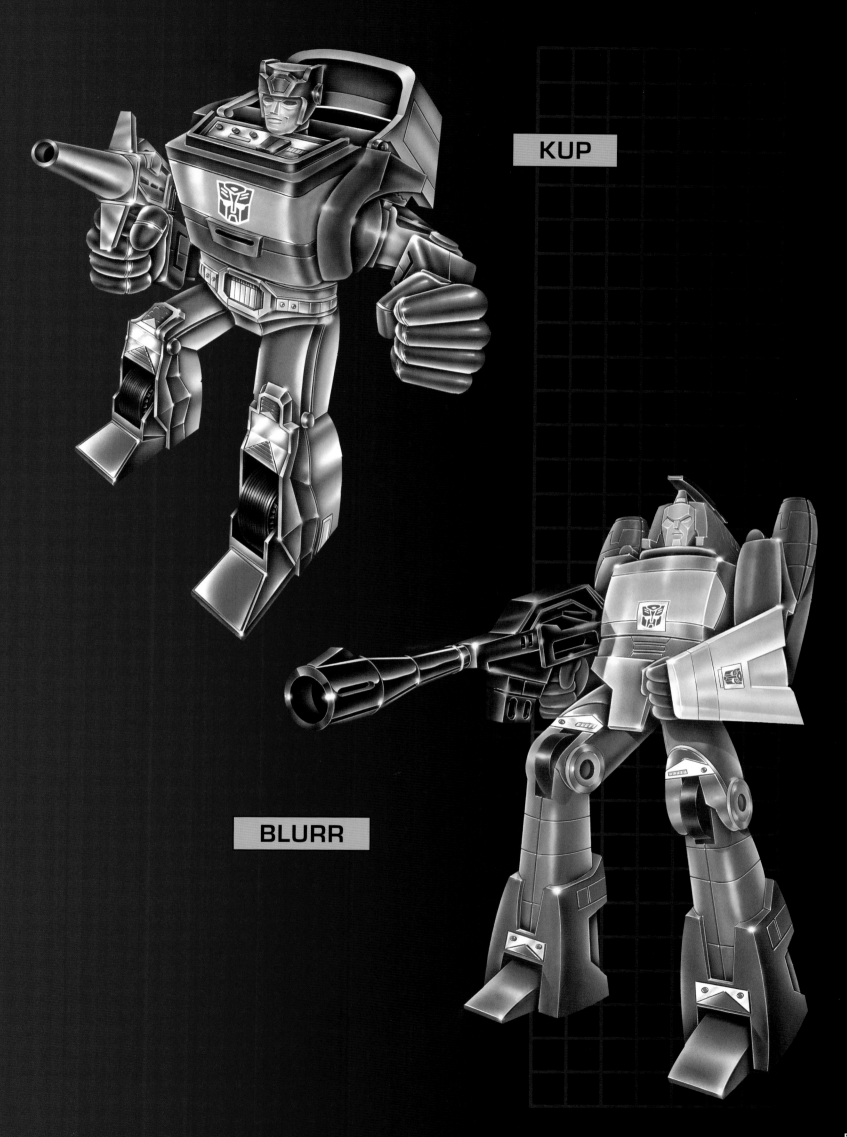

KUP

BLURR

51

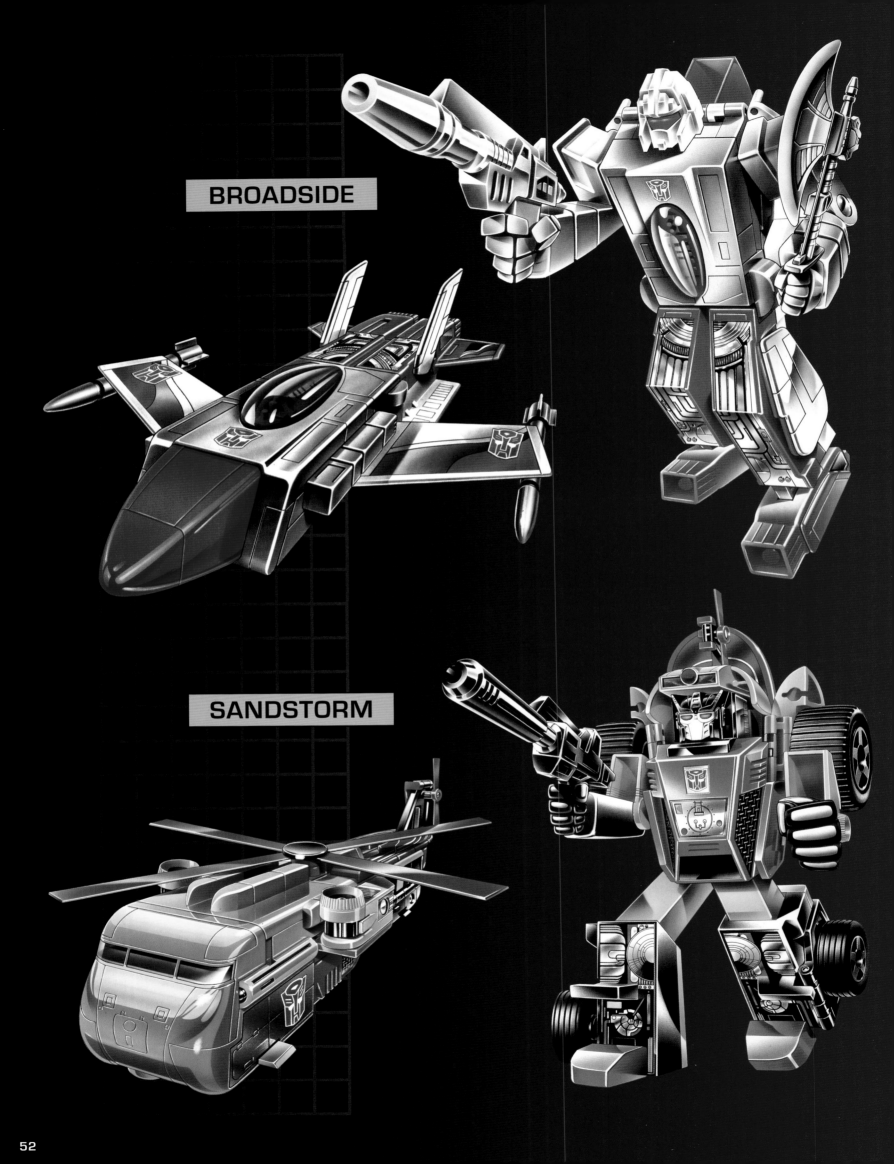

BROADSIDE

SANDSTORM

52

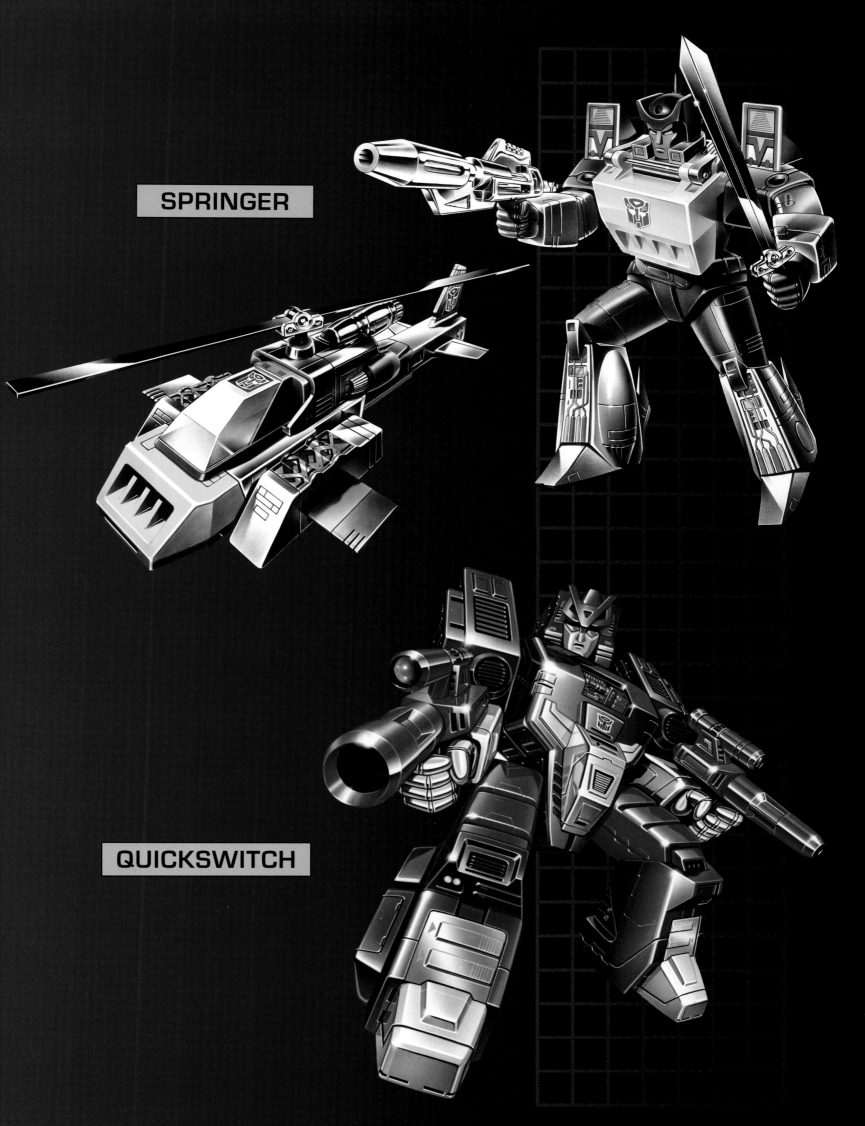

SPRINGER

QUICKSWITCH

53

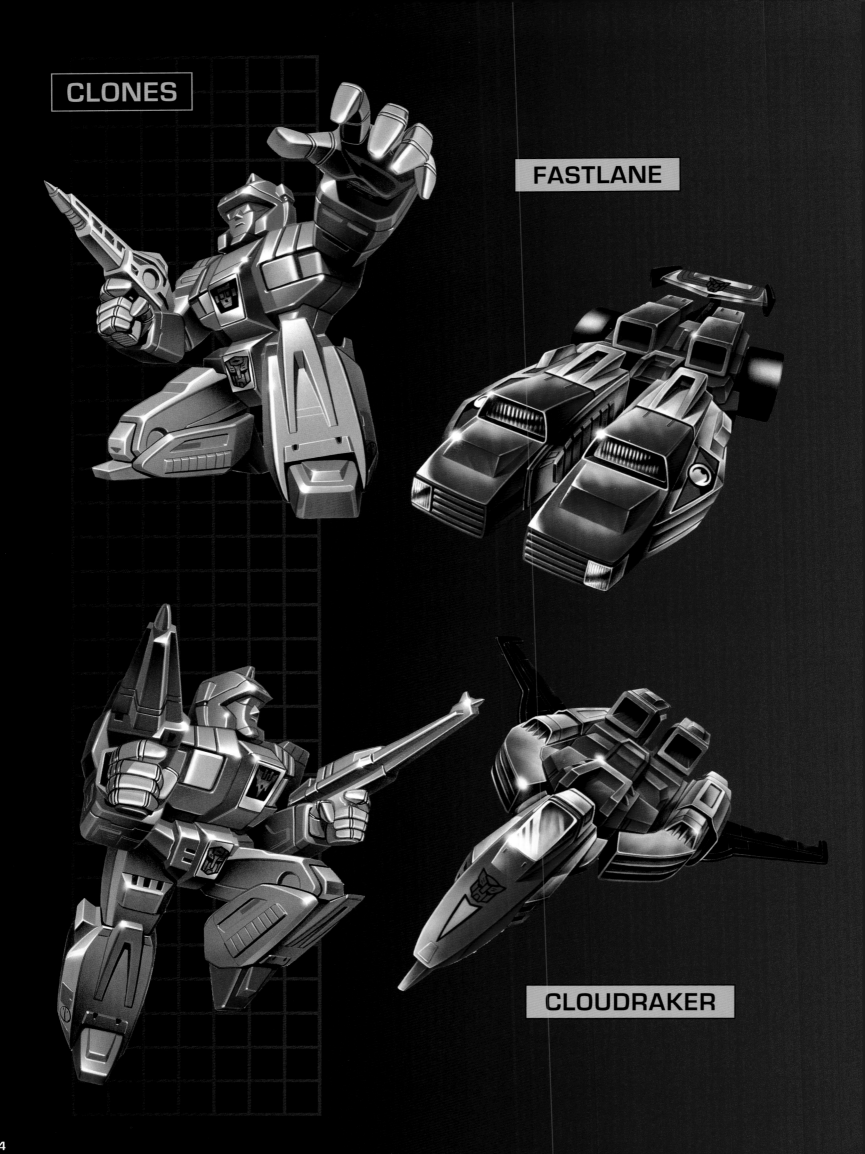

CLONES

FASTLANE

CLOUDRAKER

54

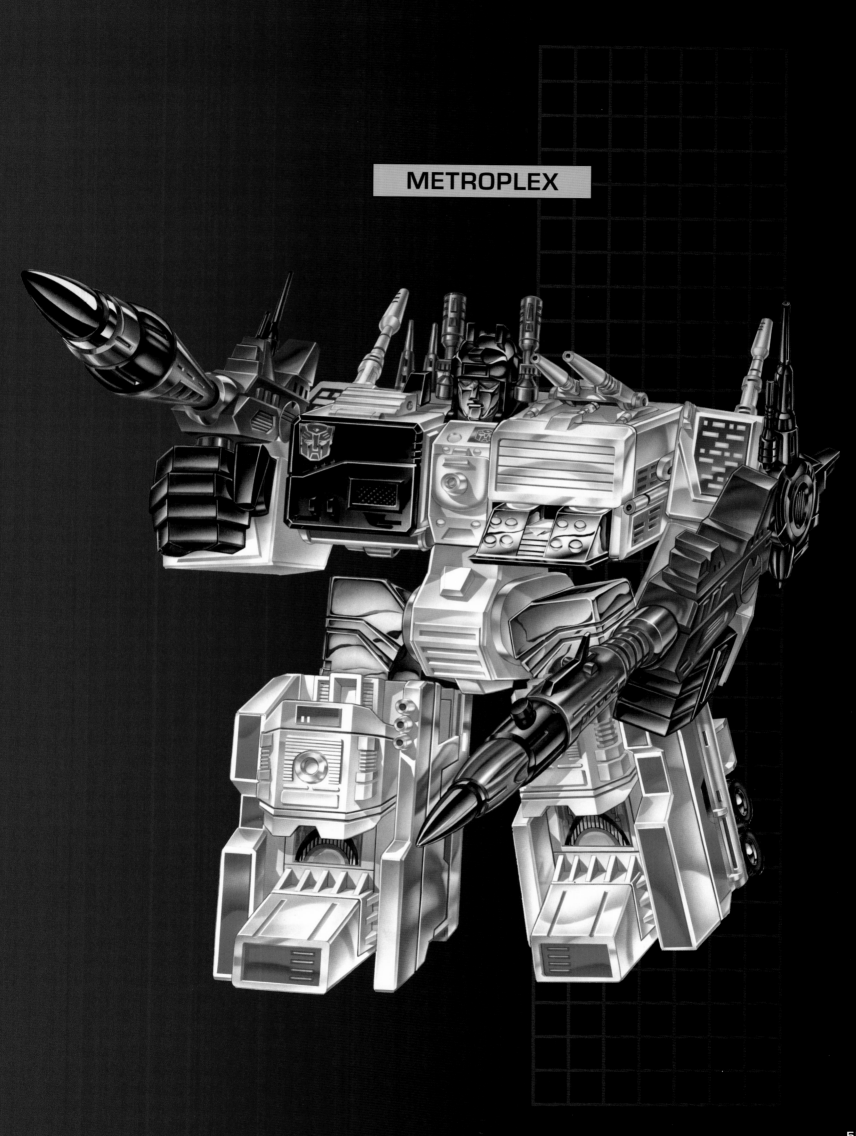

METROPLEX

GUZZLE

SIZZLE

FIZZLE

MONSTERBOTS

GROTUSQUE

REPUGNUS

DOUBLECROSS

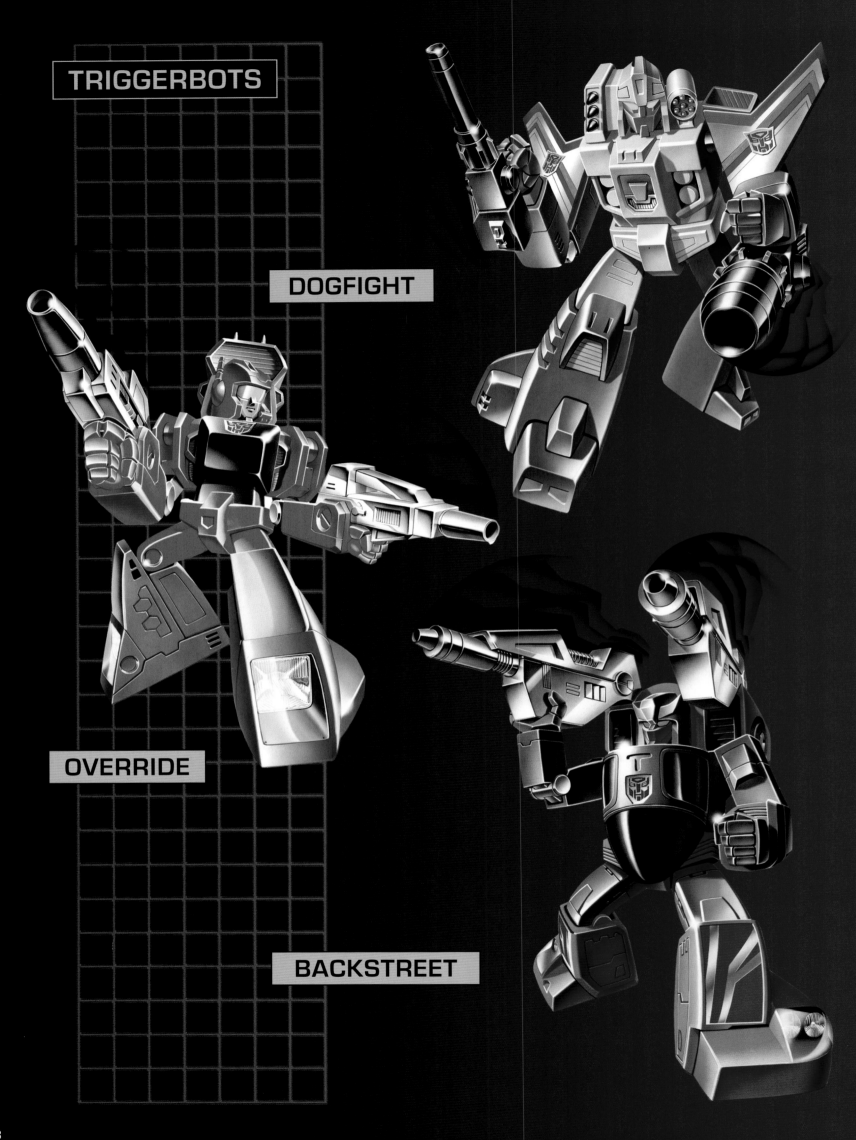

TRIGGERBOTS

DOGFIGHT

OVERRIDE

BACKSTREET

58

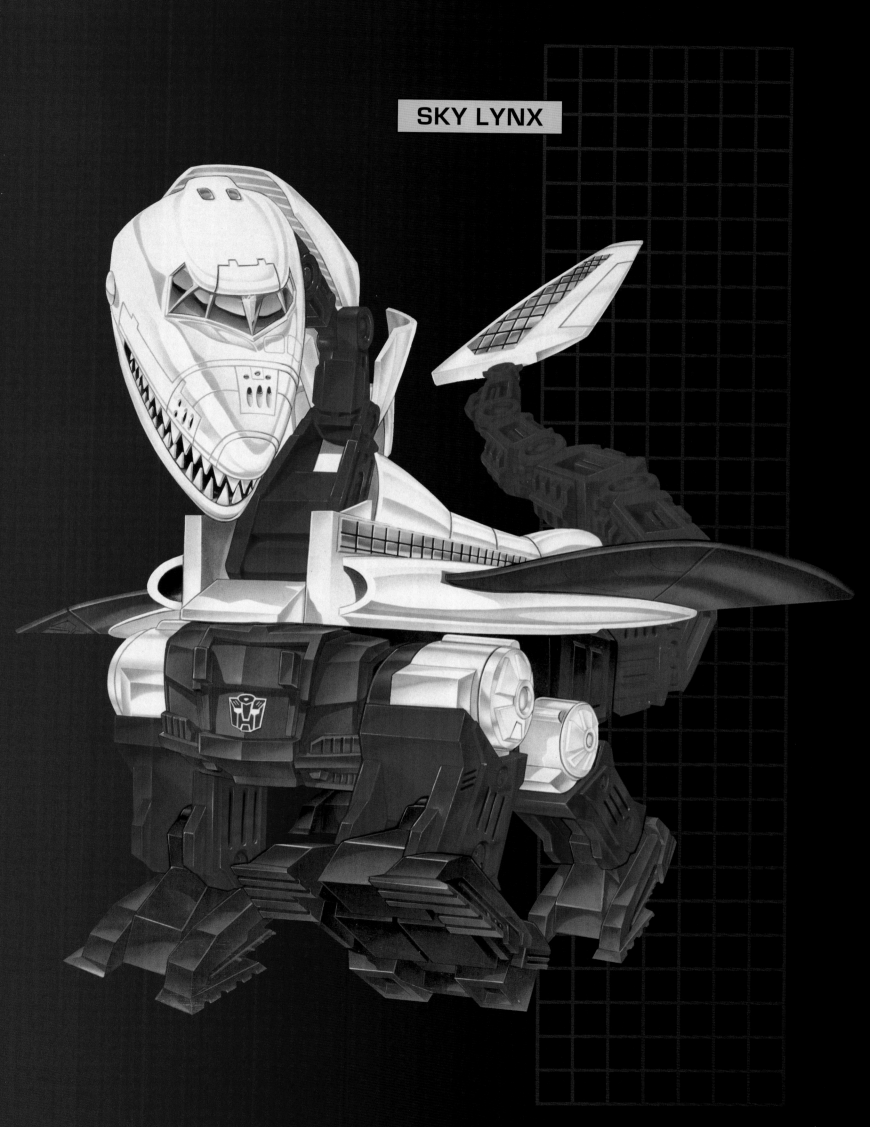

SKY LYNX

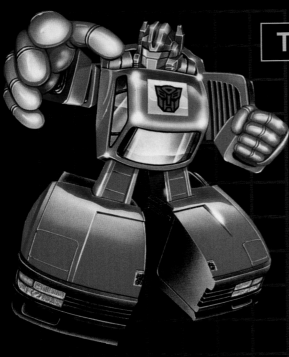

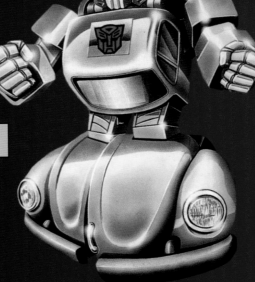

GOLDBUG

CHASE

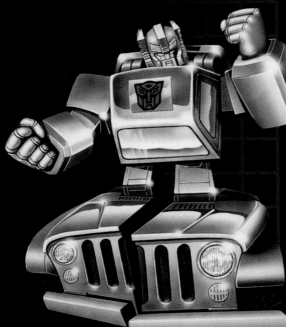

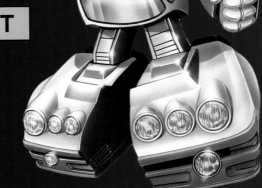

SEARCHLIGHT

ROLLBAR

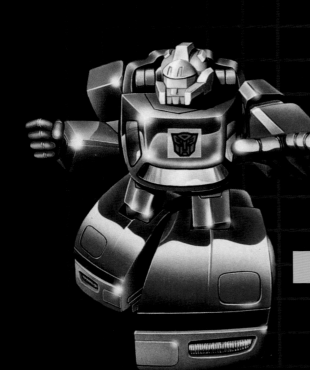

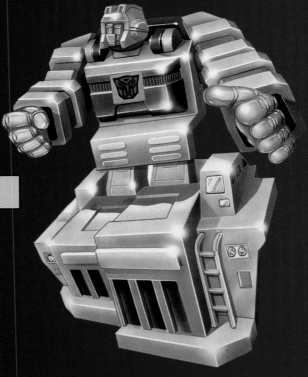

WIDELOAD

FREEWAY

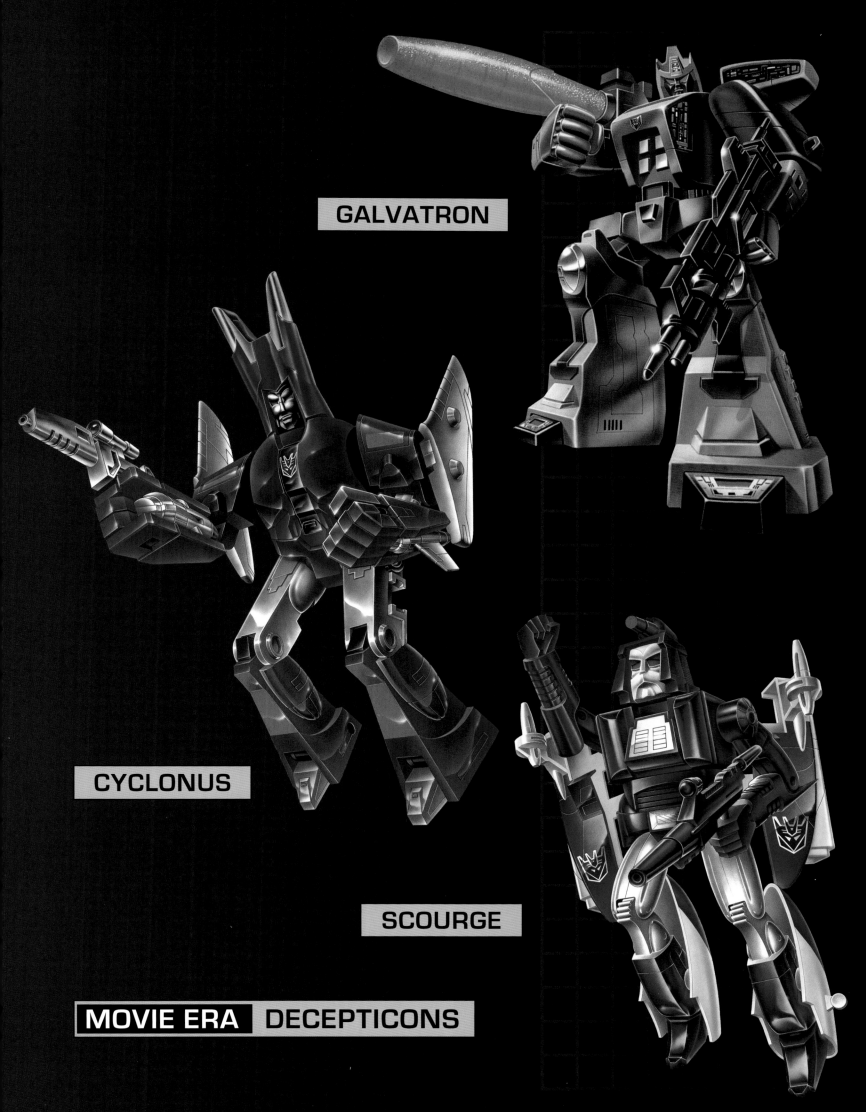

GALVATRON

CYCLONUS

SCOURGE

MOVIE ERA DECEPTICONS

6

TRYPTICON

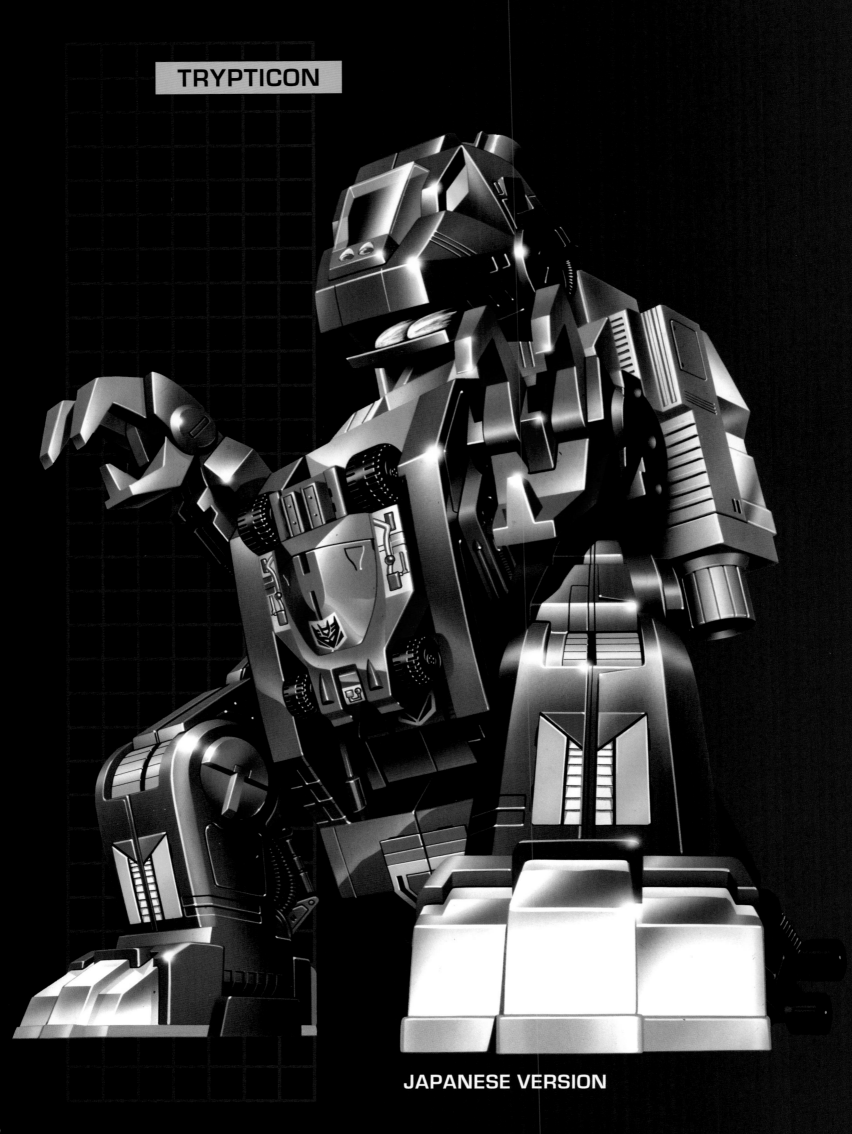

JAPANESE VERSION

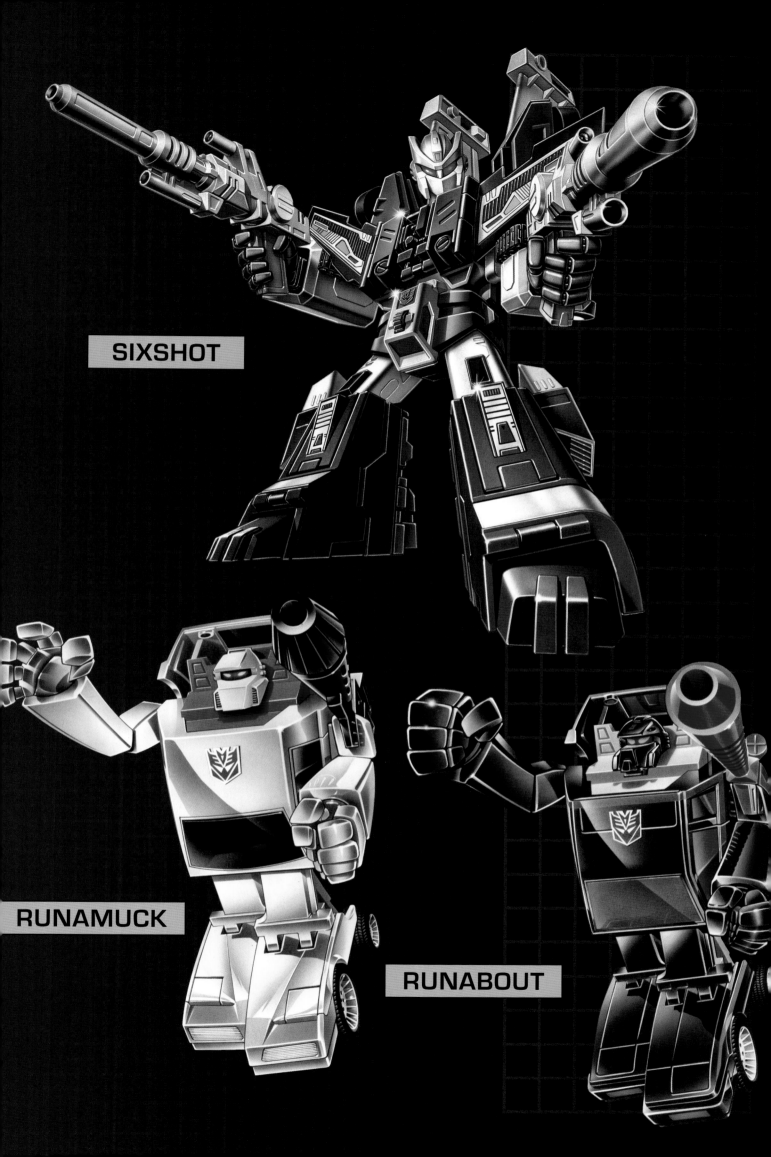

SIXSHOT

RUNAMUCK

RUNABOUT

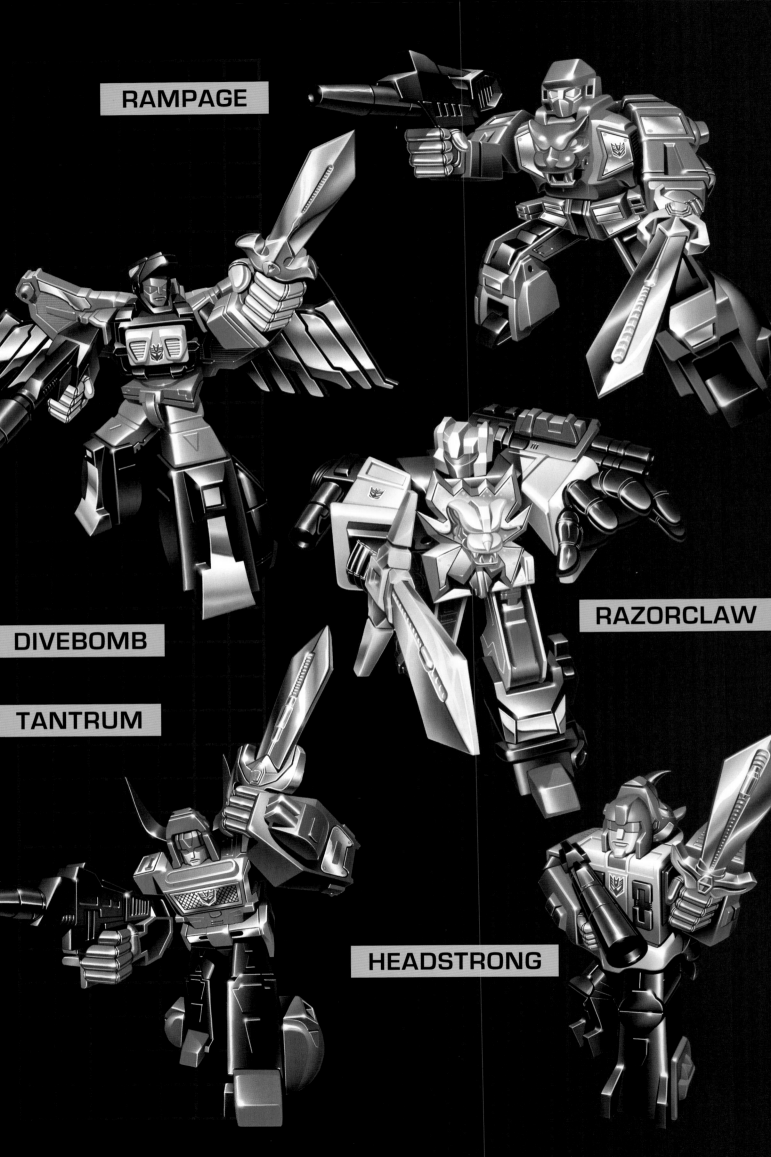

RAMPAGE

DIVEBOMB

TANTRUM

RAZORCLAW

HEADSTRONG

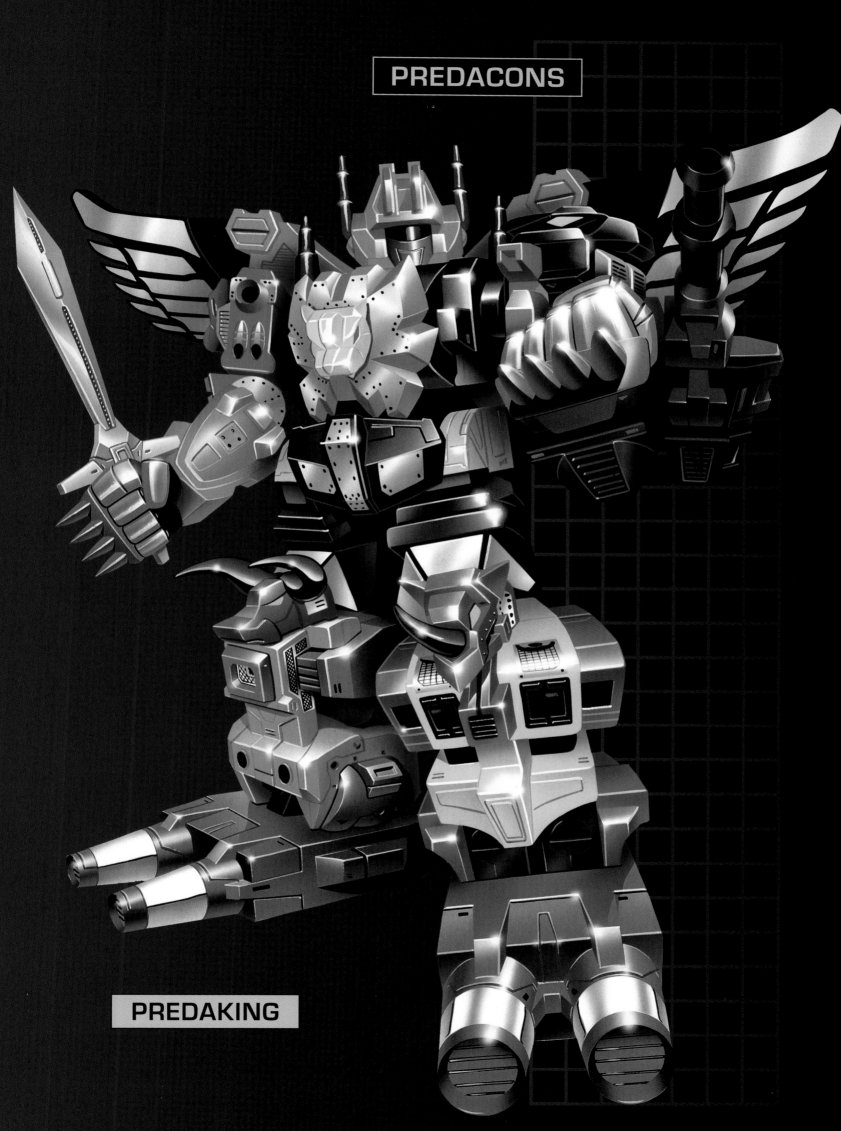

PREDAKING

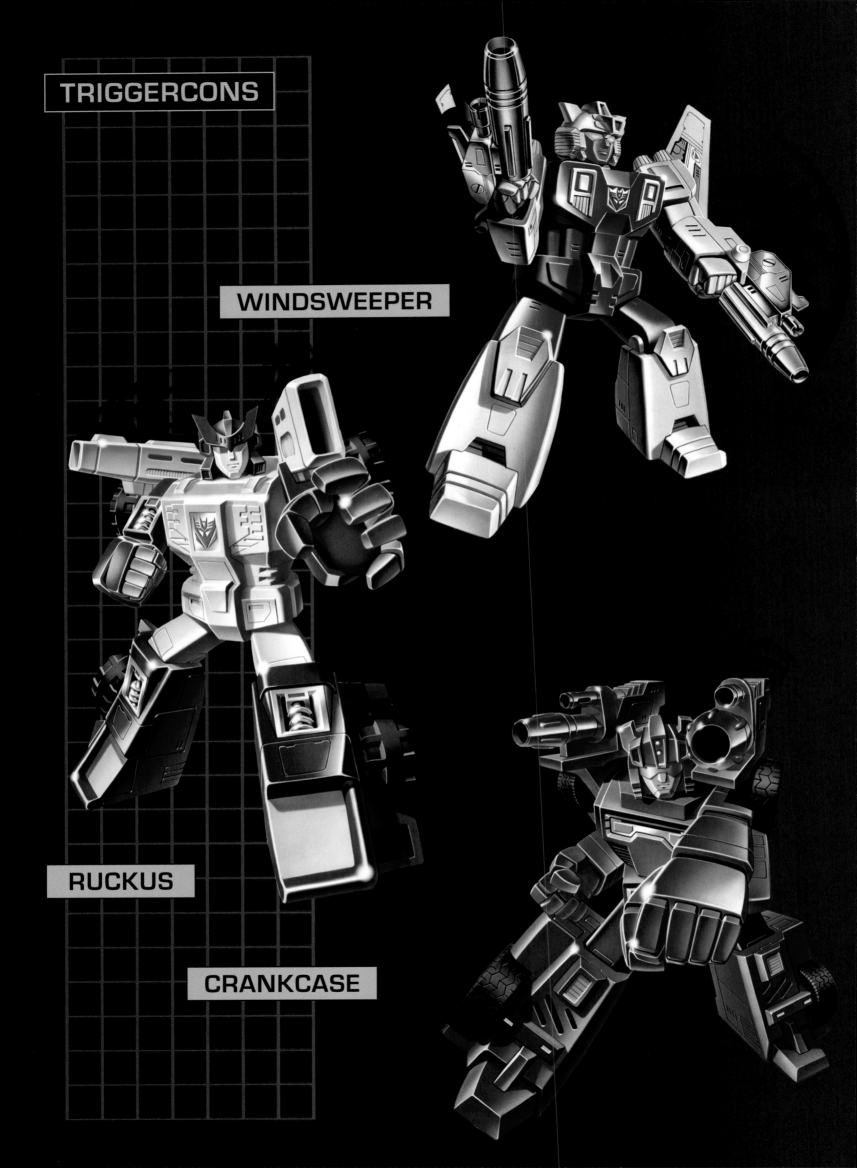

TRIGGERCONS

WINDSWEEPER

RUCKUS

CRANKCASE

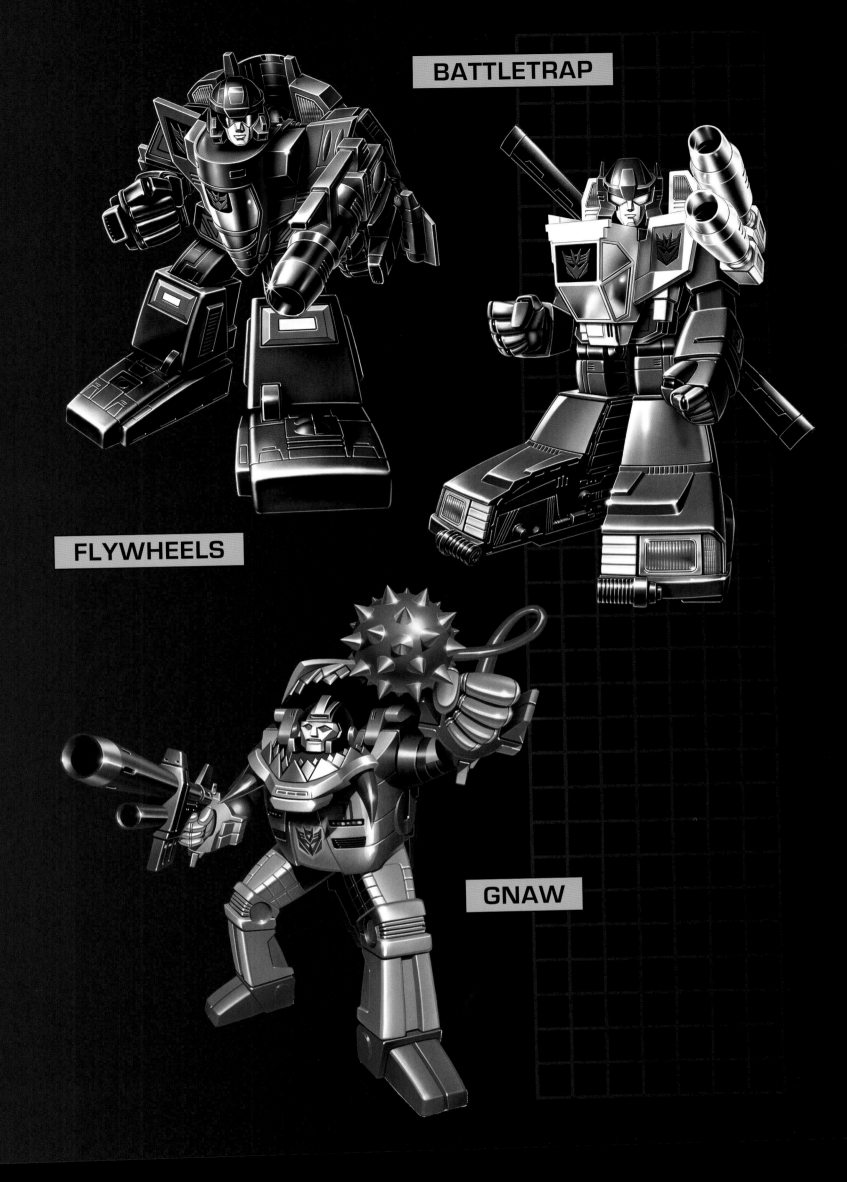

BATTLETRAP

FLYWHEELS

GNAW

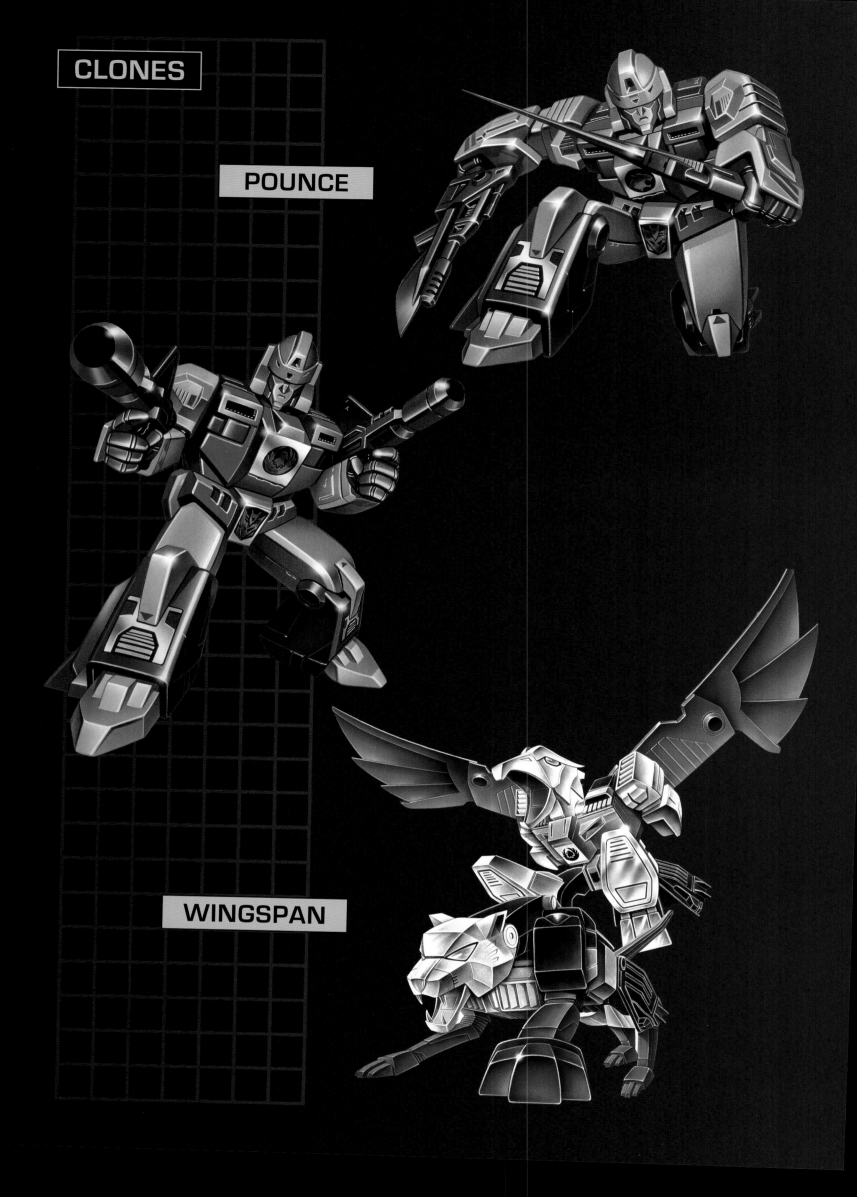

CLONES

POUNCE

WINGSPAN

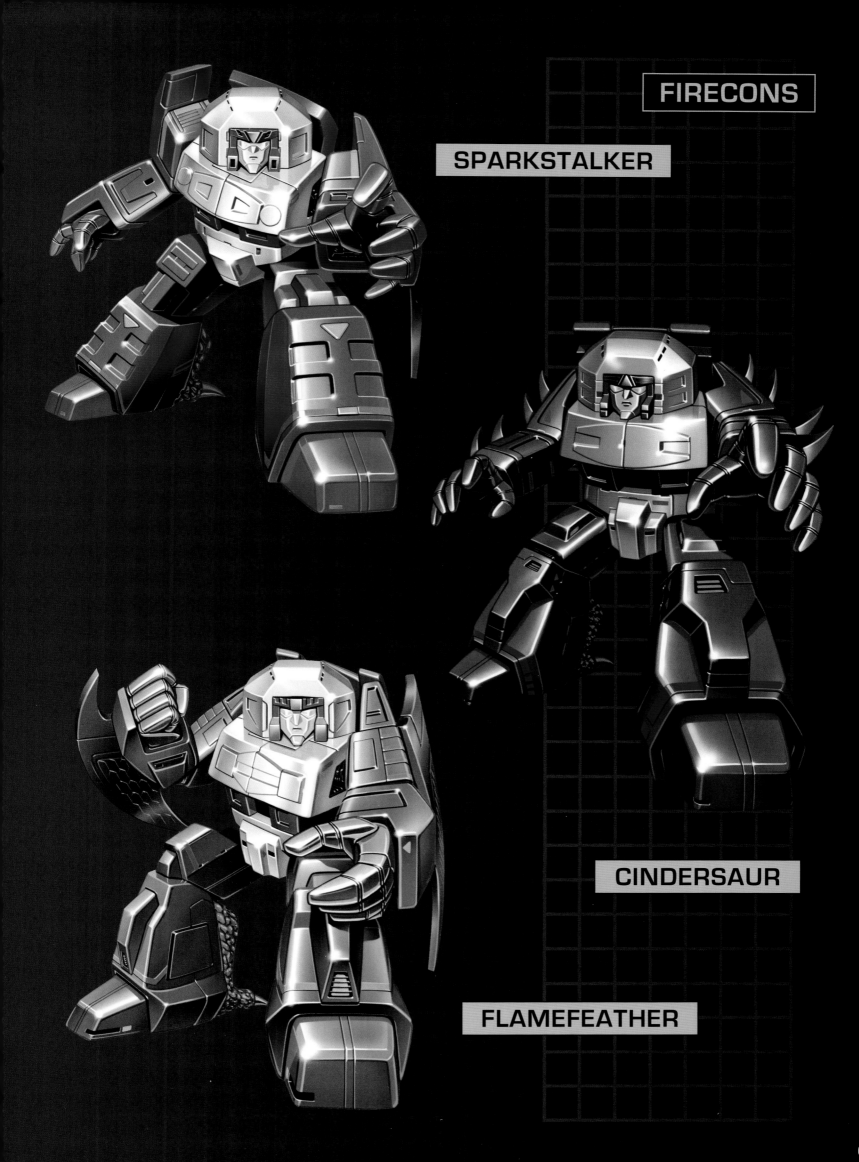

FIRECONS

SPARKSTALKER

CINDERSAUR

FLAMEFEATHER

69

Part Two: More than Meets the Eye

While the artistic style of The Transformers was remarkably consistent for the first twelve years of the brand, it would not be accurate to say that the packages stagnated; far from it. While the basic form of a glossy, airbrushed robot in a perspective-defying pose would remain an identifying element of the brand through 1995, the backgrounds on which they were set varied substantially. The red and purple fading grids of 1984-1986 gave way to grids with a bolder explosion of color by 1987. As the brand became increasingly dominated by sublines in the late '80s, so too did the packaging diverge. Micromasters, Pretenders, and Action Masters packaging each had a different feel to them. By now, you've no doubt noticed that the backgrounds of each chapter are different. They change to reflects the underlying packaging aesthetic of the era each chapter represents.

The aforementioned dominance of sublines is the subject of Part Two of this book. Beginning in late 1985 with the advent of the special teams, Transformers gradually transitioned from a line with numerous divergent teams (such as the Dinobots and the Constructicons) to a line where most toys could be pigeonholed by their gimmick. In early years, there was a sharp divide between the Autobot and the Decepticon teams. By the end, this was no longer the case. Instead, there were good guy and bad guy Micromasters, Headmasters, Pretenders, and the like.

Chapter Three covers Scramble City, the Japanese name for the special teams of interchangeable combiners. These seven groups bulked up the 1986 through 1988 product lines. Though in theory each smaller toy could form an arm or leg on any team, in practice this ability was not showcased in any US fiction. (In Japan the concept was explored.) The odd team out is the Seacons. They were the only team to not have a rival on the opposite side. Additionally, each of the smaller Seacon toys could become either a limb or a weapon, and thus the toy was billed as a Targetmaster. Which brings us neatly to...

Chapter Four, the Nebulan Era. Head-, Target-, and Powermasters dominated much of the product line in 1987 and 1988. The conceit was that the Transformers from Cybertron partnered with the inhabitants of Nebulos to bolster their abilities. Their small partners could become the heads, guns, or engines of robots, and unlock features of the toys as they did so. Once again, parts could be swapped, specifically the heads of the Headmasters; once again, this concept went largely unexplored in the US but did get some traction in Japan.

The Pretenders are the subject of Chapter Five. Transformers could now disguise themselves beyond a simple conversion to an alternate mode; now they could encase themselves in a living suit of armor. In the two years Pretenders were sold, 1988 and 1989, the concept got more and more elaborate, to the point where a vehicle could disgorge a shell that could convert to an alternate mode containing a small robot. The artwork from this period attempts to demonstrate these features, resulting in a single character having as many as five distinct modes illustrated, as seen on page 116.

Feeling the pressure from Galoob's Micro Machines, Hasbro introduced the Micromasters as about half of the 1989 product line. These tiny but fully functional Transformers had downsized to conserve fuel, or so the story went. For the first time, Transformers had associated vehicles and playsets for them to interact with, a practice that had served Hasbro well with their flagship G.I. Joe line. Micromasters continued through 1990, with the introduction of Combiners, two robots sharing a single alternate mode.

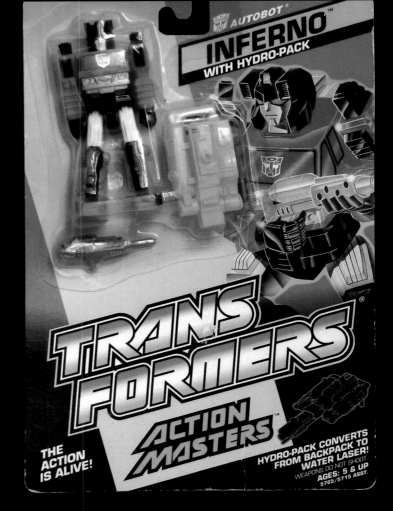

Action Master Inferno MOC (Mint On Card)

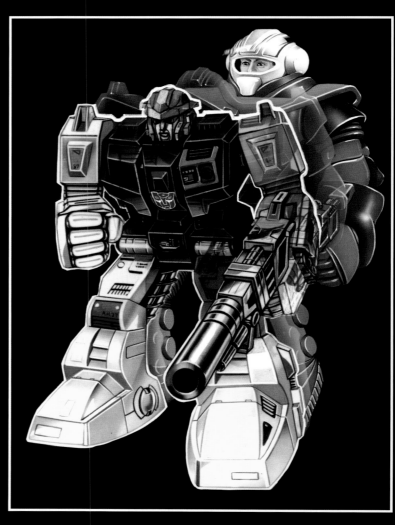

Pretender Proof-of-Concept Illustration

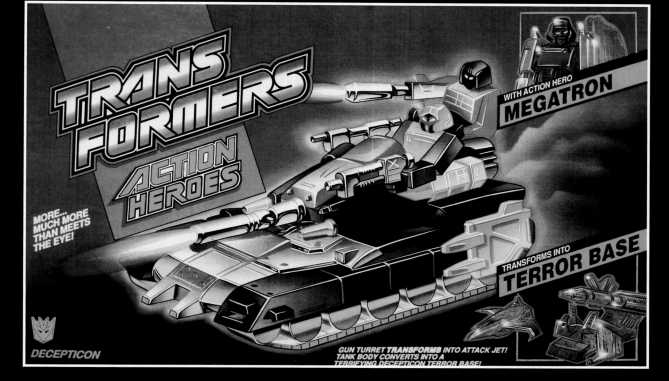

Early Action Masters Packaging Mock-Up

Generation 1 comes to a close in Chapter Seven, the Action Masters. In response to shrinking sales, Hasbro sought to cut costs by transferring the core feature of the line, the ability to convert, from the figures to their accessories. Like Micromasters, Action Masters featured vehicles that could convert to bases. For the first (but definitely not the last) time, the majority of the line was made up of classic characters in new bodies, showing that Hasbro was starting to recognize the value of the characters they had created. Alas, it wasn't enough, and Transformers left US shelves for a few years after the 1990 product line ran its course. Our seventh chapter is the first in the book to feature serious omissions, perhaps because of a lack of enthusiasm for the line among the current adult collectors, who supplied much of the content of this volume.

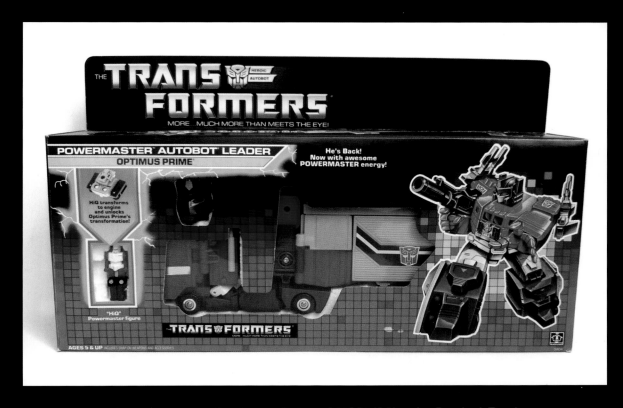

Powermaster Optimus Prime MISB (Mint In Sealed Box)

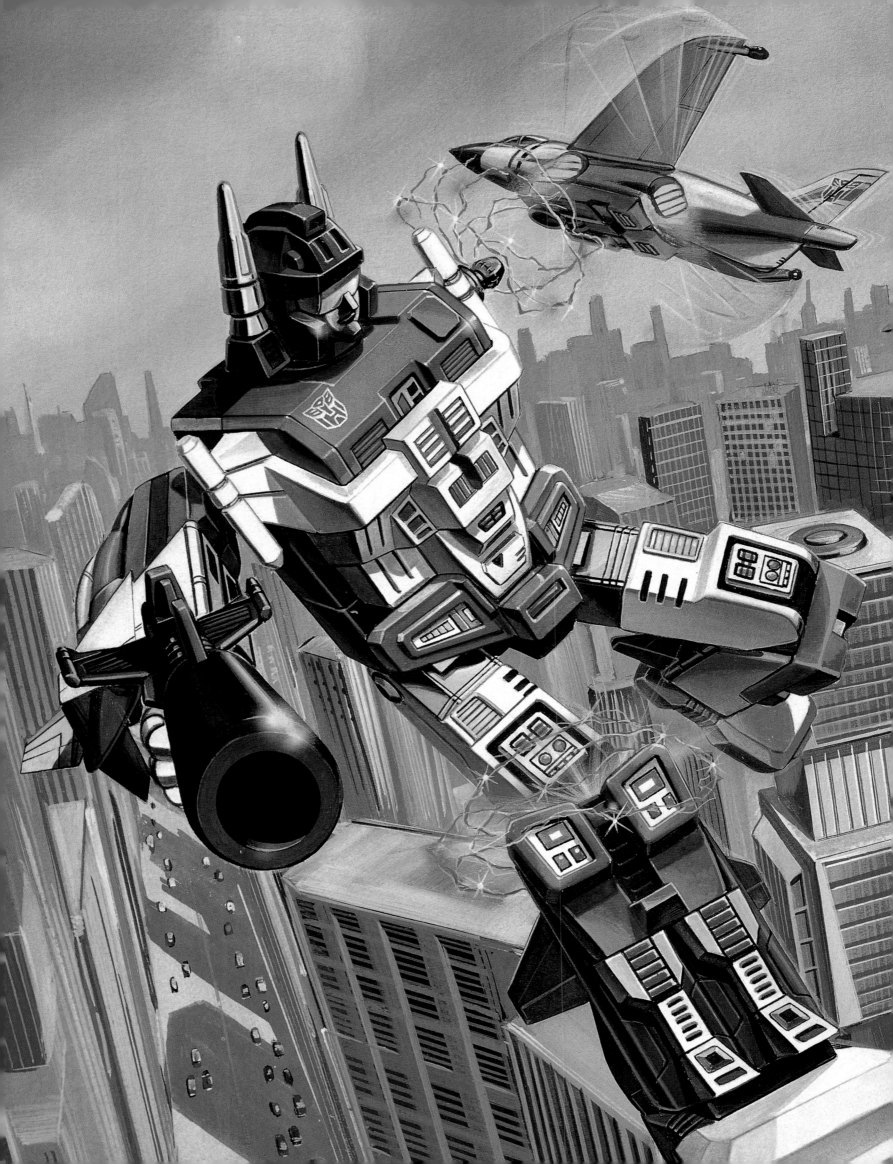

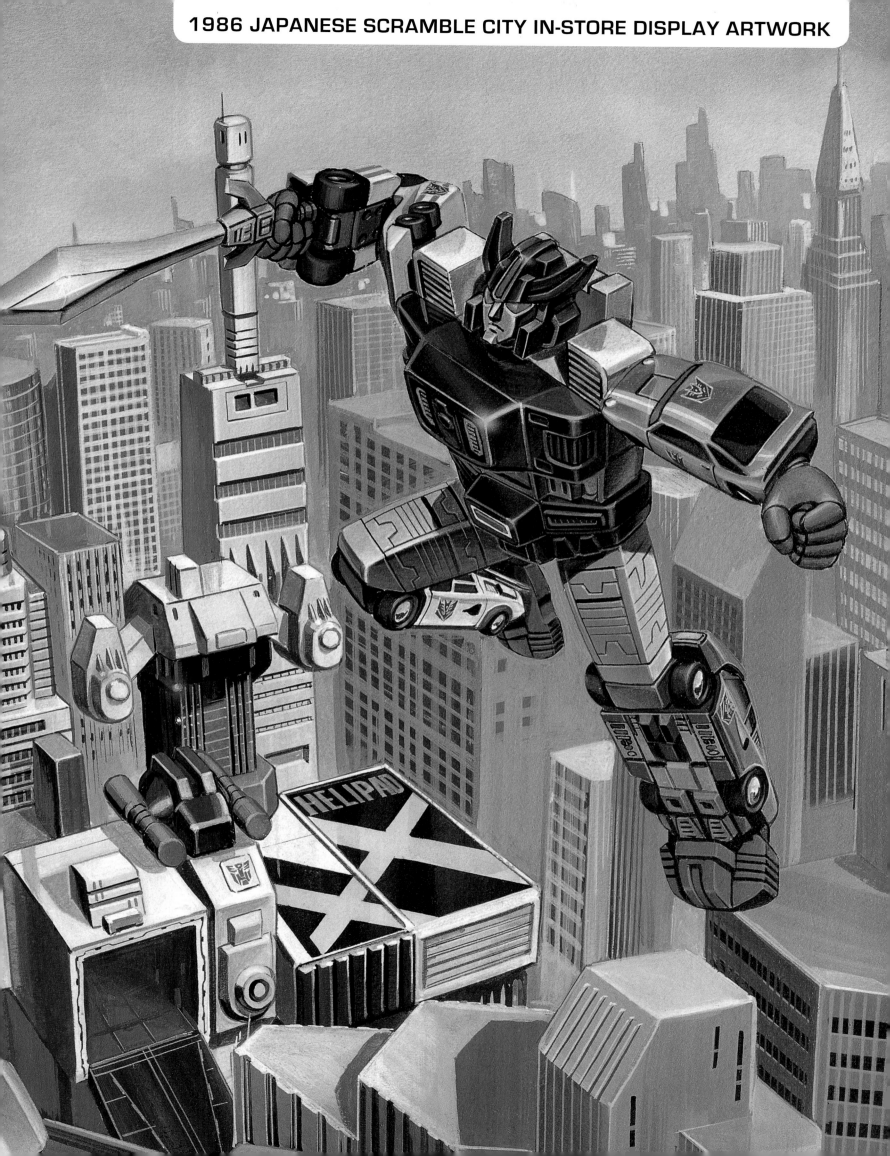

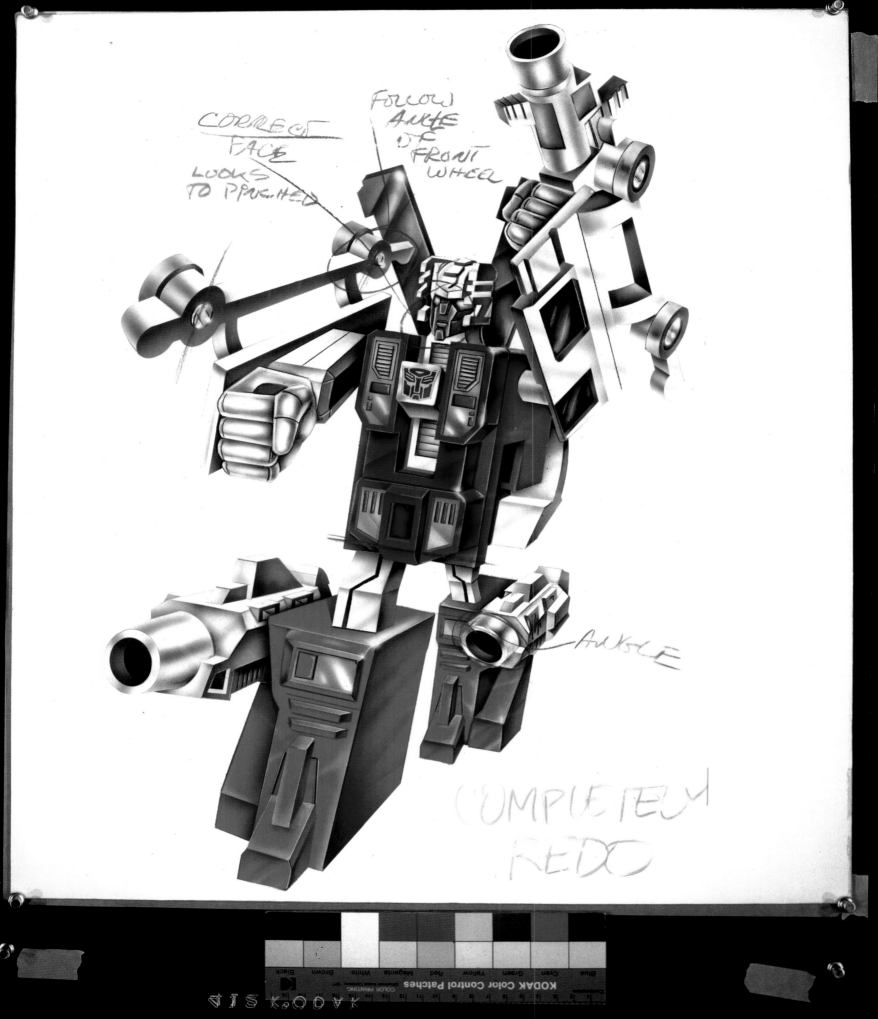

EARLY DRAFT OF BLADES ARTWORK

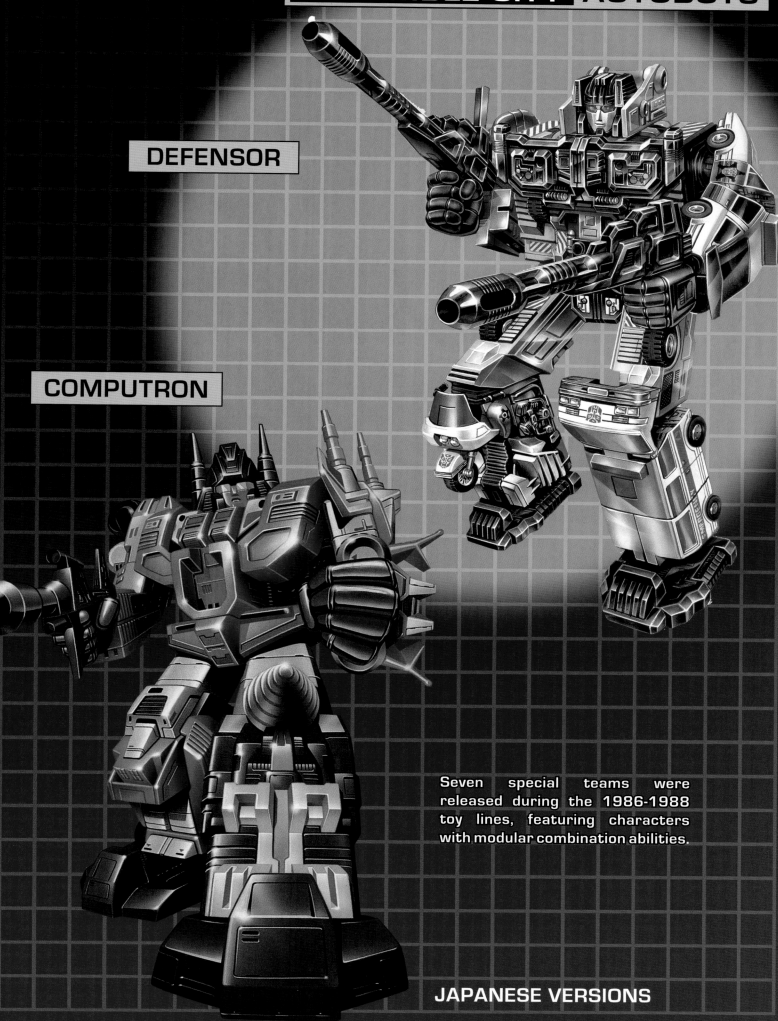

DEFENSOR

COMPUTRON

Seven special teams were
released during the 1986-1988
toy lines, featuring characters
with modular combination abilities.

JAPANESE VERSIONS

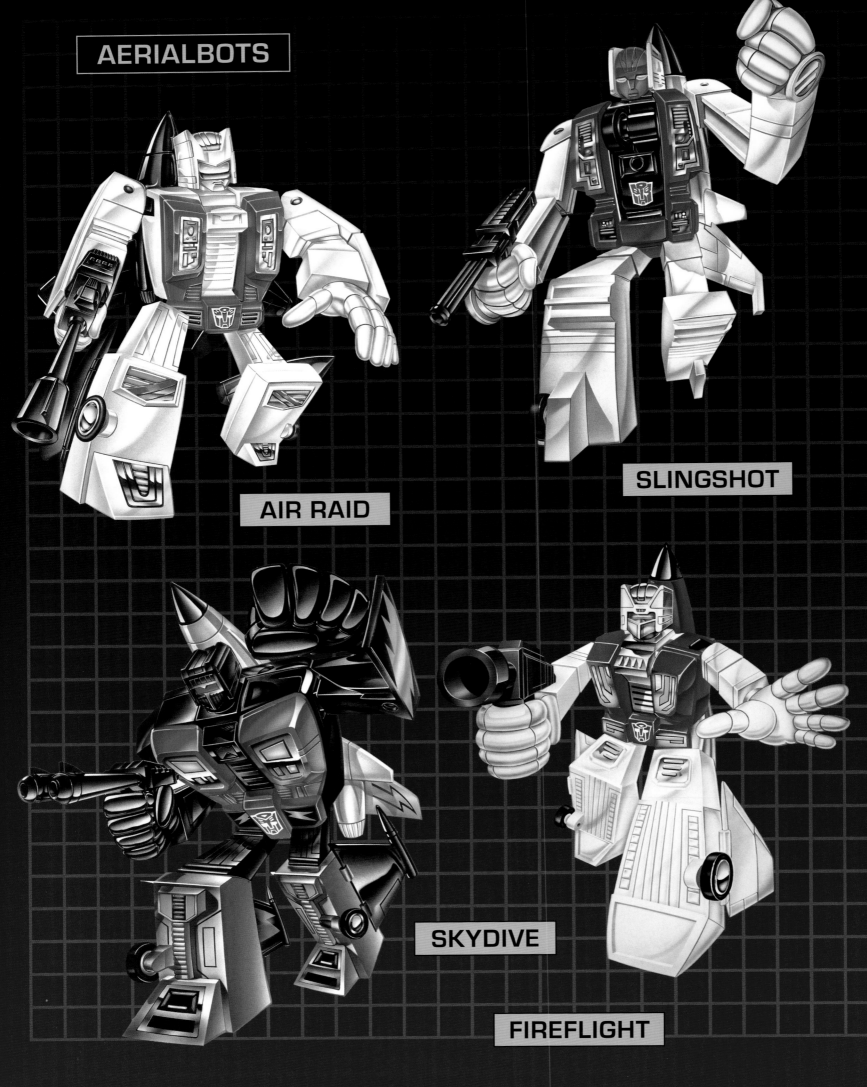

AERIALBOTS

AIR RAID

SLINGSHOT

SKYDIVE

FIREFLIGHT

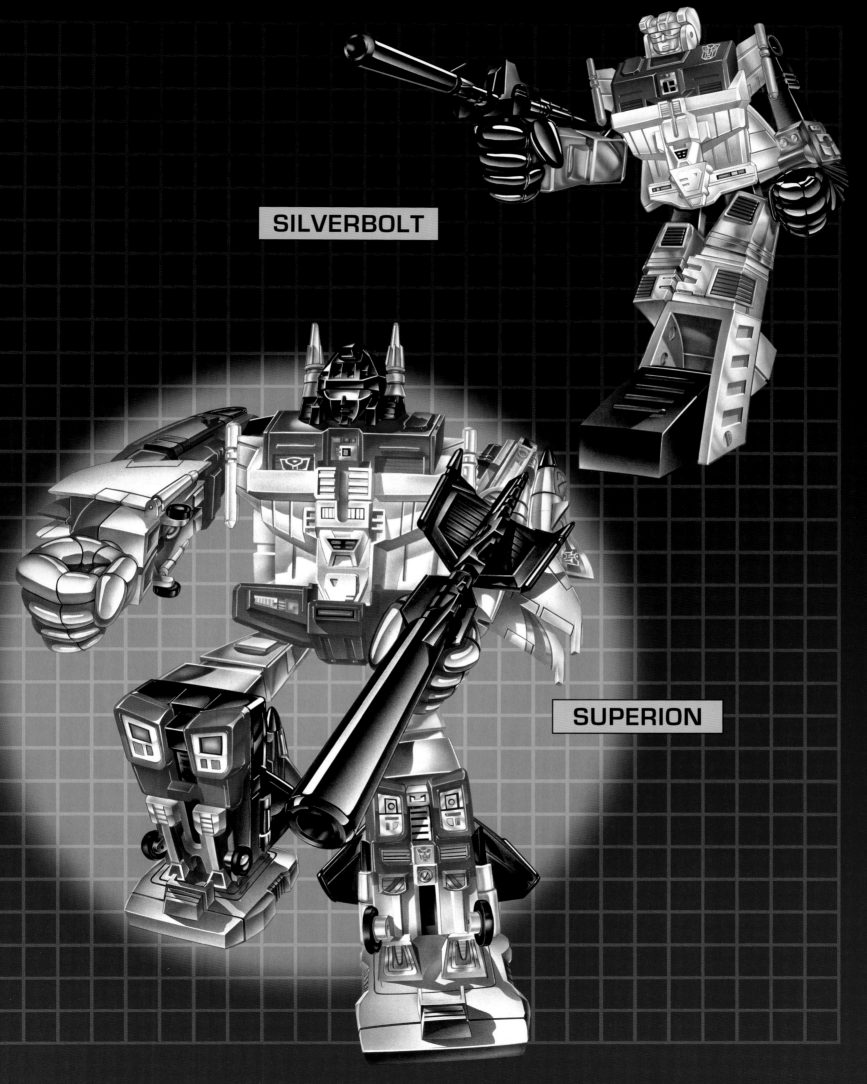

SILVERBOLT

SUPERION

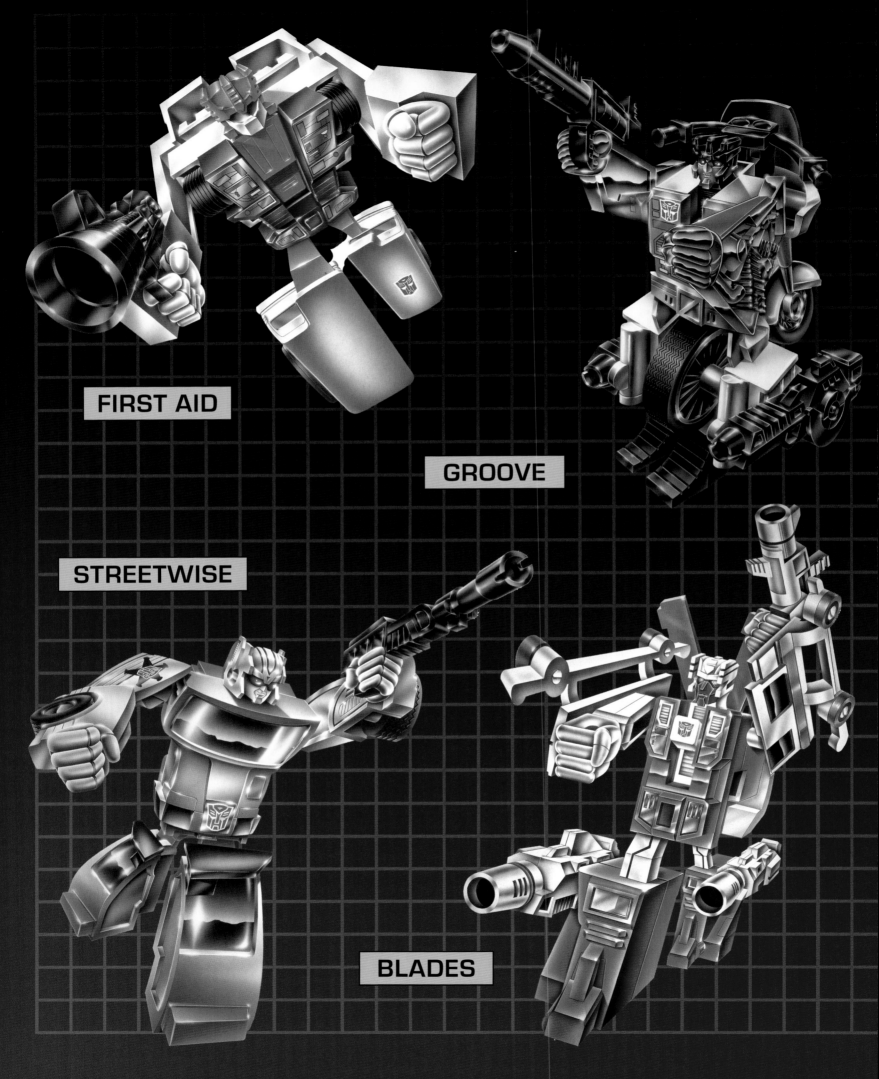

FIRST AID

GROOVE

STREETWISE

BLADES

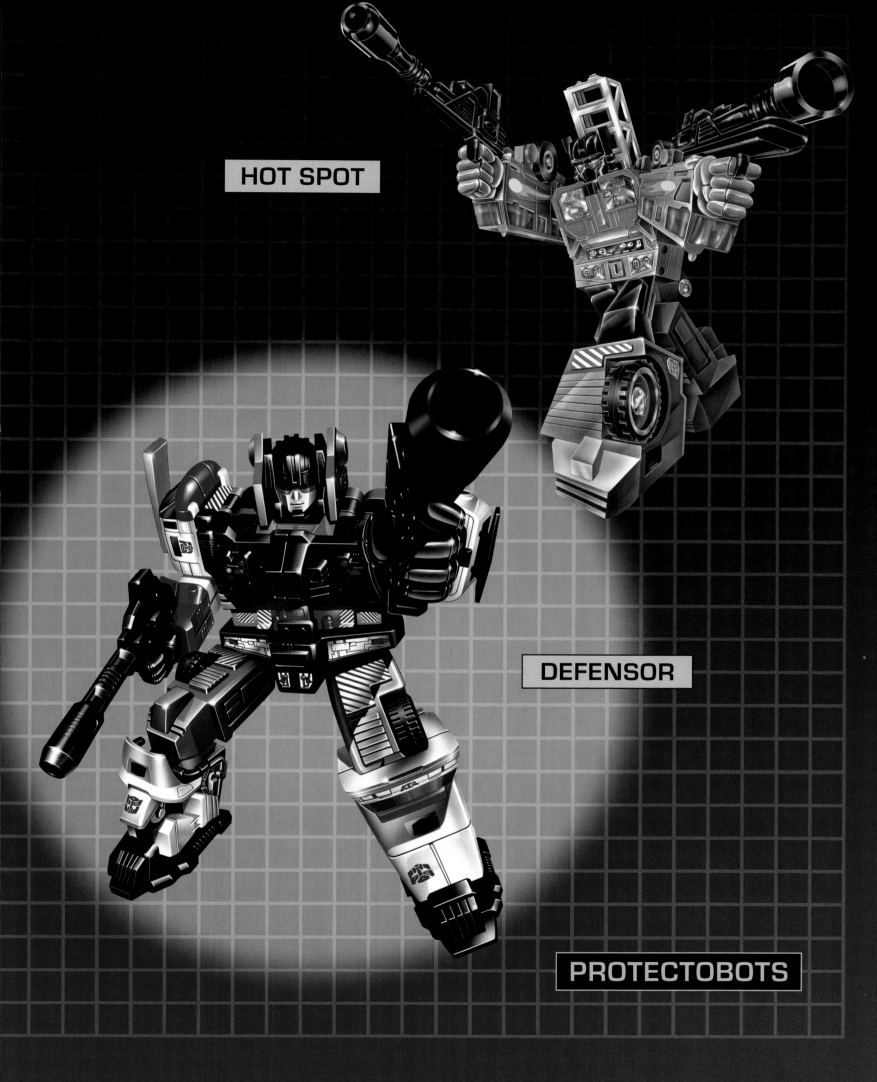

HOT SPOT

DEFENSOR

PROTECTOBOTS

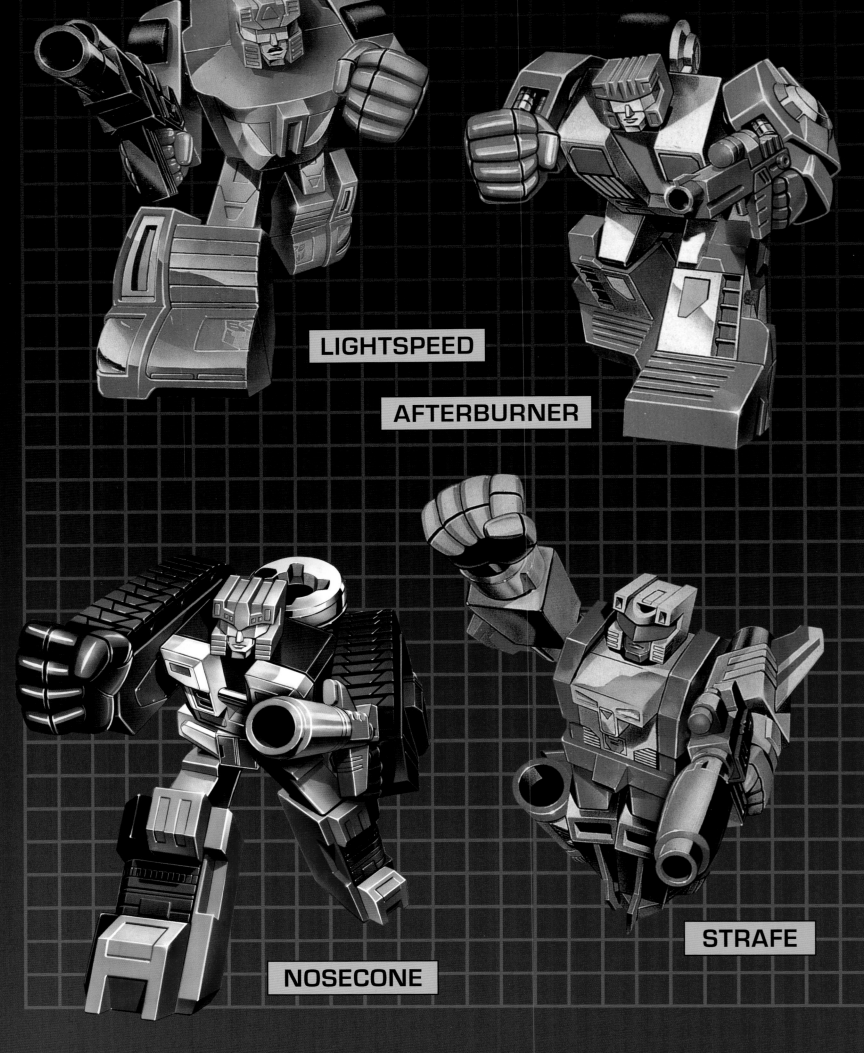

LIGHTSPEED

AFTERBURNER

NOSECONE

STRAFE

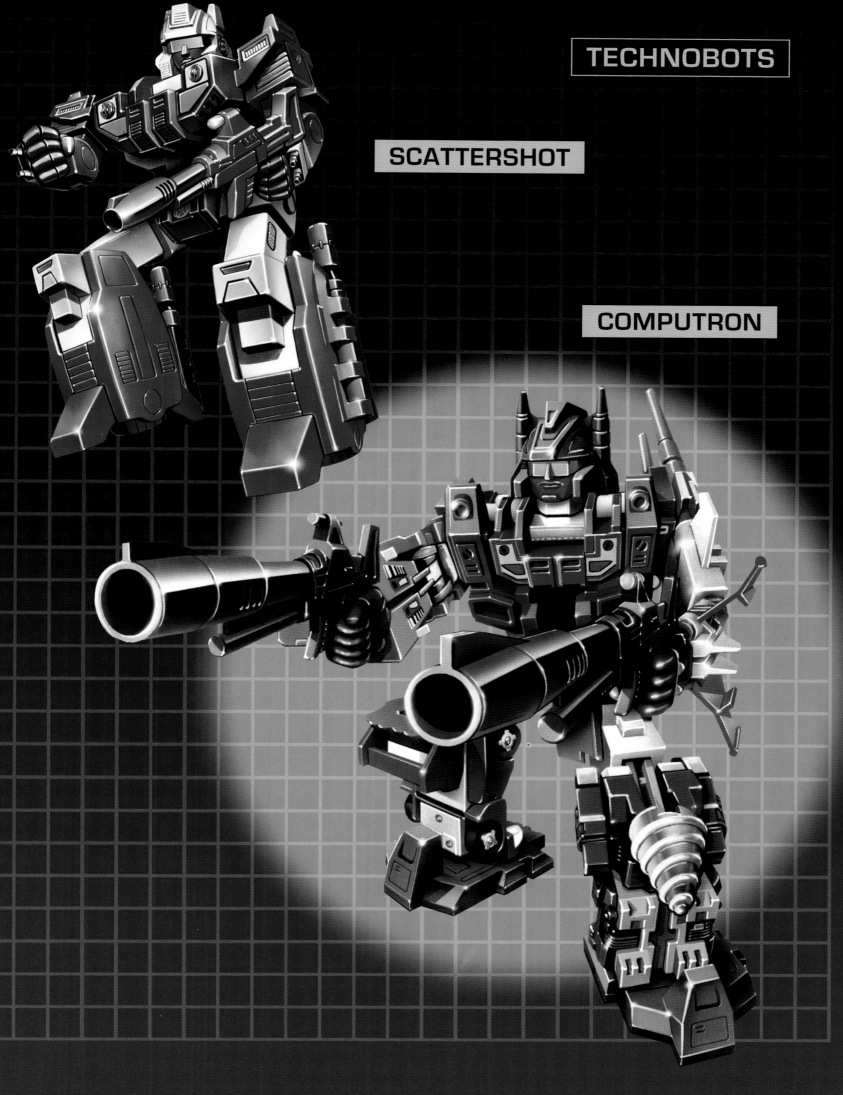

TECHNOBOTS

SCATTERSHOT

COMPUTRON

81

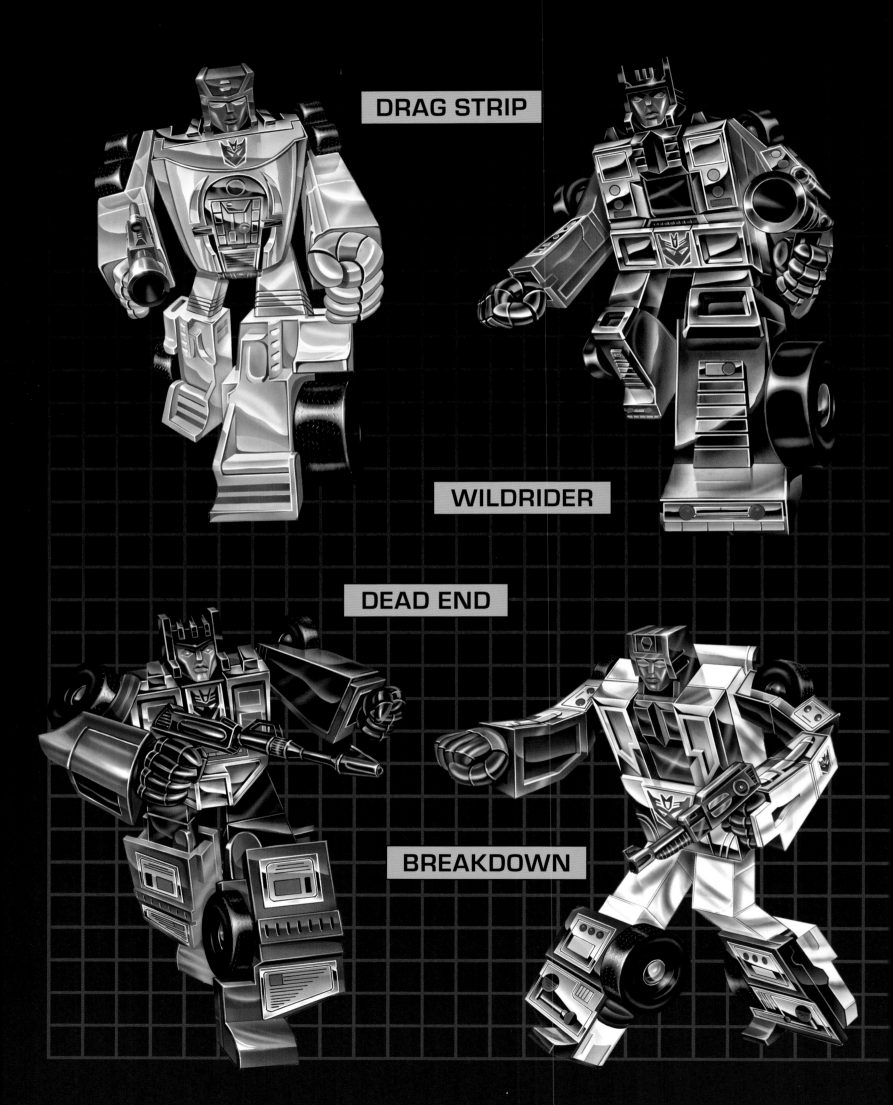

DRAG STRIP

WILDRIDER

DEAD END

BREAKDOWN

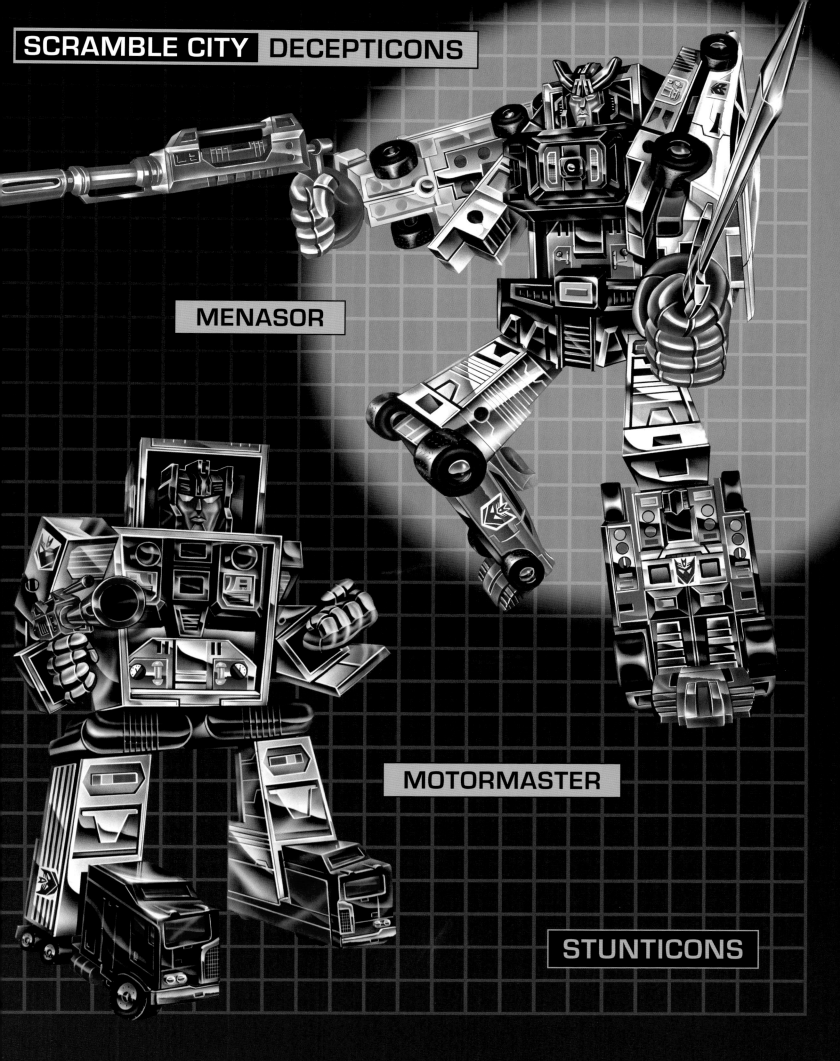

MENASOR

MOTORMASTER

STUNTICONS

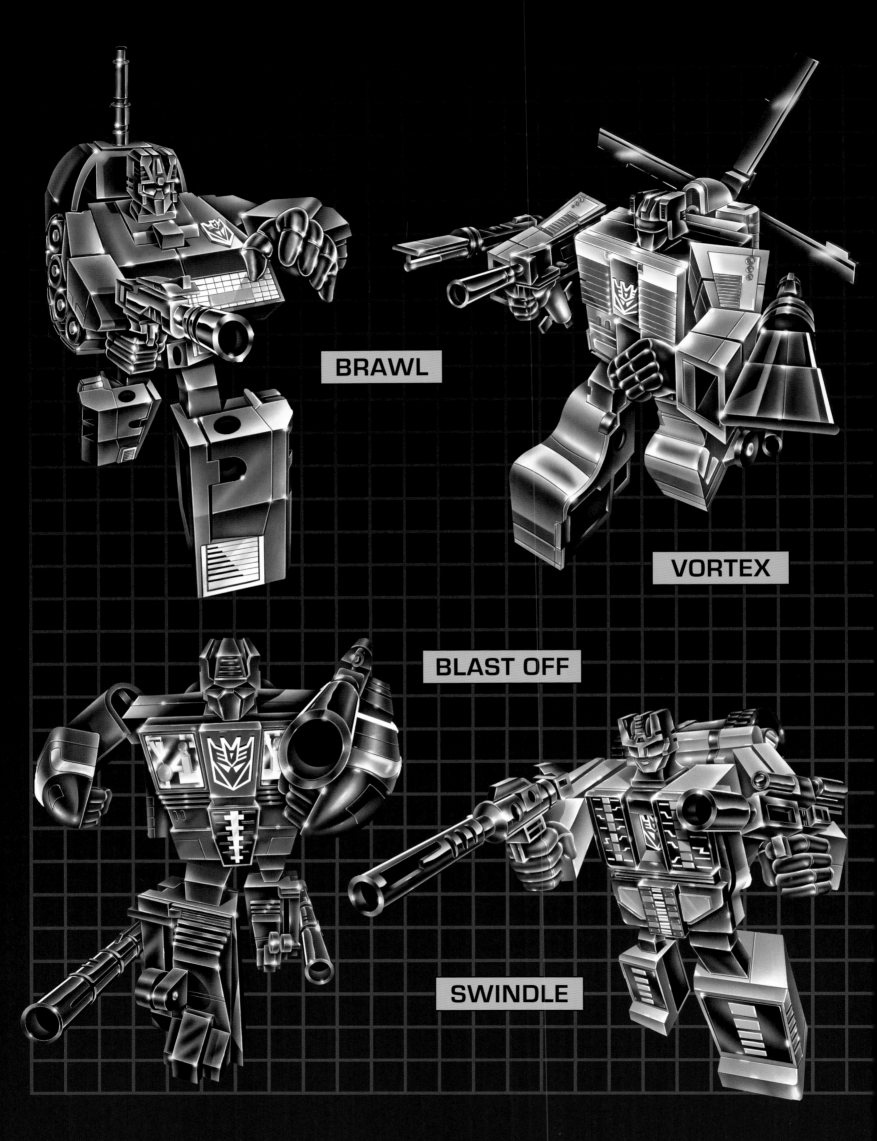

BRAWL

VORTEX

BLAST OFF

SWINDLE

84

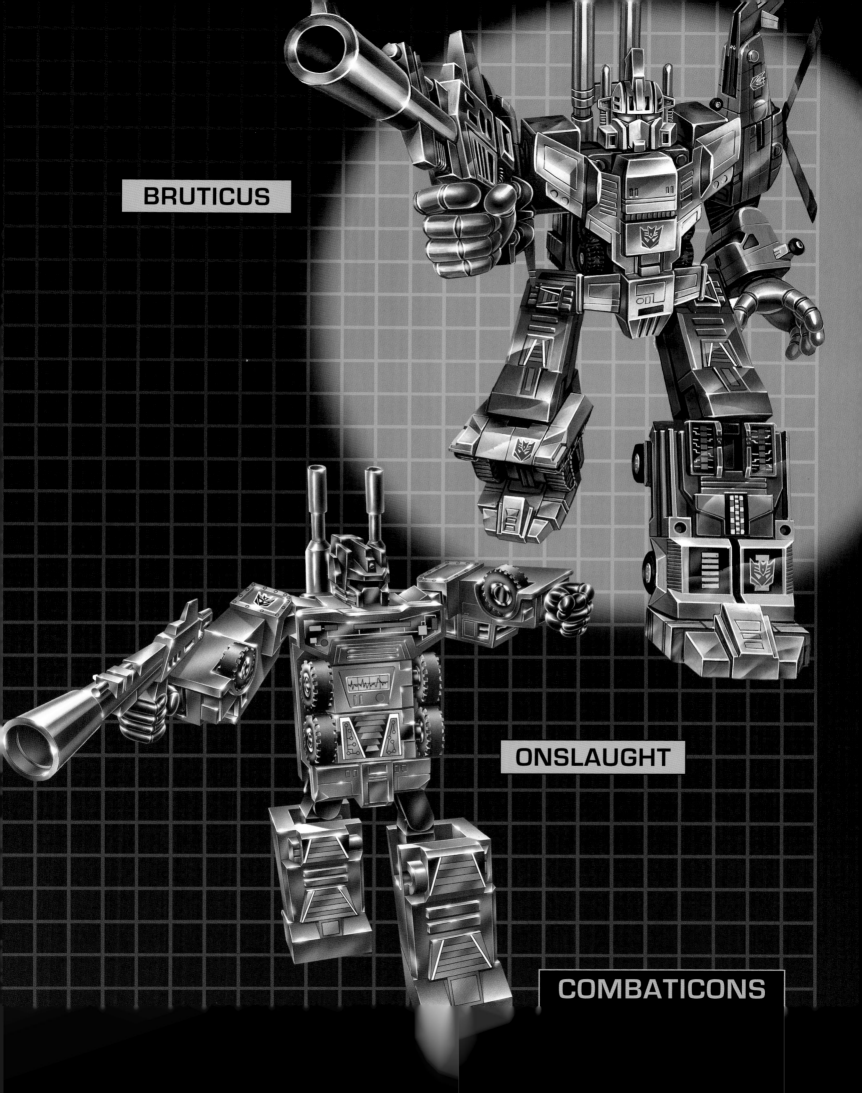

BRUTICUS

ONSLAUGHT

COMBATICONS

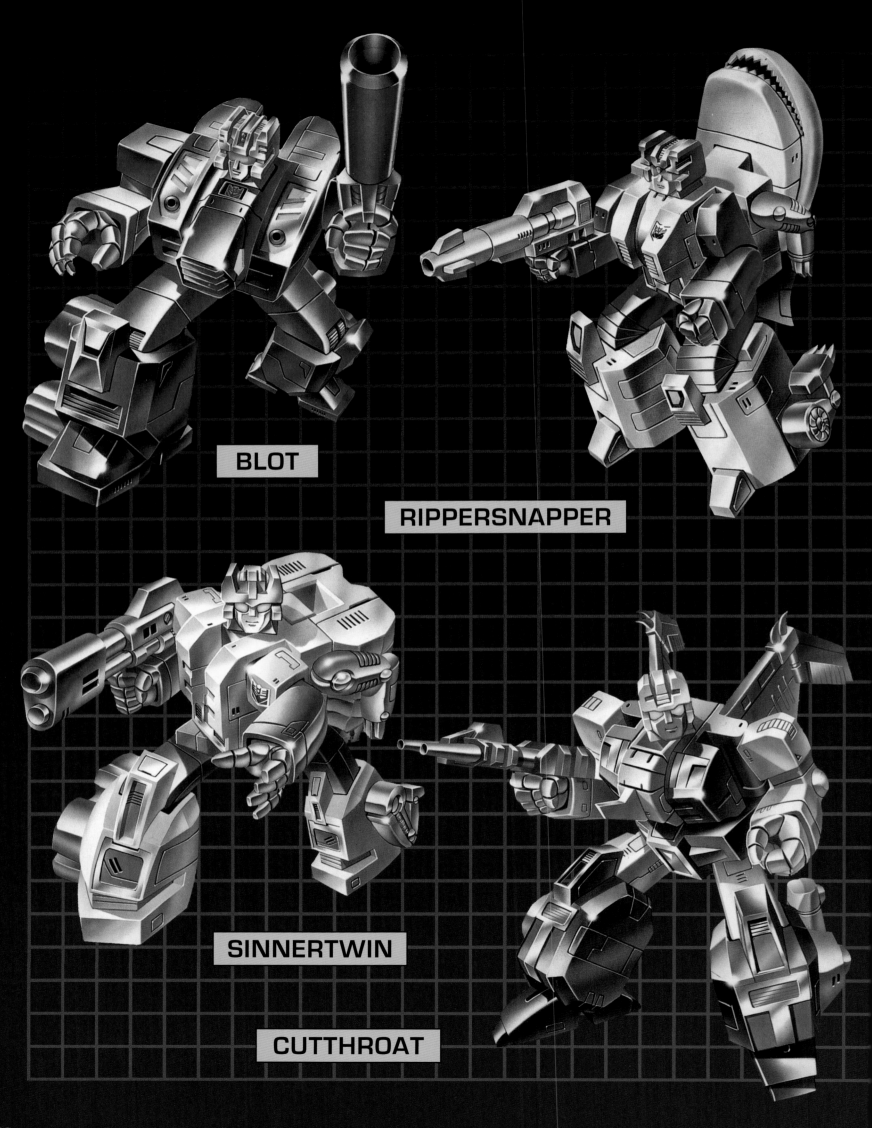

BLOT

RIPPERSNAPPER

SINNERTWIN

CUTTHROAT

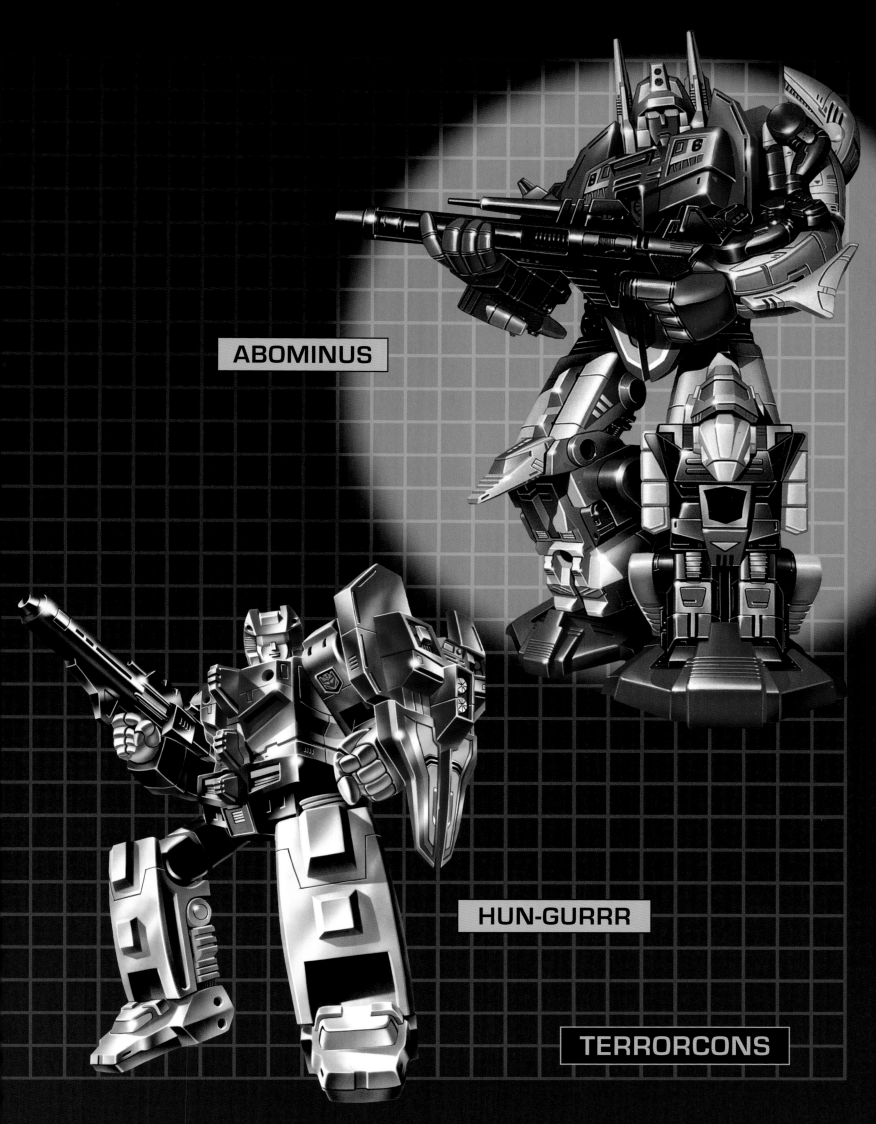

ABOMINUS

HUN-GURRR

TERRORCONS

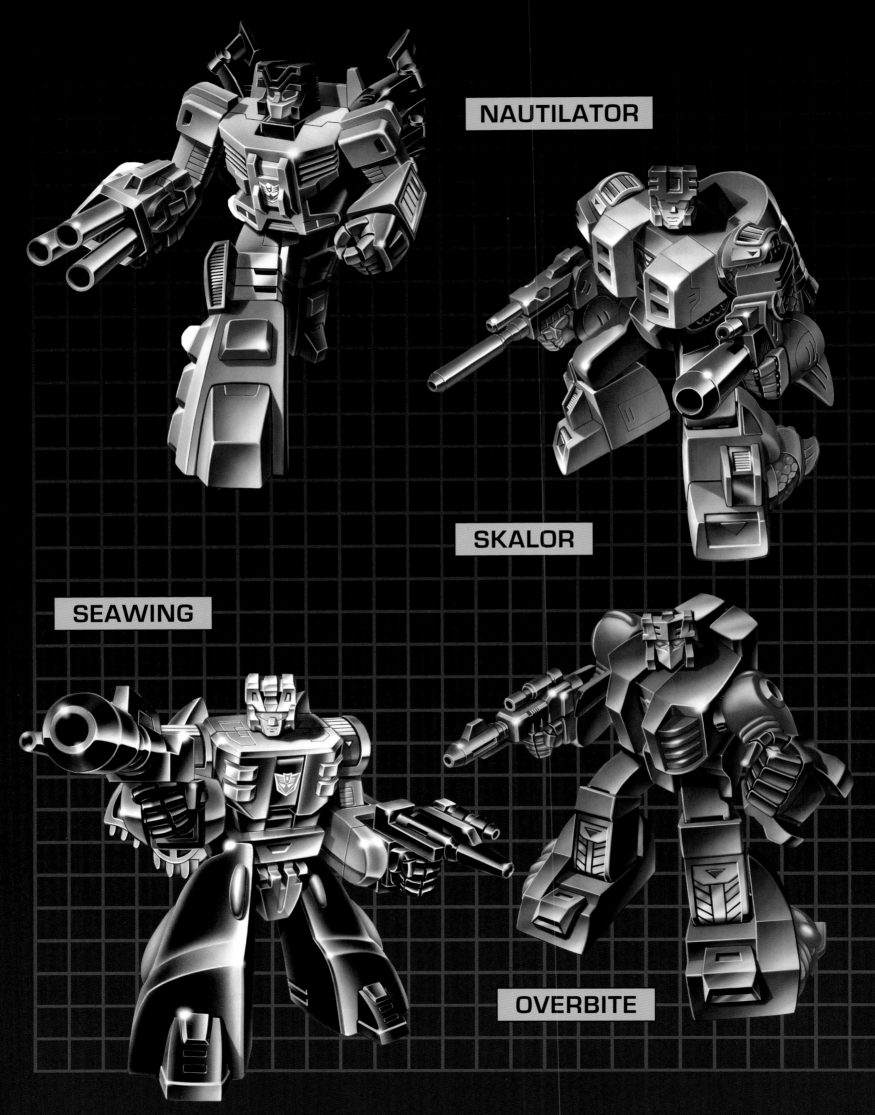

NAUTILATOR

SKALOR

SEAWING

OVERBITE

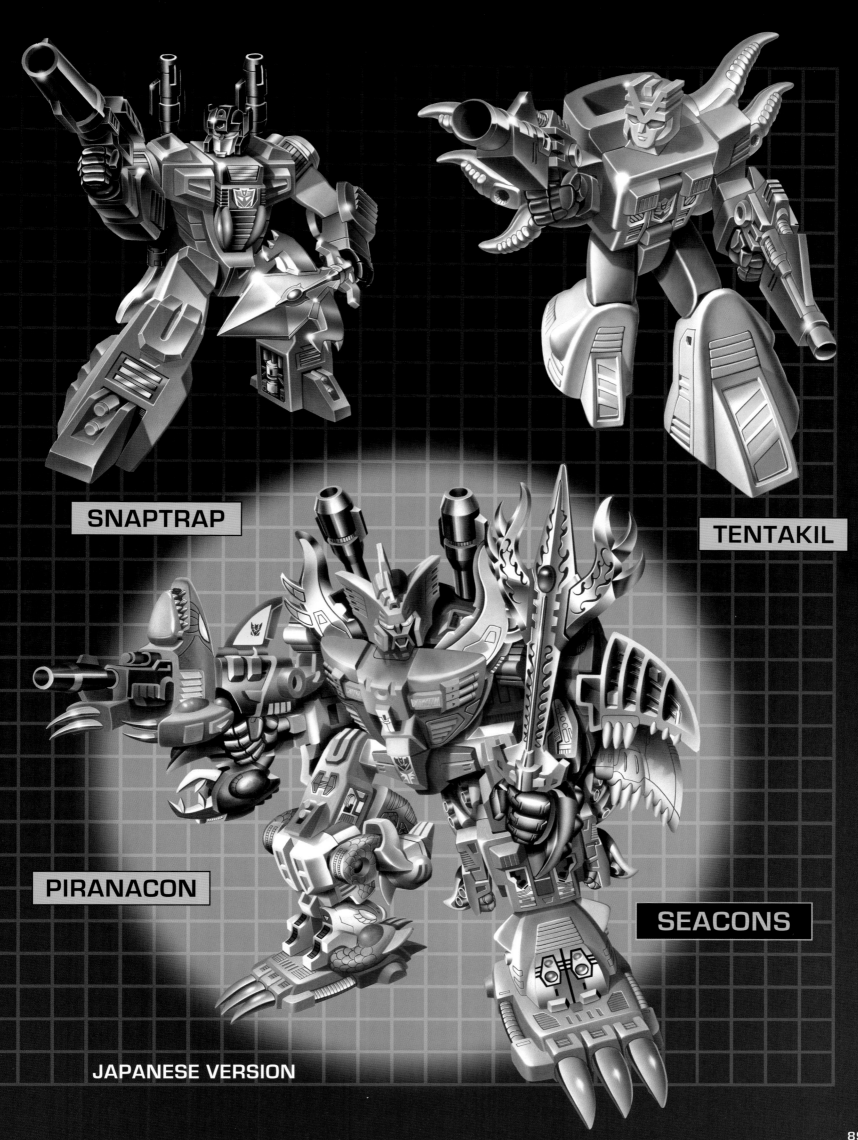

SNAPTRAP

TENTAKIL

PIRANACON

SEACONS

JAPANESE VERSION

89

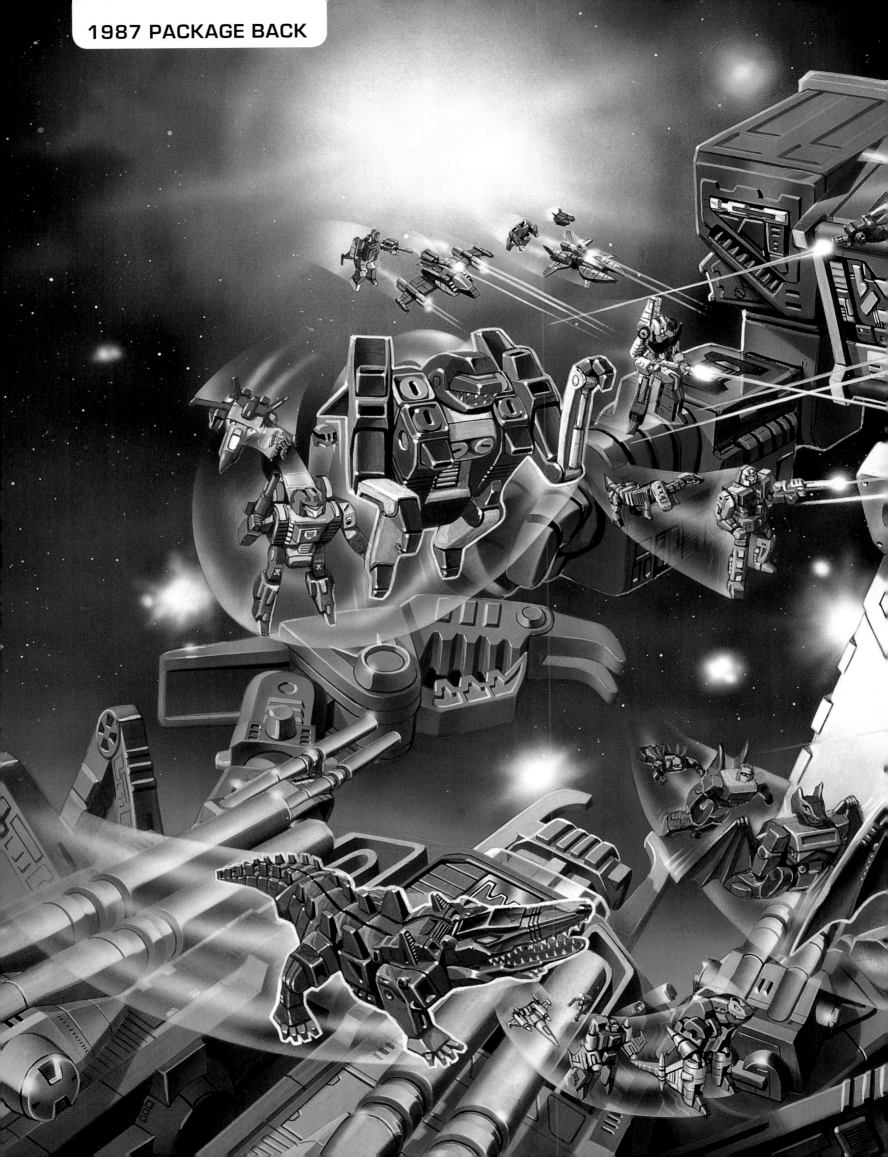

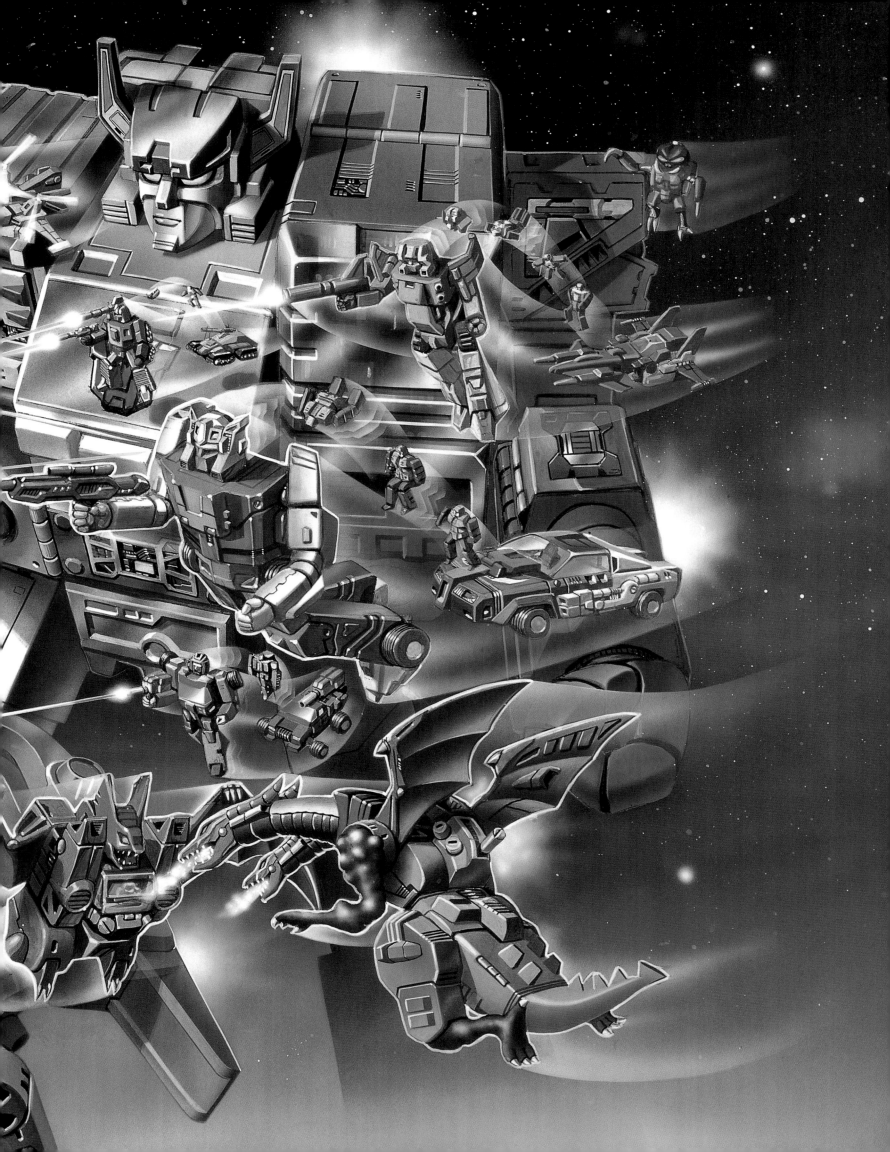

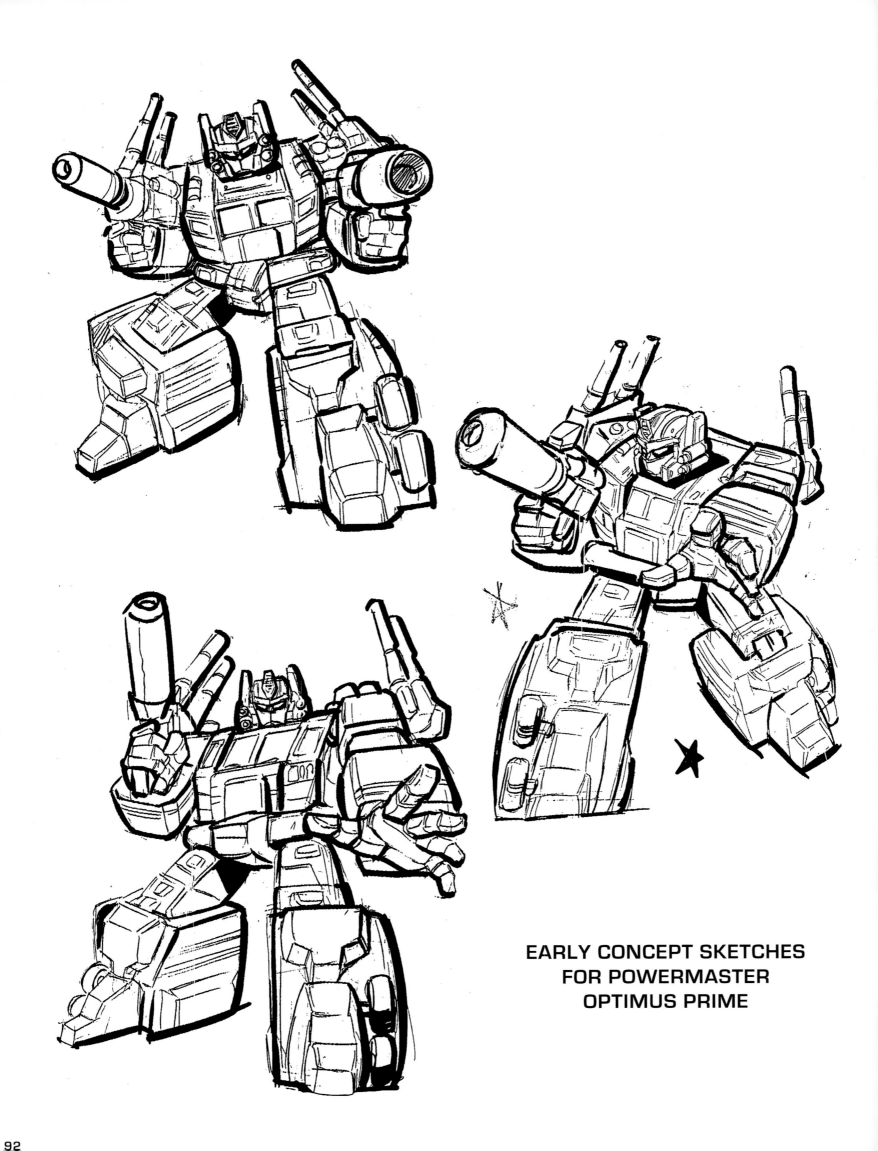

EARLY CONCEPT SKETCHES
FOR POWERMASTER
OPTIMUS PRIME

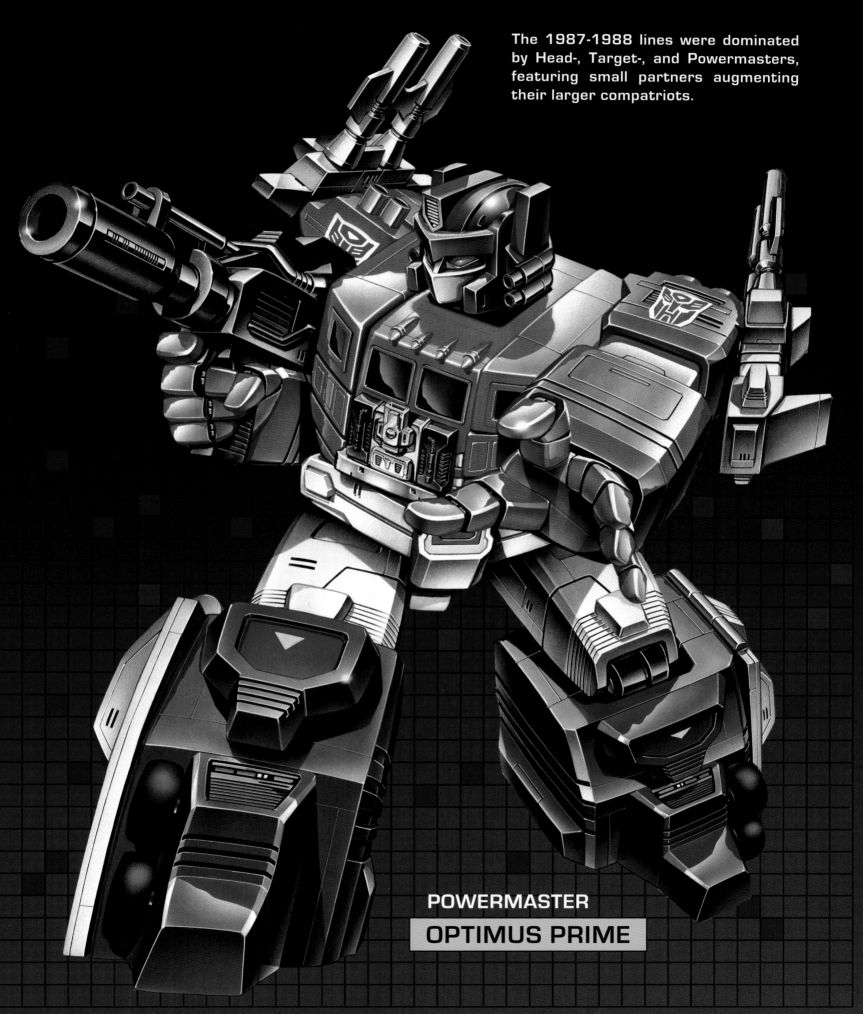

The 1987-1988 lines were dominated by Head-, Target-, and Powermasters, featuring small partners augmenting their larger compatriots.

POWERMASTER
OPTIMUS PRIME

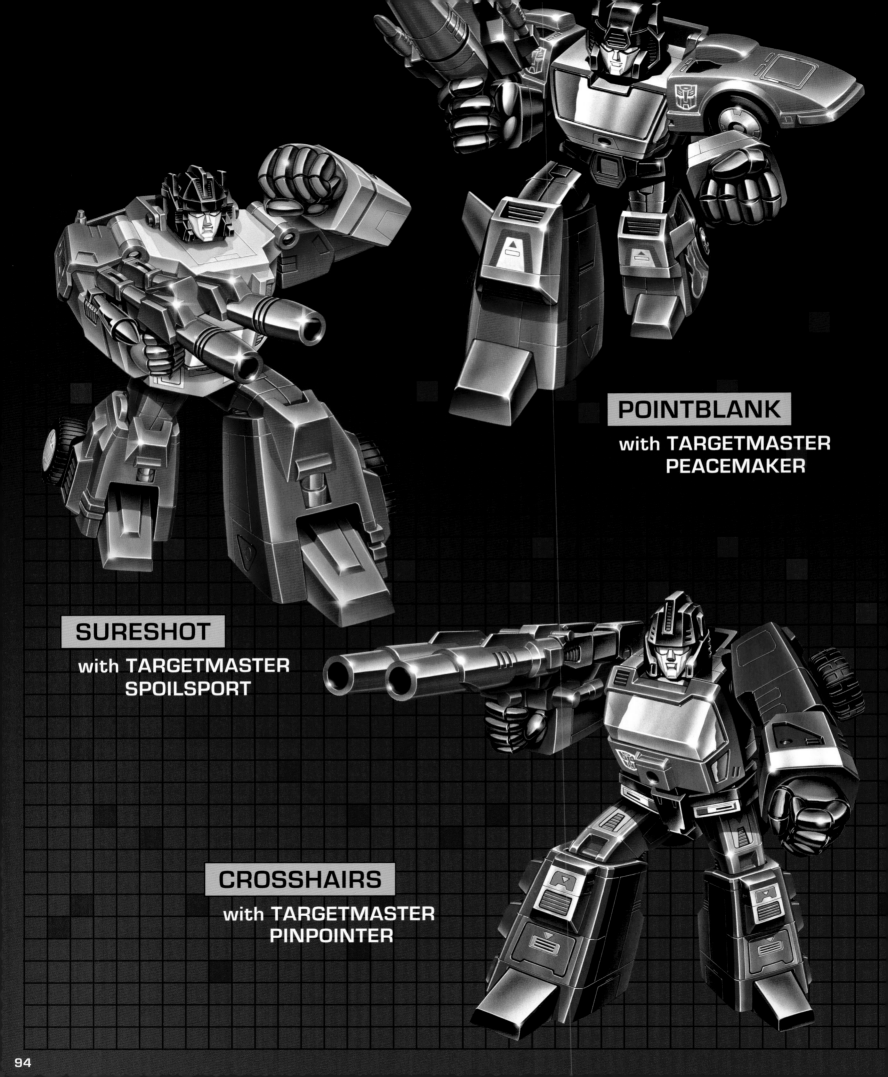

POINTBLANK

with **TARGETMASTER PEACEMAKER**

SURESHOT

with **TARGETMASTER SPOILSPORT**

CROSSHAIRS

with **TARGETMASTER PINPOINTER**

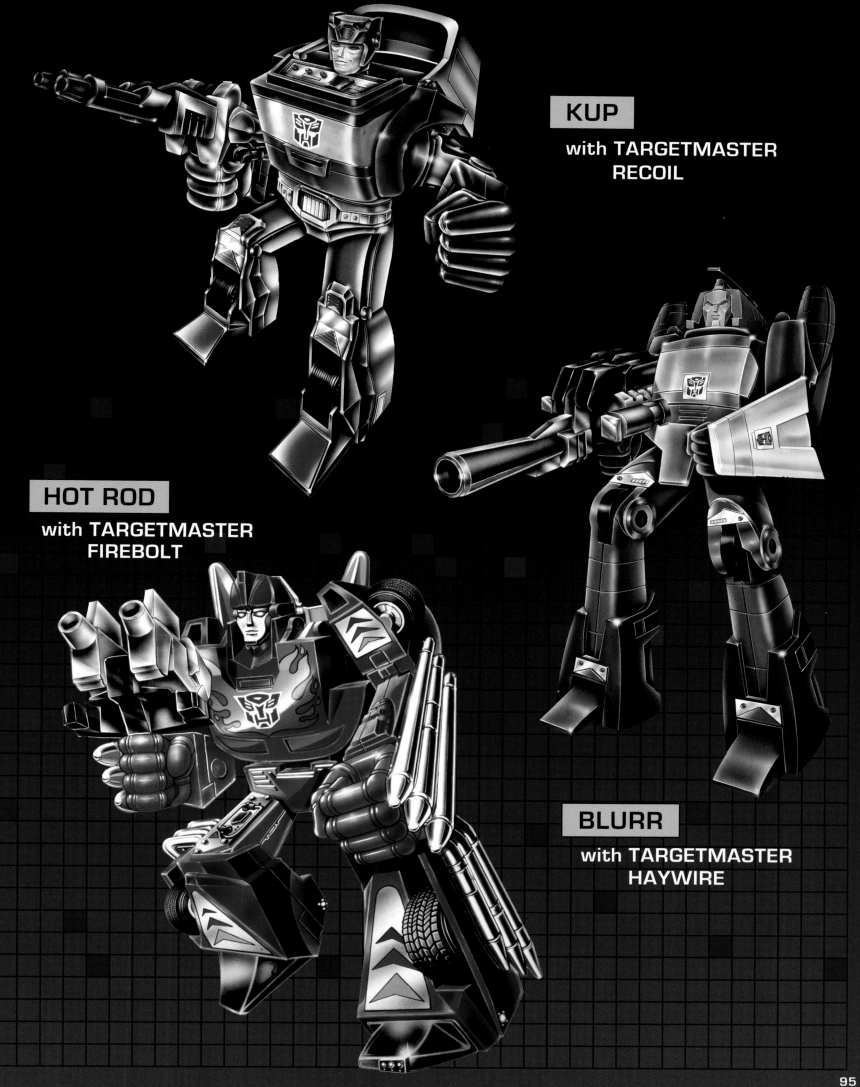

KUP

with **TARGETMASTER RECOIL**

HOT ROD

with **TARGETMASTER FIREBOLT**

BLURR

with **TARGETMASTER HAYWIRE**

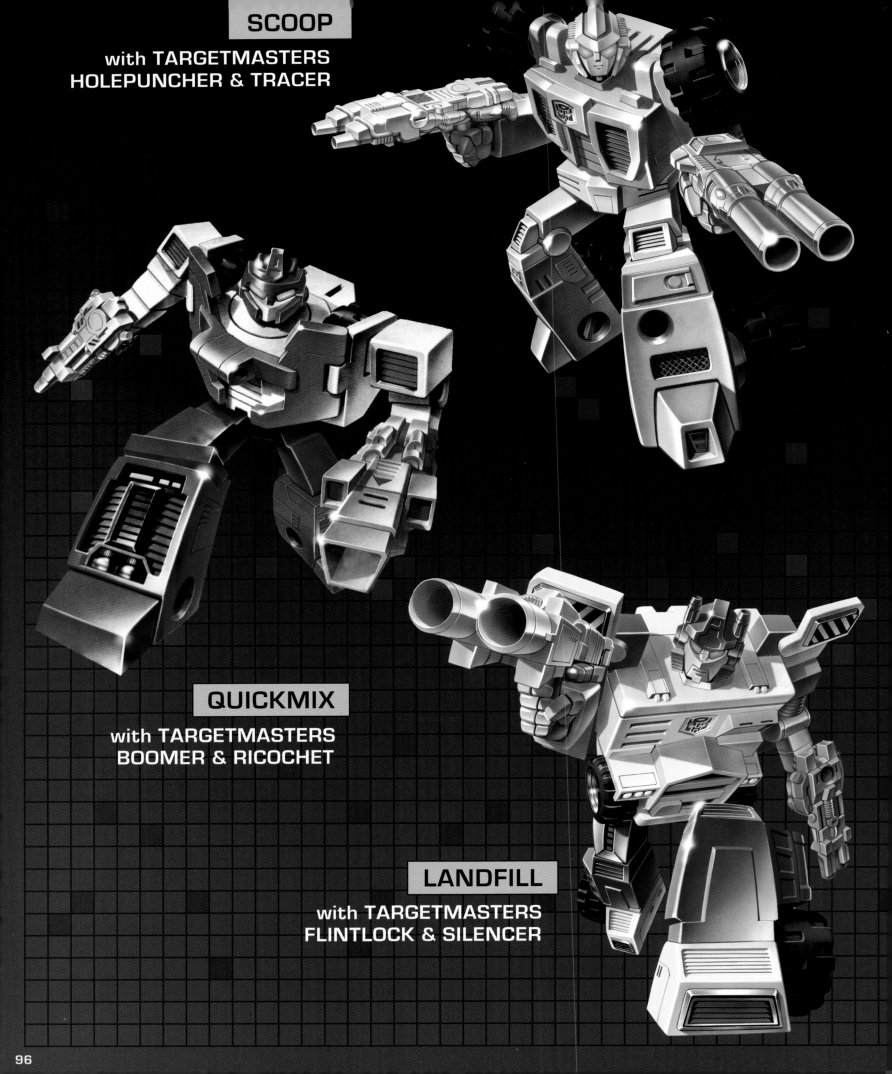

SCOOP

with **TARGETMASTERS HOLEPUNCHER & TRACER**

QUICKMIX

with **TARGETMASTERS BOOMER & RICOCHET**

LANDFILL

with **TARGETMASTERS FLINTLOCK & SILENCER**

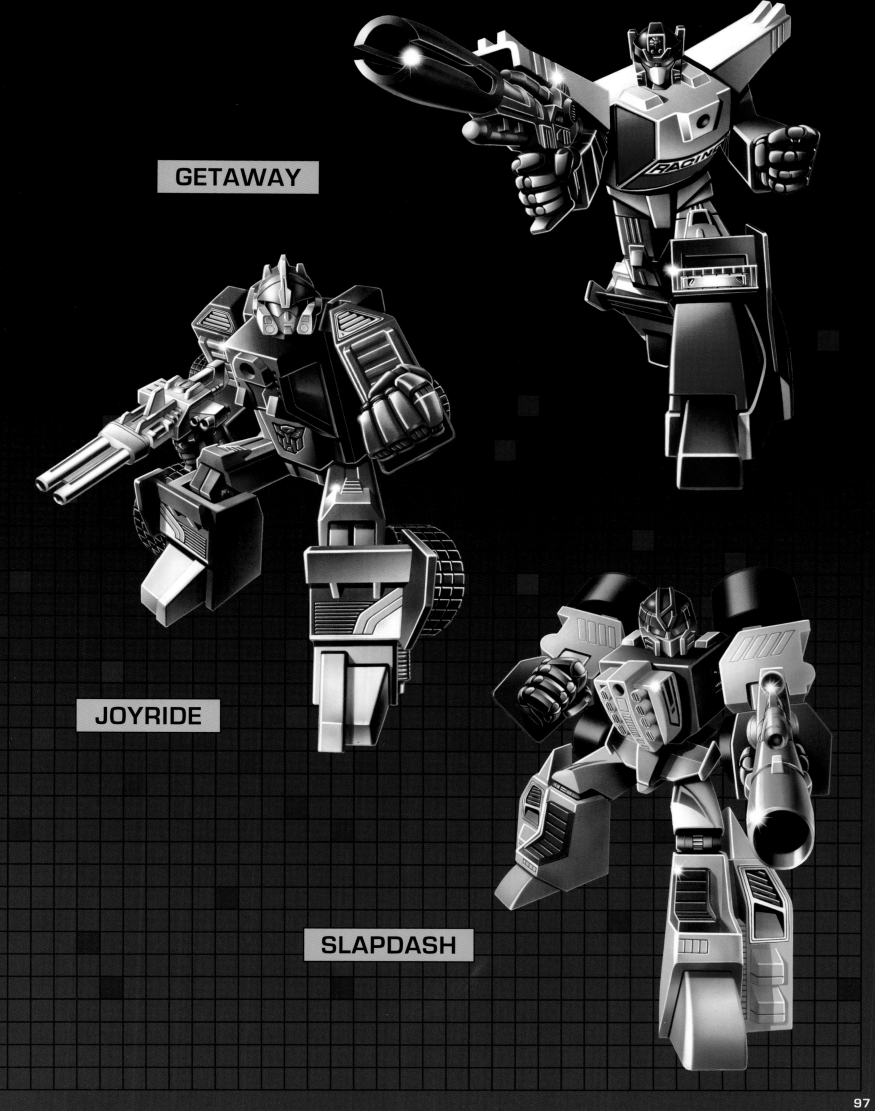

GETAWAY

JOYRIDE

SLAPDASH

97

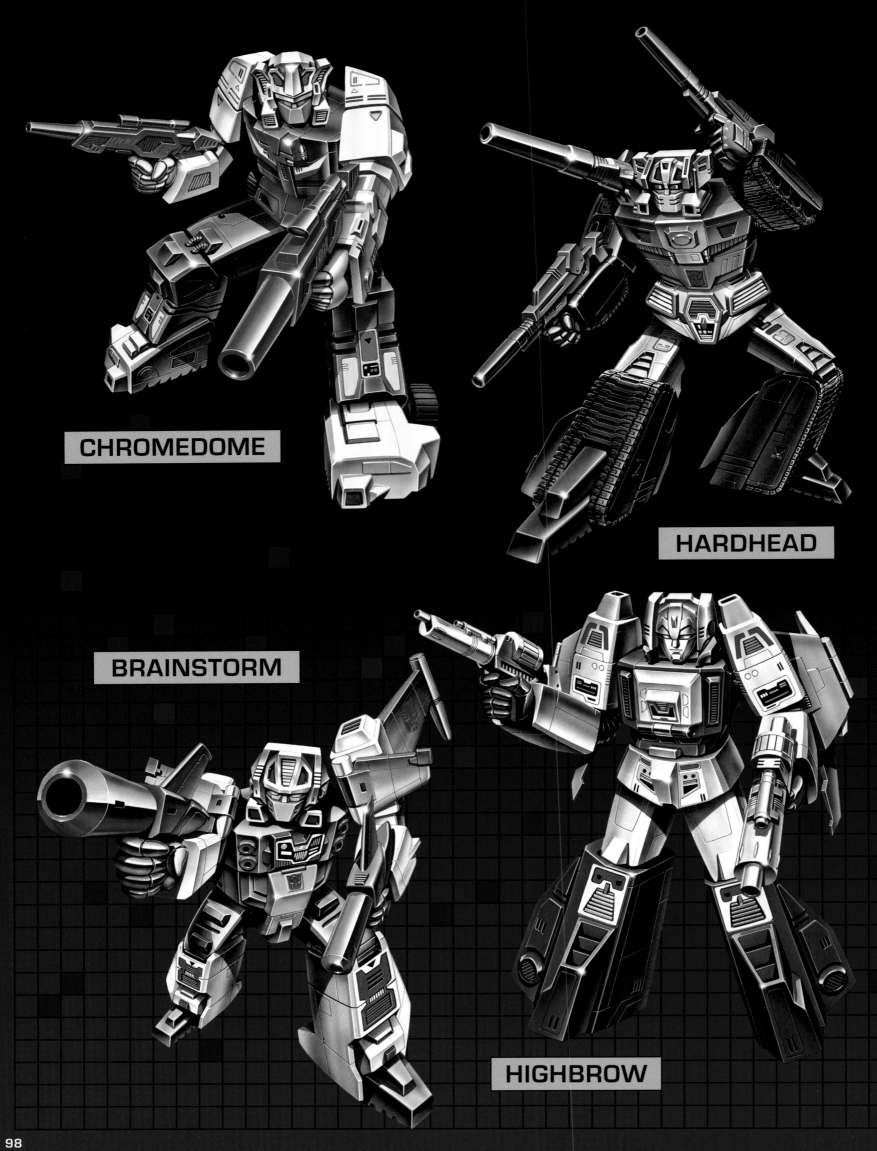

CHROMEDOME

HARDHEAD

BRAINSTORM

HIGHBROW

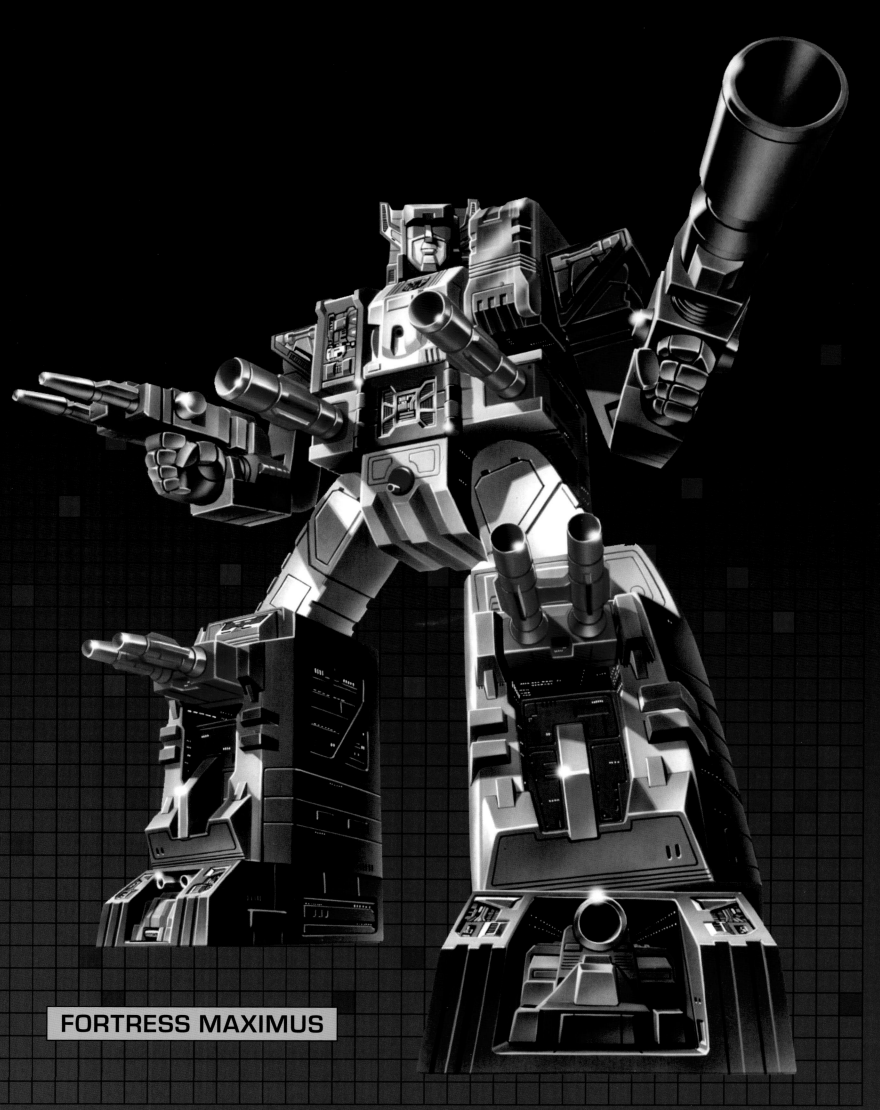

FORTRESS MAXIMUS

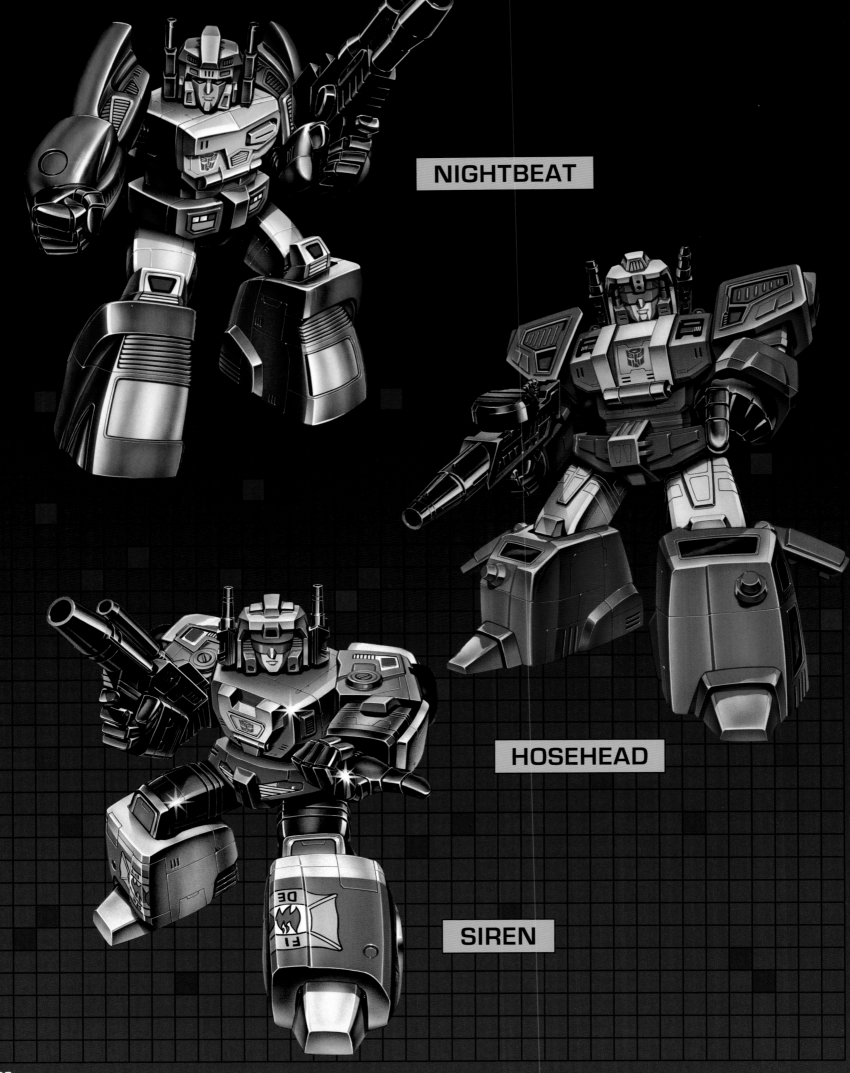

NIGHTBEAT

HOSEHEAD

SIREN

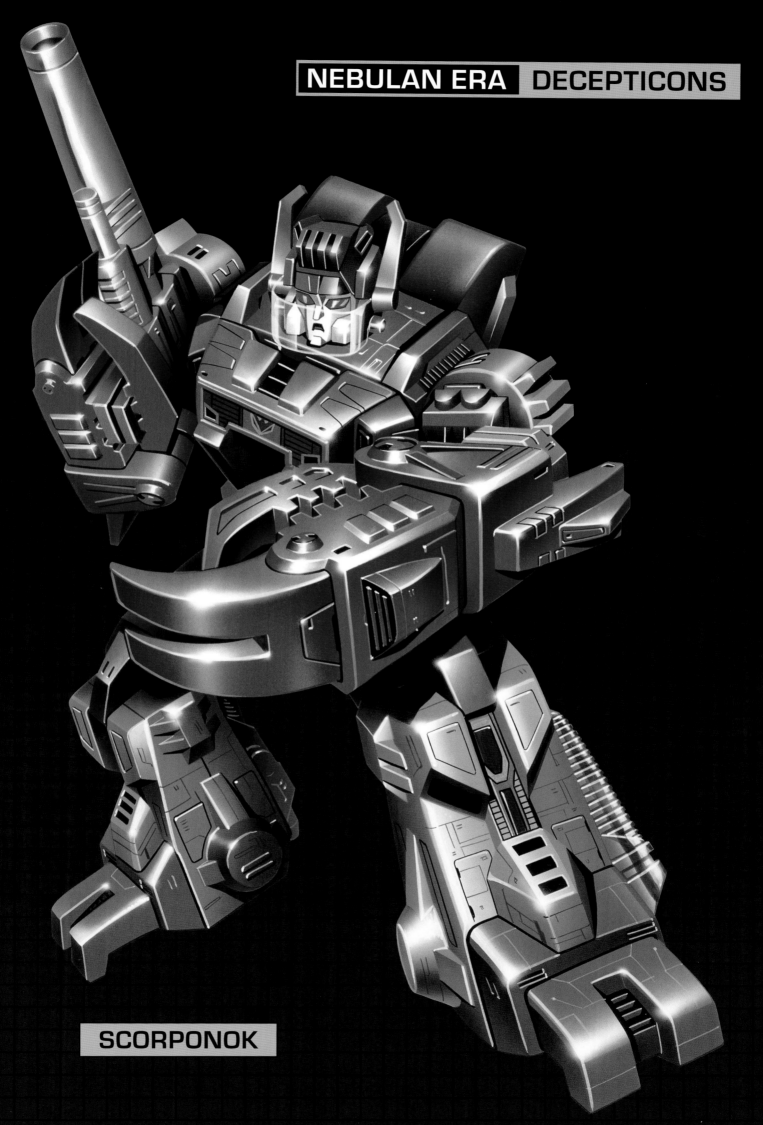

SCORPONOK

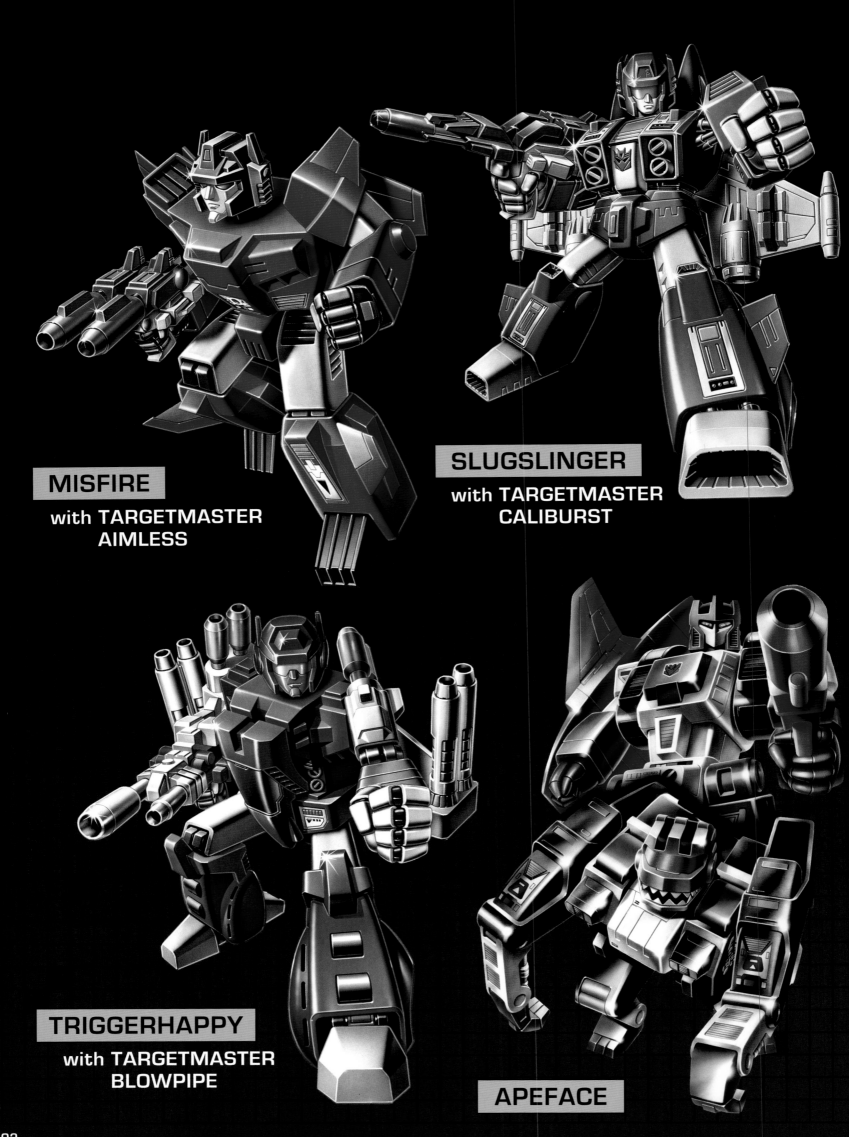

MISFIRE
with **TARGETMASTER AIMLESS**

SLUGSLINGER
with **TARGETMASTER CALIBURST**

TRIGGERHAPPY
with **TARGETMASTER BLOWPIPE**

APEFACE

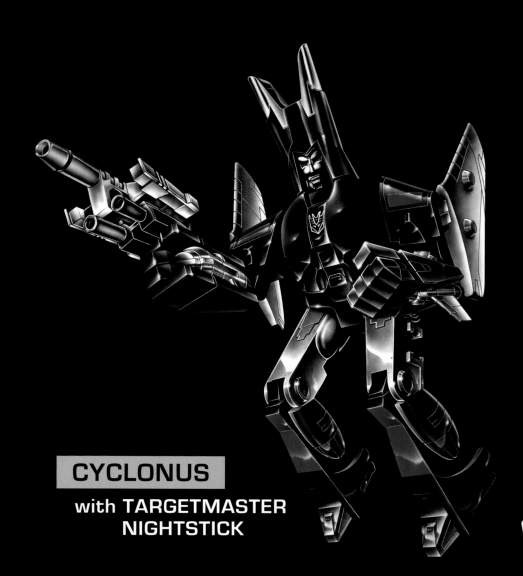

CYCLONUS

with TARGETMASTER NIGHTSTICK

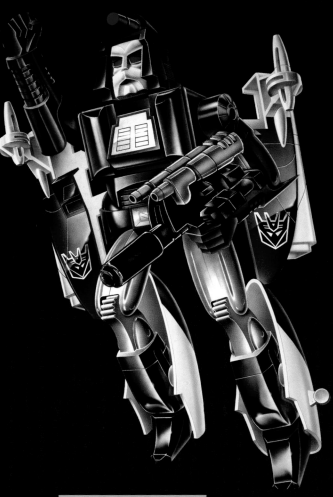

SCOURGE

with TARGETMASTER FRACAS

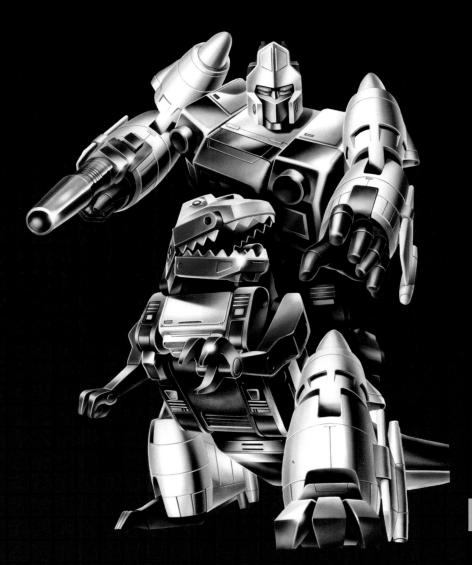

SNAPDRAGON

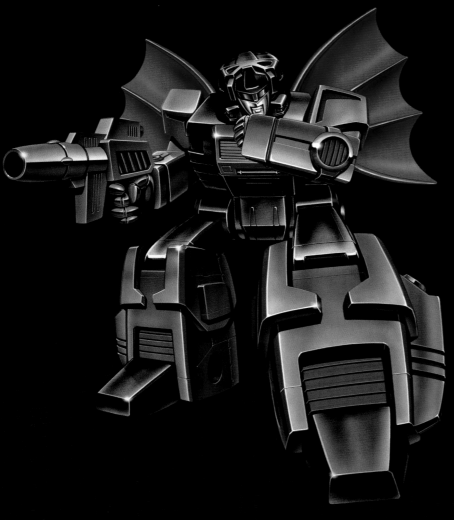

MINDWIPE

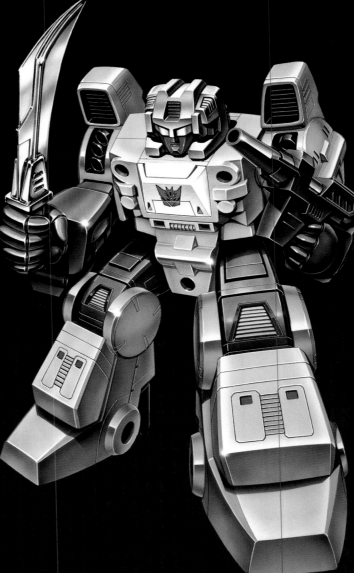

WEIRDWOLF

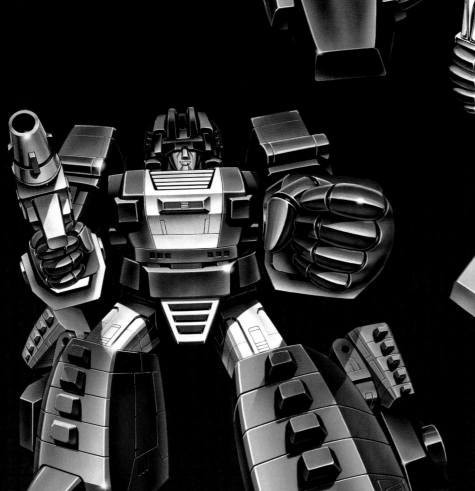

SKULLCRUNCHER

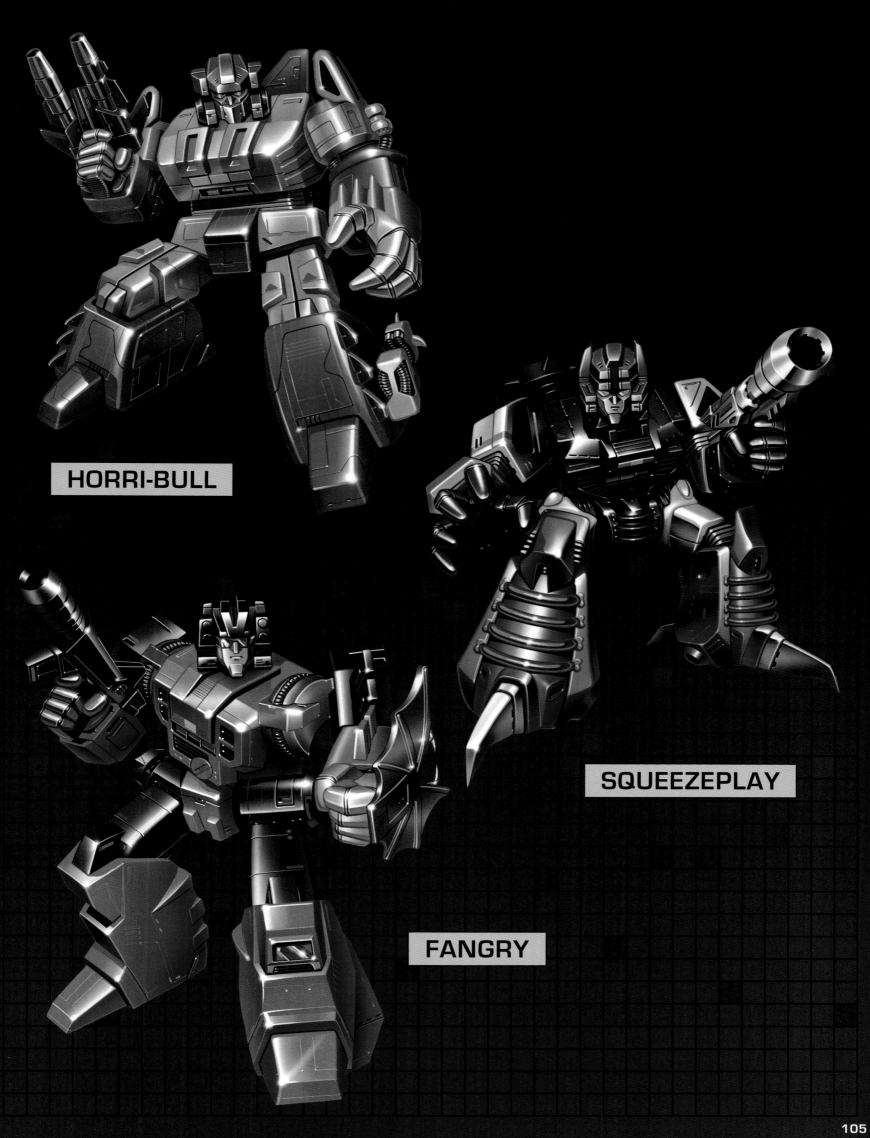

HORRI-BULL

SQUEEZEPLAY

FANGRY

NEEDLENOSE

with TARGETMASTERS
SUNBEAM & ZIGZAG

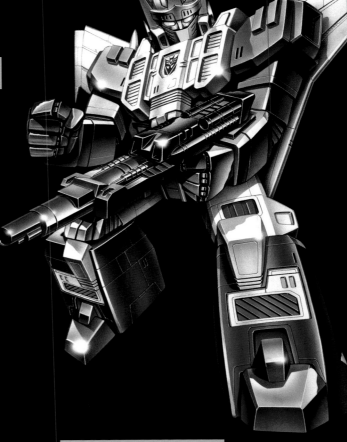

SPINISTER

with TARGETMASTERS
HAIRSPLITTER & SINGE

QUAKE

with TARGETMASTERS
TIPTOP & HEATER

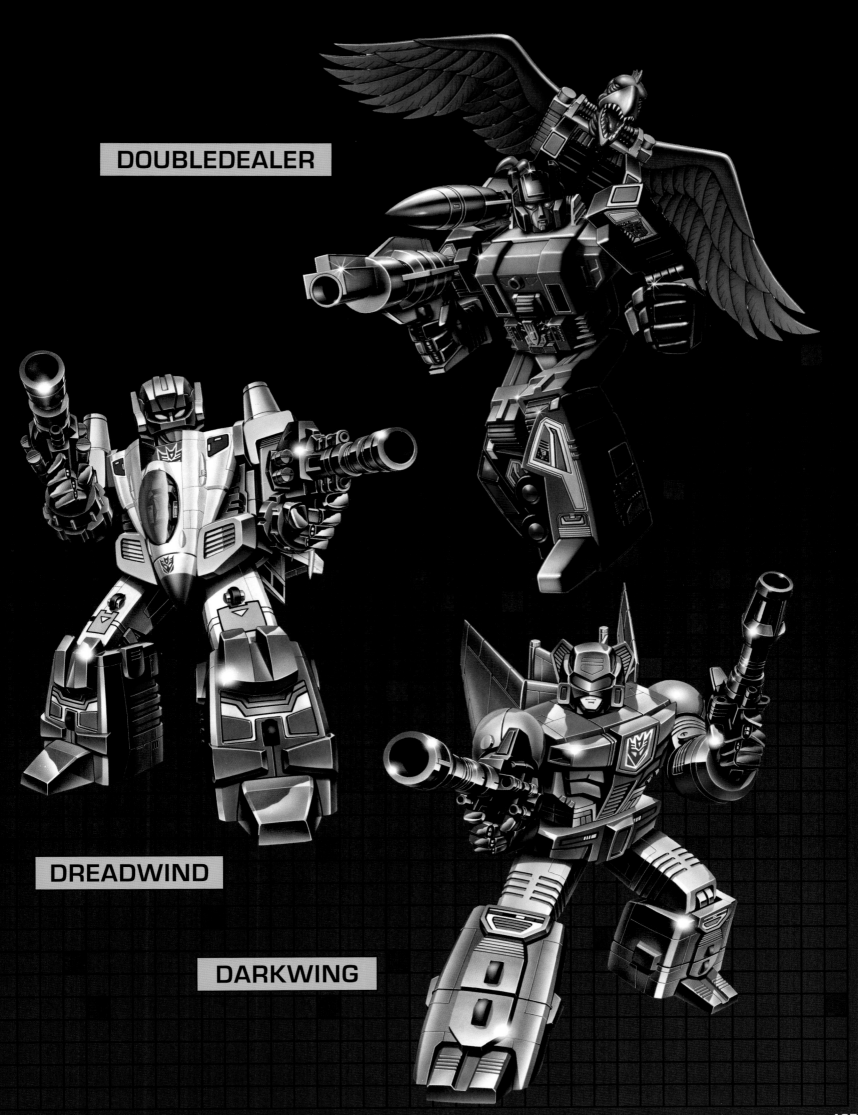

DOUBLEDEALER

DREADWIND

DARKWING

107

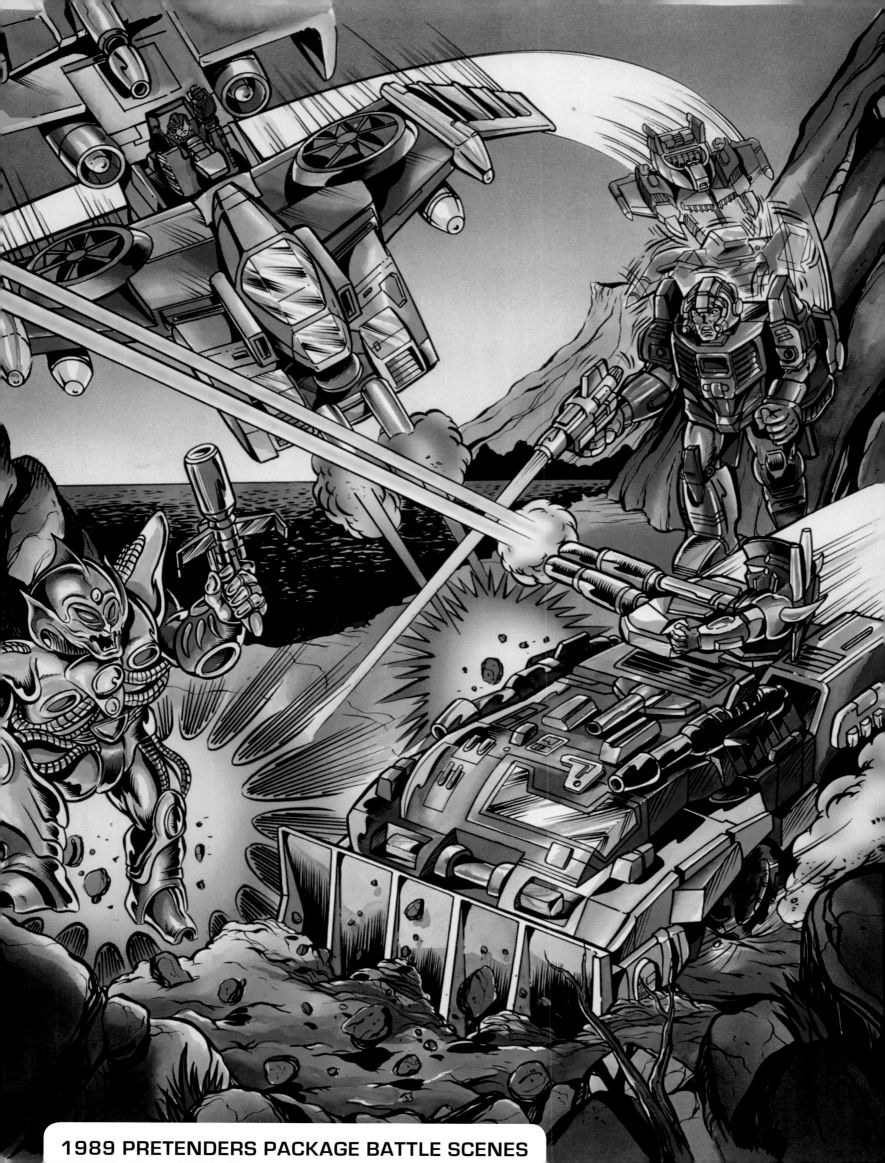

1989 PRETENDERS PACKAGE BATTLE SCENES

TRANSFORMERS
PRETENDERS LOGO

UNUSED PRETENDERS LOGO

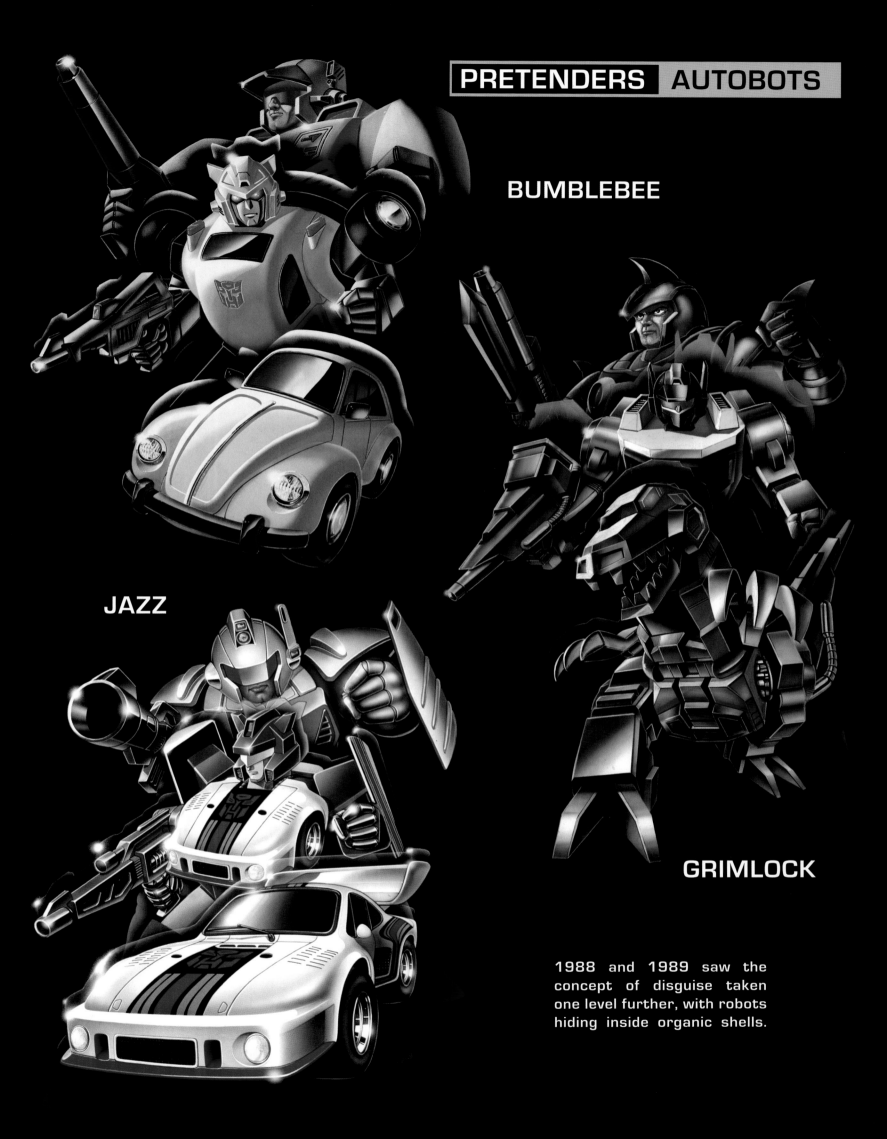

BUMBLEBEE

JAZZ

GRIMLOCK

1988 and 1989 saw the concept of disguise taken one level further, with robots hiding inside organic shells.

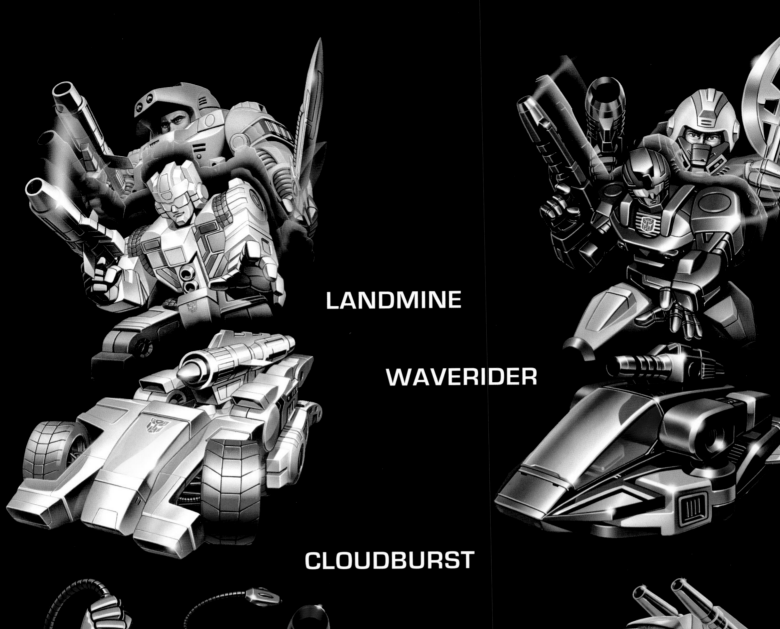

LANDMINE

WAVERIDER

CLOUDBURST

CHAINCLAW

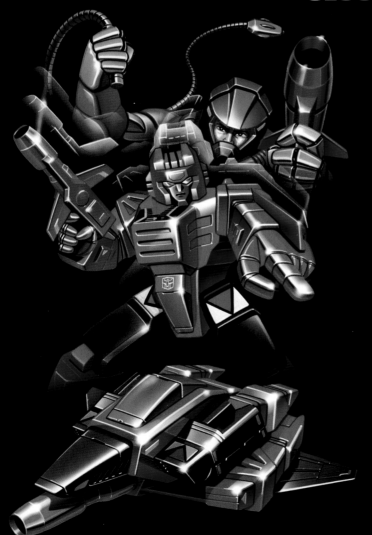

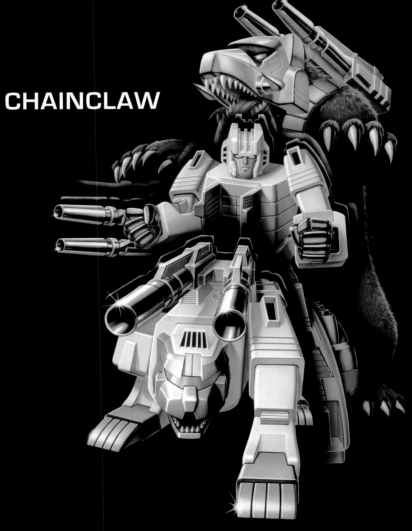

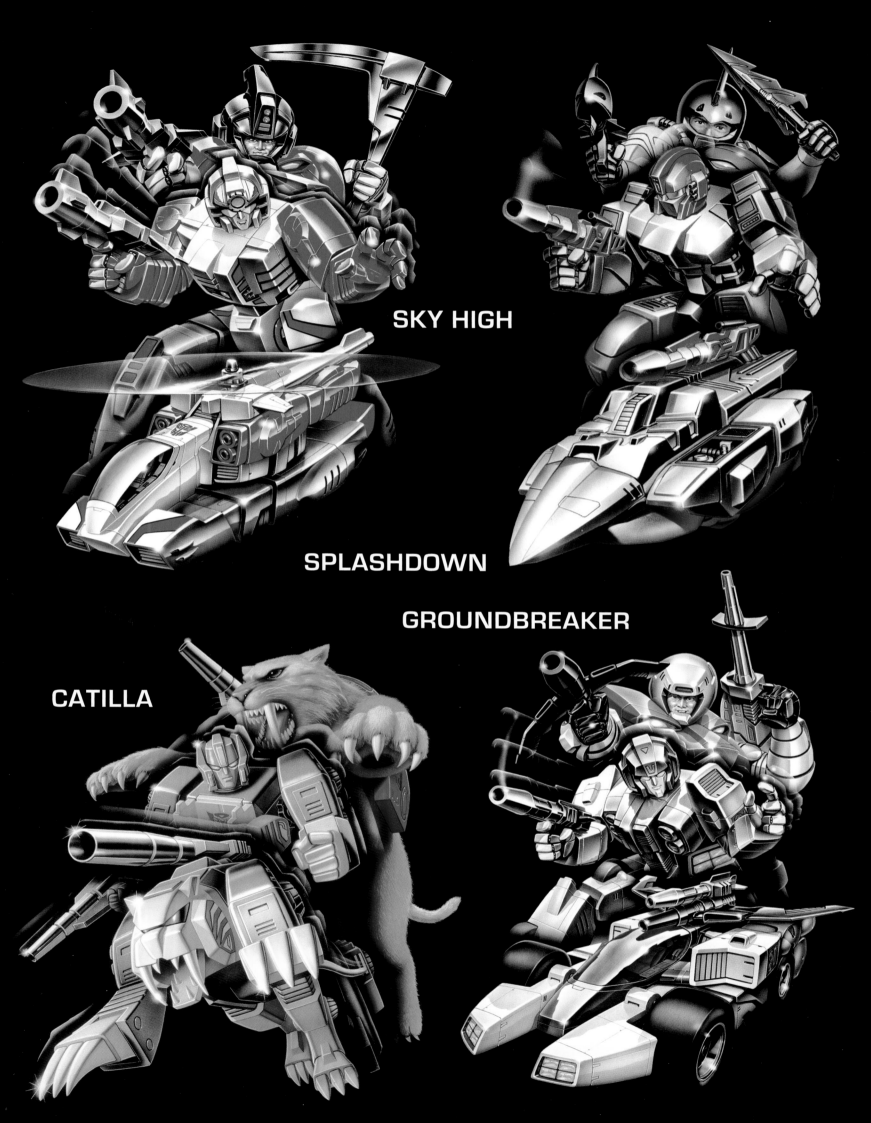

SKY HIGH

SPLASHDOWN

GROUNDBREAKER

CATILLA

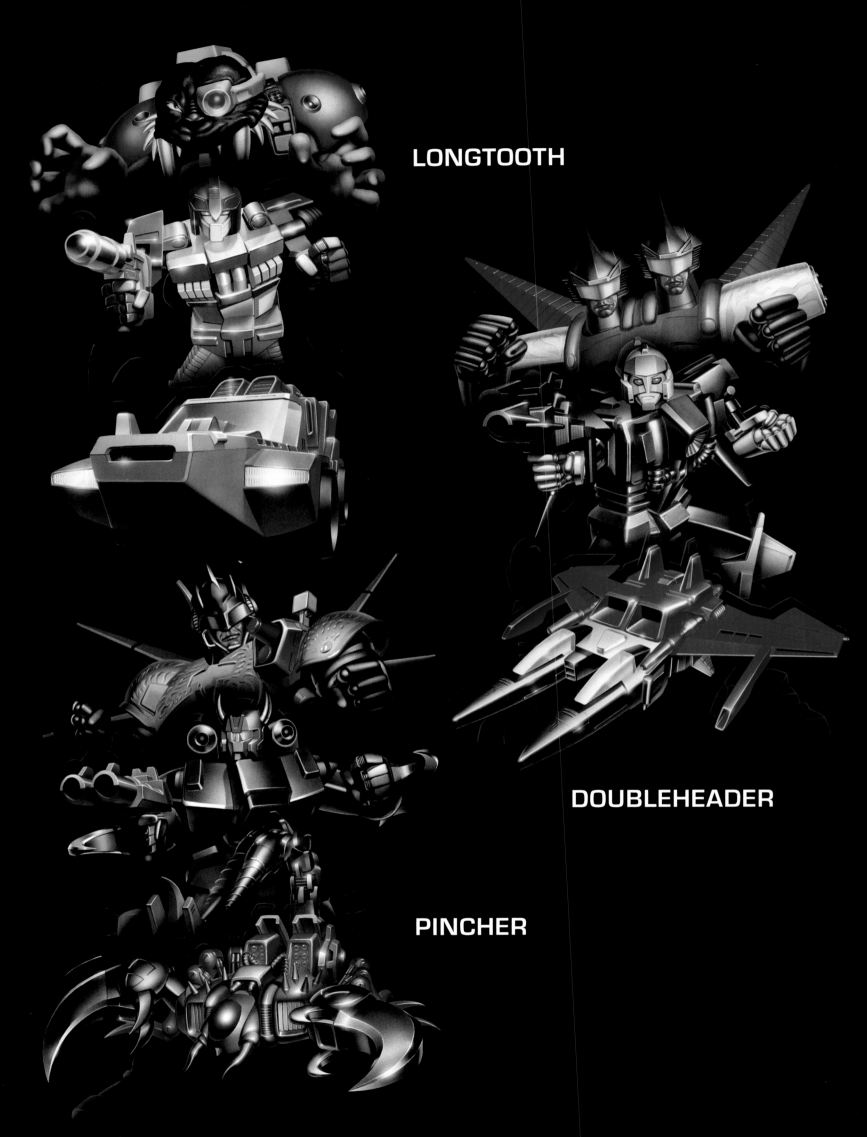

LONGTOOTH

DOUBLEHEADER

PINCHER

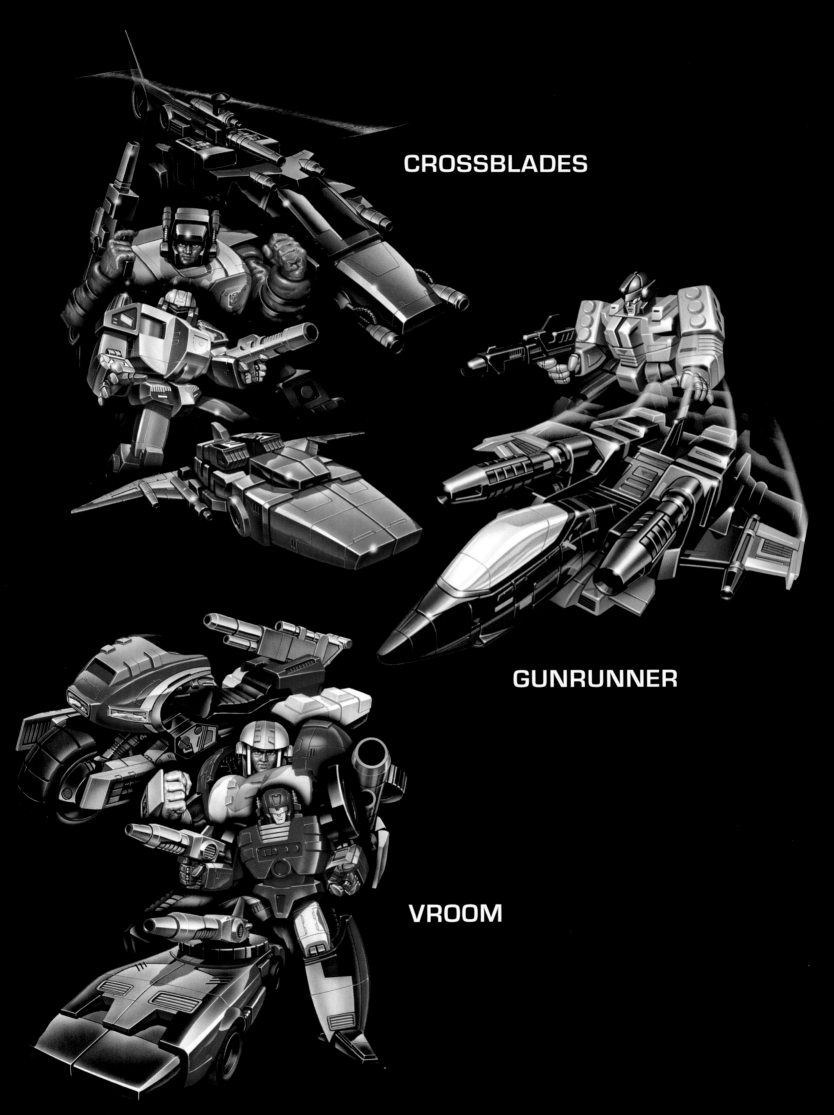

CROSSBLADES

GUNRUNNER

VROOM

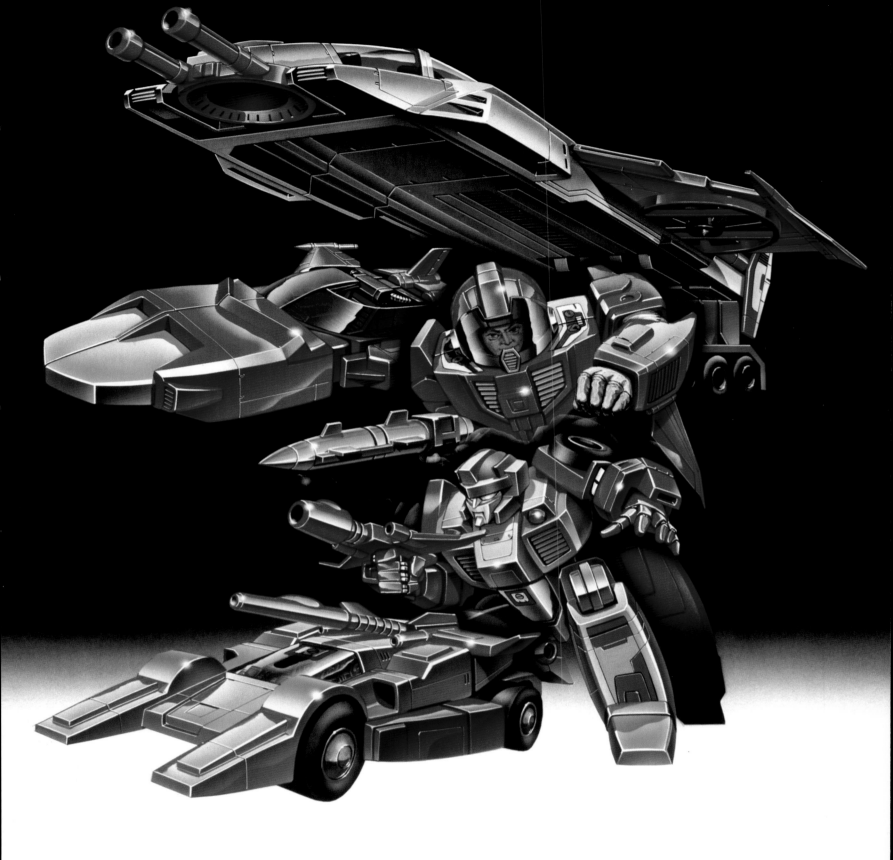

SKYHAMMER

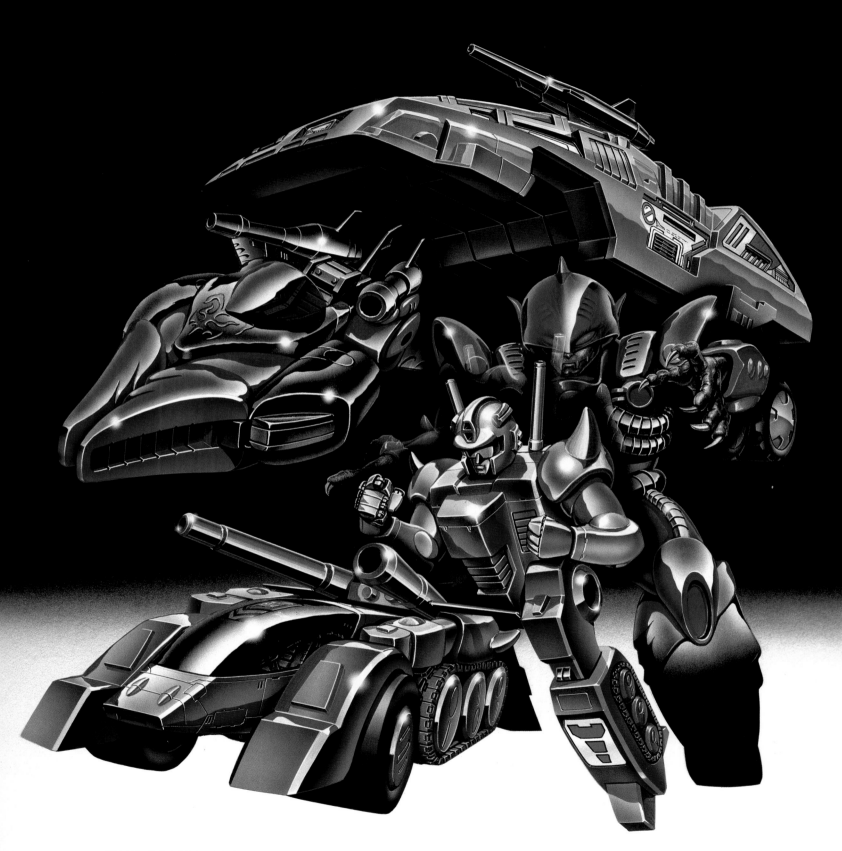

ROADBLOCK

BOMB-BURST

SKULLGRIN

SUBMARAUDER

CARNIVAC

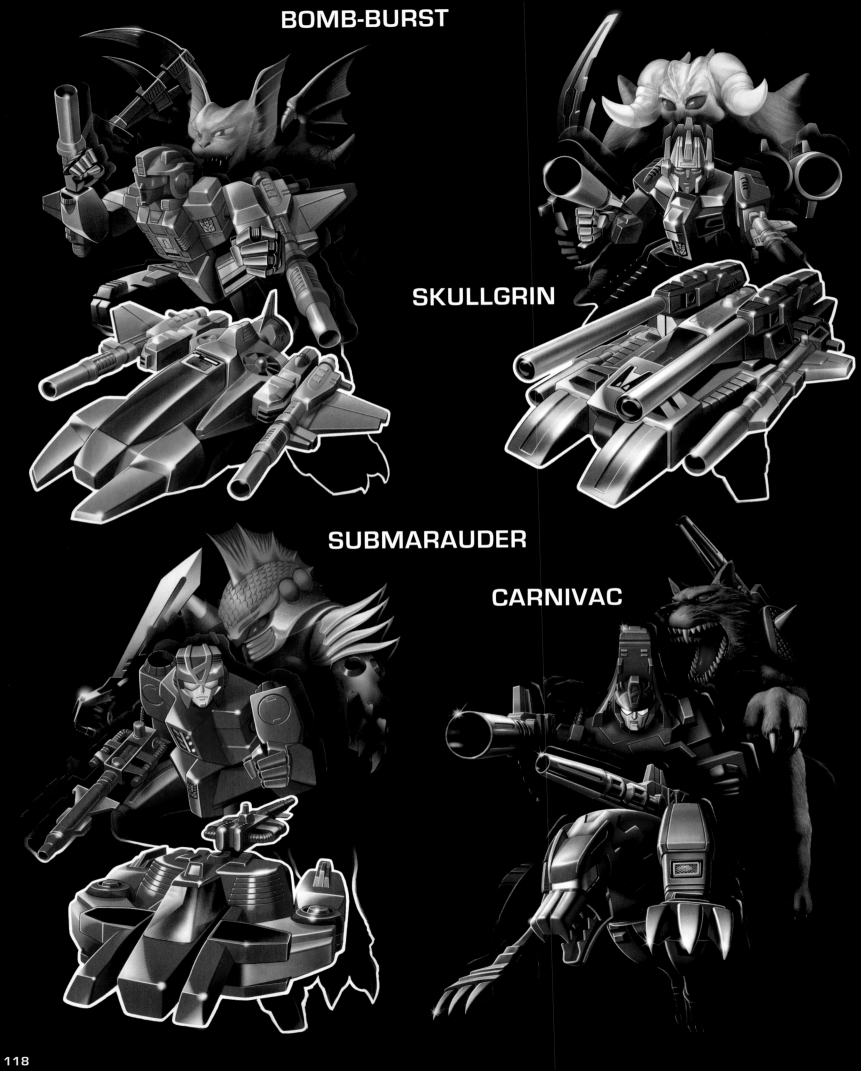

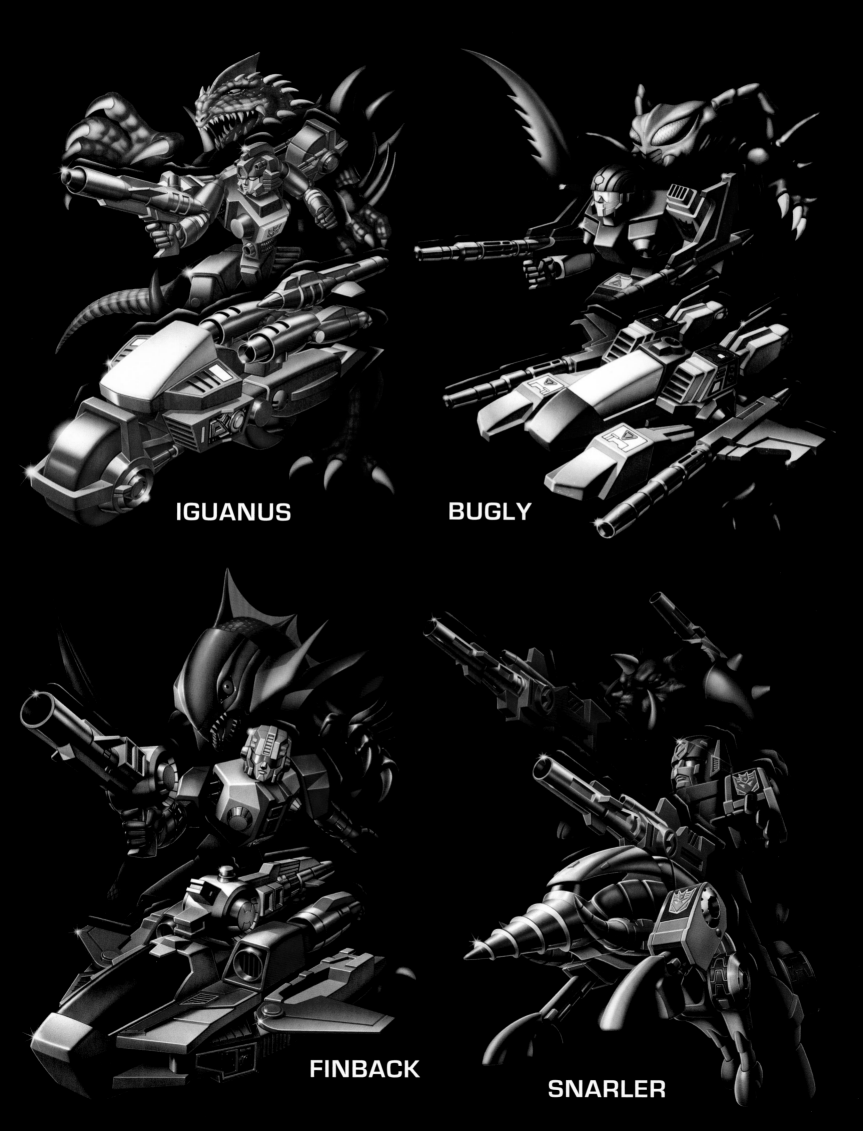

IGUANUS

BUGLY

FINBACK

SNARLER

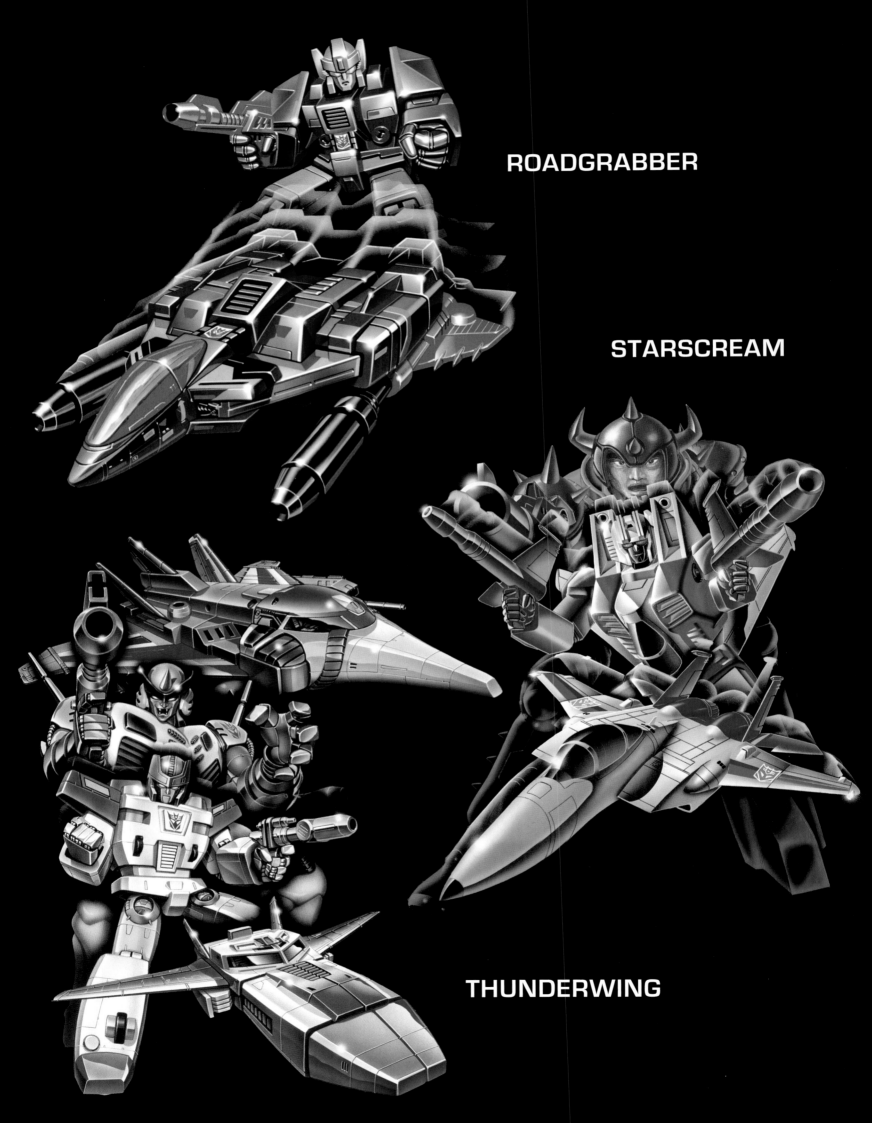

ROADGRABBER

STARSCREAM

THUNDERWING

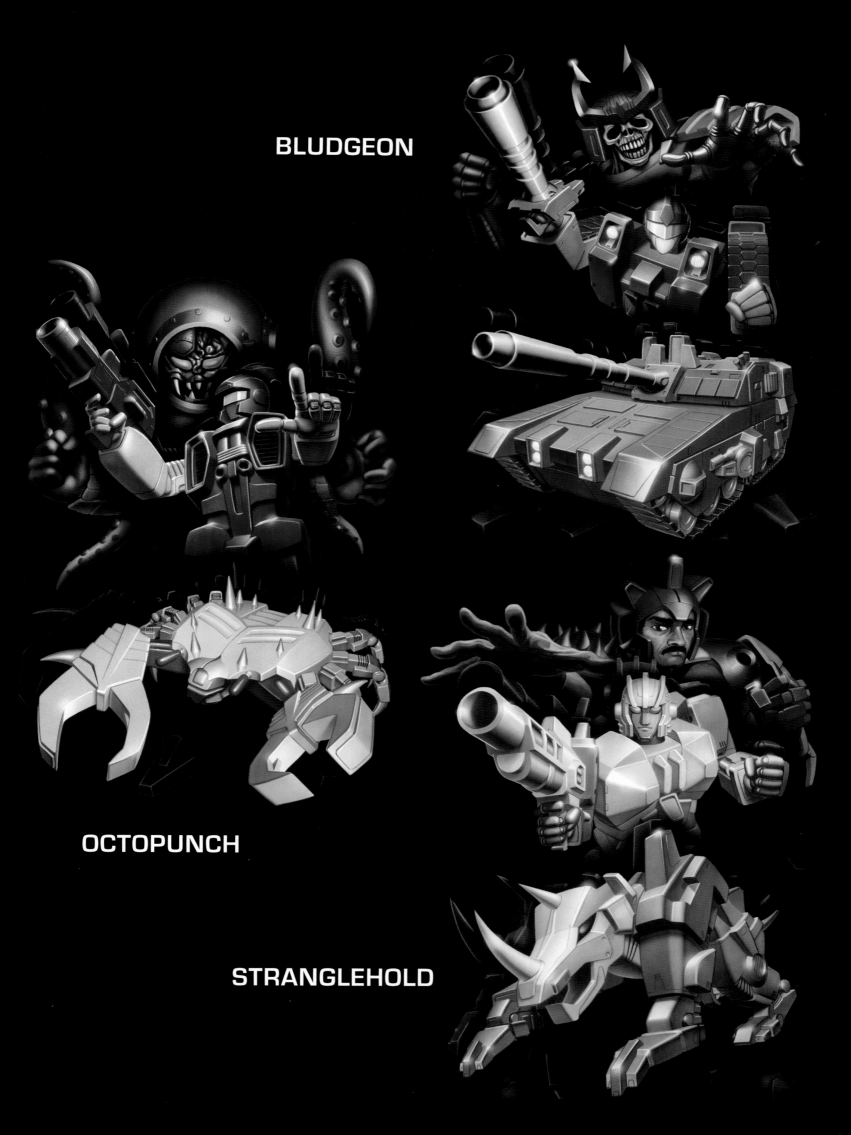

BLUDGEON

OCTOPUNCH

STRANGLEHOLD

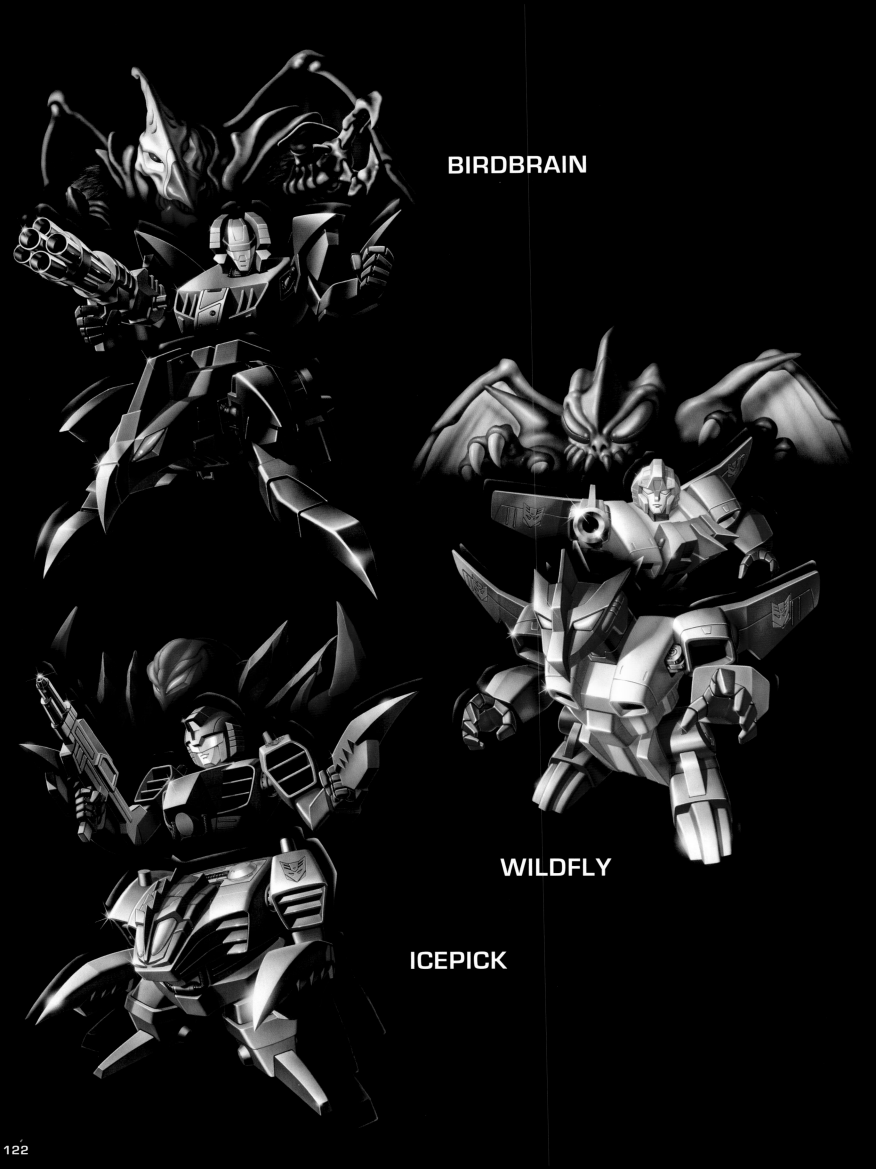

BIRDBRAIN

WILDFLY

ICEPICK

BRISTLEBACK

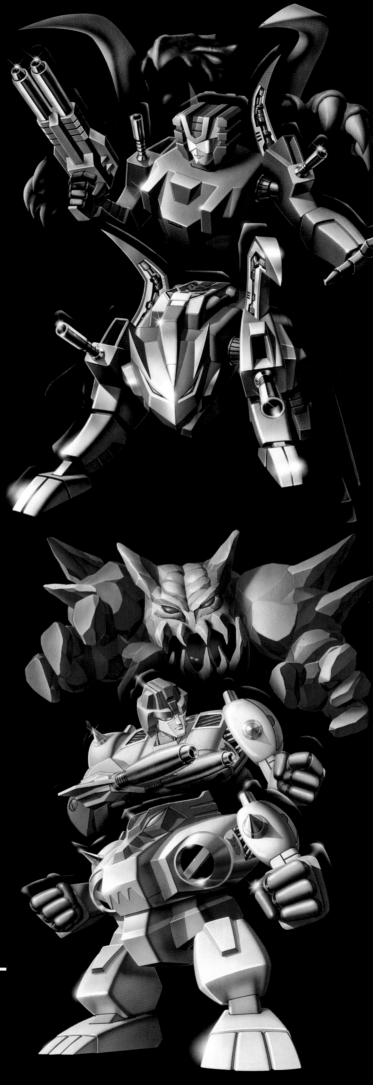

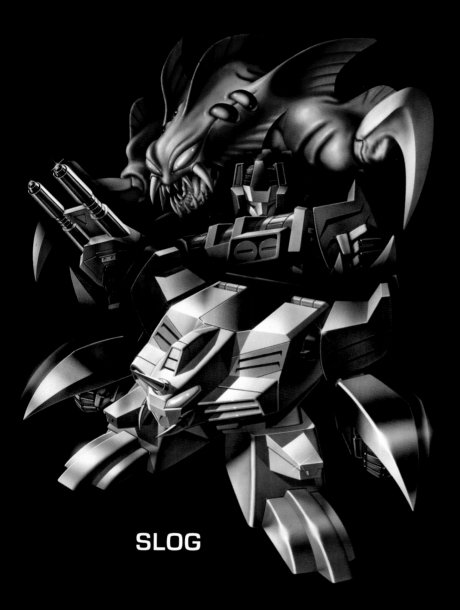

SLOG

SCOWL

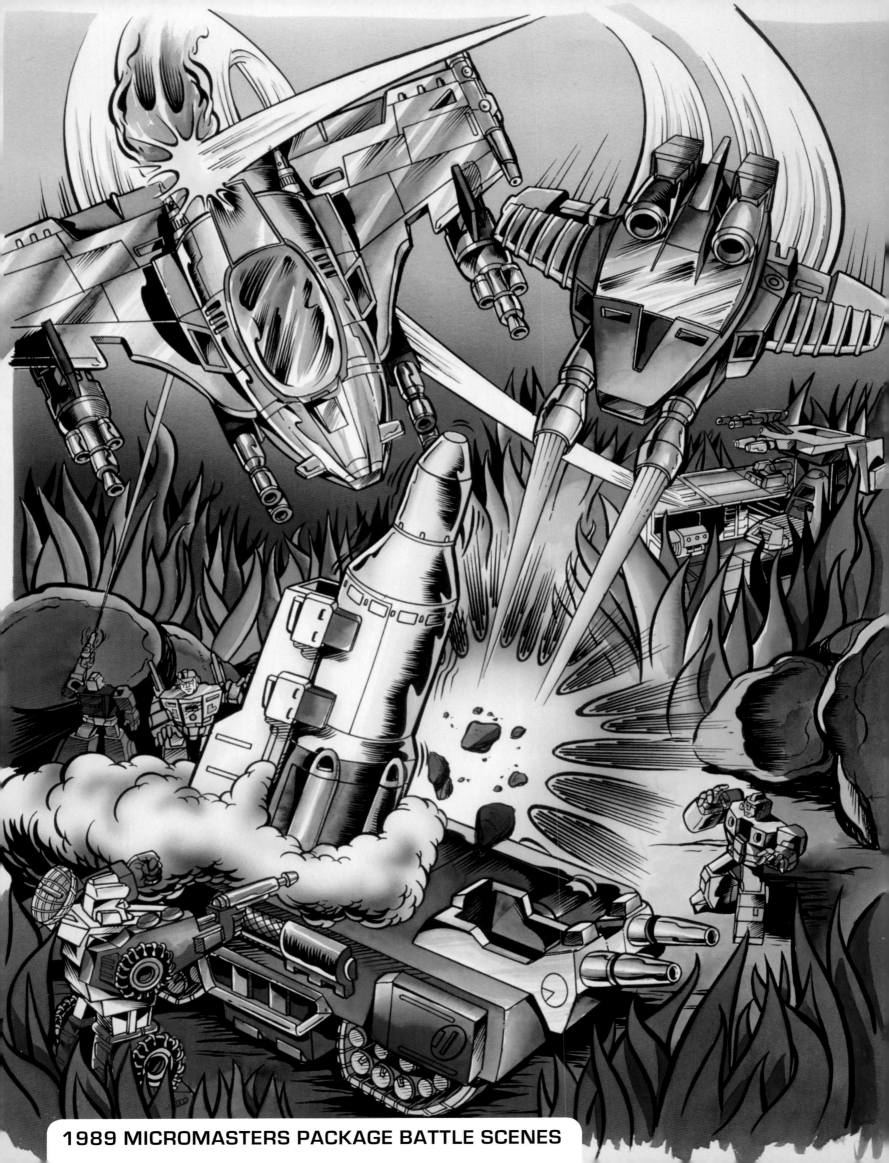

1989 MICROMASTERS PACKAGE BATTLE SCENES

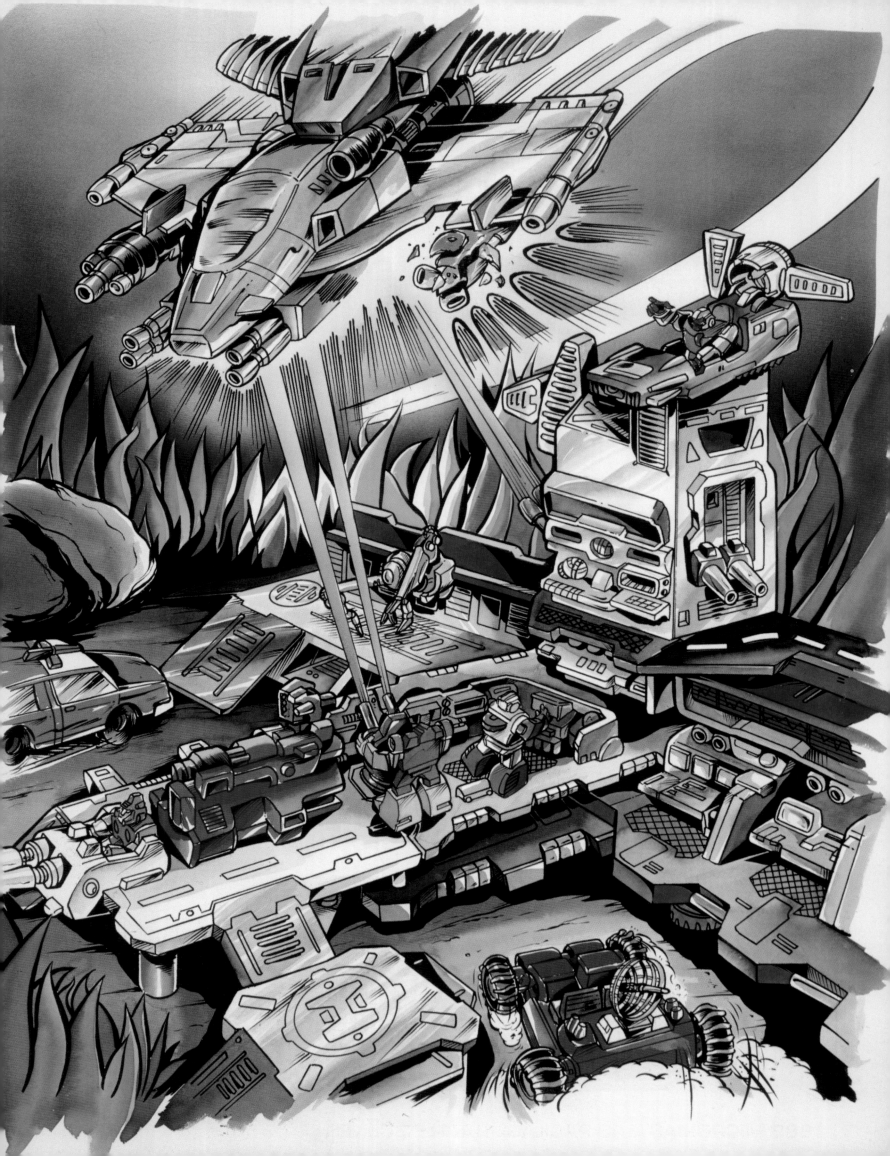

Classic Autobot Logo
with technicals

PANTONE 187C

PANTONE 805c

PANTONE 021c

PANTONE 265c

PANTONE PROCESS YELLOWc

GENERATION 2

G2 Logo with
Pantone Guide

THE TRANSFORMERS®
PRETENDERS™

Pretender and Micromaster Logos

MICRO
TRANSFORMERS

Autobot Sigils 1990 [left]
1988-1989 [above]

Autobot Logo, 1988-1990

MICROMASTERS AUTOBOTS

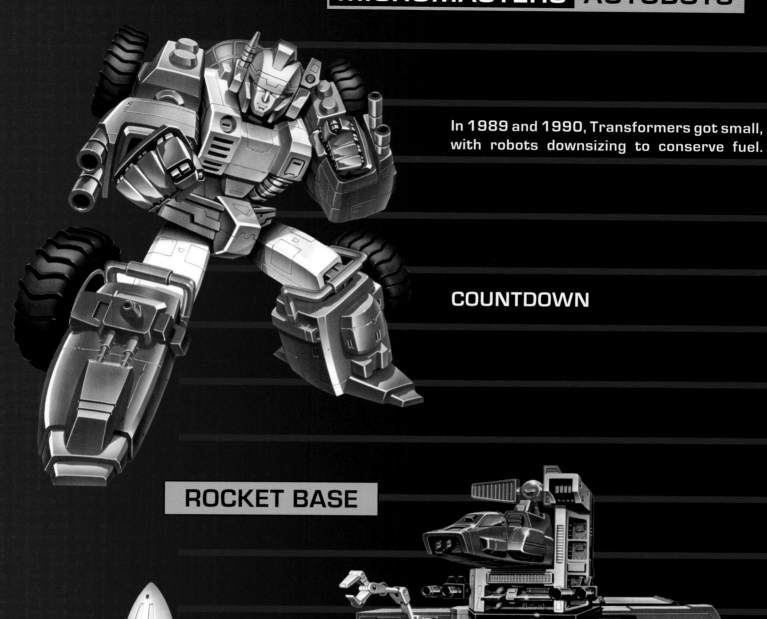

In 1989 and 1990, Transformers got small, with robots downsizing to conserve fuel.

COUNTDOWN

ROCKET BASE

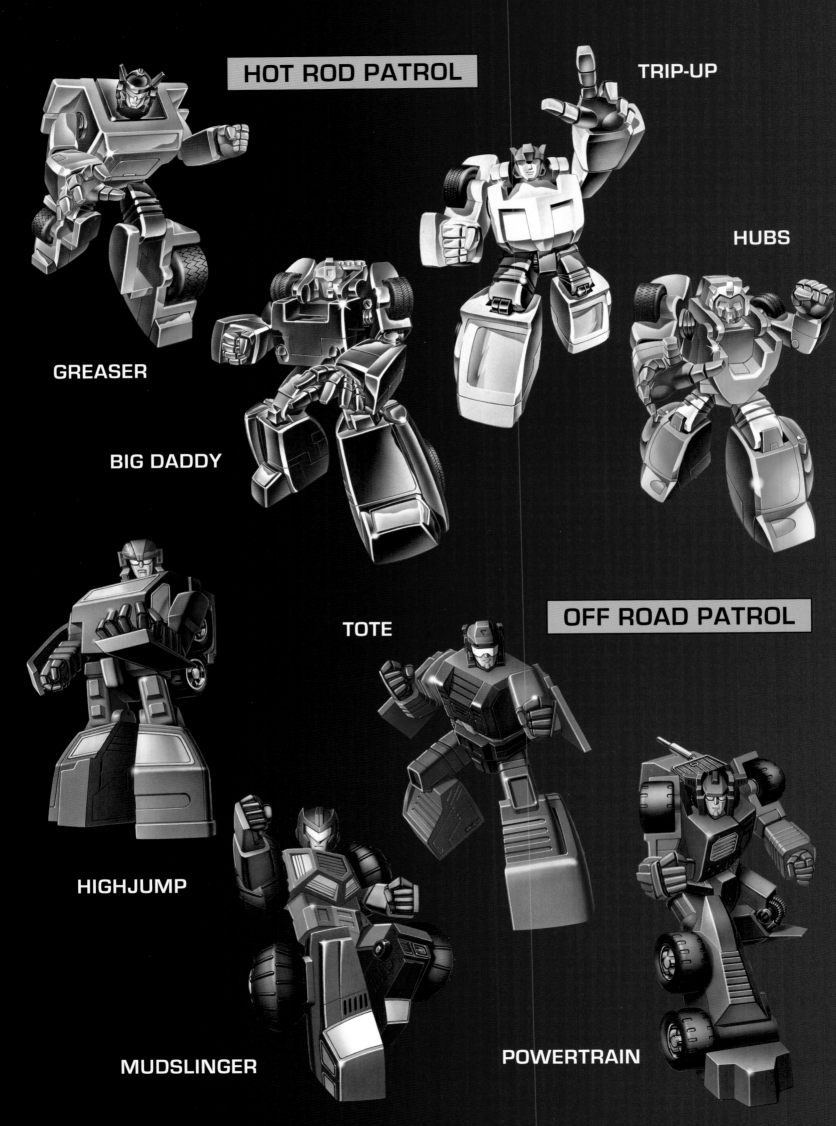

HOT ROD PATROL

TRIP-UP

HUBS

GREASER

BIG DADDY

TOTE

OFF ROAD PATROL

HIGHJUMP

MUDSLINGER

POWERTRAIN

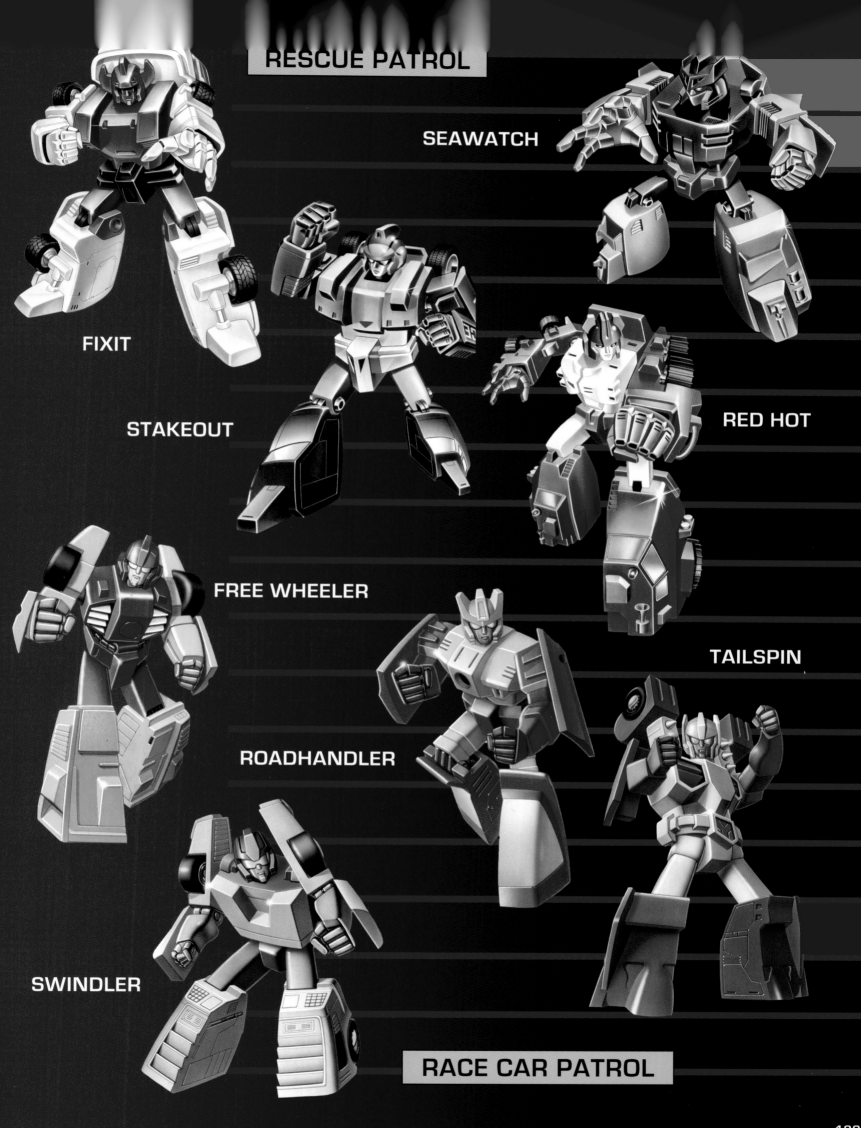

RESCUE PATROL

FIXIT

SEAWATCH

STAKEOUT

RED HOT

FREE WHEELER

TAILSPIN

ROADHANDLER

SWINDLER

RACE CAR PATROL

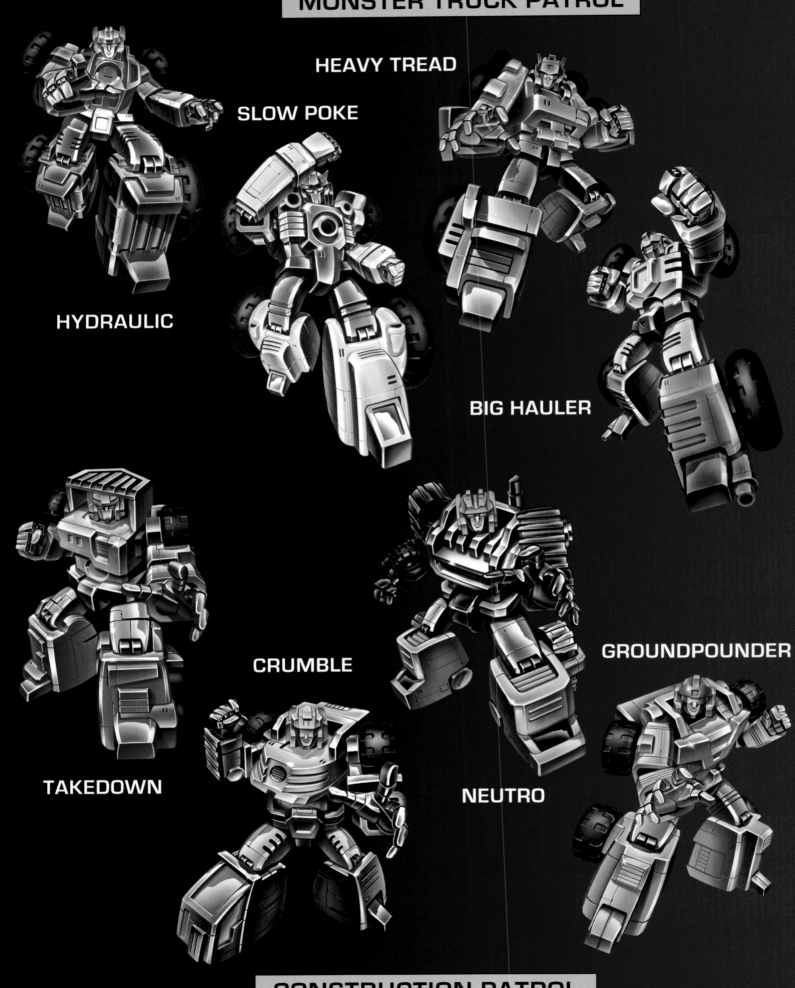

MONSTER TRUCK PATROL

HEAVY TREAD

SLOW POKE

HYDRAULIC

BIG HAULER

CRUMBLE

GROUNDPOUNDER

TAKEDOWN

NEUTRO

CONSTRUCTION PATROL

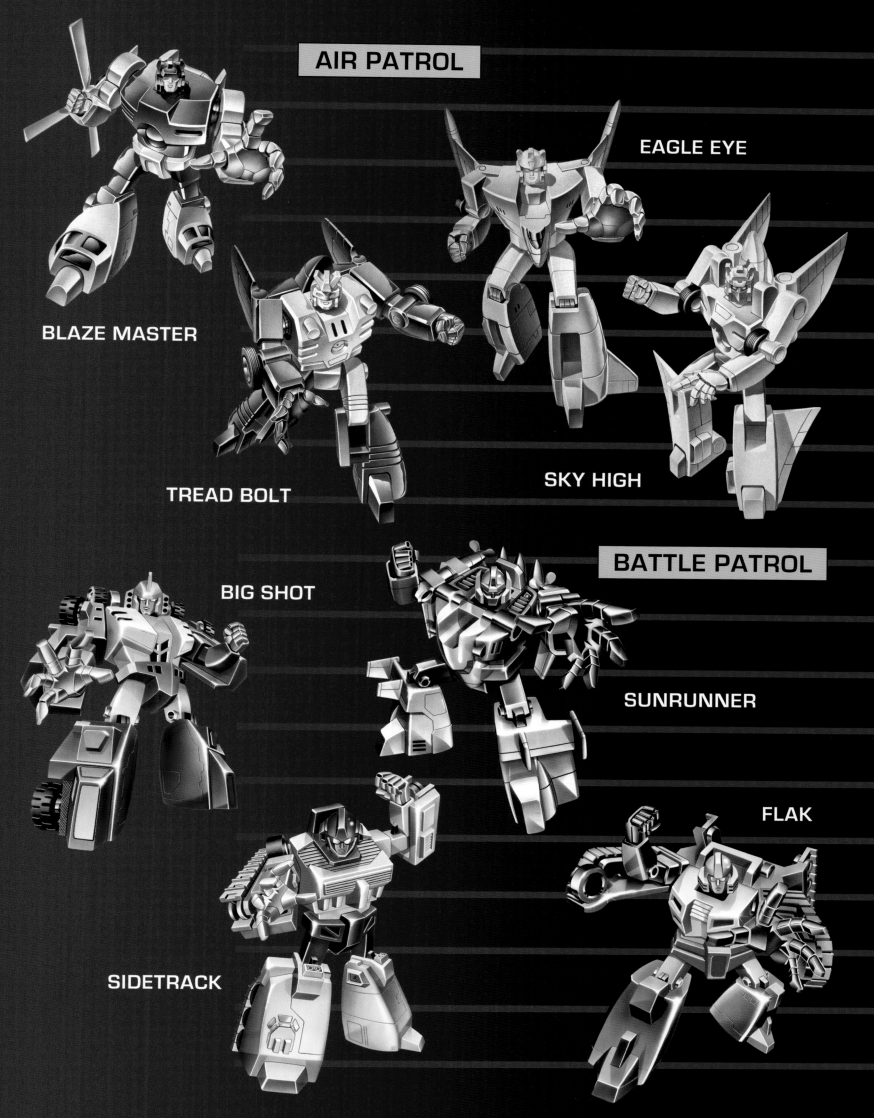

AIR PATROL

EAGLE EYE

BLAZE MASTER

TREAD BOLT

SKY HIGH

BIG SHOT

BATTLE PATROL

SUNRUNNER

FLAK

SIDETRACK

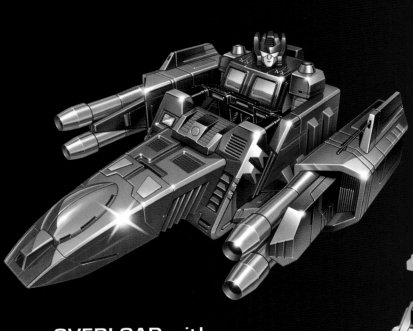

OVERLOAD with
CAR CARRIER

ERECTOR with
CRANE

IRONWORKS with
CONSTRUCTION STATION

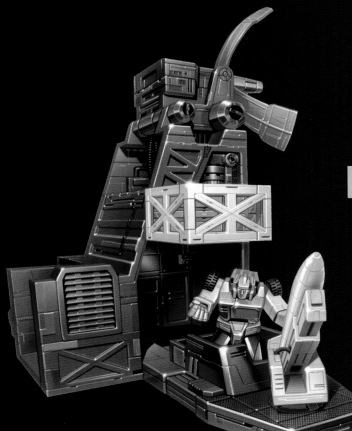

HOT HOUSE with
FIRE STATION

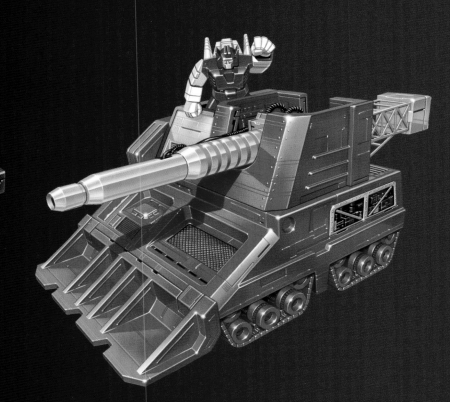

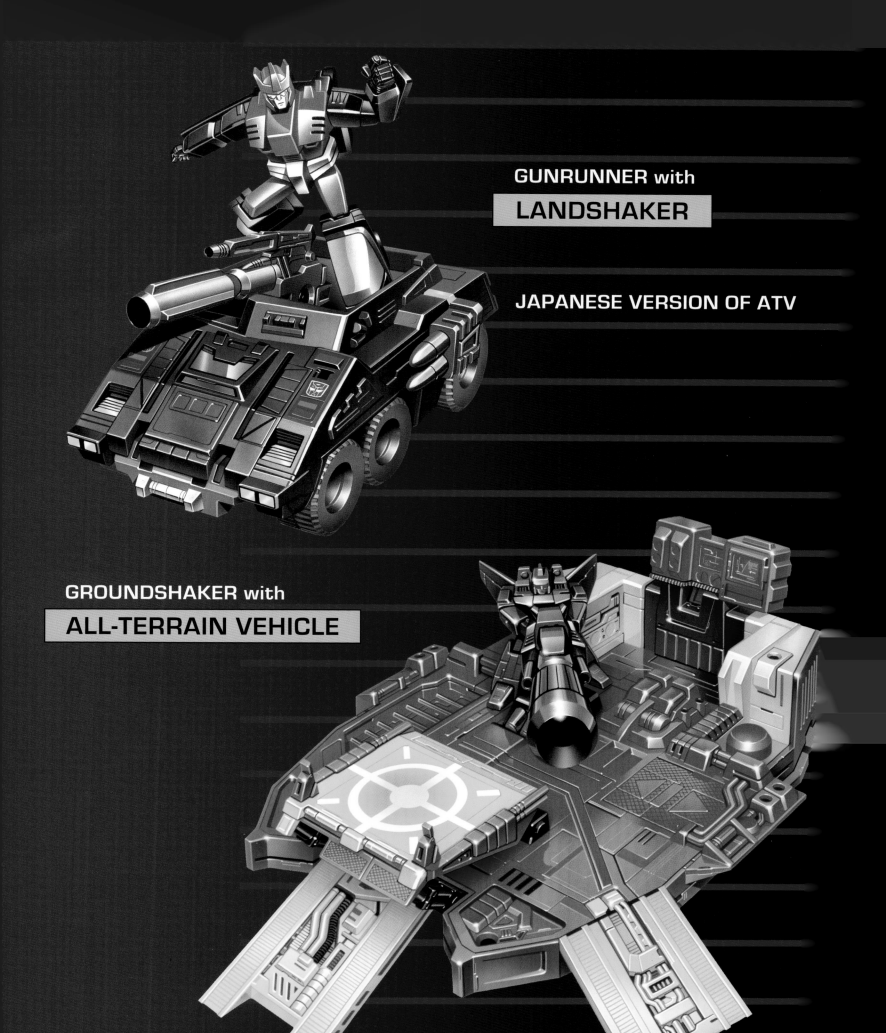

GUNRUNNER with
LANDSHAKER

JAPANESE VERSION OF ATV

GROUNDSHAKER with
ALL-TERRAIN VEHICLE

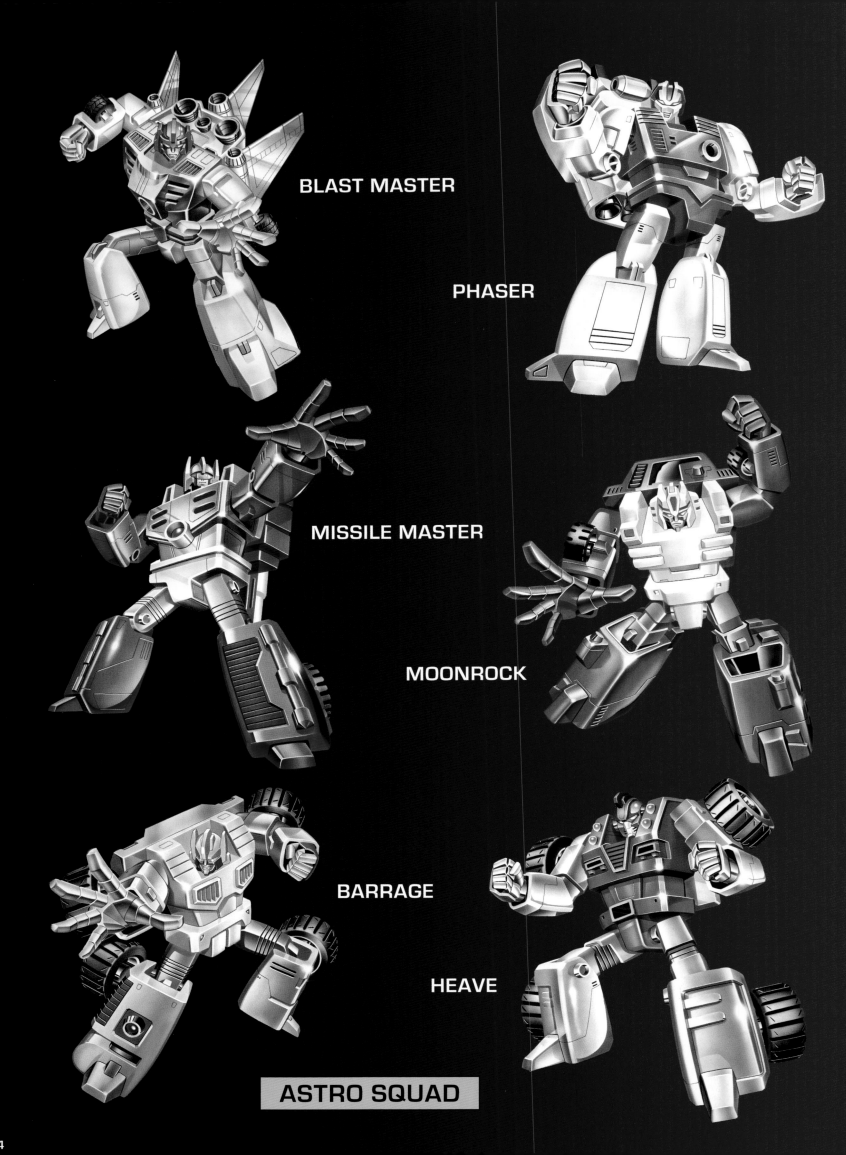

BLAST MASTER

PHASER

MISSILE MASTER

MOONROCK

BARRAGE

HEAVE

ASTRO SQUAD

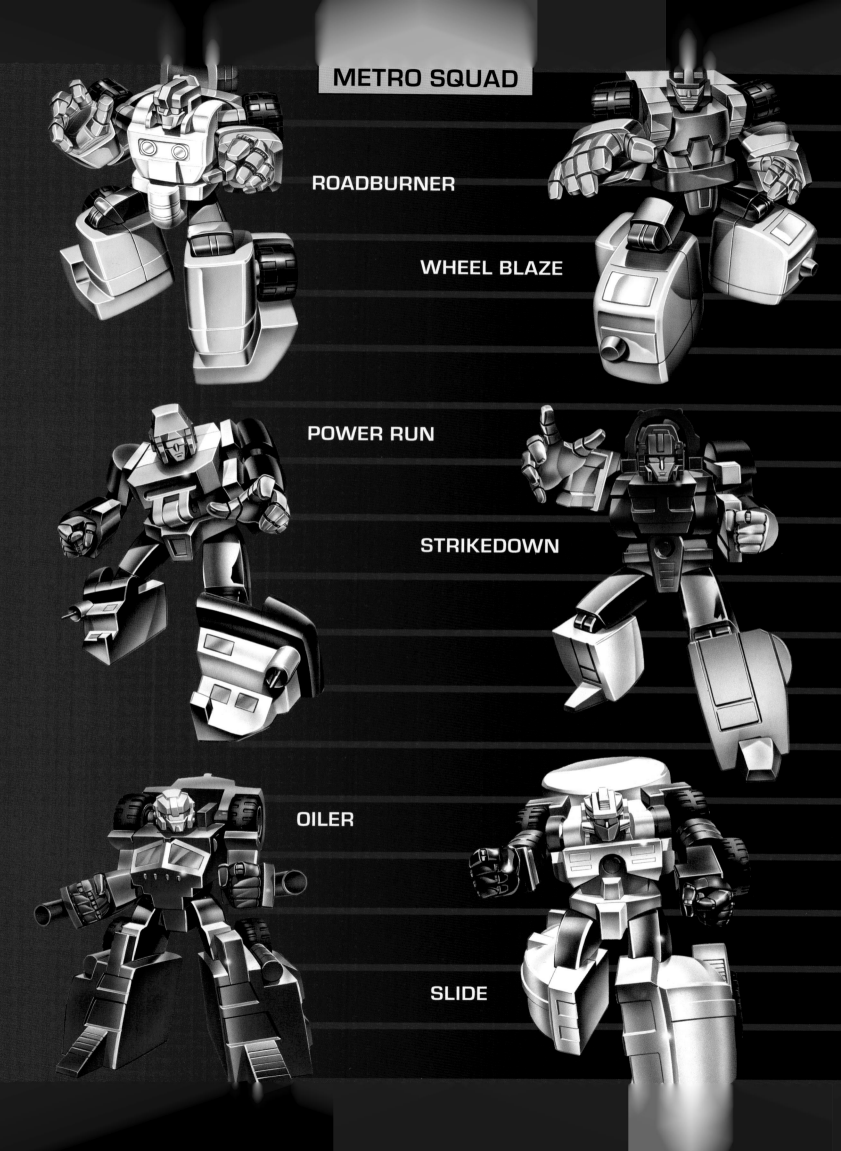

METRO SQUAD

ROADBURNER

WHEEL BLAZE

POWER RUN

STRIKEDOWN

OILER

SLIDE

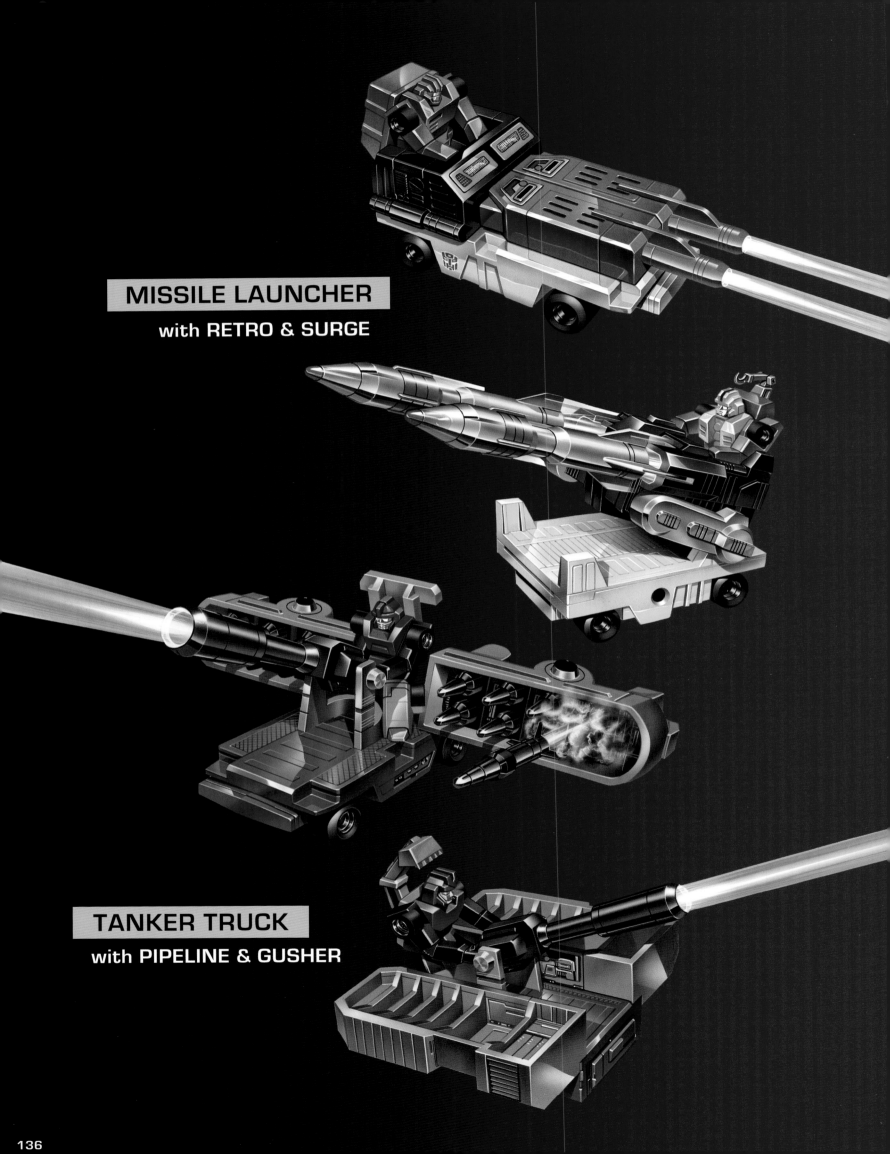

MISSILE LAUNCHER

with **RETRO & SURGE**

TANKER TRUCK

with **PIPELINE & GUSHER**

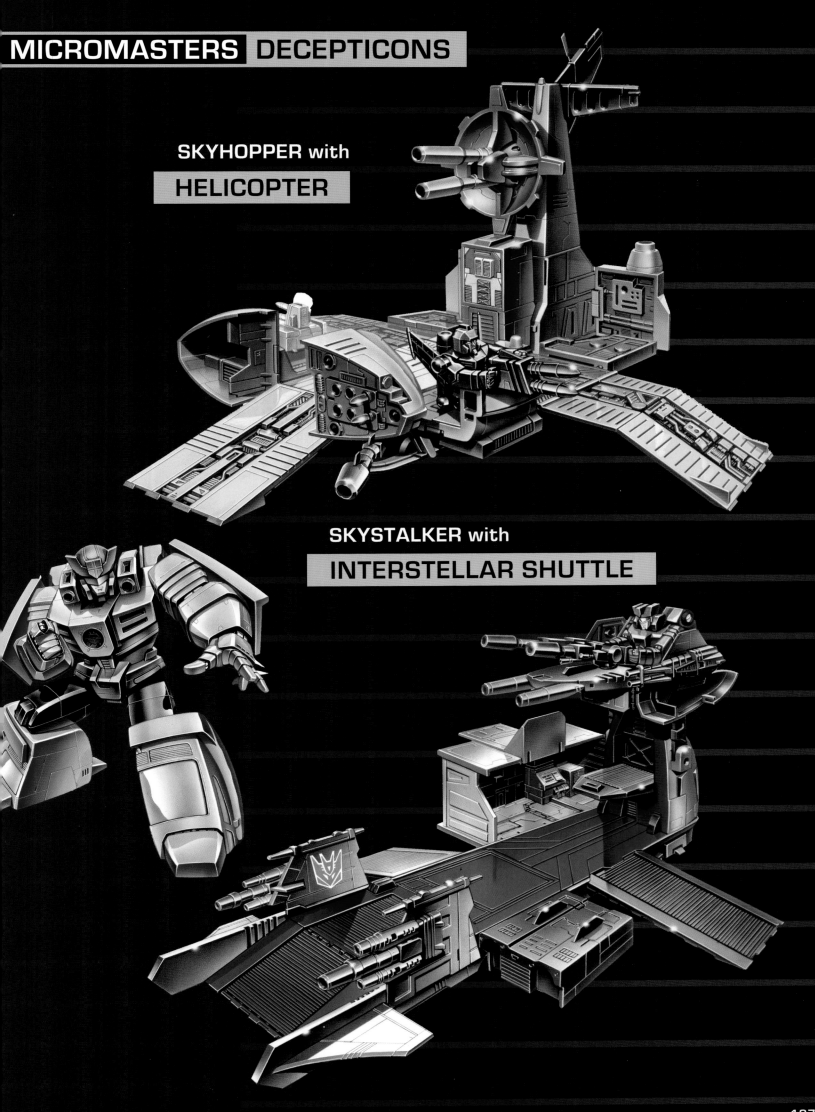

MICROMASTERS DECEPTICONS

SKYHOPPER with
HELICOPTER

SKYSTALKER with
INTERSTELLAR SHUTTLE

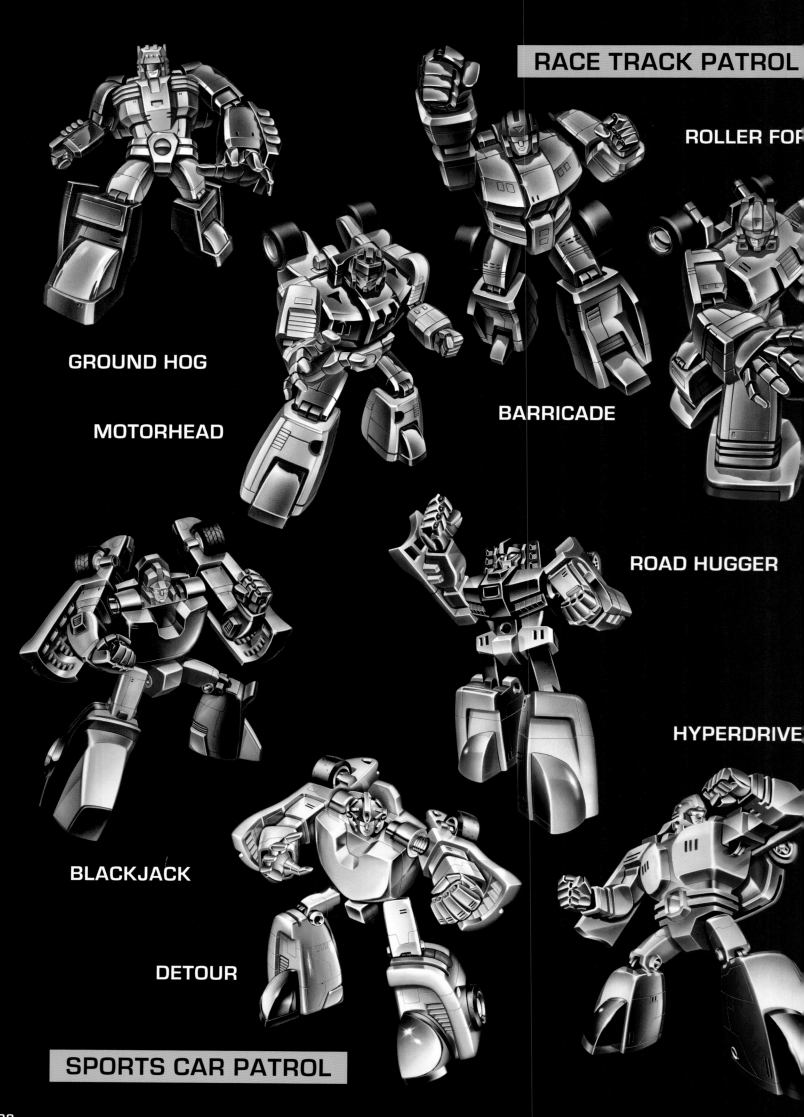

ROLLER FOR

GROUND HOG

MOTORHEAD

BARRICADE

ROAD HUGGER

HYPERDRIVE

BLACKJACK

DETOUR

SPORTS CAR PATROL

138

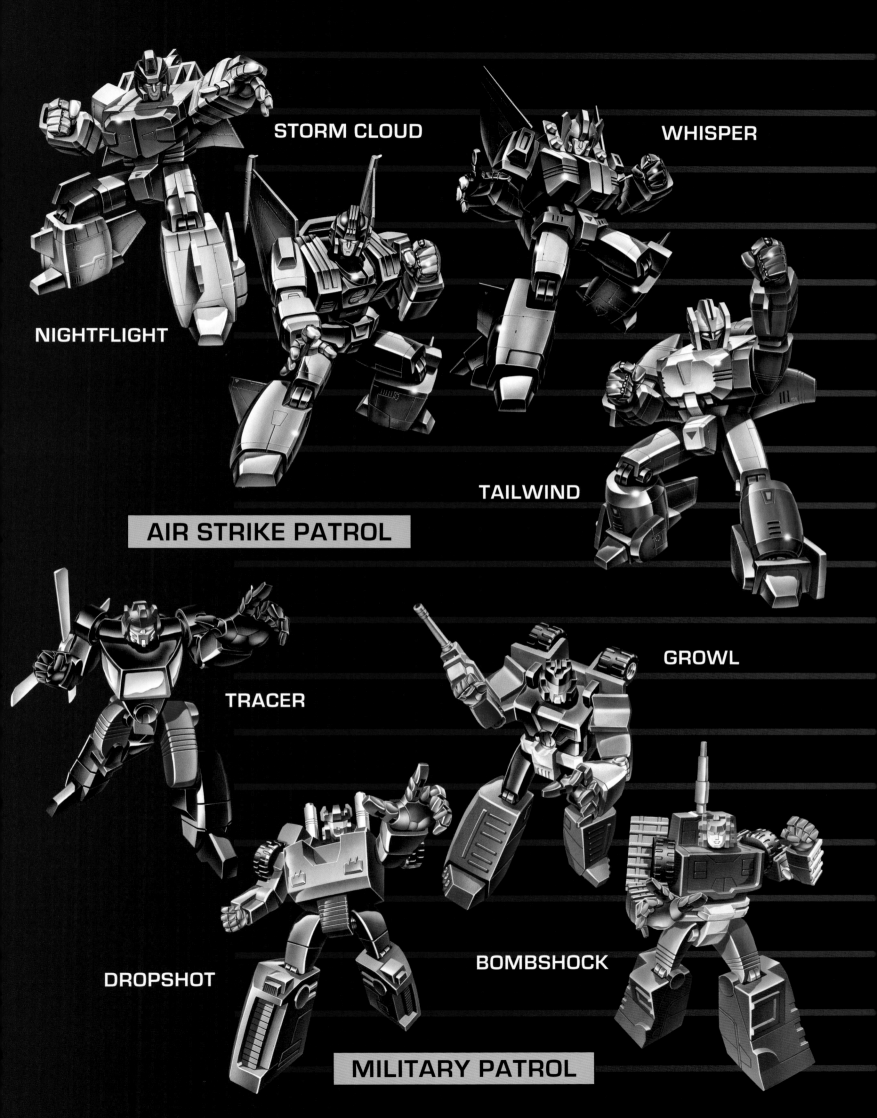

STORM CLOUD

WHISPER

NIGHTFLIGHT

TAILWIND

AIR STRIKE PATROL

GROWL

TRACER

DROPSHOT

BOMBSHOCK

MILITARY PATROL

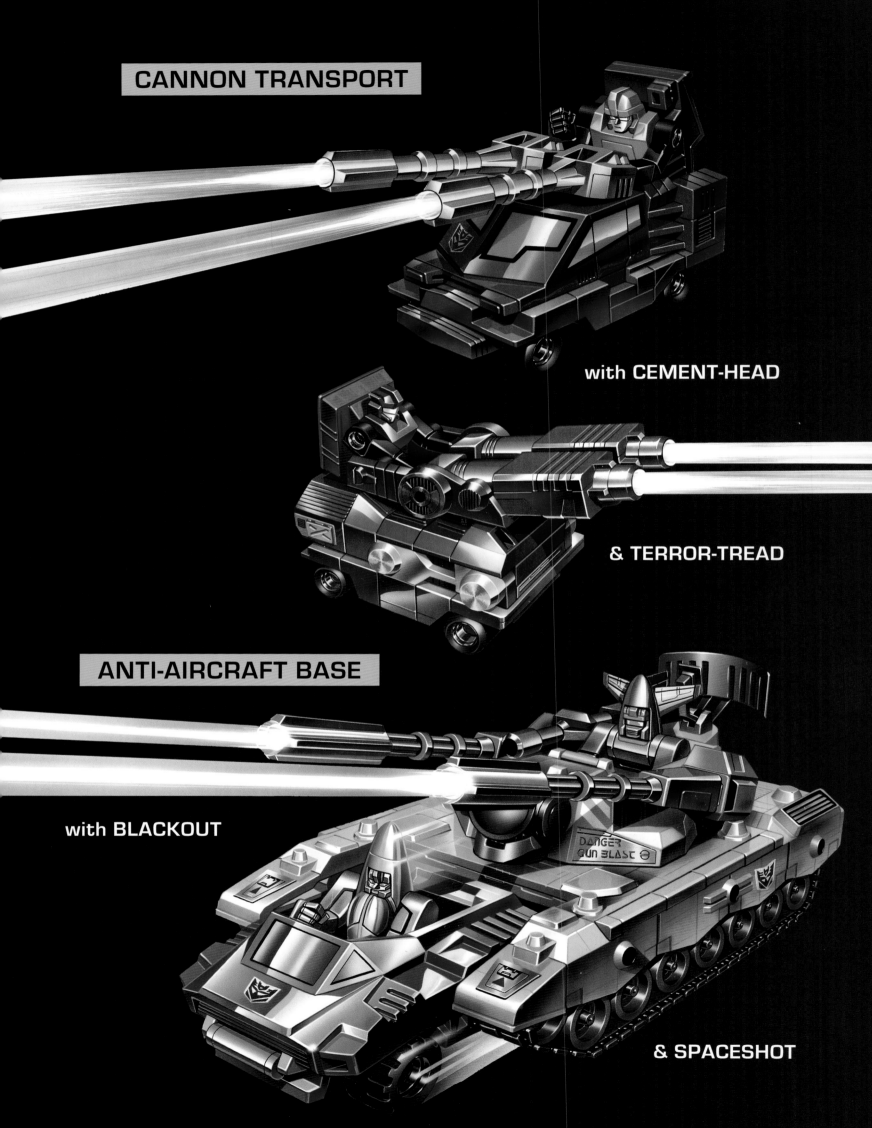

CANNON TRANSPORT

with **CEMENT-HEAD**

& **TERROR-TREAD**

ANTI-AIRCRAFT BASE

with **BLACKOUT**

& **SPACESHOT**

FLATTOP with
AIRCRAFT CARRIER

ROUGHSTUFF with
MILITARY TRANSPORT

GREASEPIT with
GAS STATION

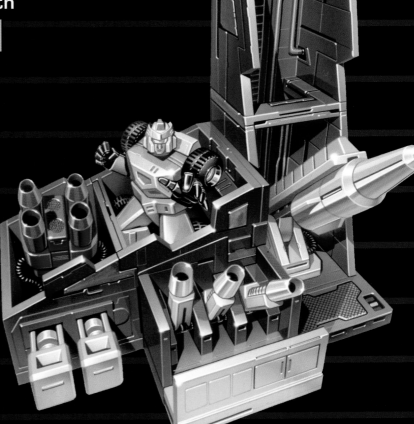

AIRWAVE with
AIRPORT

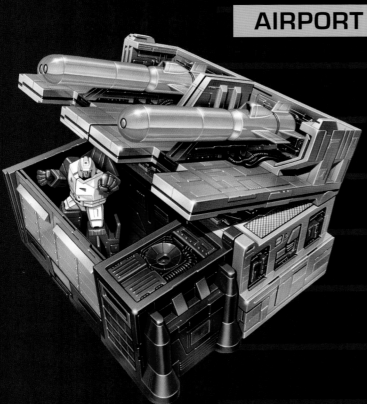

DIRECT-HIT

POWER PUNCH

VANQUISH

FIRESHOT

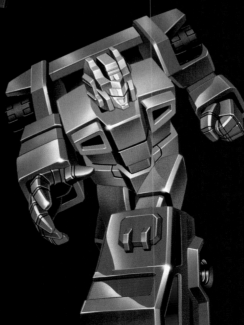

HALF-TRACK

MELTDOWN

142

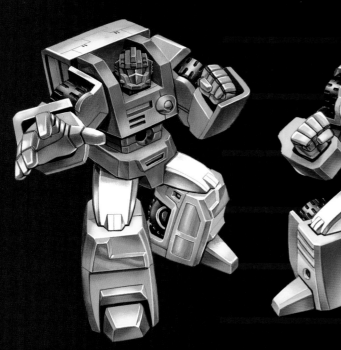
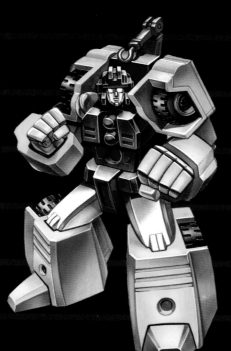

CONSTRUCTOR SQUAD

STONECRUNCHER

EXCAVATOR

GRIT

KNOCKOUT

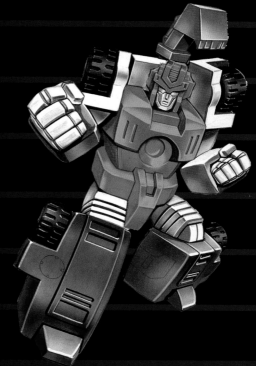

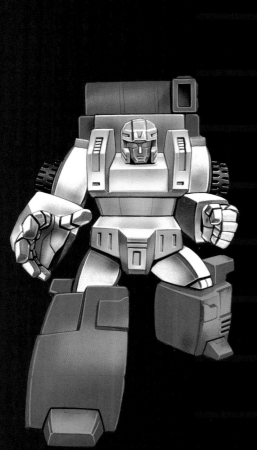

SLEDGE

HAMMER

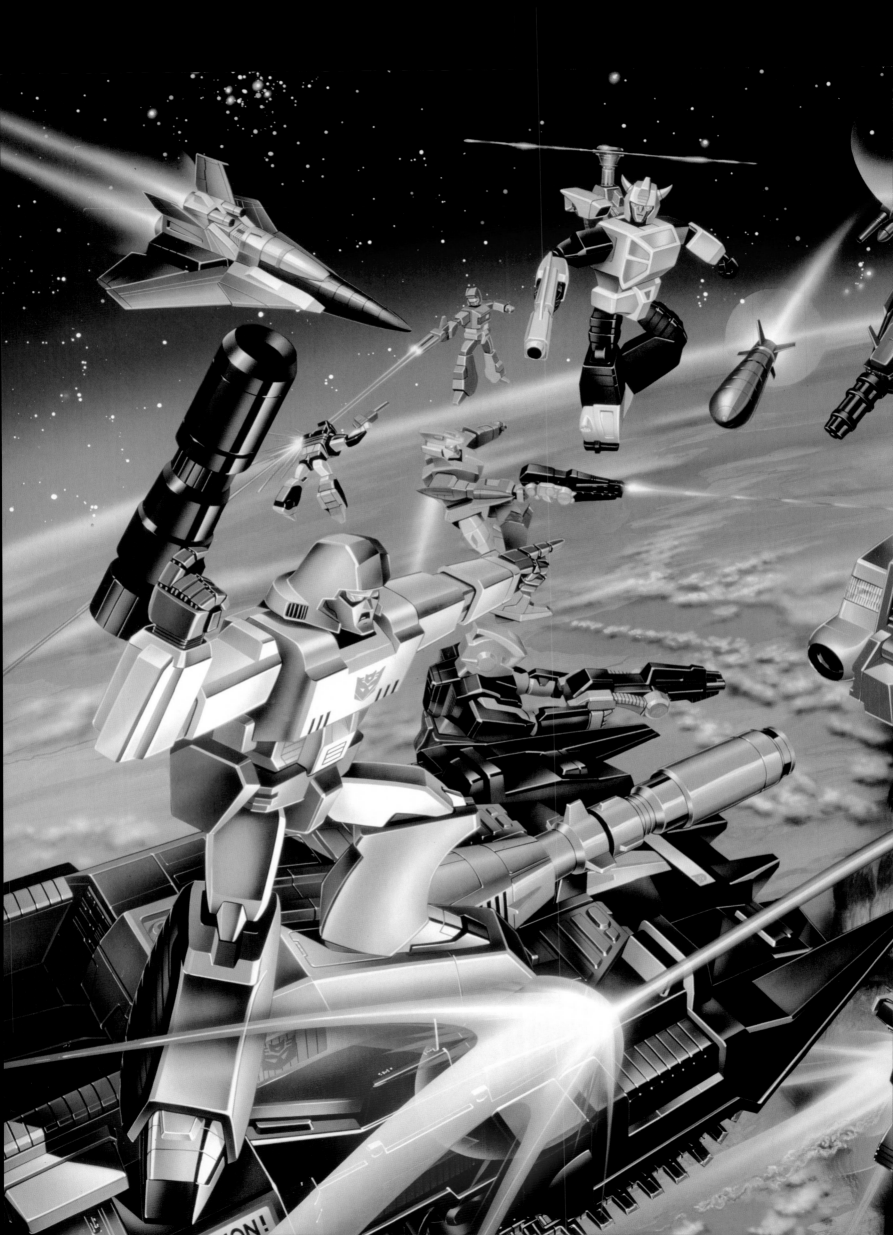

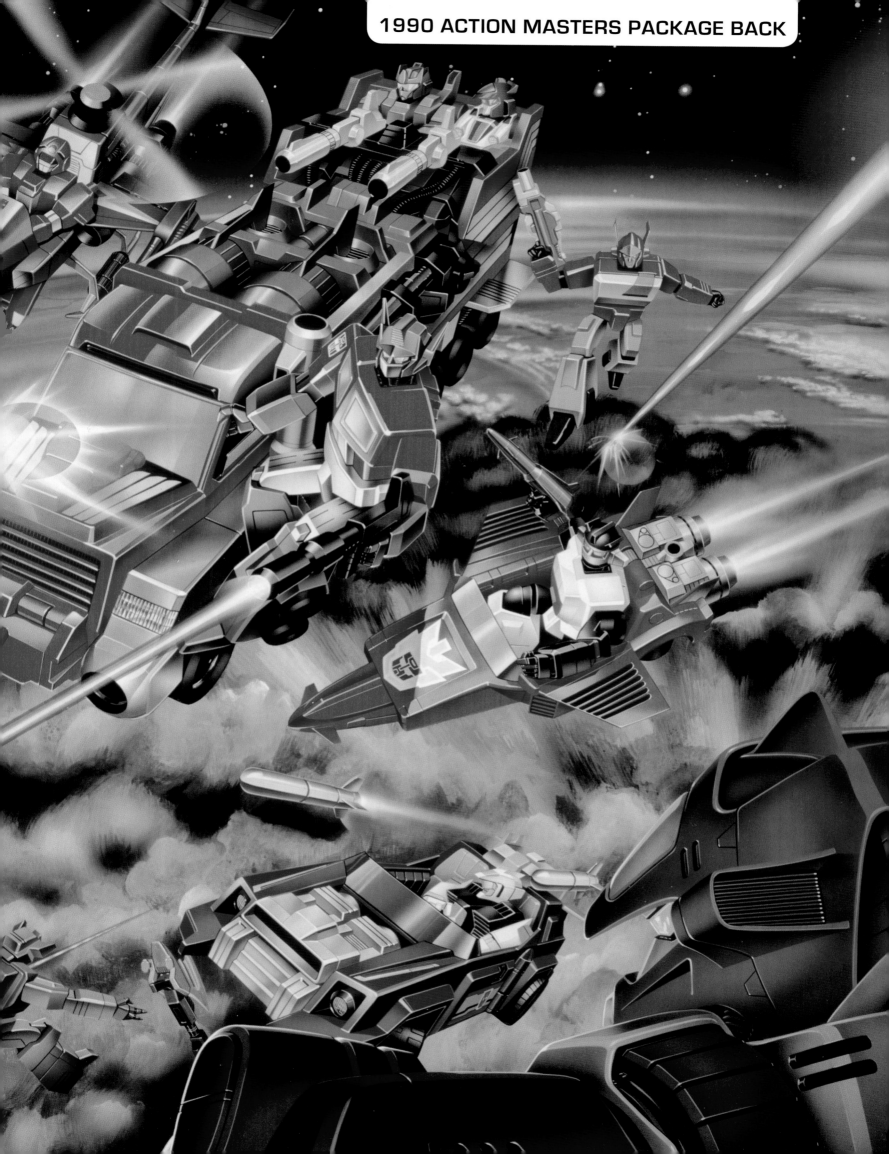

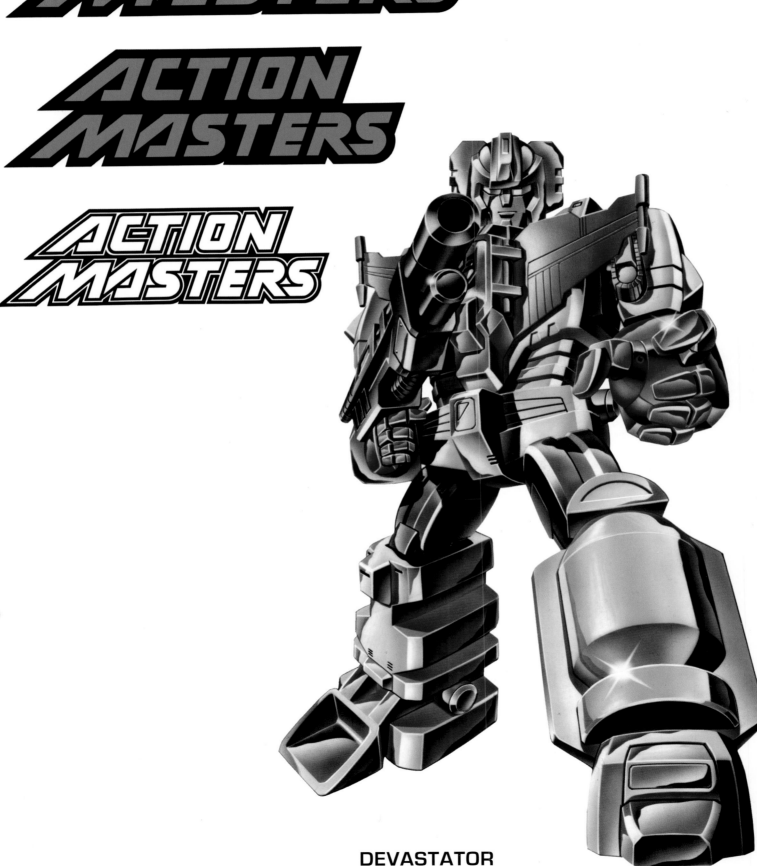

DEVASTATOR

ACTION MASTERS AUTOBOTS

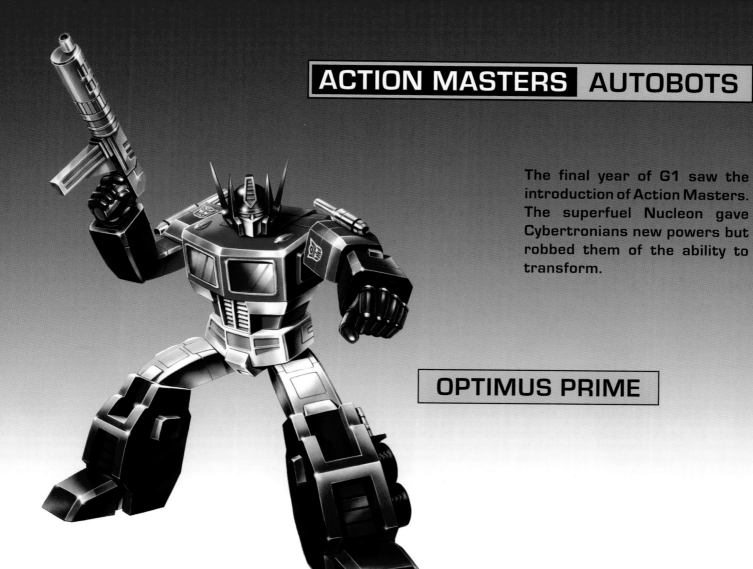

The final year of G1 saw the introduction of Action Masters. The superfuel Nucleon gave Cybertronians new powers but robbed them of the ability to transform.

OPTIMUS PRIME

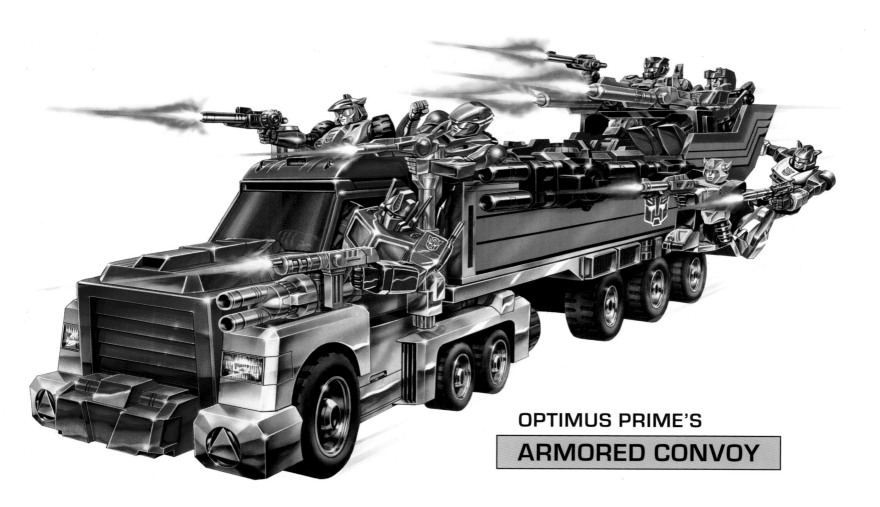

OPTIMUS PRIME'S
ARMORED CONVOY

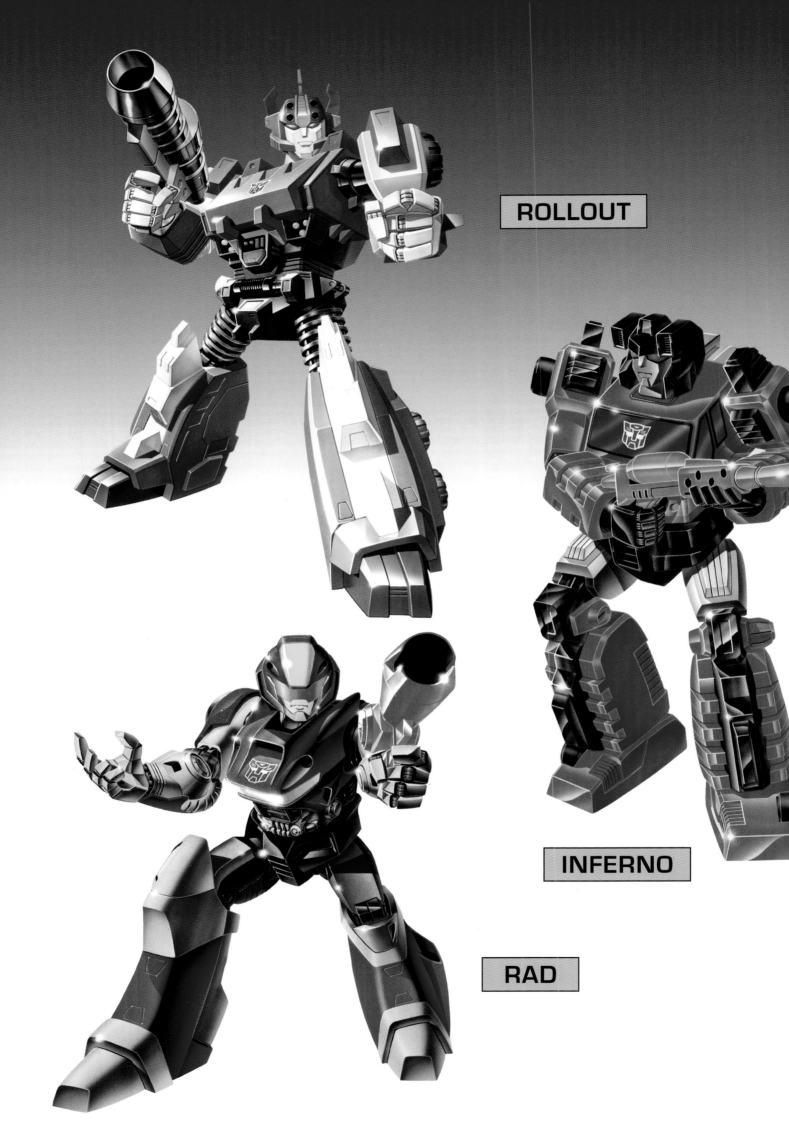

ROLLOUT

INFERNO

RAD

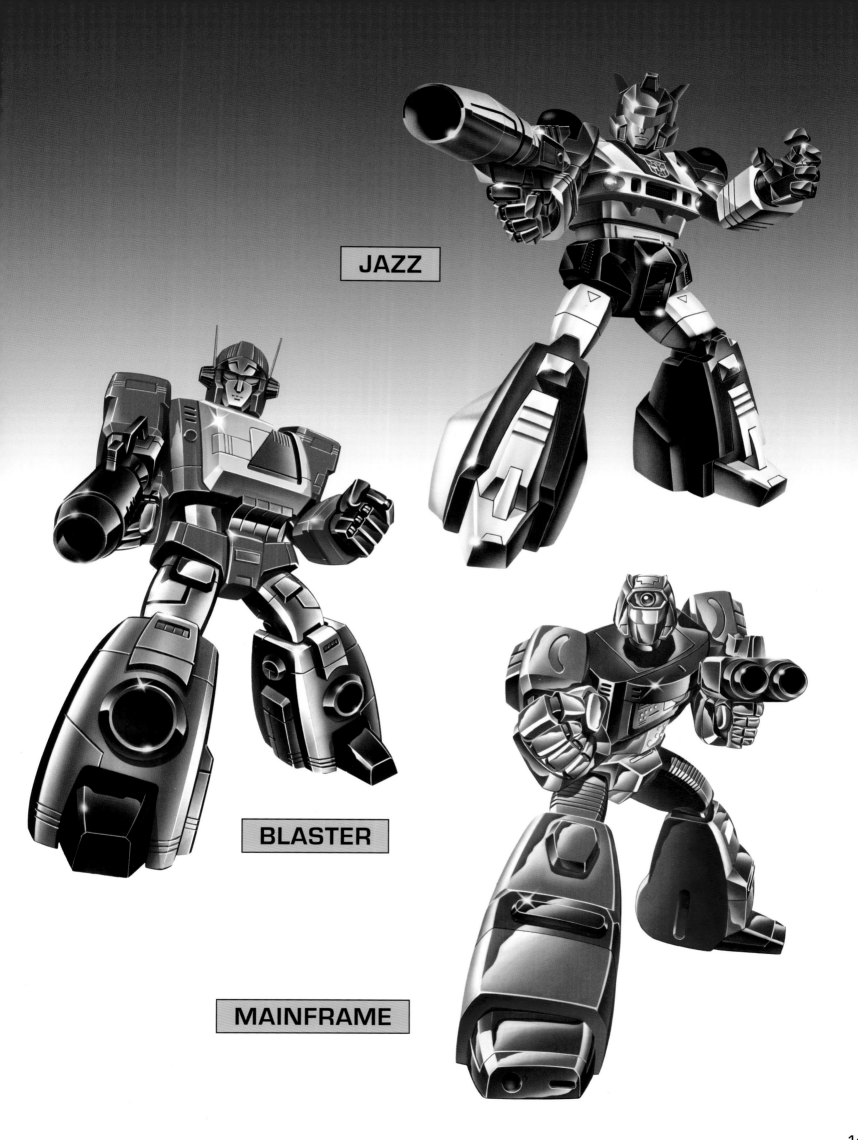

JAZZ

BLASTER

MAINFRAME

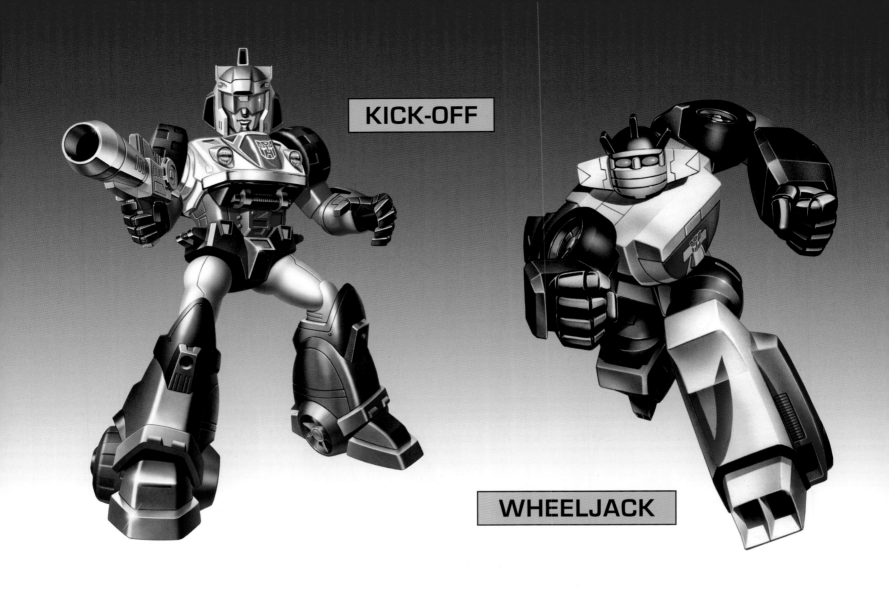

KICK-OFF

WHEELJACK

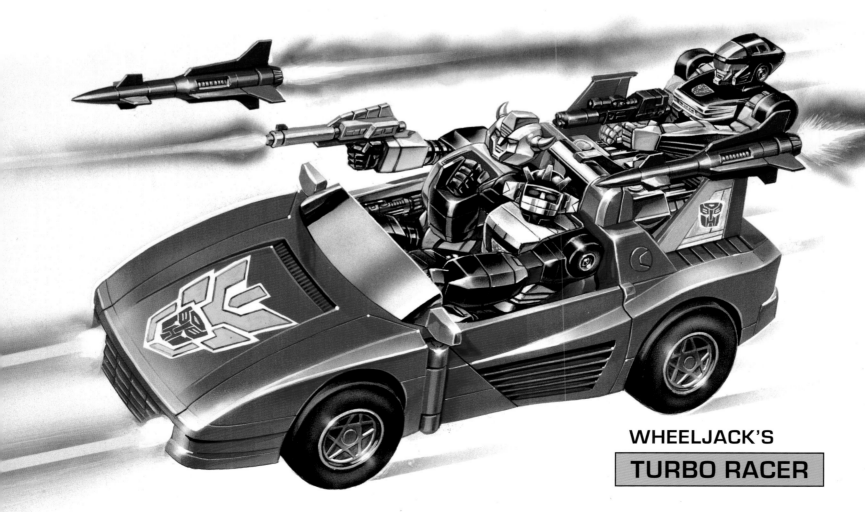

WHEELJACK'S
TURBO RACER

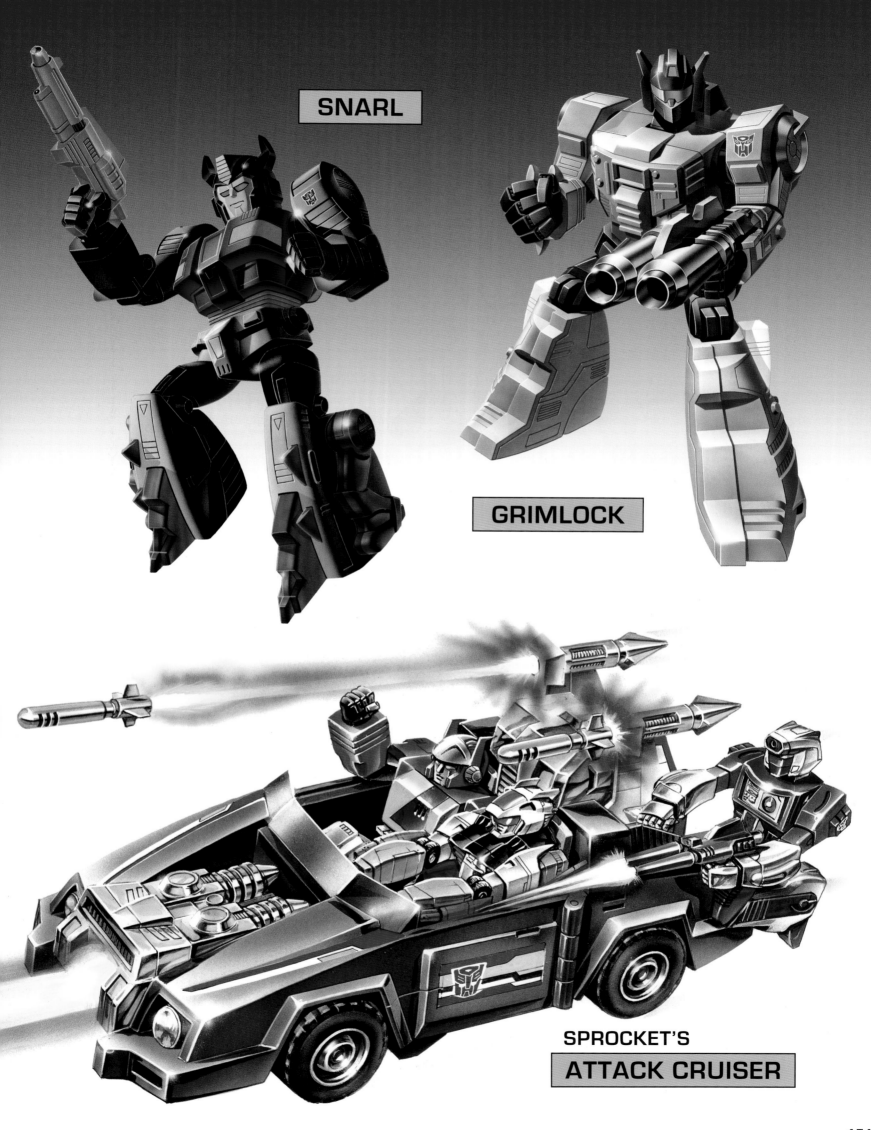

SNARL

GRIMLOCK

SPROCKET'S
ATTACK CRUISER

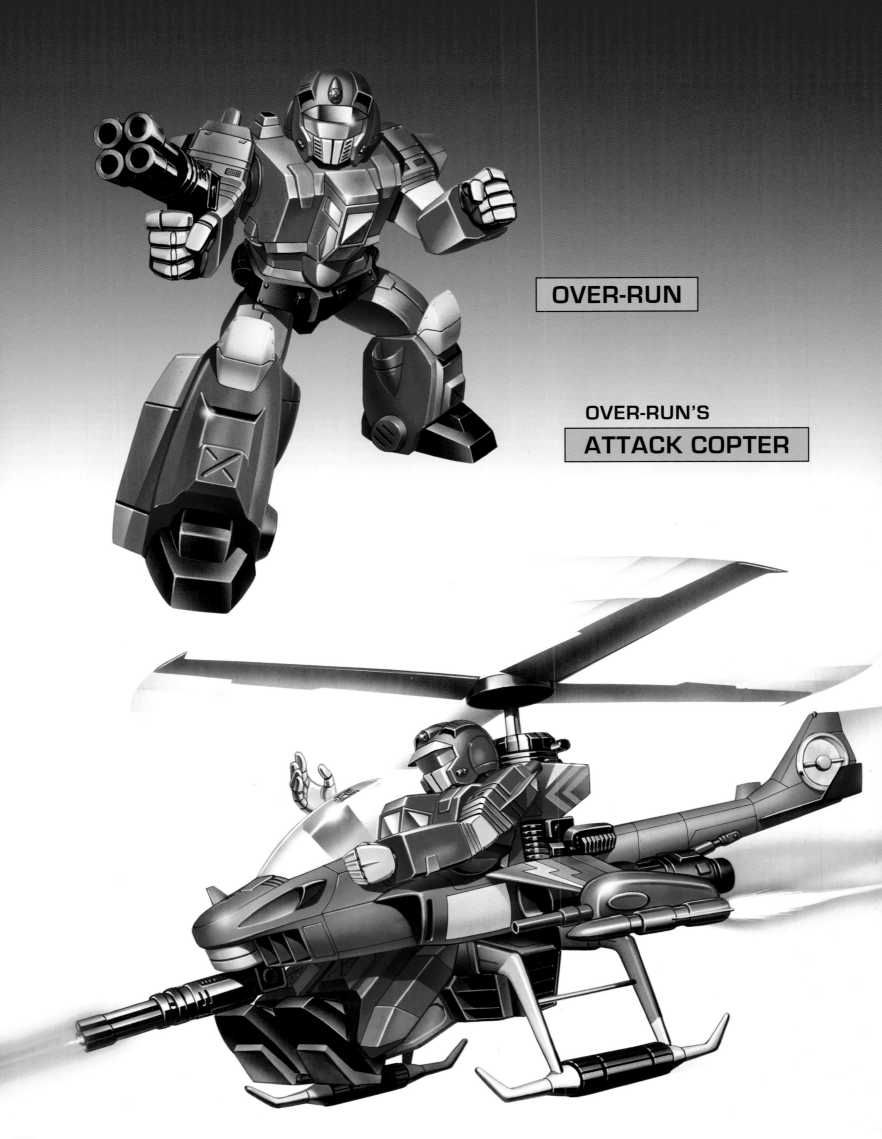

OVER-RUN

OVER-RUN'S
ATTACK COPTER

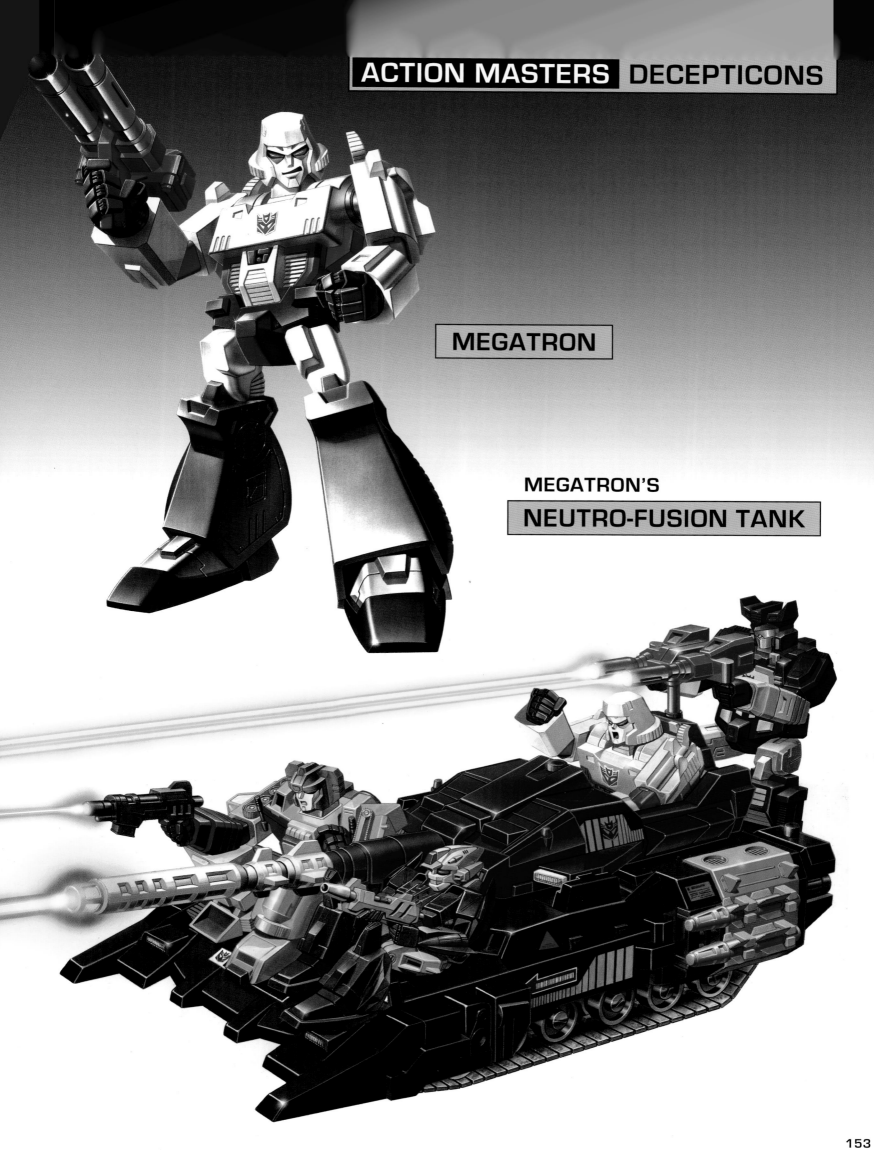

MEGATRON

MEGATRON'S
NEUTRO-FUSION TANK

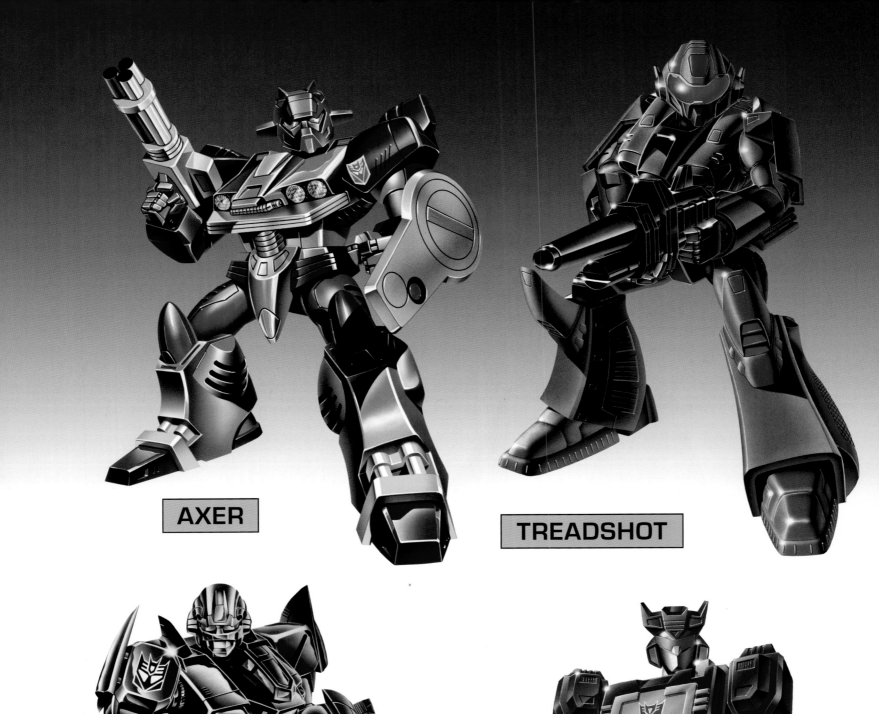

AXER

TREADSHOT

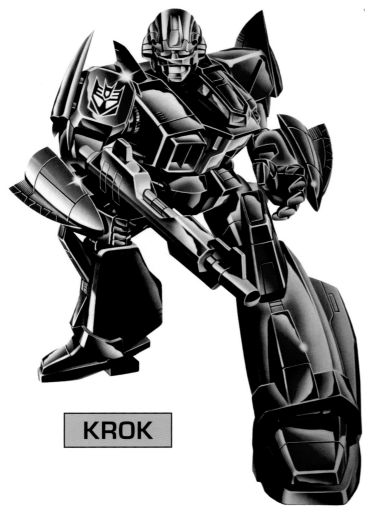

KROK

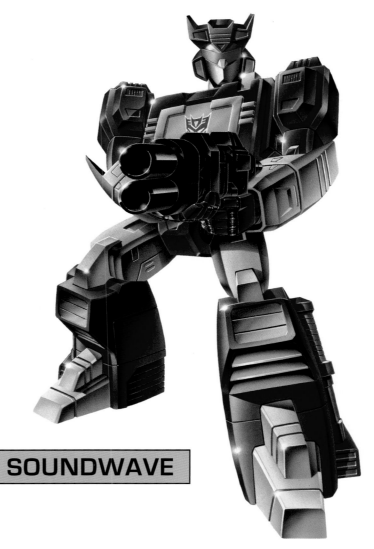

SOUNDWAVE

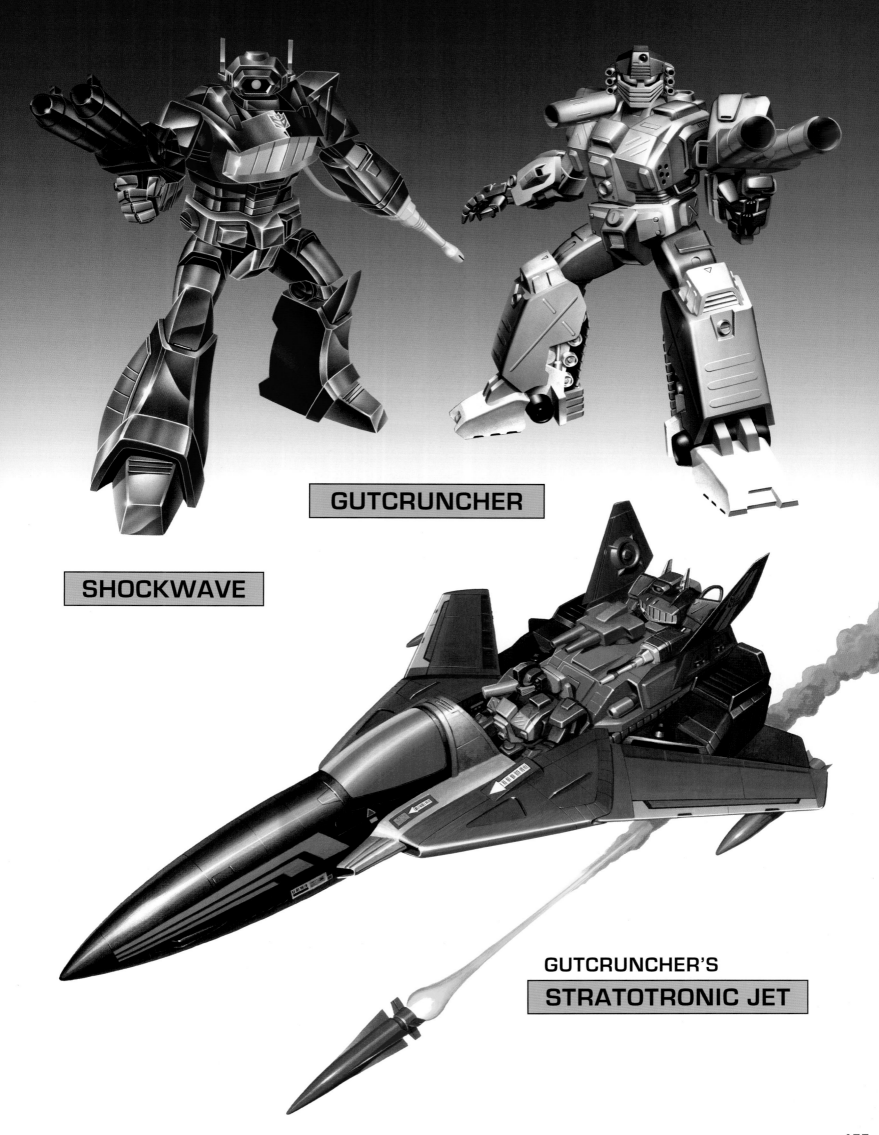

SHOCKWAVE

GUTCRUNCHER

GUTCRUNCHER'S
STRATOTRONIC JET

155

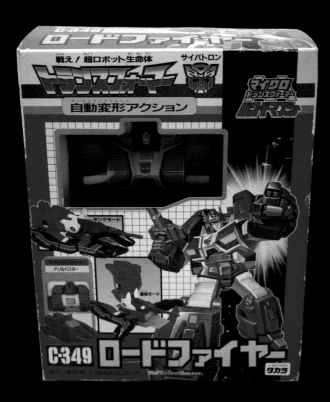

Roadfire (Zone)
MIB (Mint In Box)

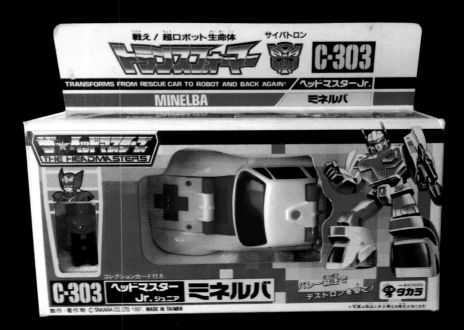

Minera (Masterforce)
MISB (Mint In Sealed Box)

Part Three: Made In Japan

Though Transformers disappeared from US shelves in 1991, this was not the case in Japan. The product line had already converged with, and then diverged from, the US marketing strategy. Observing the tremendous success of the US launch of Transformers in the States in 1984, Takara partnered with Hasbro to replace ageing Micro Change and Diaclone products with the innovative new take provided by The Transformers marketing machine. The American cartoon was dubbed into Japanese, and Transformers became a smash hit in Japan.

So great was its success that, while the American Transformers cartoon ended in 1987 with a three-part miniseries devoted to the Head- and Targetmasters, in Japan there would be three more full cartoon series. The first series was a 35-episode anime called Headmasters (1987). Though tonally quite similar to the third season of the US cartoon, it began to introduce some new characters unique to the Japanese market and thus is the subject of our Chapter Eight, along with a few characters from earlier years who had divergent artwork from their US counterparts.

Chapter Nine continues to examine The Transformers in Japan with Masterforce (1988), a 47-episode anime. This line was unique among Transformers series in its strong focus on the human component. Indeed, the stars of the show and many of the villains were humans piloting Transtector mecha, rather than robots from the planet Cybertron. While there were some unique molds introduced in Masterforce, much of the artwork in this chapter consists of American toys from the 1988 line, repainted for the Japanese market.

Not so with Victory (1989), the third Japanese Transformers anime and the subject of our Chapter Ten. Almost all of the toys were developed exclusively for the Japanese market, and featured a host of new gimmicks. The Pretenders and Micromasters of 1989 had little place in this line, which included such sublines as the Brainmasters, whose faces could become smaller robots; the Breastmasters, whose chestplates could become weapons or animals; and the Multiforce, small robots who could become the top or bottom halves of midsized robots and who could all combine into a larger form. This feature would be echoed years later in 2004 with the Powerlinx gimmick of Transformers Energon.

Chapter Eleven finishes the Japanese portion of the book. It covers all subsequent Japanese franchises, starting with Zone (1990). Zone received a single direct-to-video anime episode, the last Japanese Transformers cartoon for over a decade. The lines continued to contract in size, with The Return of Convoy (1991) and Operation Combination (1992) lines closing out the Japanese contribution to Transformers Generation 1 in 1992. Zone and The Return of Convoy each featured a few new anchor pieces, with the line bulked out by Micromasters imported from the US. Operation Combination was more of a mixed bag, with new Micromaster six-combiner teams fighting alongside toys imported from the UK and even redecoes of Scramble City molds from late 1985.

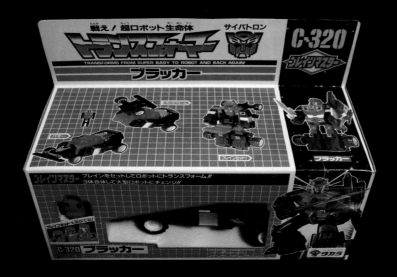

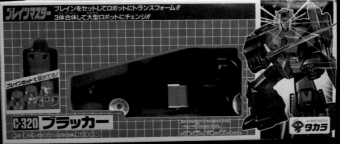

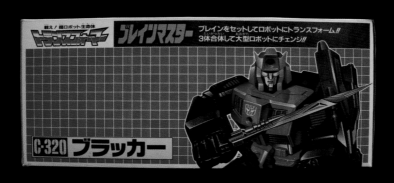

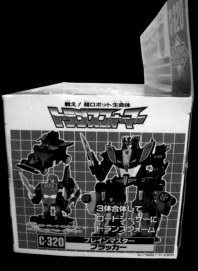

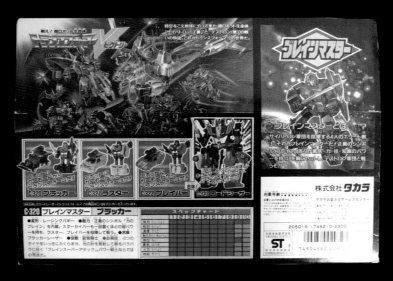

Blacker (Victory) 360° View
MISB (Mint In Sealed Box)

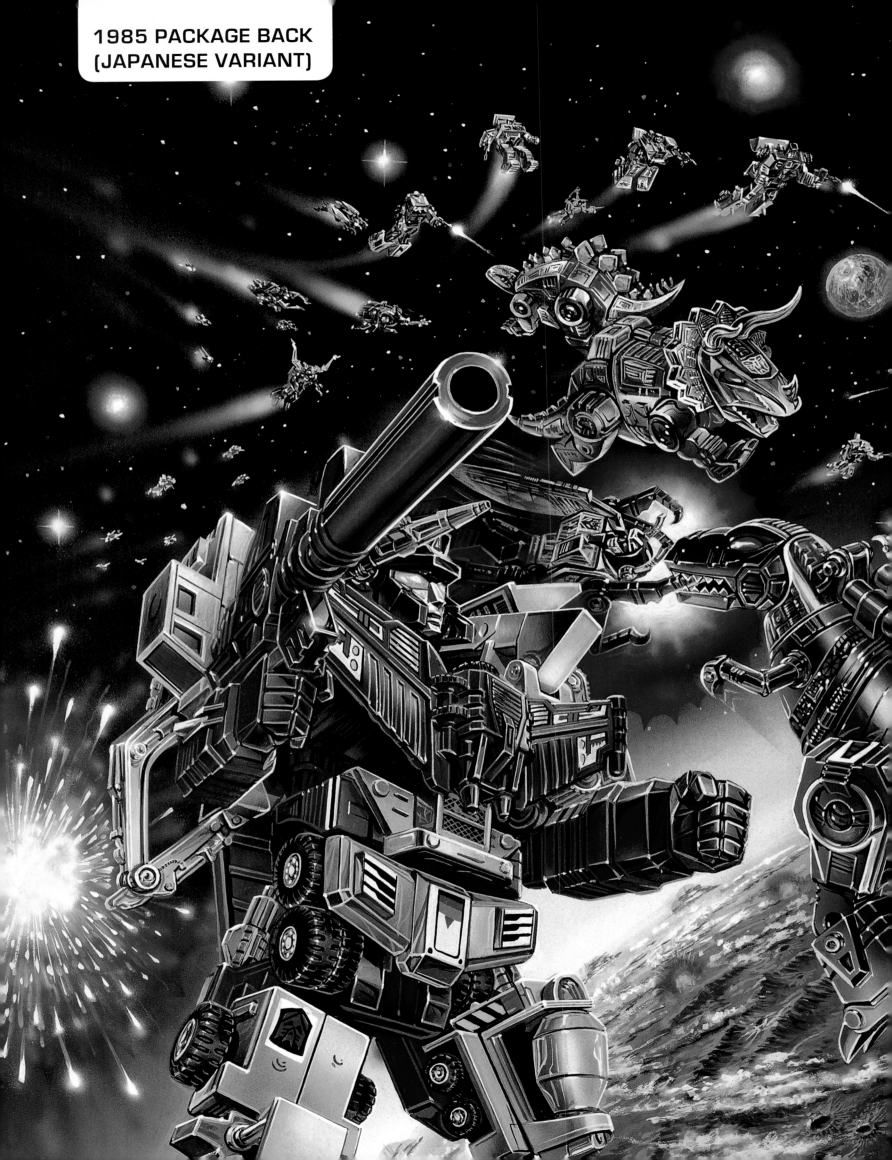

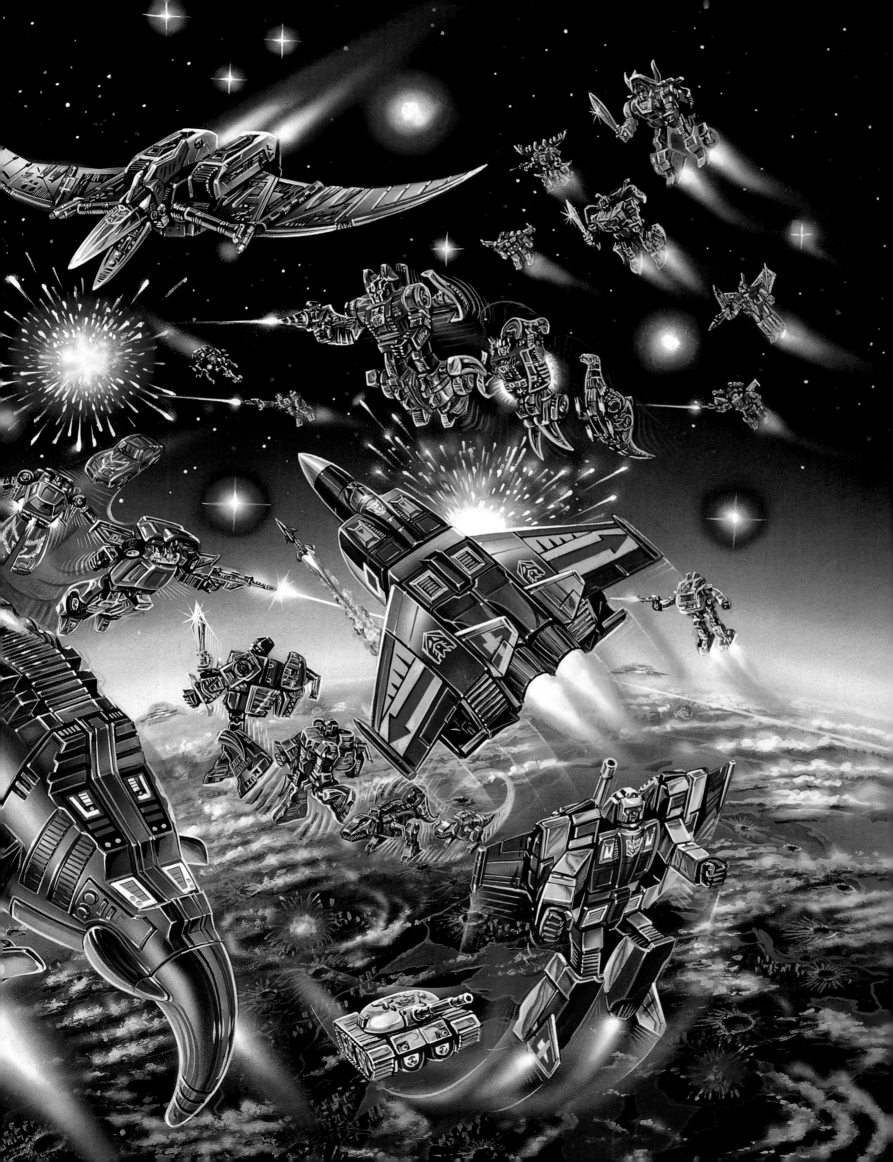

FLARE JET HEAD

MOON JET HEAD

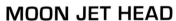

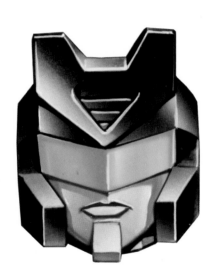

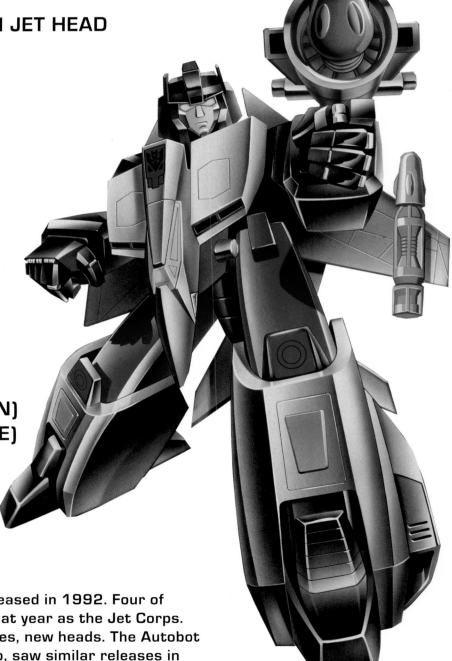

DARK JET HEAD

SHADOW JET (JAPAN)
aka FALCON (EUROPE)

Europe saw six Predator toys released in 1992. Four of
them saw releases in Japan later that year as the Jet Corps.
They had new names and, in three cases, new heads. The Autobot
Turbomasters AKA Road Corps, too, saw similar releases in
Europe and Japan, though with only one new head. (See page 172)

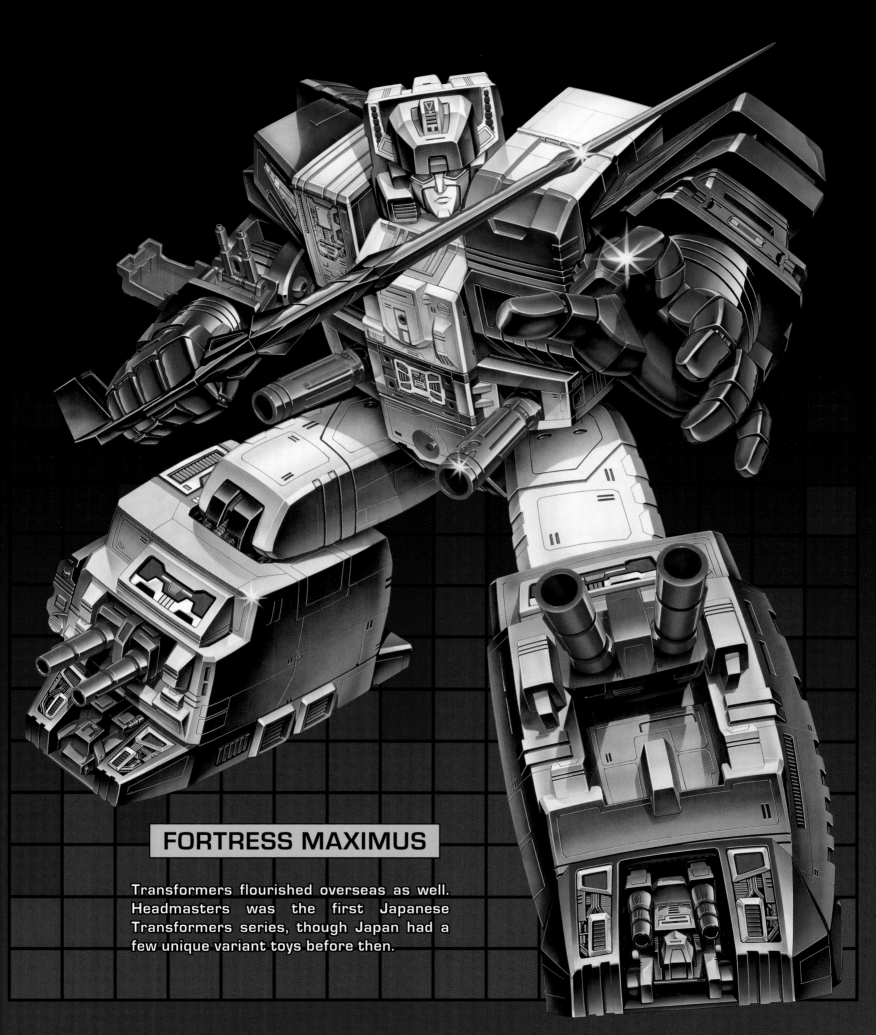

FORTRESS MAXIMUS

Transformers flourished overseas as well. Headmasters was the first Japanese Transformers series, though Japan had a few unique variant toys before then.

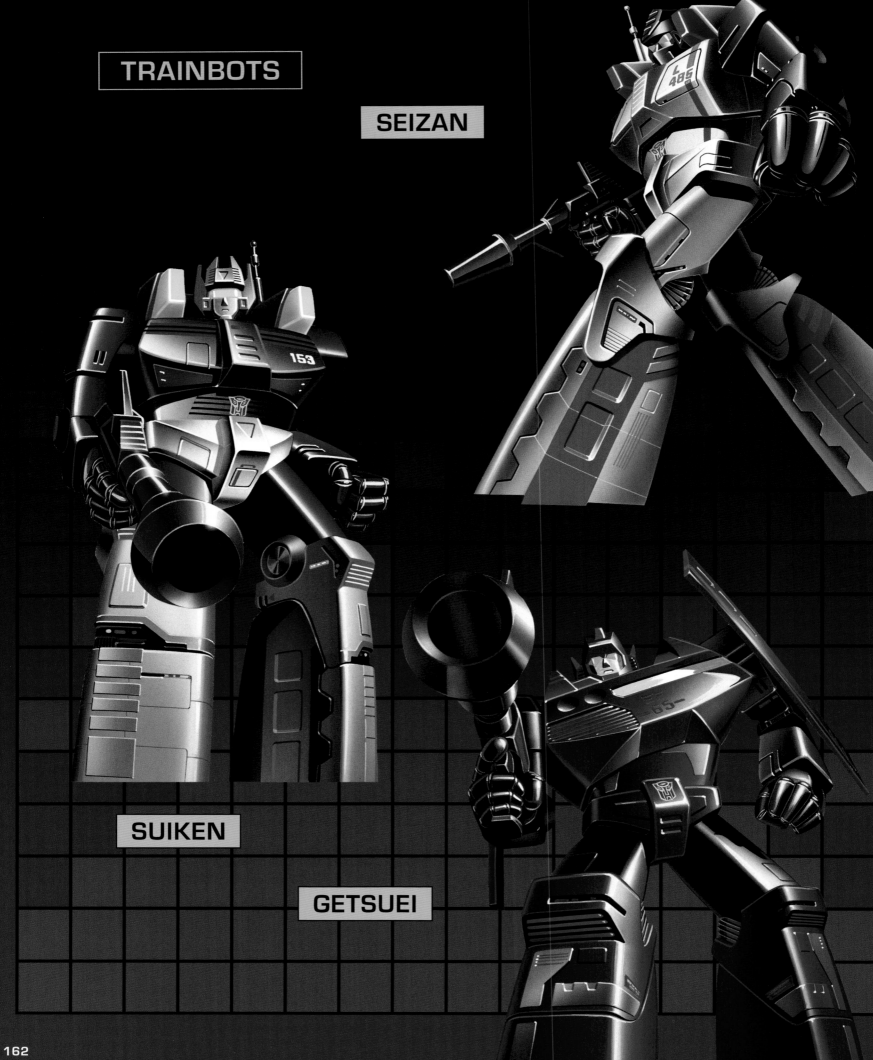

TRAINBOTS

SEIZAN

SUIKEN

GETSUEI

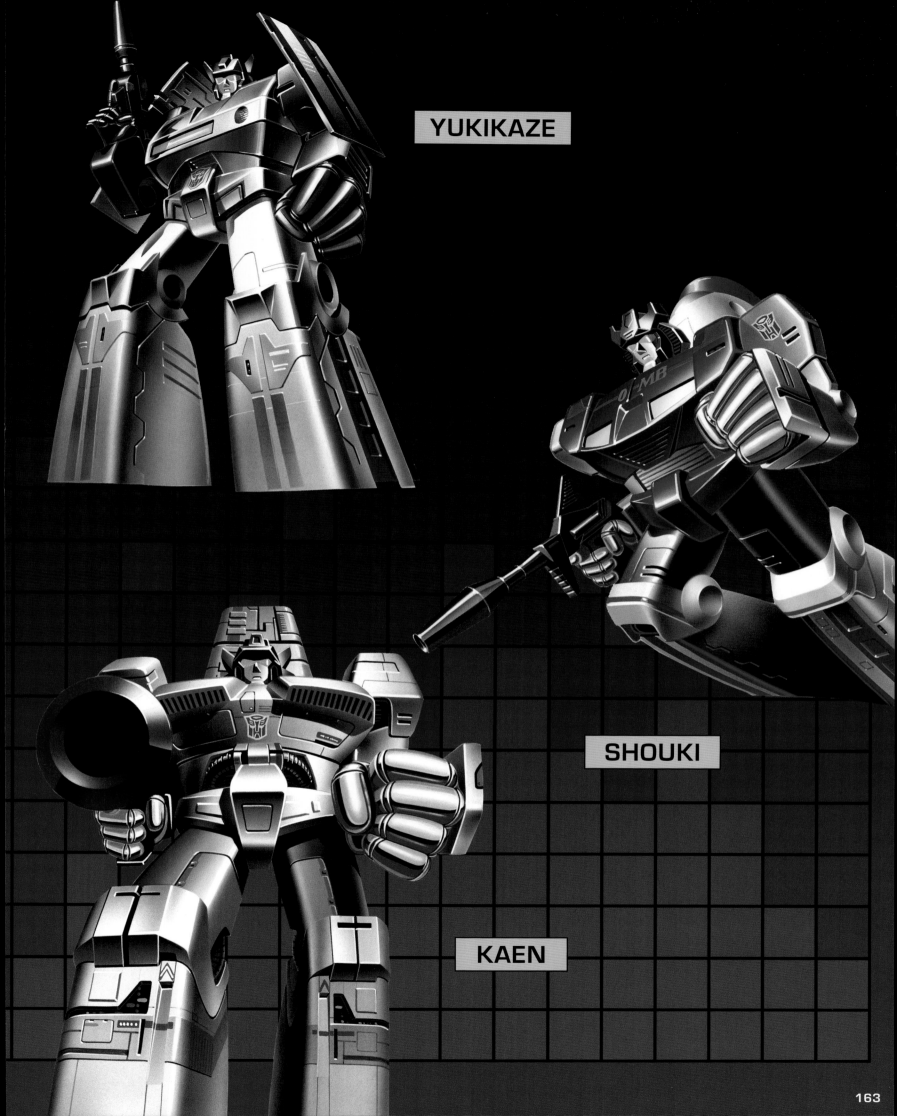

YUKIKAZE

SHOUKI

KAEN

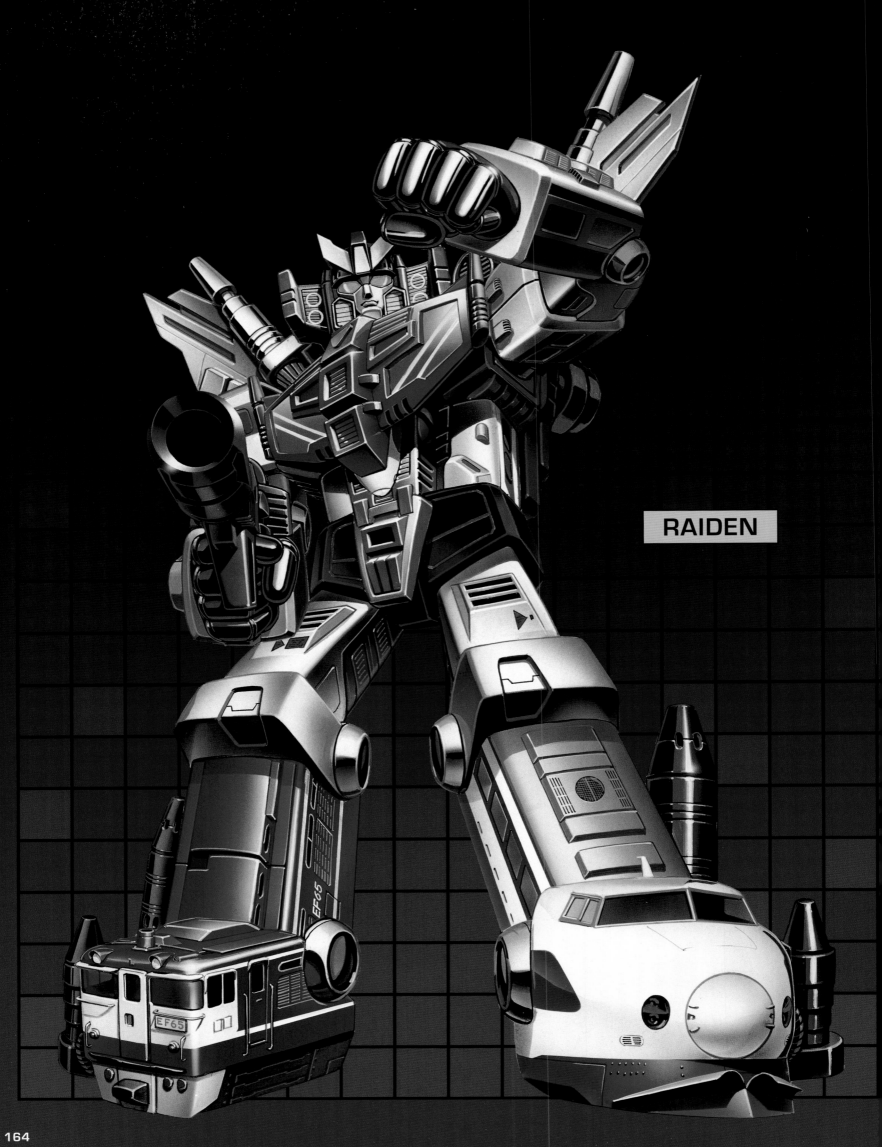

RAIDEN

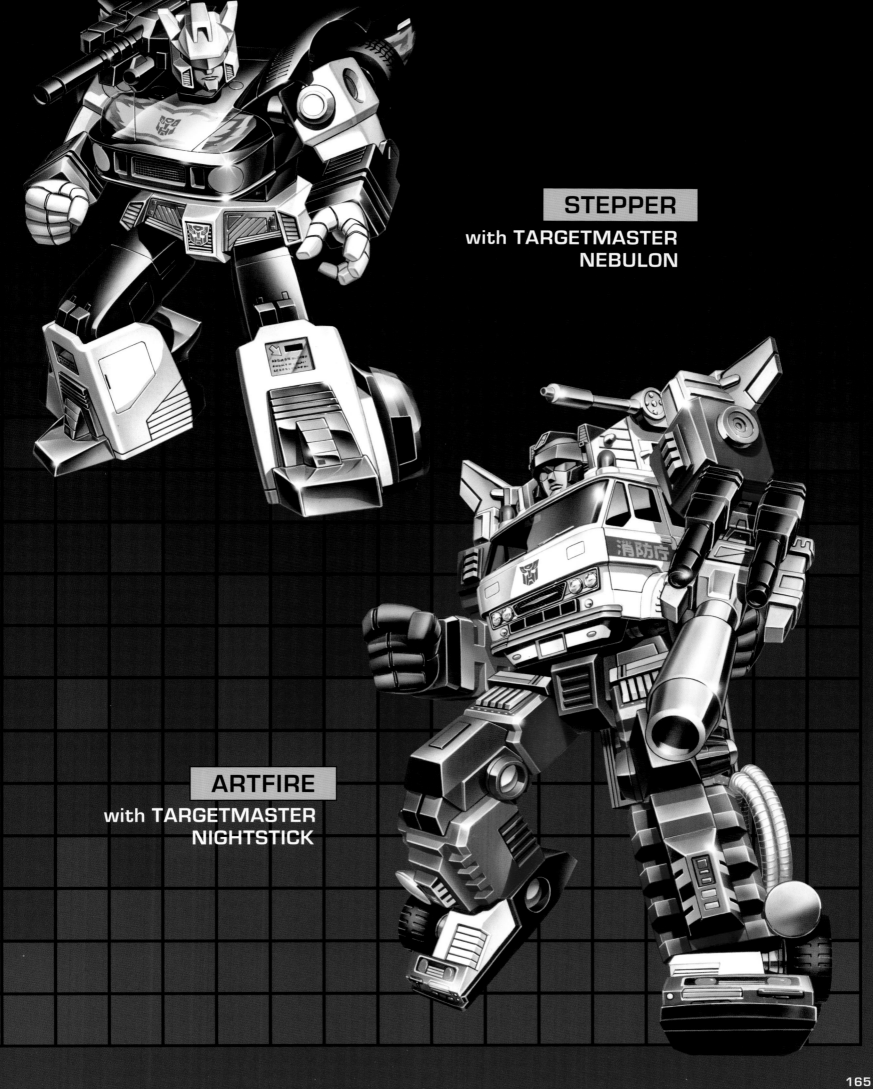

STEPPER
with TARGETMASTER NEBULON

ARTFIRE
with TARGETMASTER NIGHTSTICK

165

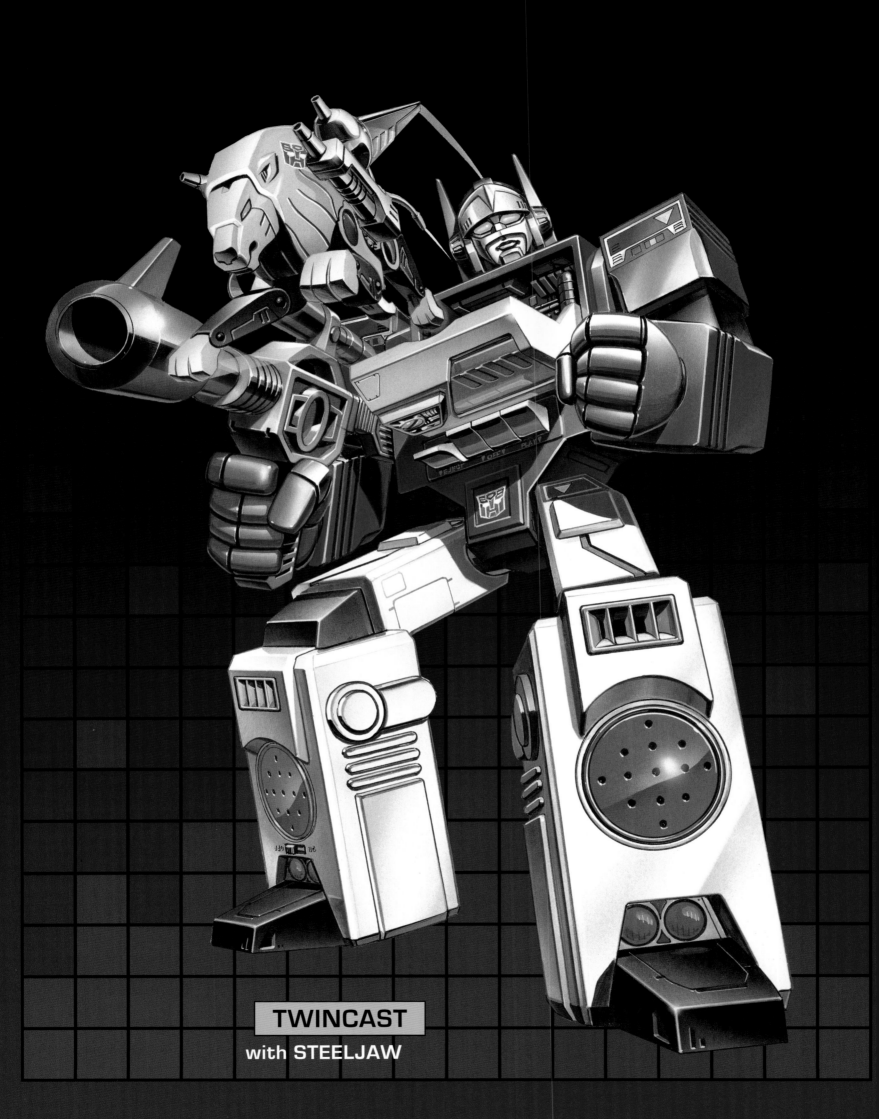

TWINCAST

with **STEELJAW**

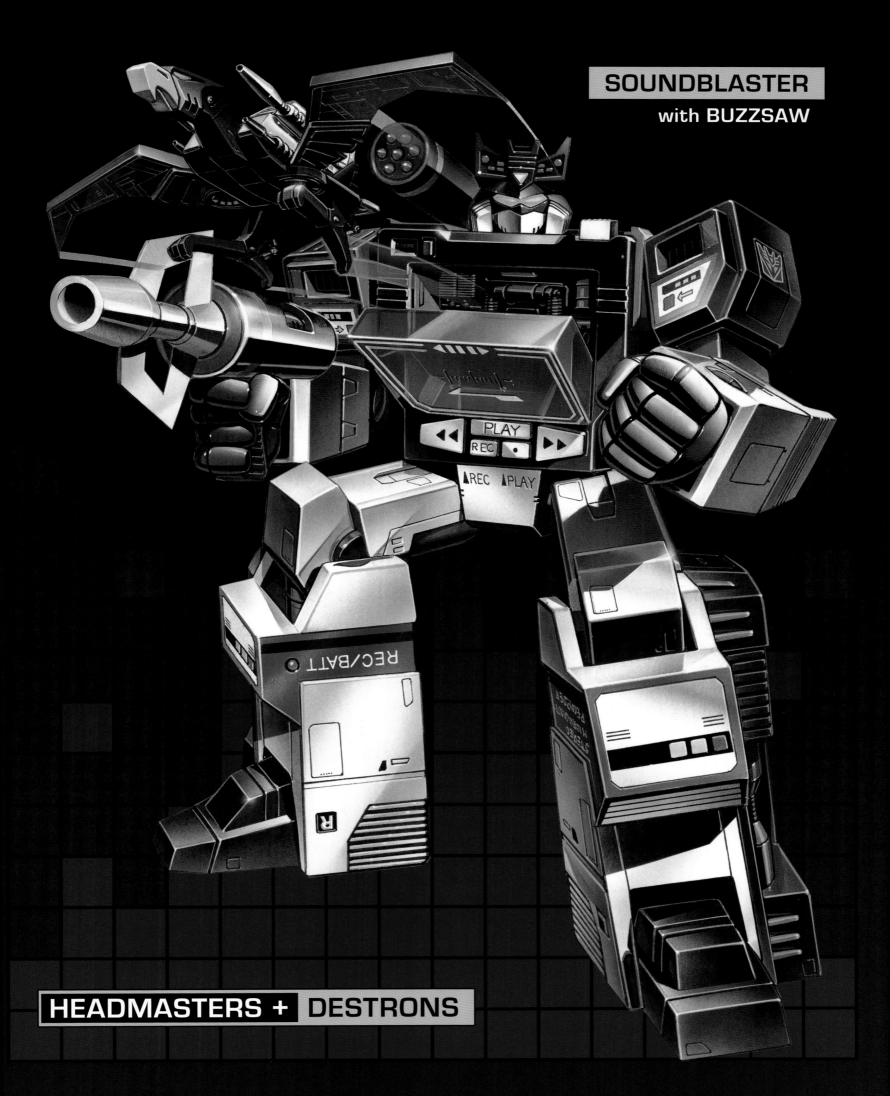

SOUNDBLASTER
with BUZZSAW

HEADMASTERS + DESTRONS

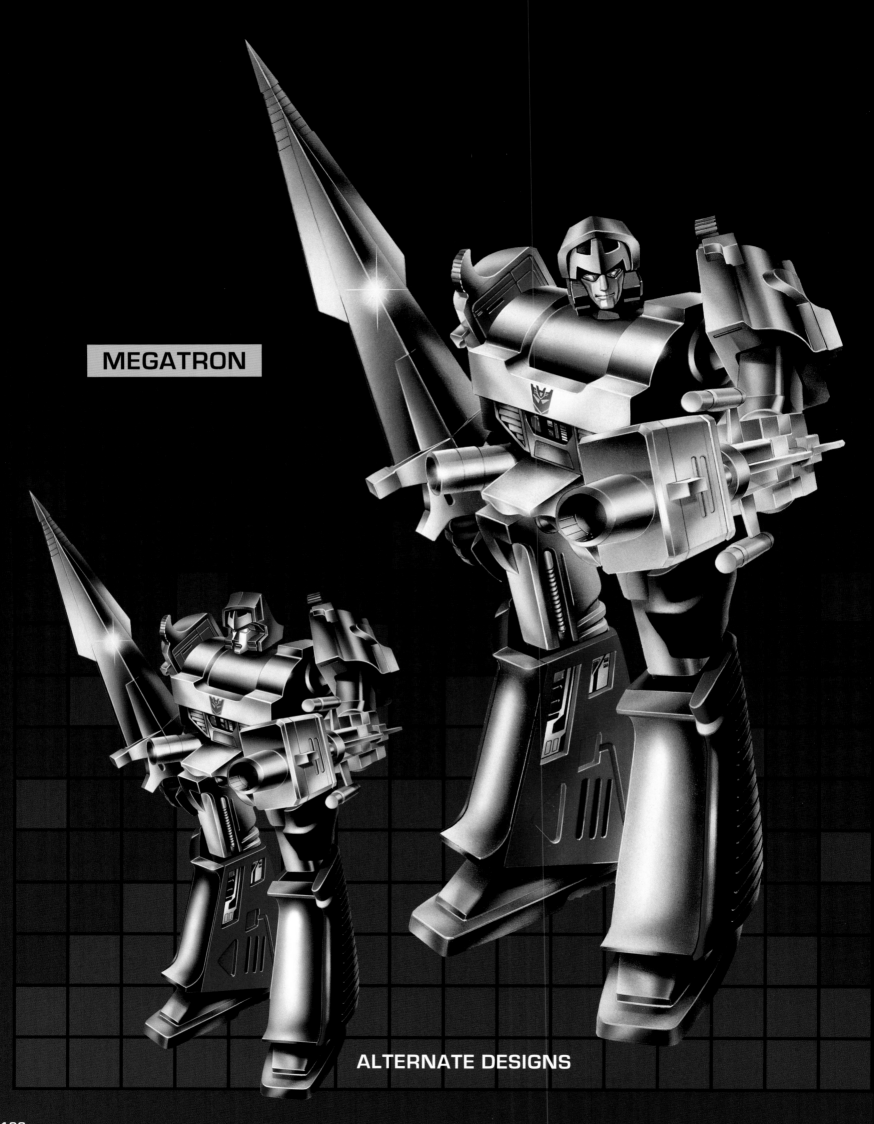

MEGATRON

ALTERNATE DESIGNS

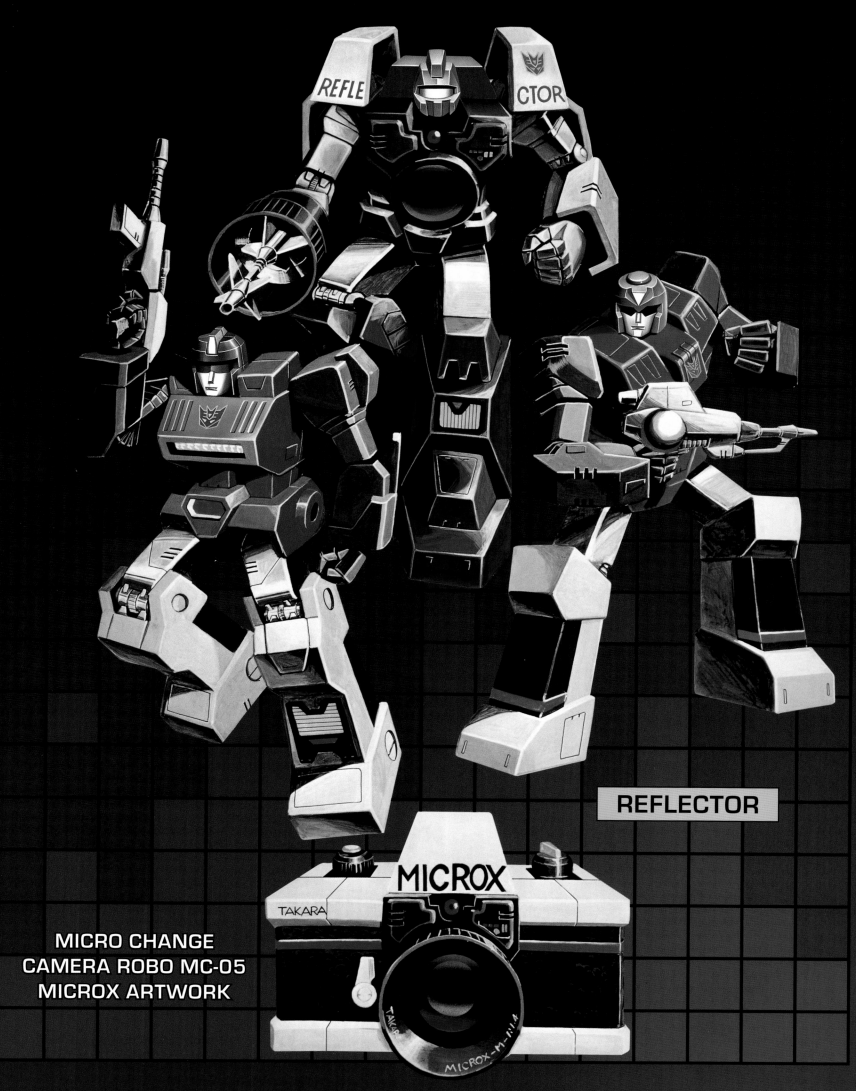

REFLECTOR

MICRO CHANGE
CAMERA ROBO MC-05
MICROX ARTWORK

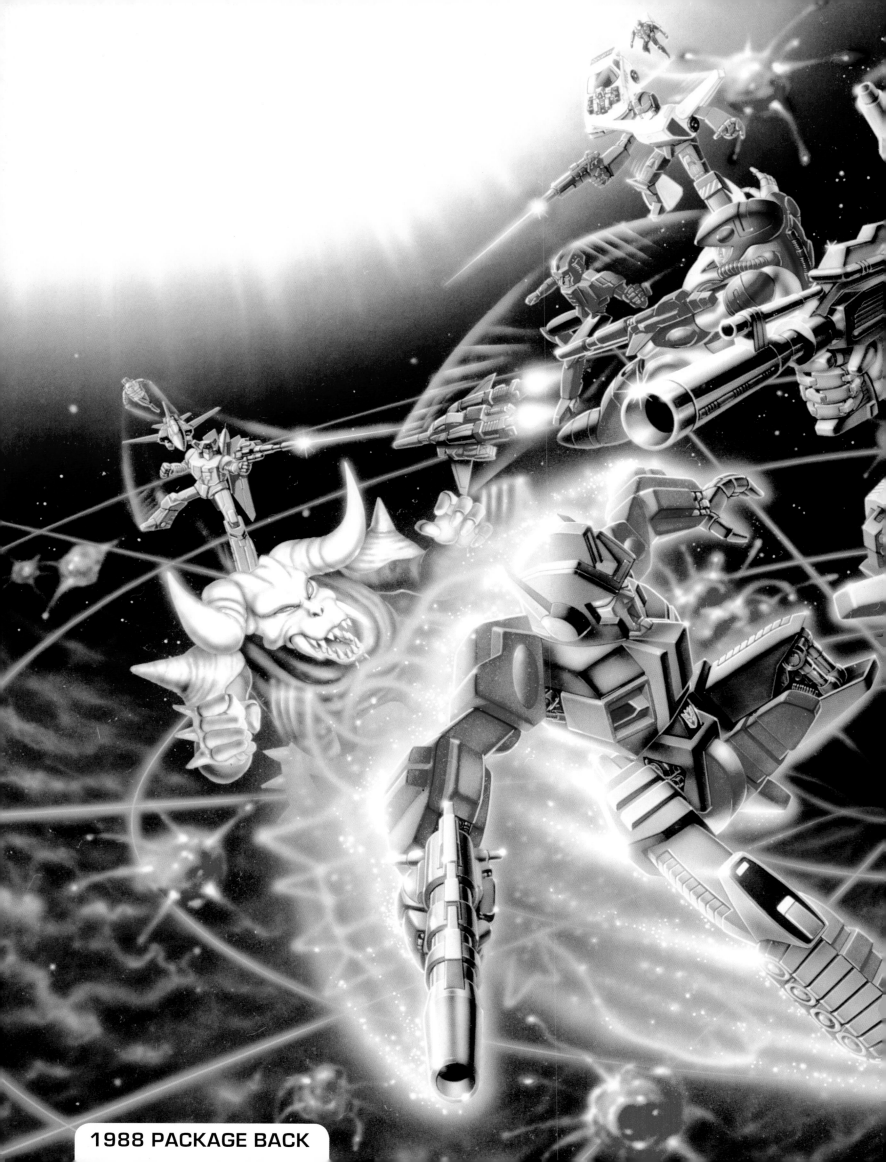

1988 PACKAGE BACK

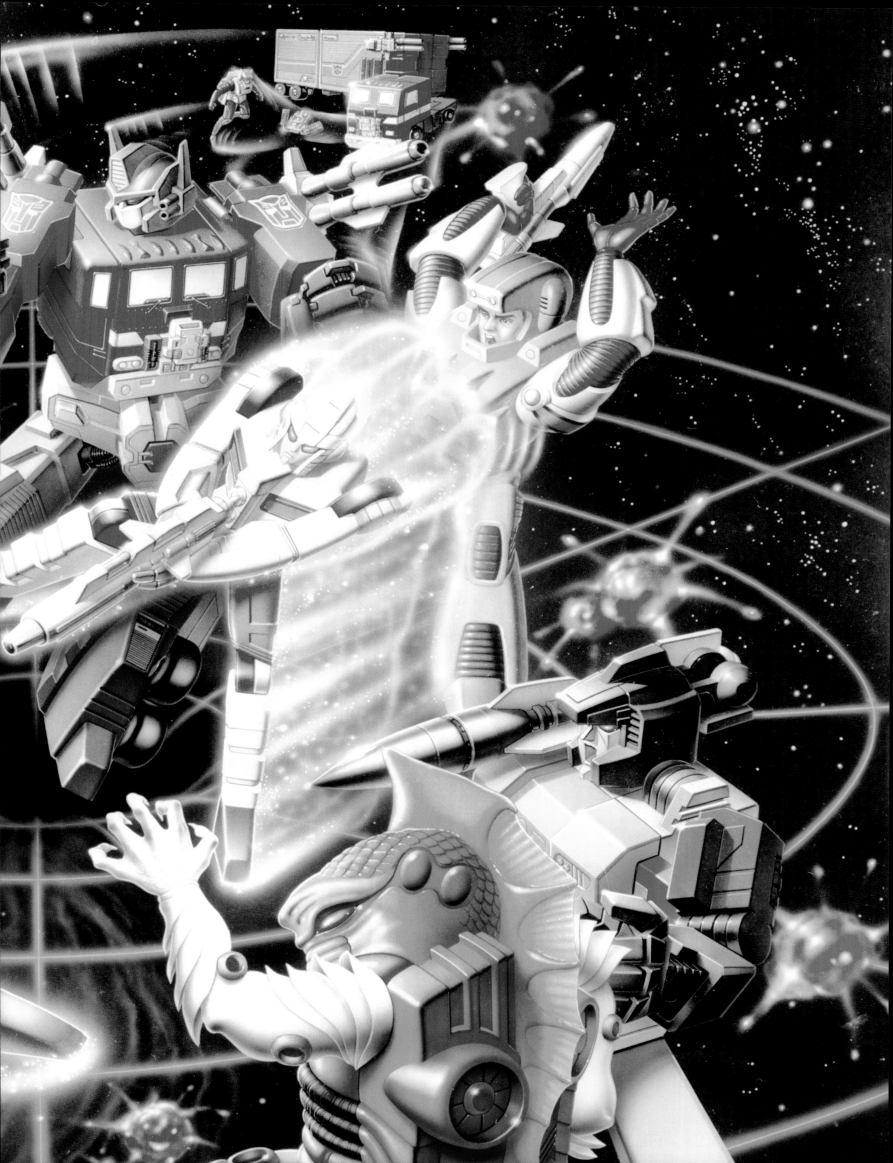

MACH ROAD HEAD

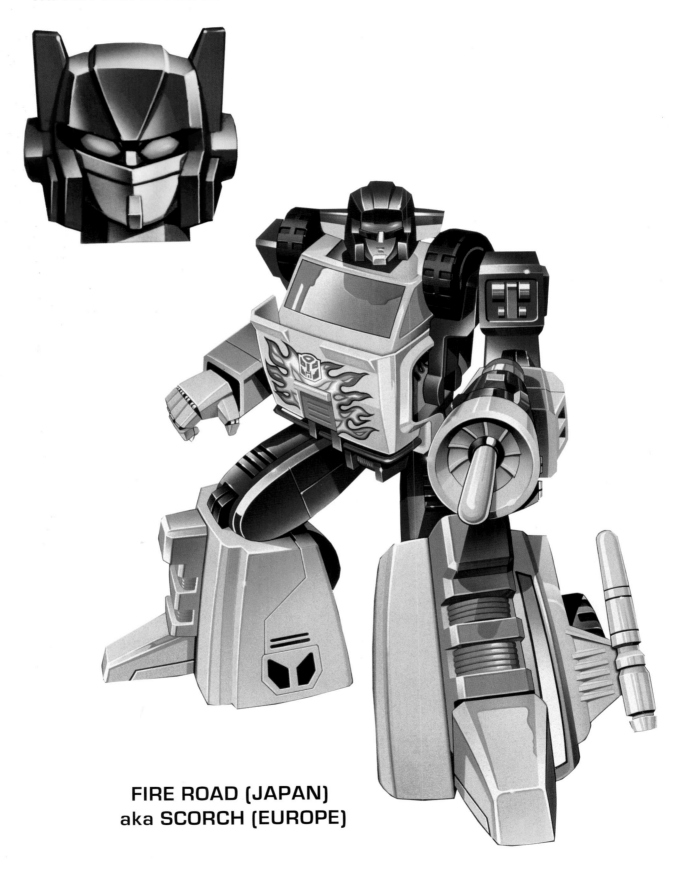

FIRE ROAD (JAPAN)
aka SCORCH (EUROPE)

MASTERFORCE CYBERTRONS

The second Japanese series was Masterforce. Though there were a few unique toys, Masterforce largely consisted of repainted toys from America.

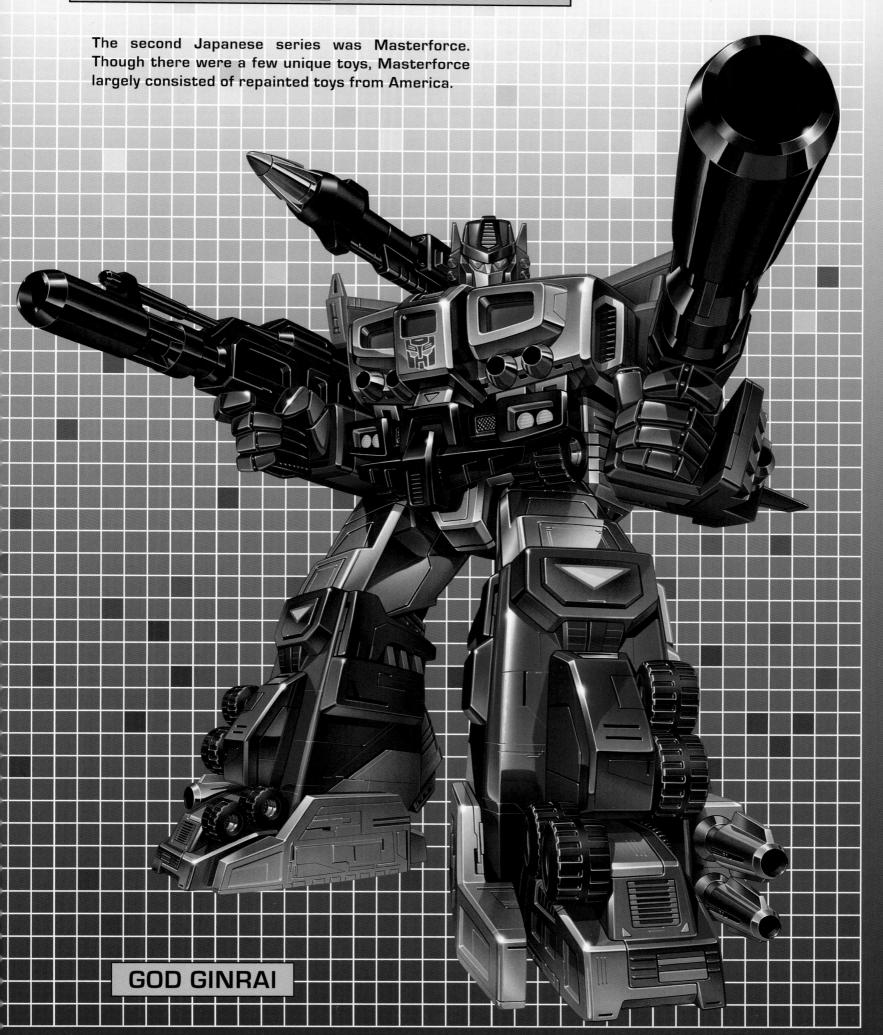

GOD GINRAI

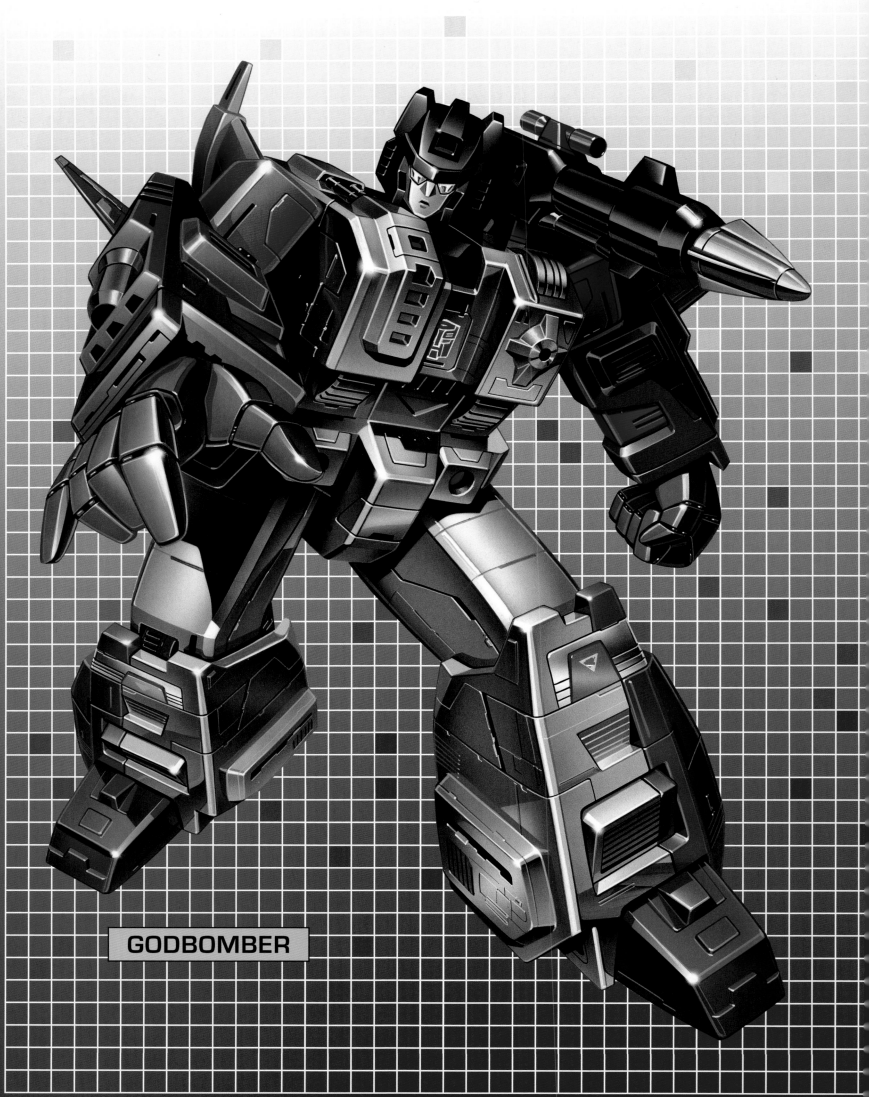

GODBOMBER

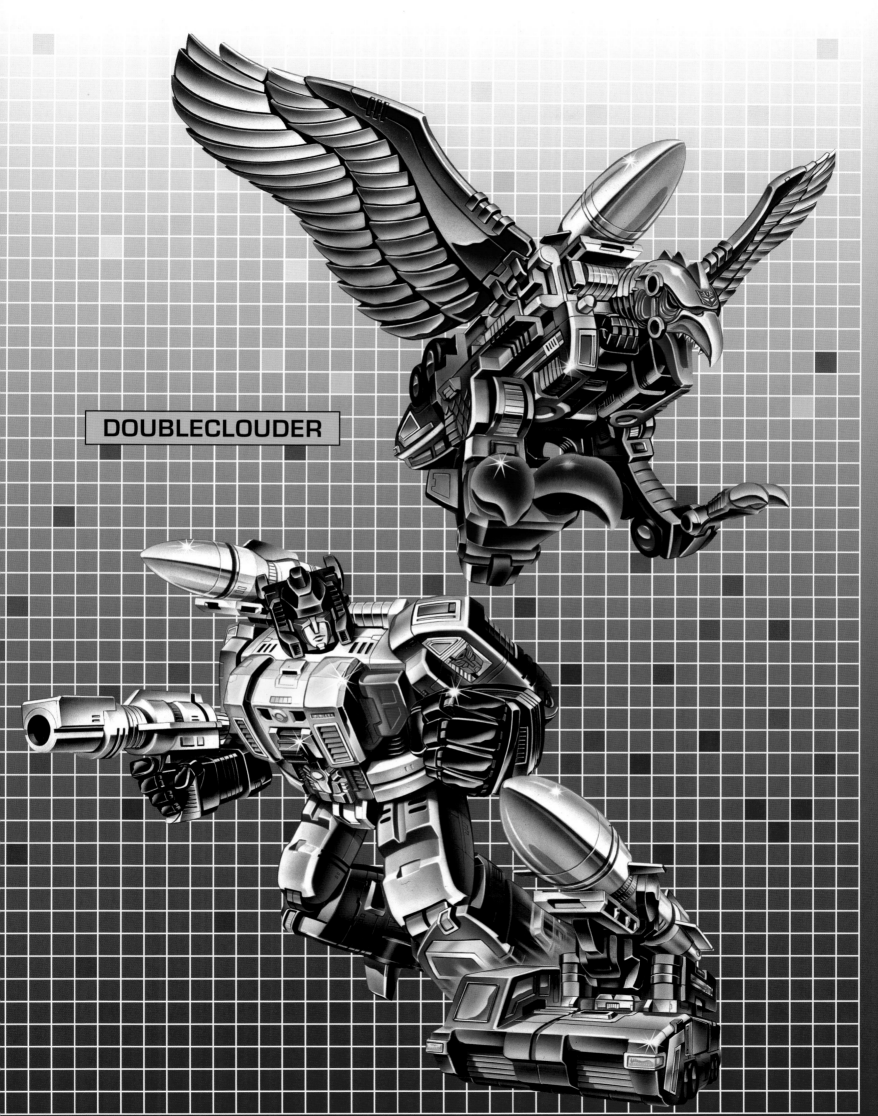

DOUBLECLOUDER

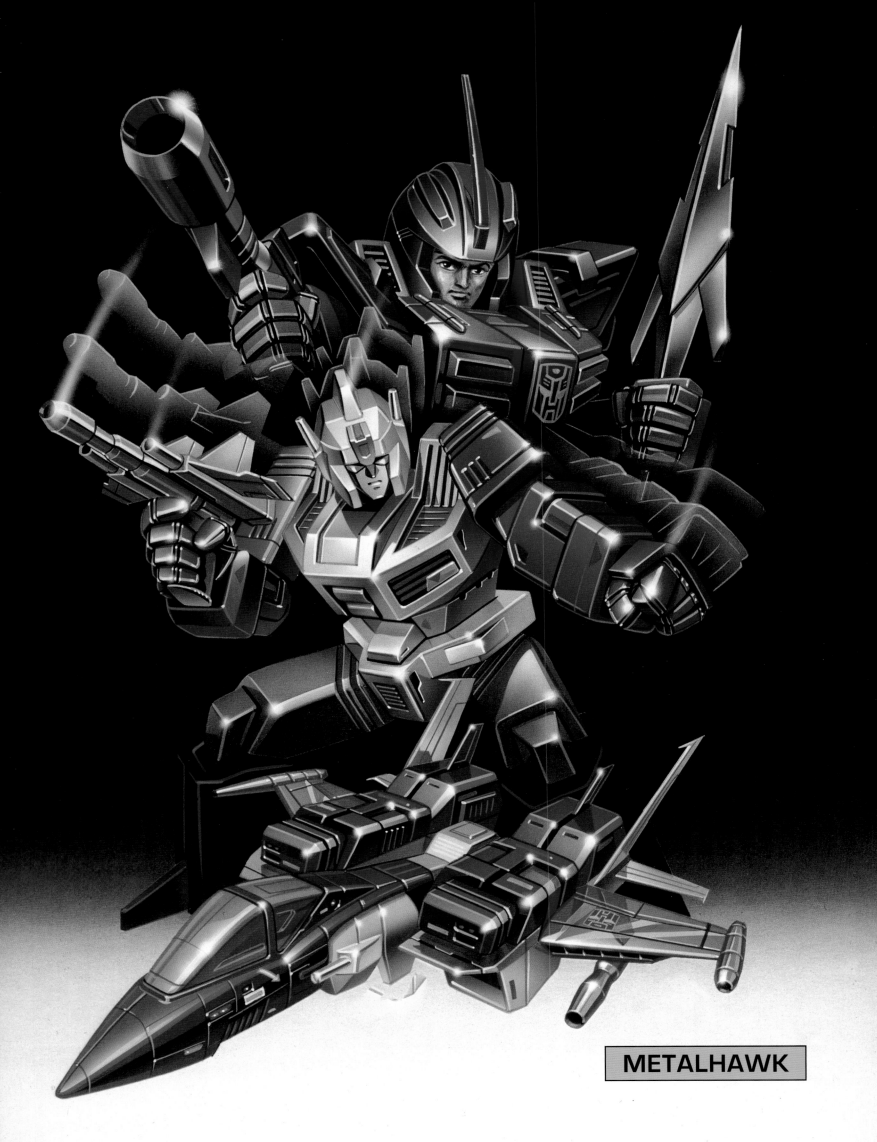

METALHAWK

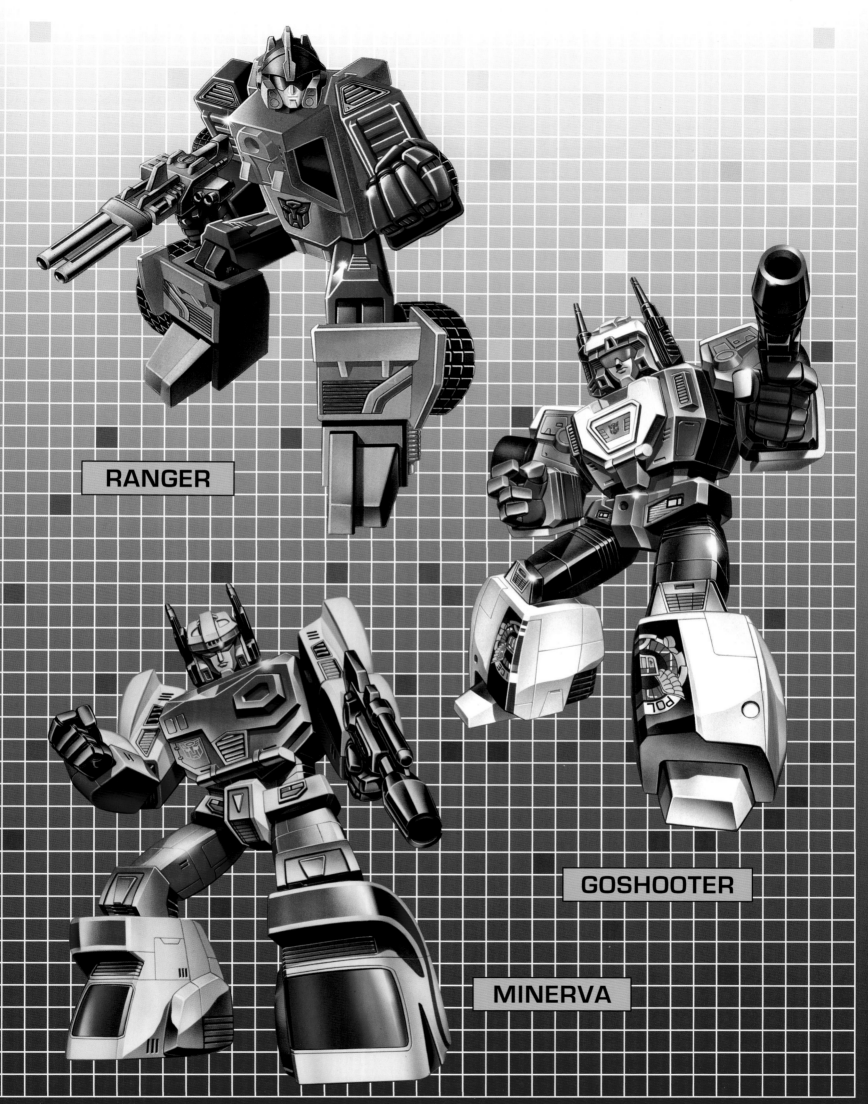

RANGER

GOSHOOTER

MINERVA

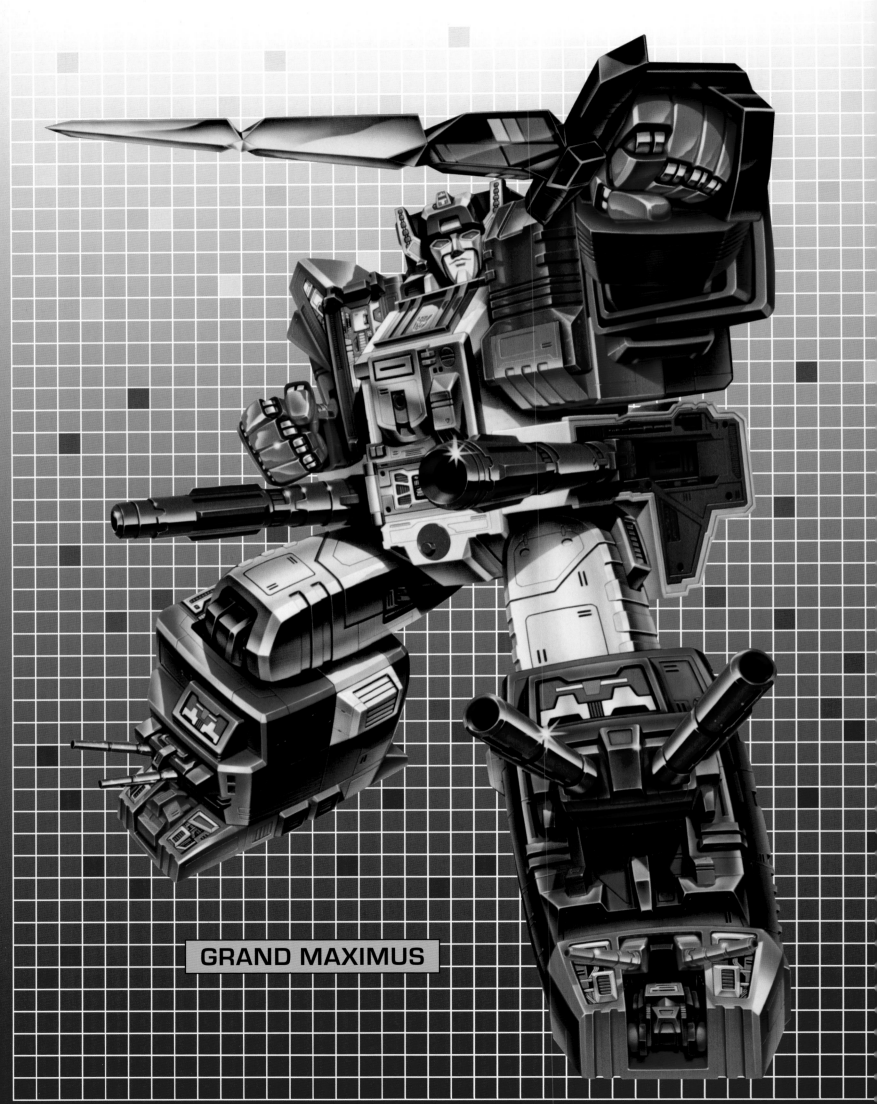

GRAND MAXIMUS

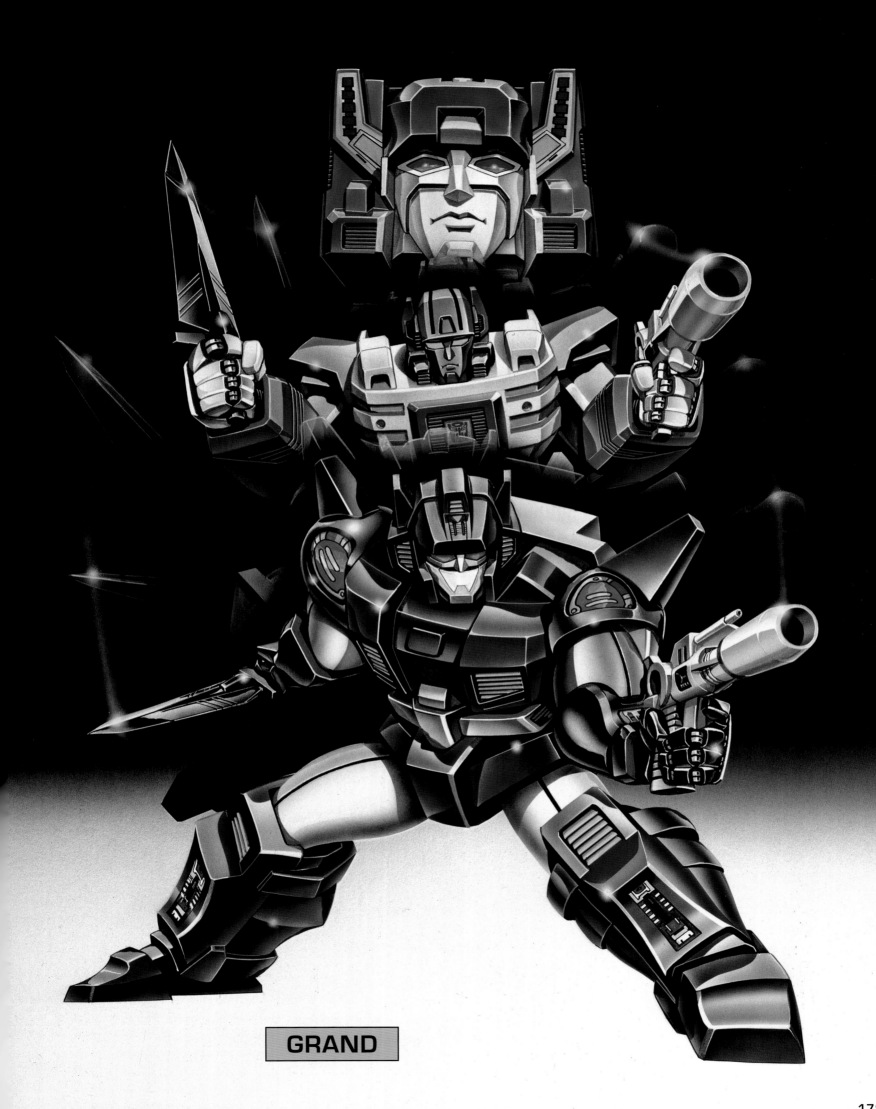

GRAND

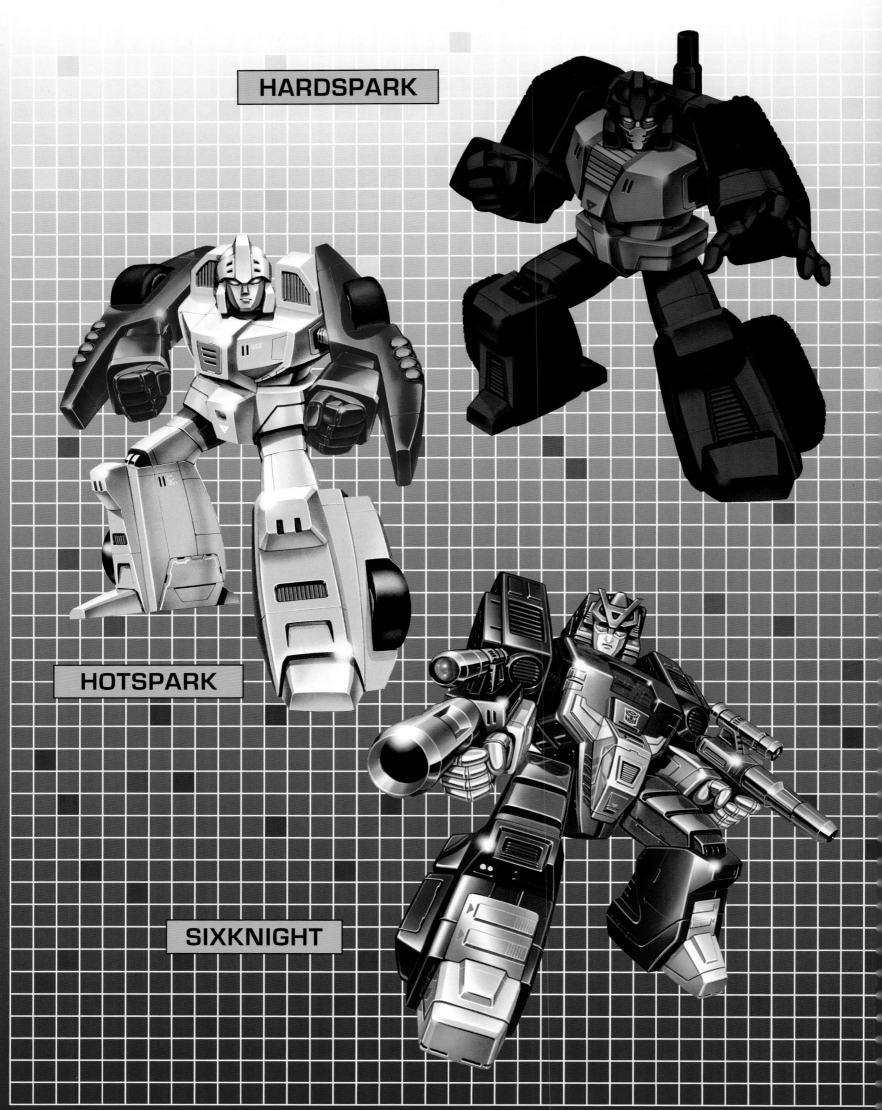

HARDSPARK

HOTSPARK

SIXKNIGHT

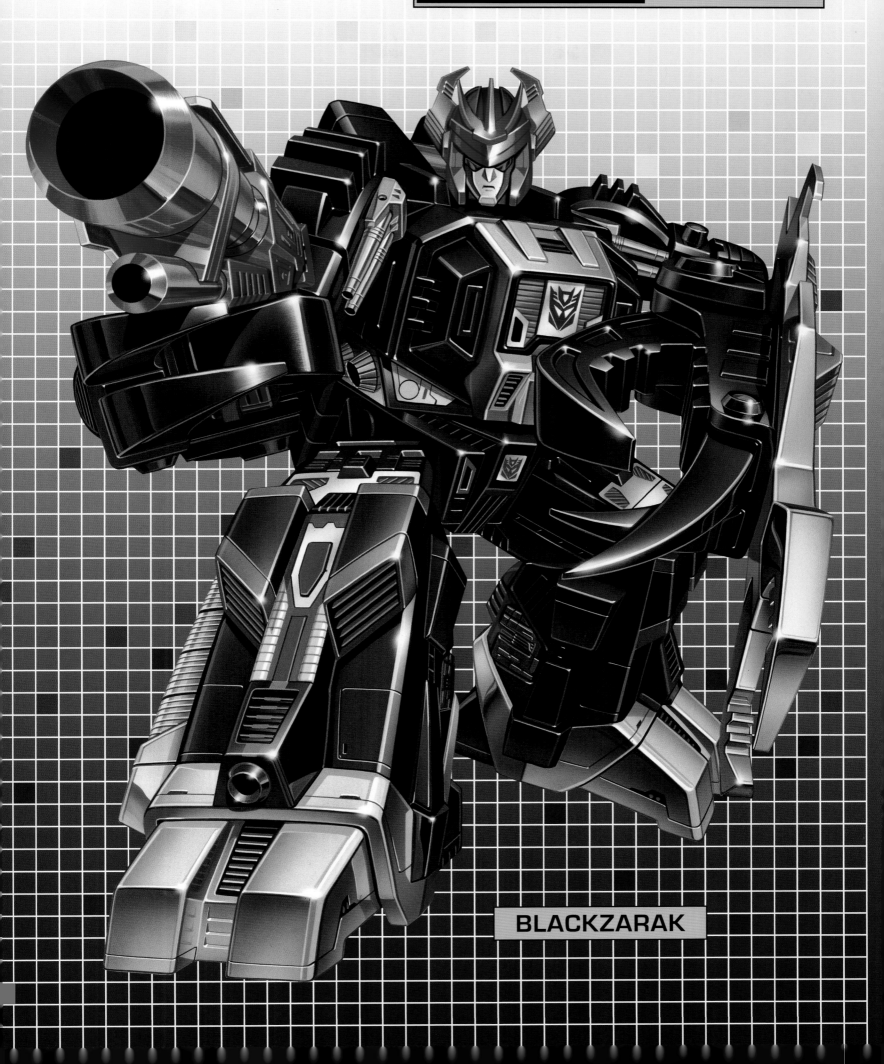

BLACKZARAK

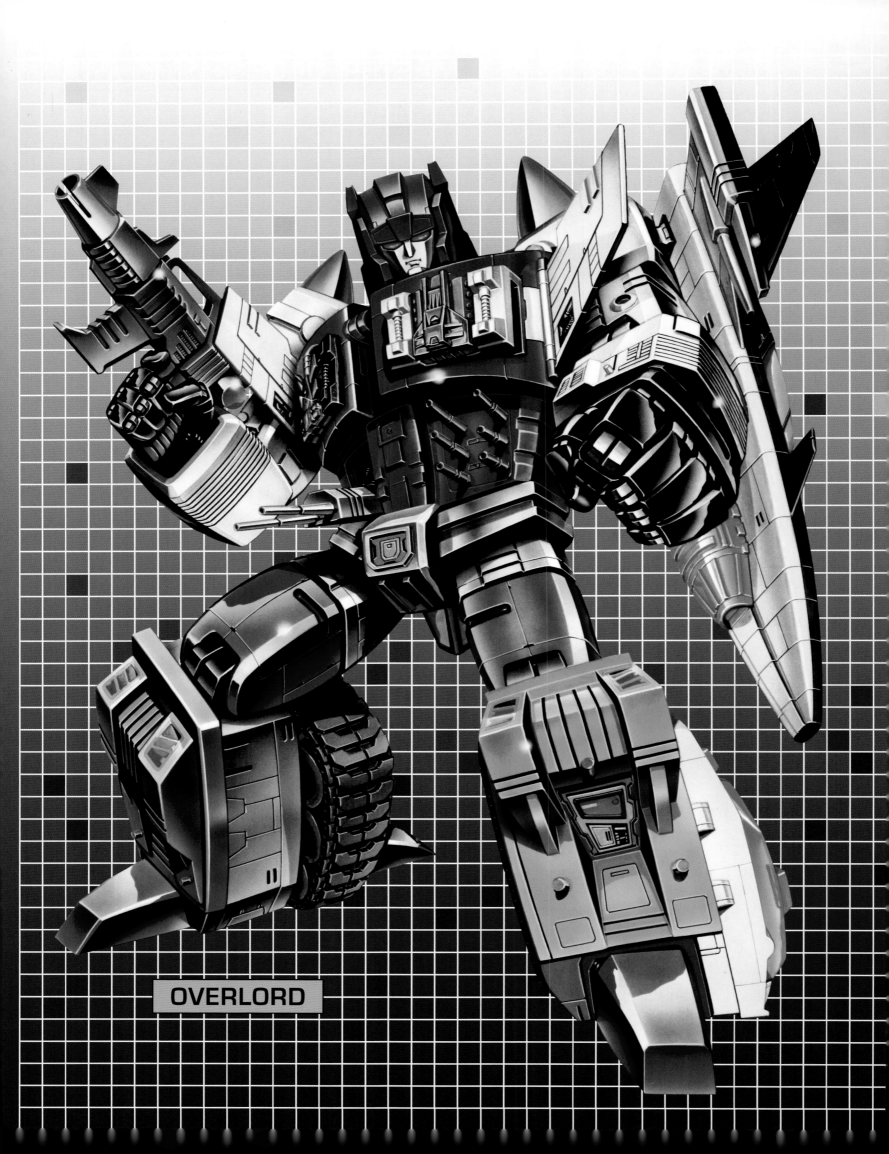

OVERLORD

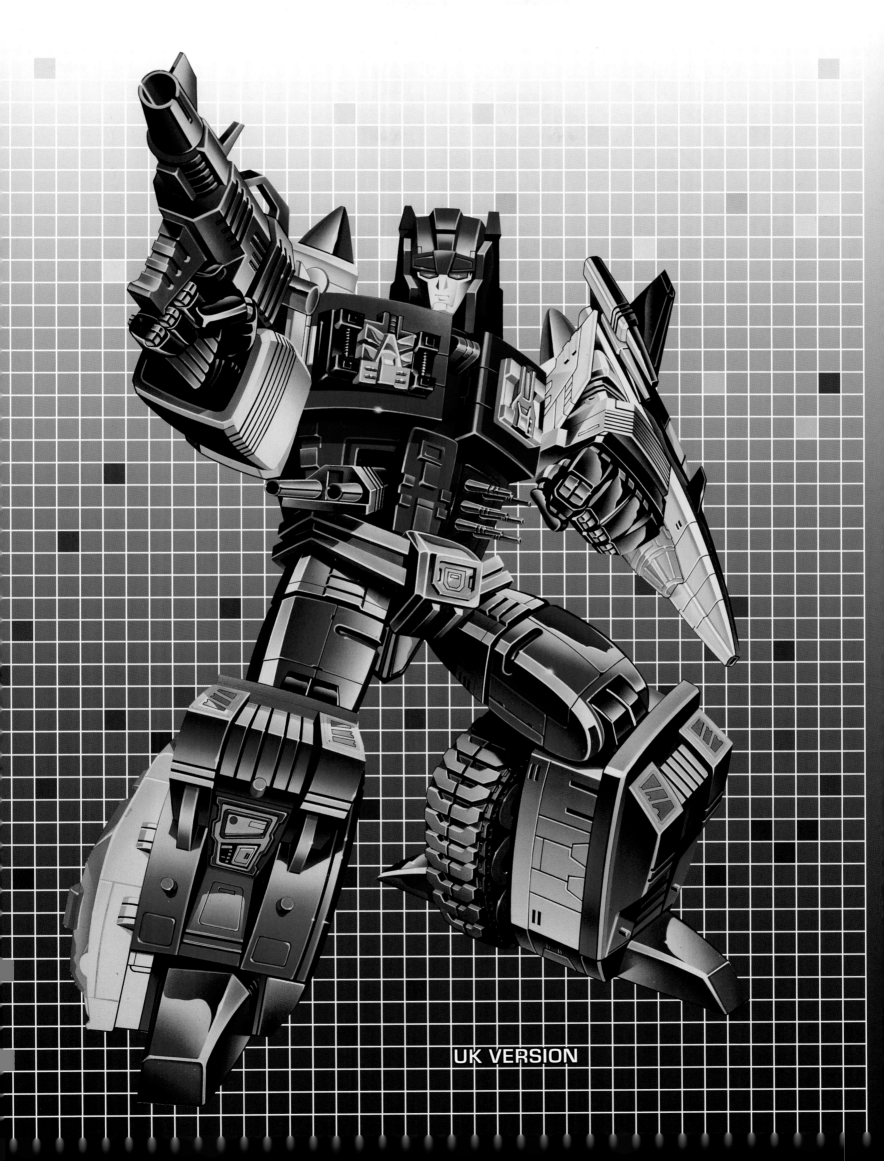

UK VERSION

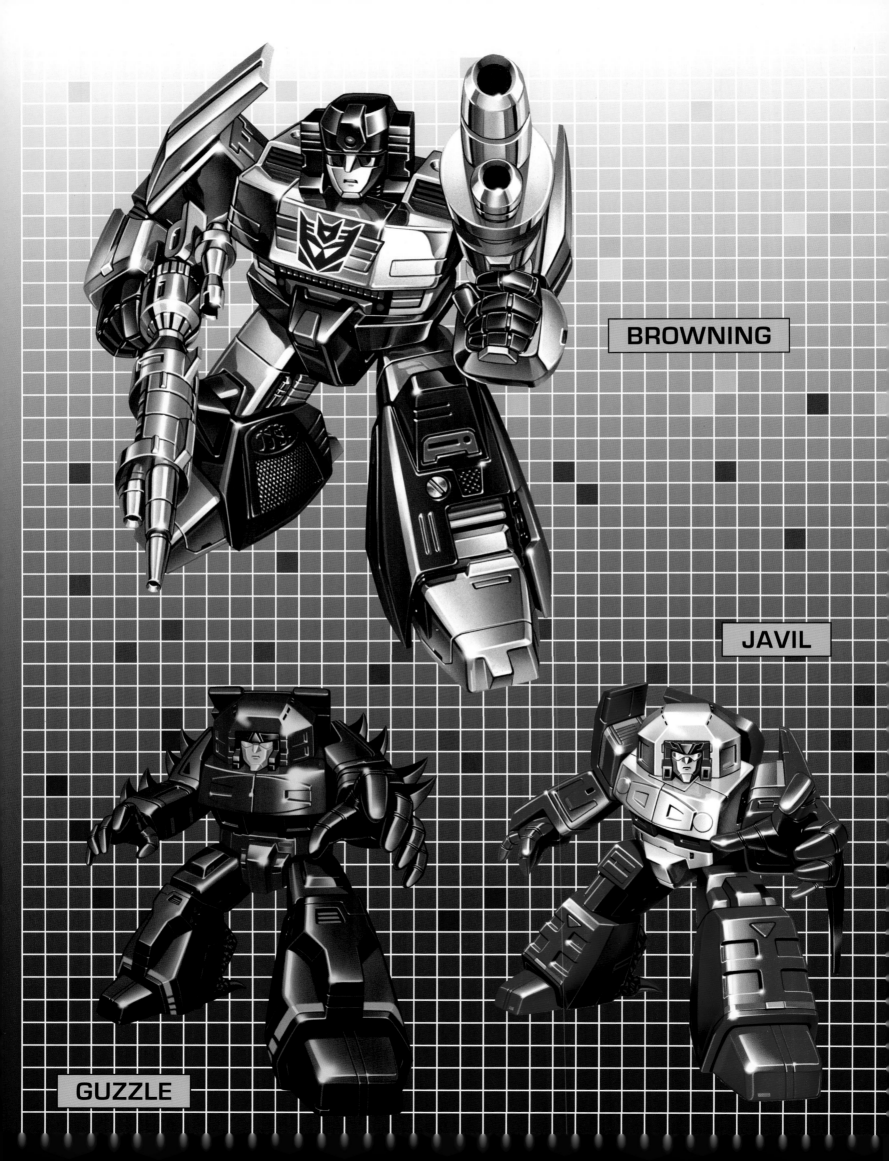

BROWNING

JAVIL

GUZZLE

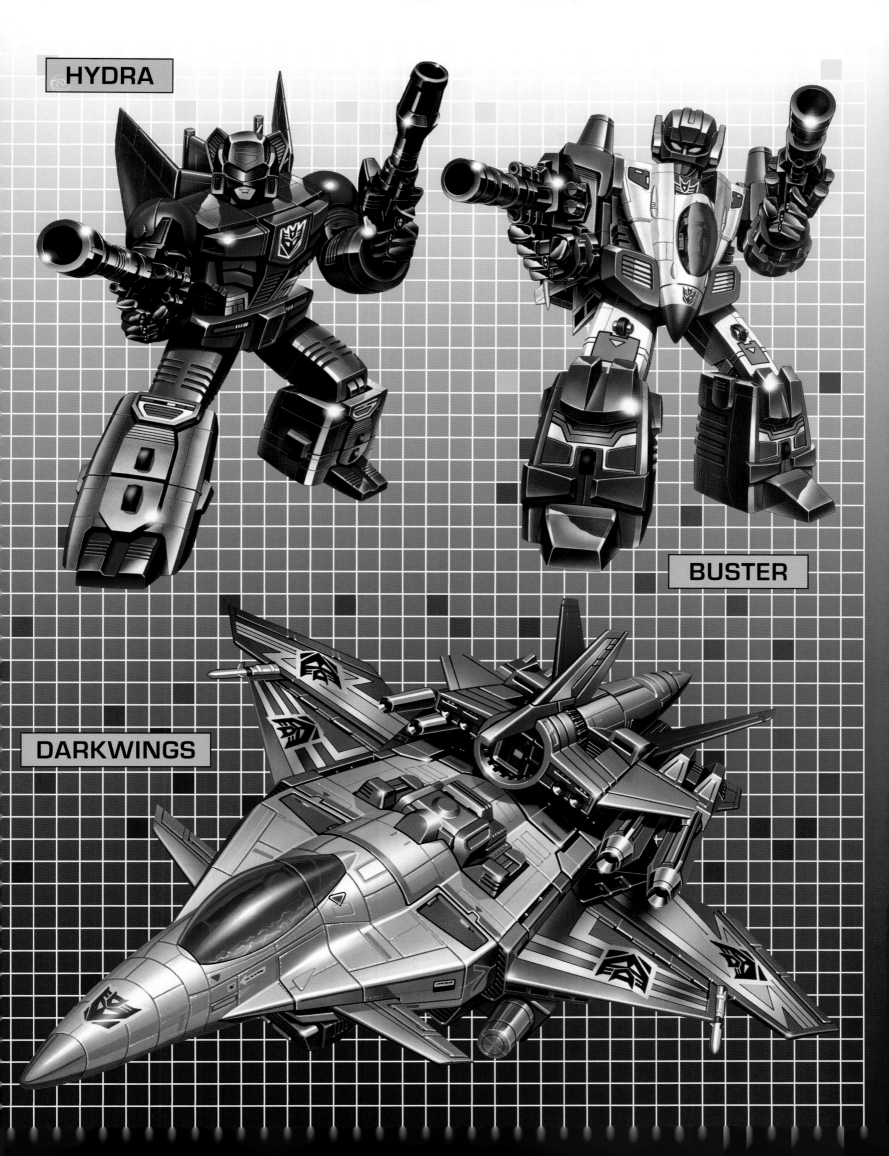

HYDRA

BUSTER

DARKWINGS

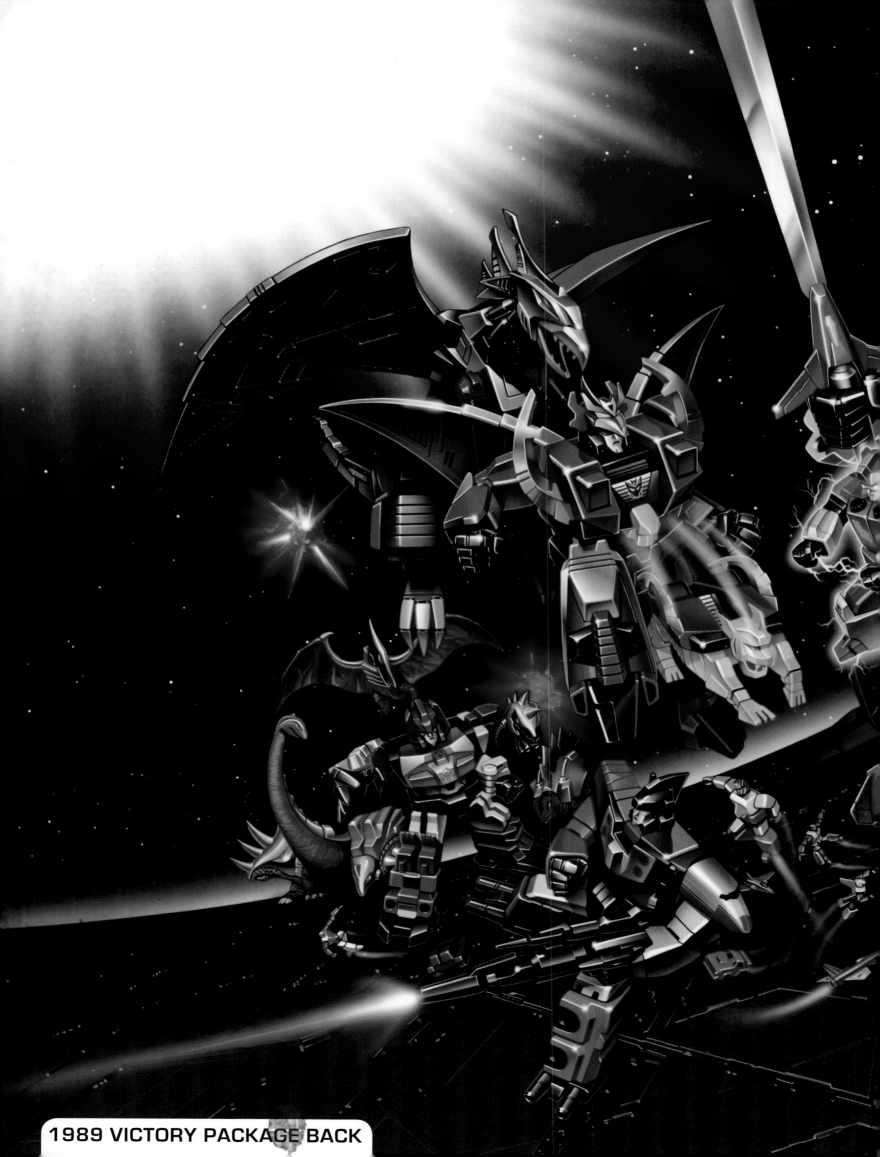

1989 VICTORY PACKAGE BACK

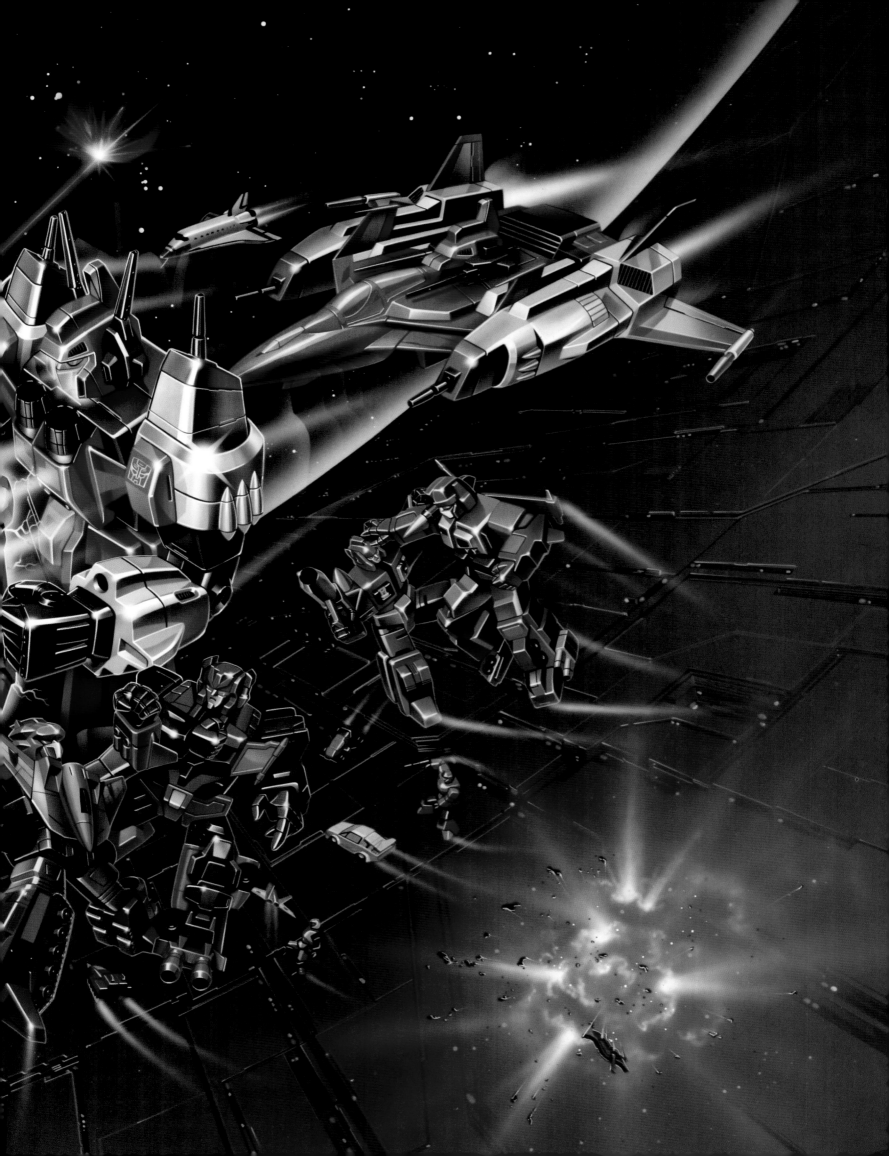

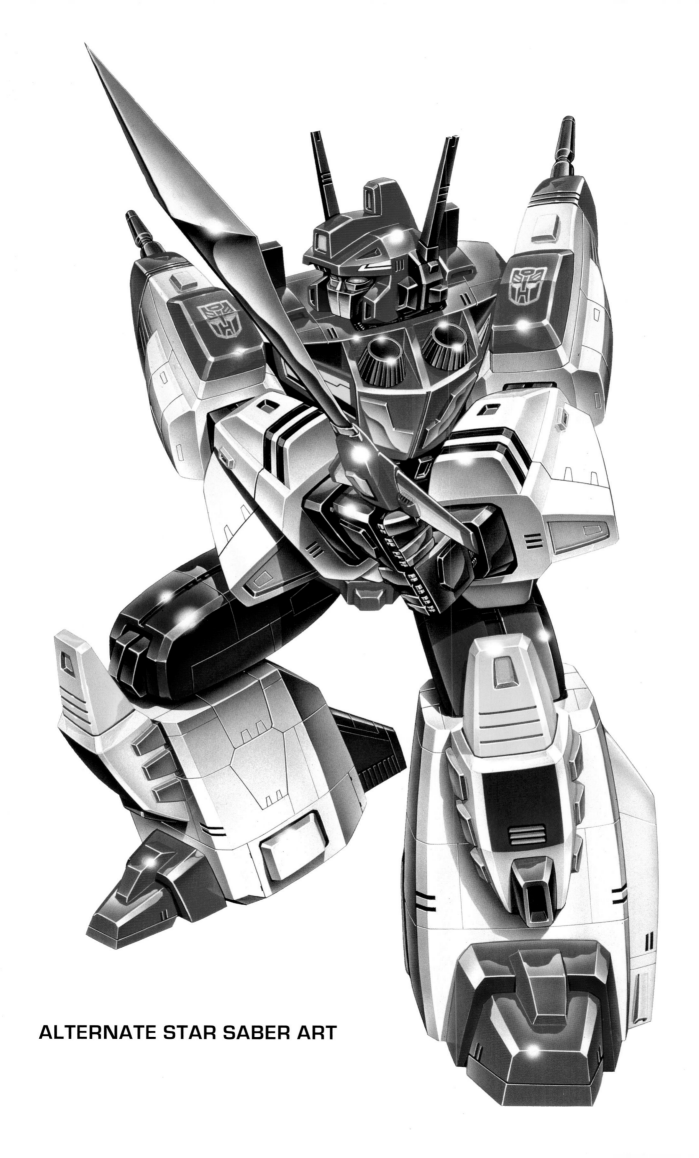

ALTERNATE STAR SABER ART

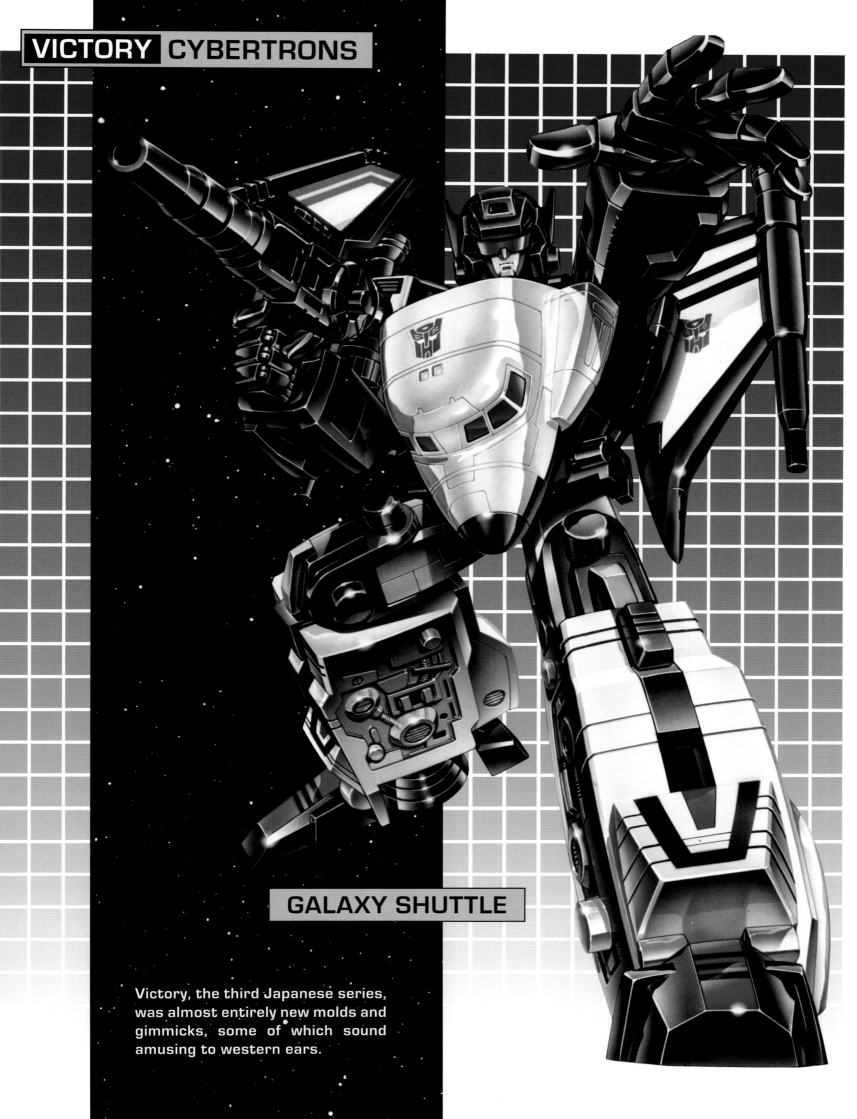

VICTORY CYBERTRONS

GALAXY SHUTTLE

Victory, the third Japanese series, was almost entirely new molds and gimmicks, some of which sound amusing to western ears.

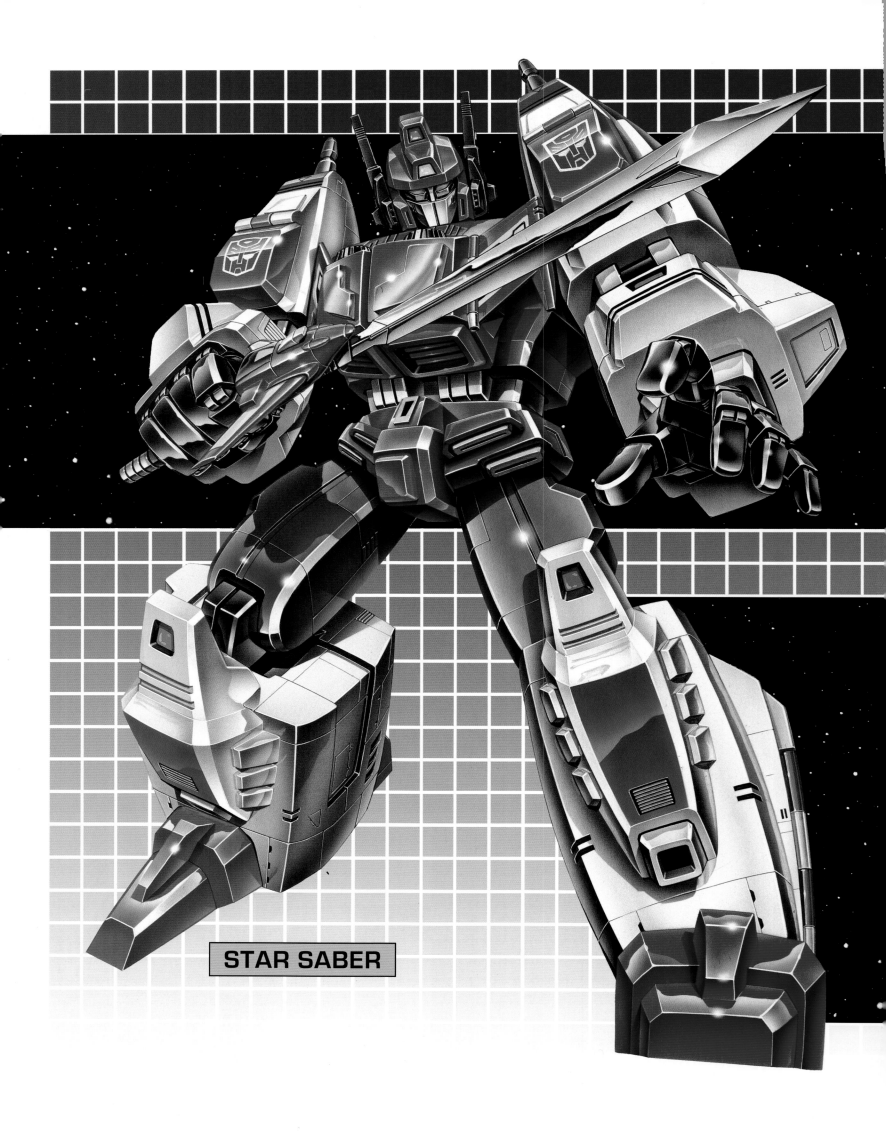

STAR SABER

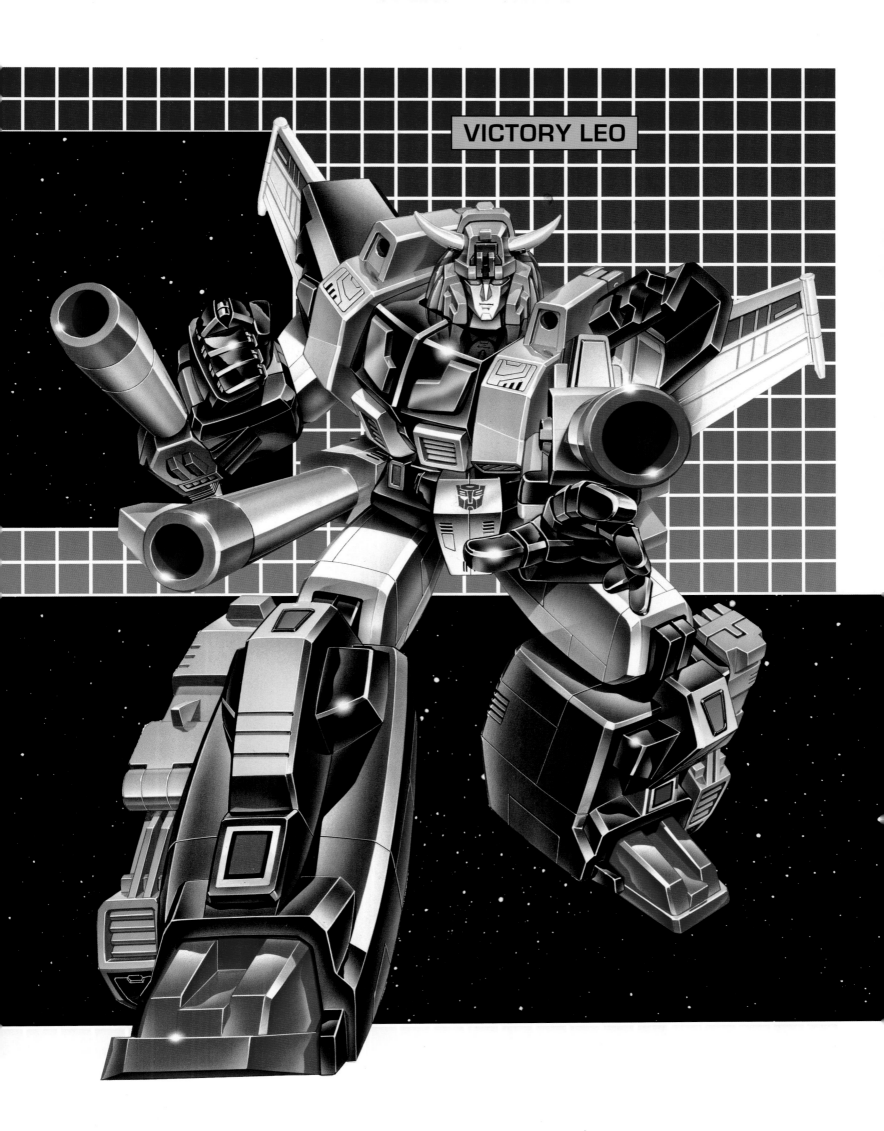

VICTORY LEO

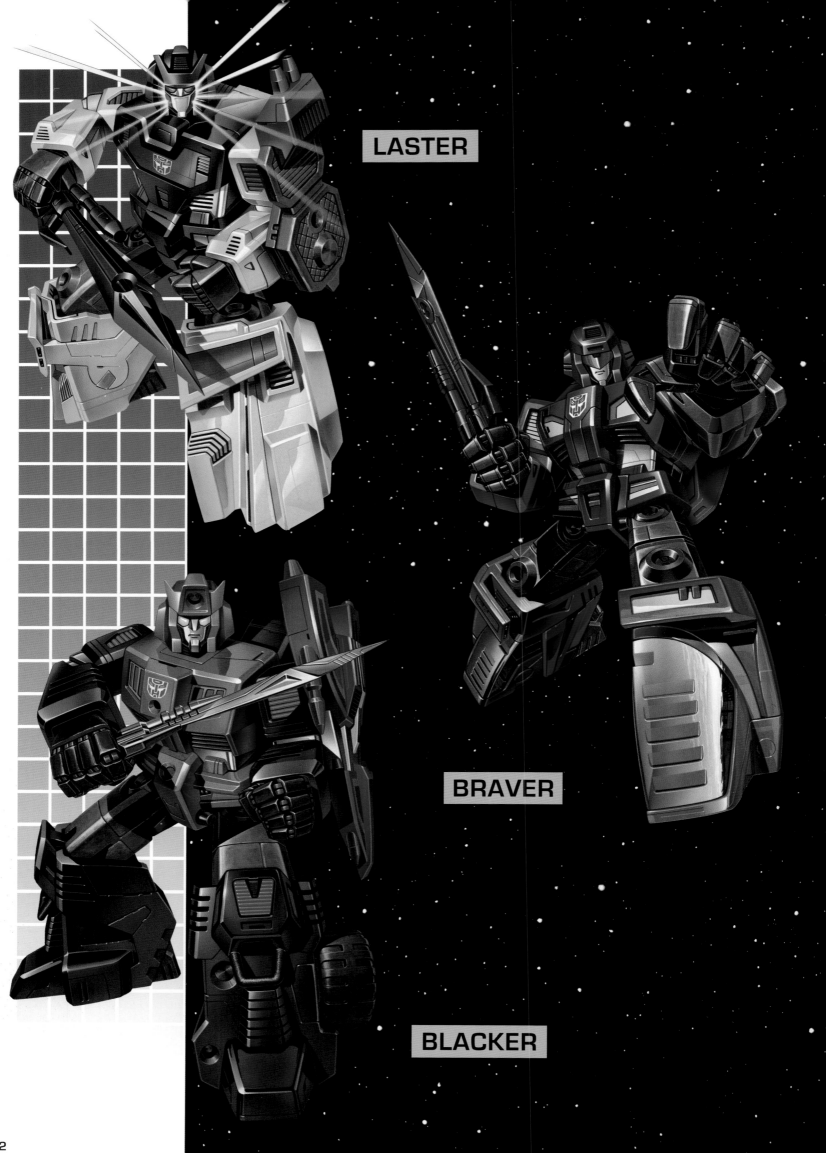

LASTER

BRAVER

BLACKER

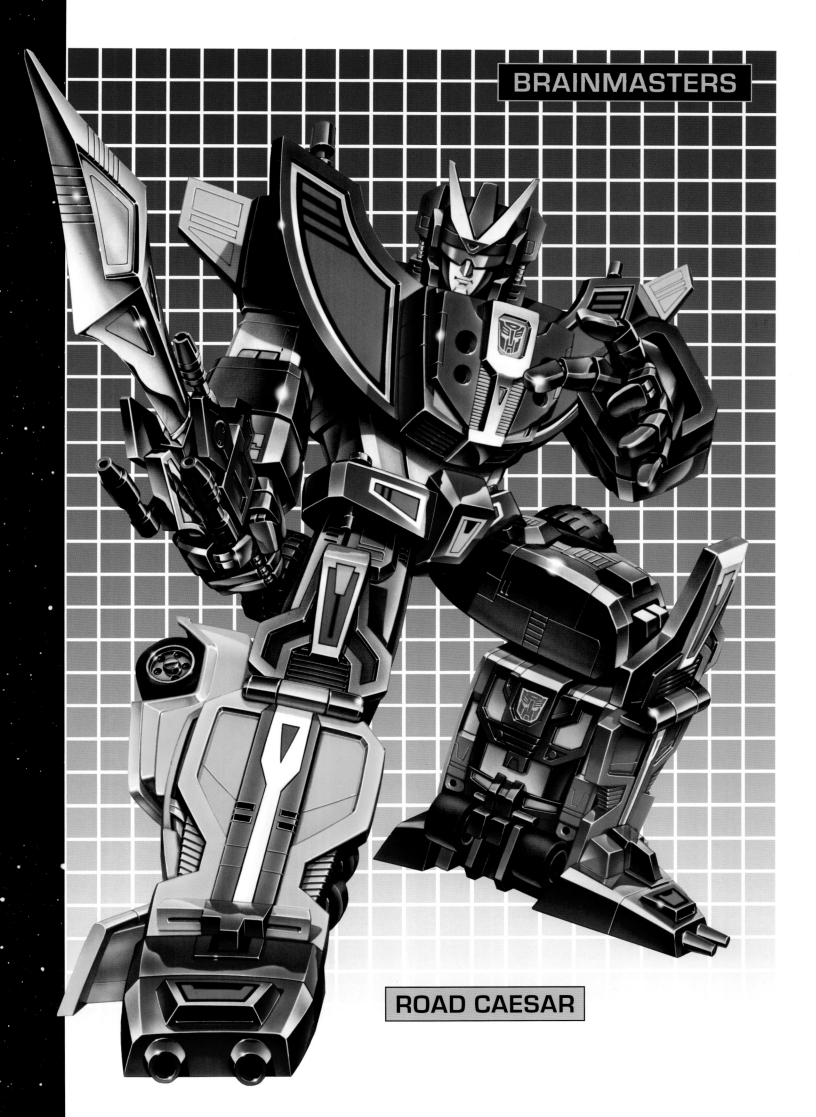

ROAD CAESAR

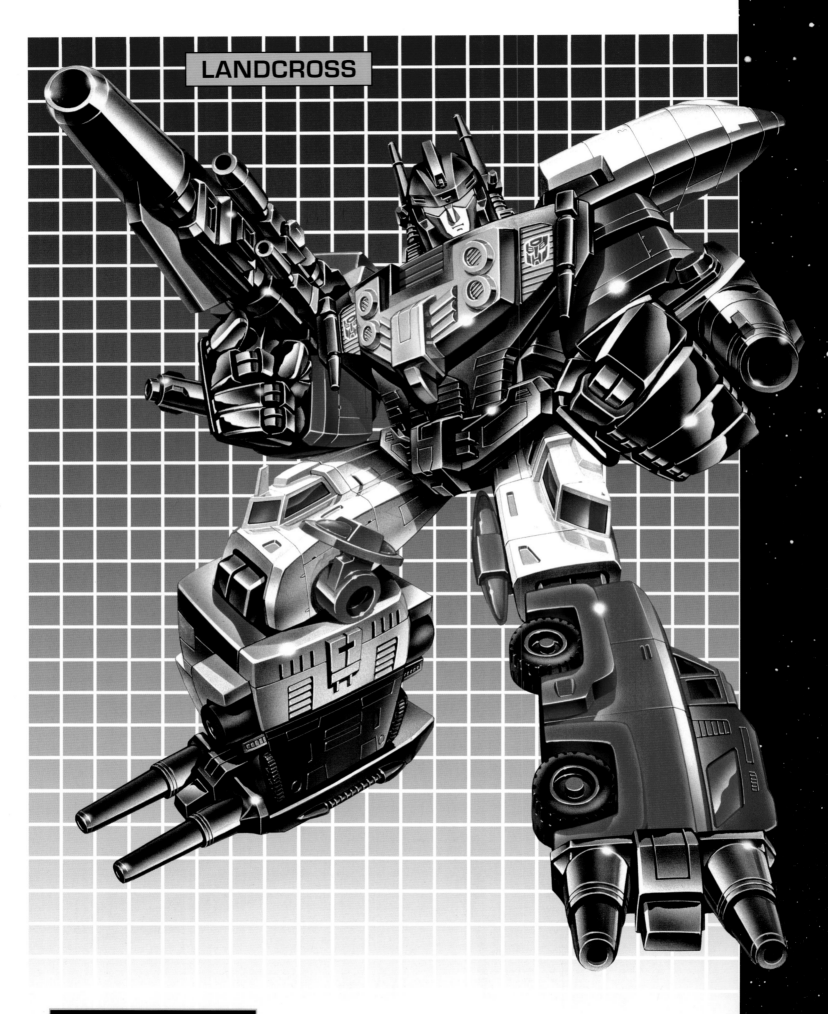

LANDCROSS

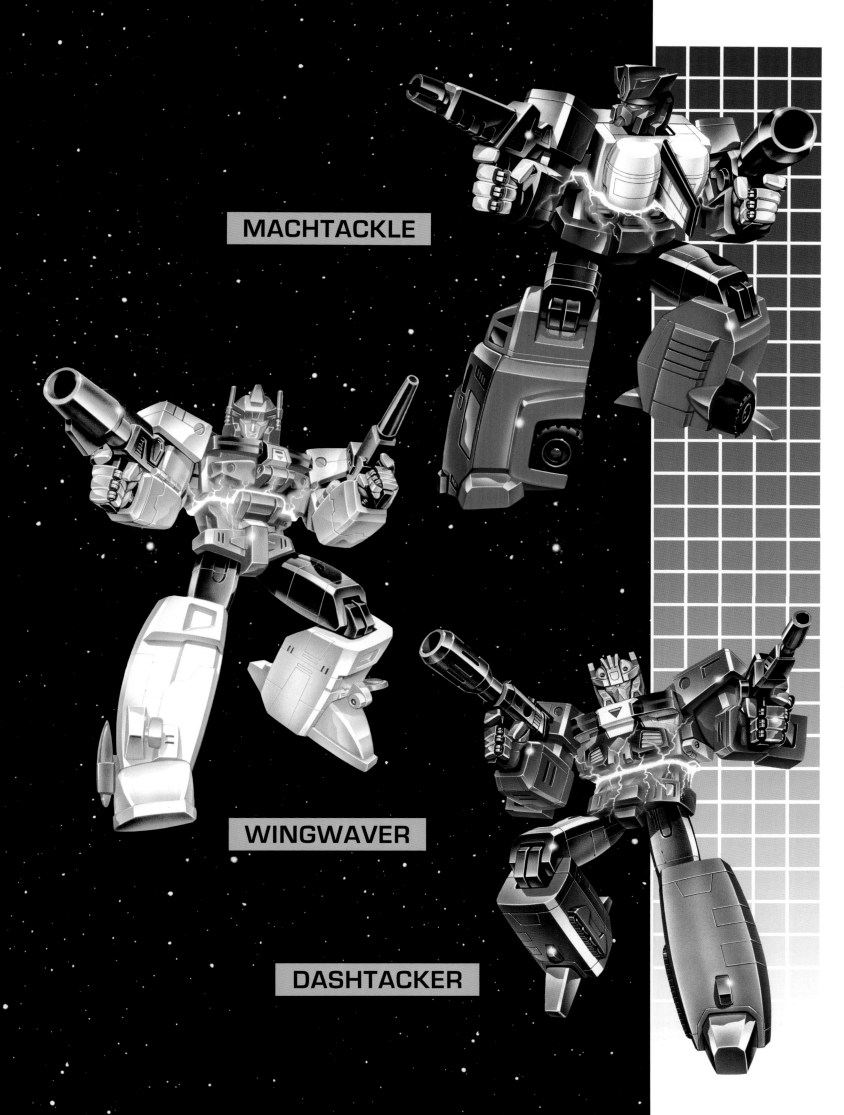

MACHTACKLE

WINGWAVER

DASHTACKER

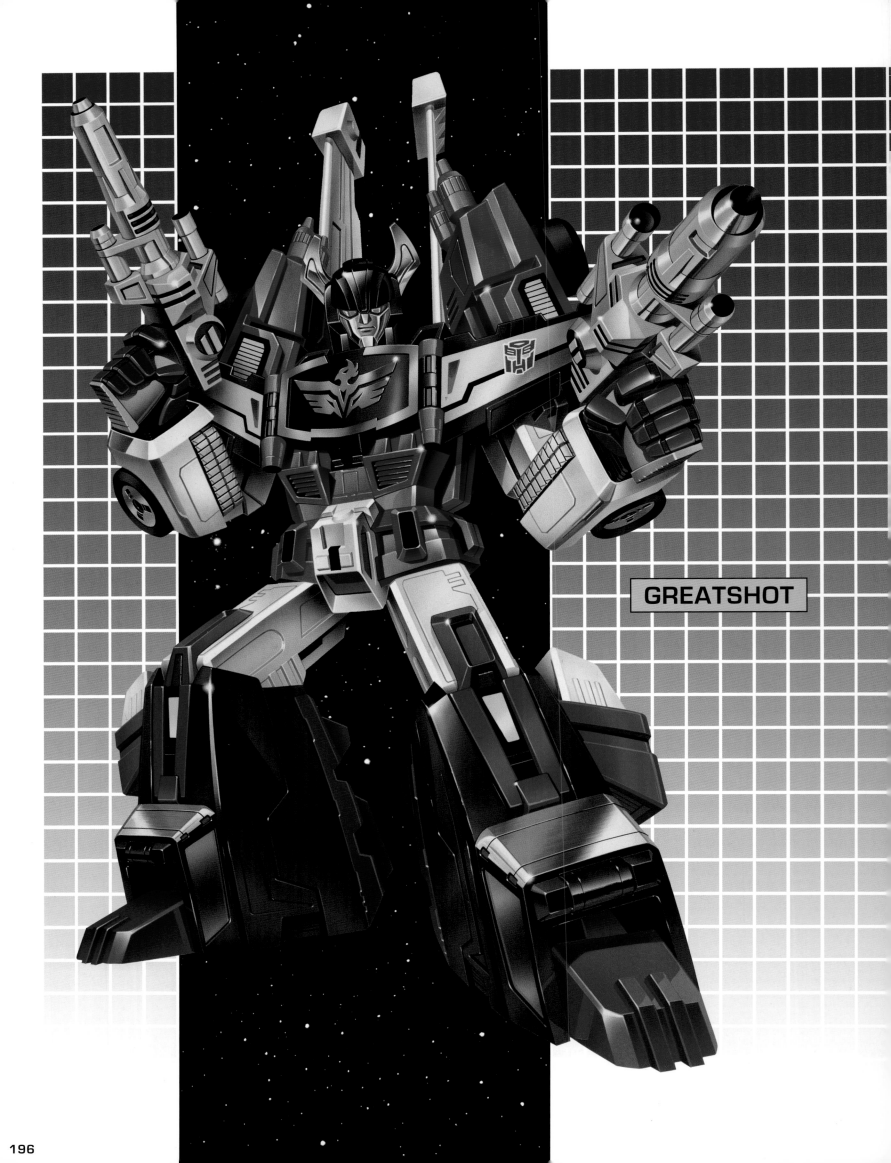

GREATSHOT

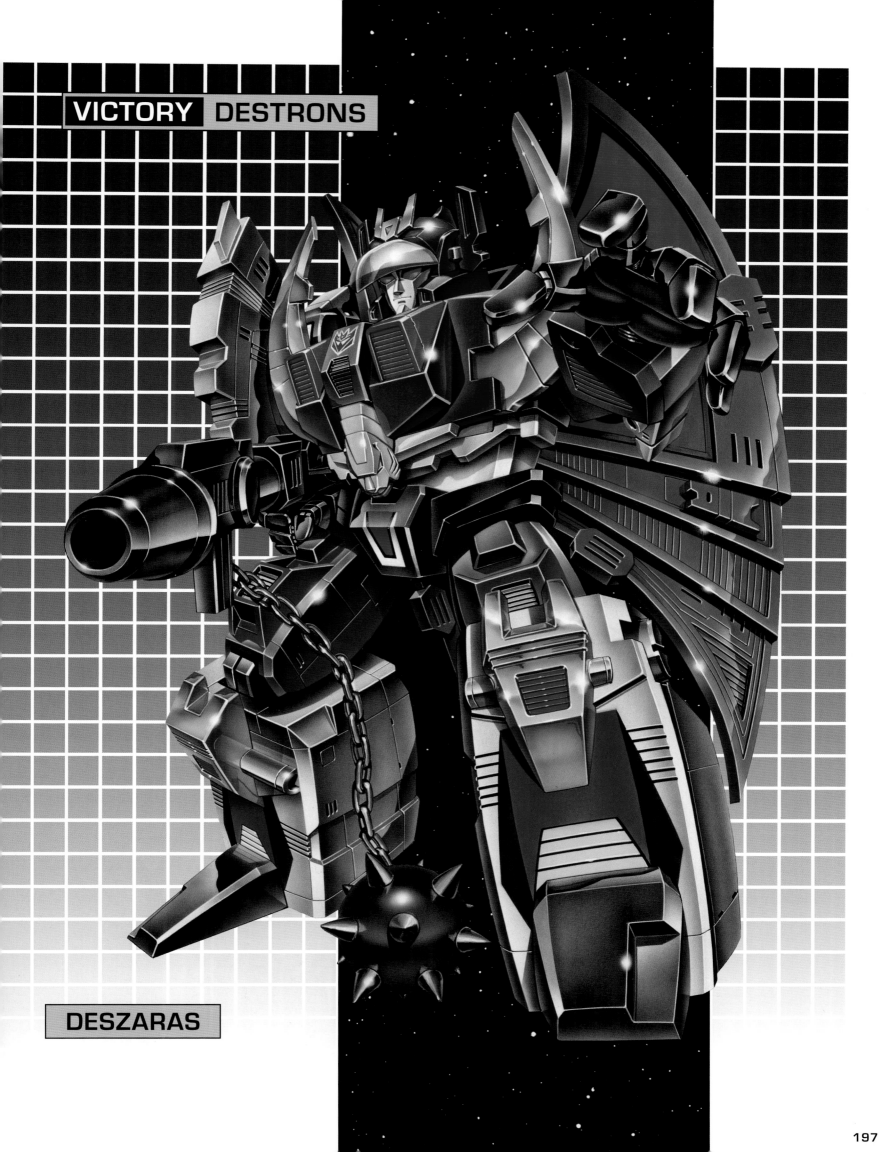

DESZARAS

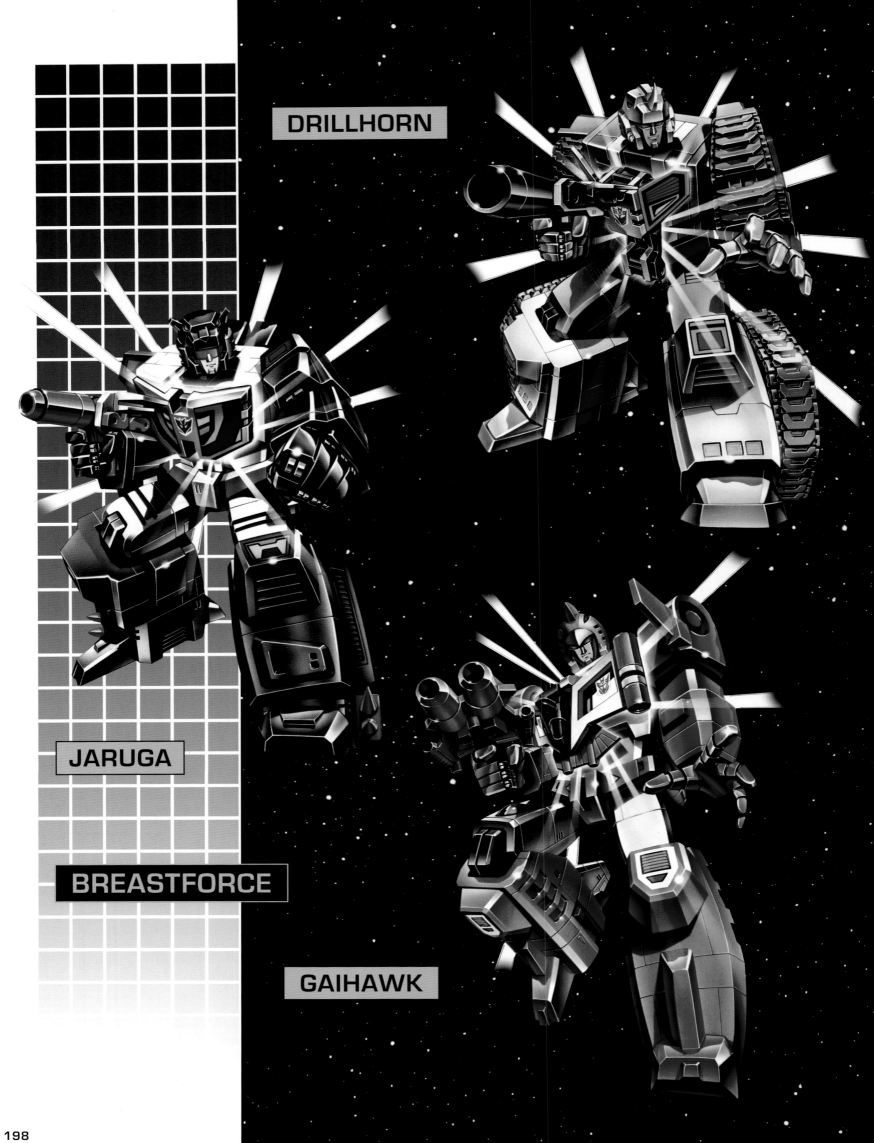

DRILLHORN

JARUGA

BREASTFORCE

GAIHAWK

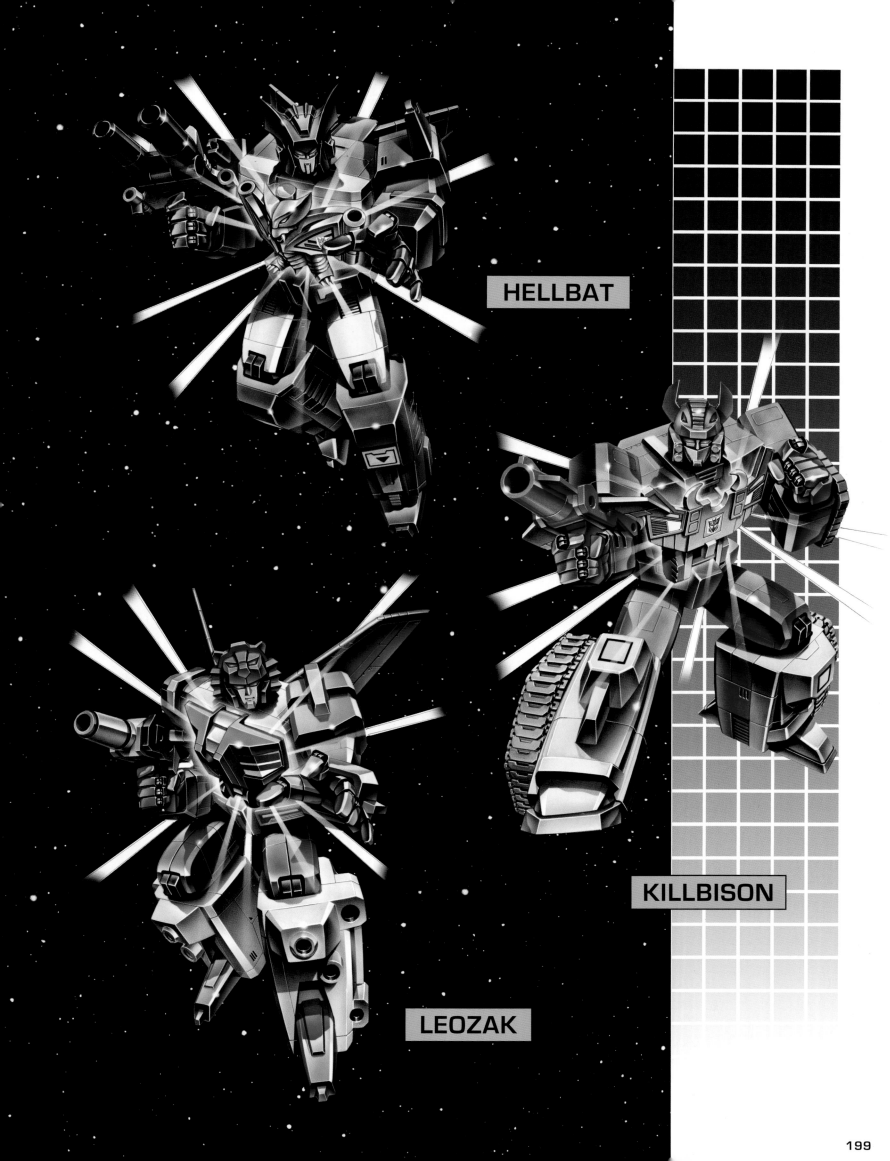

HELLBAT

KILLBISON

LEOZAK

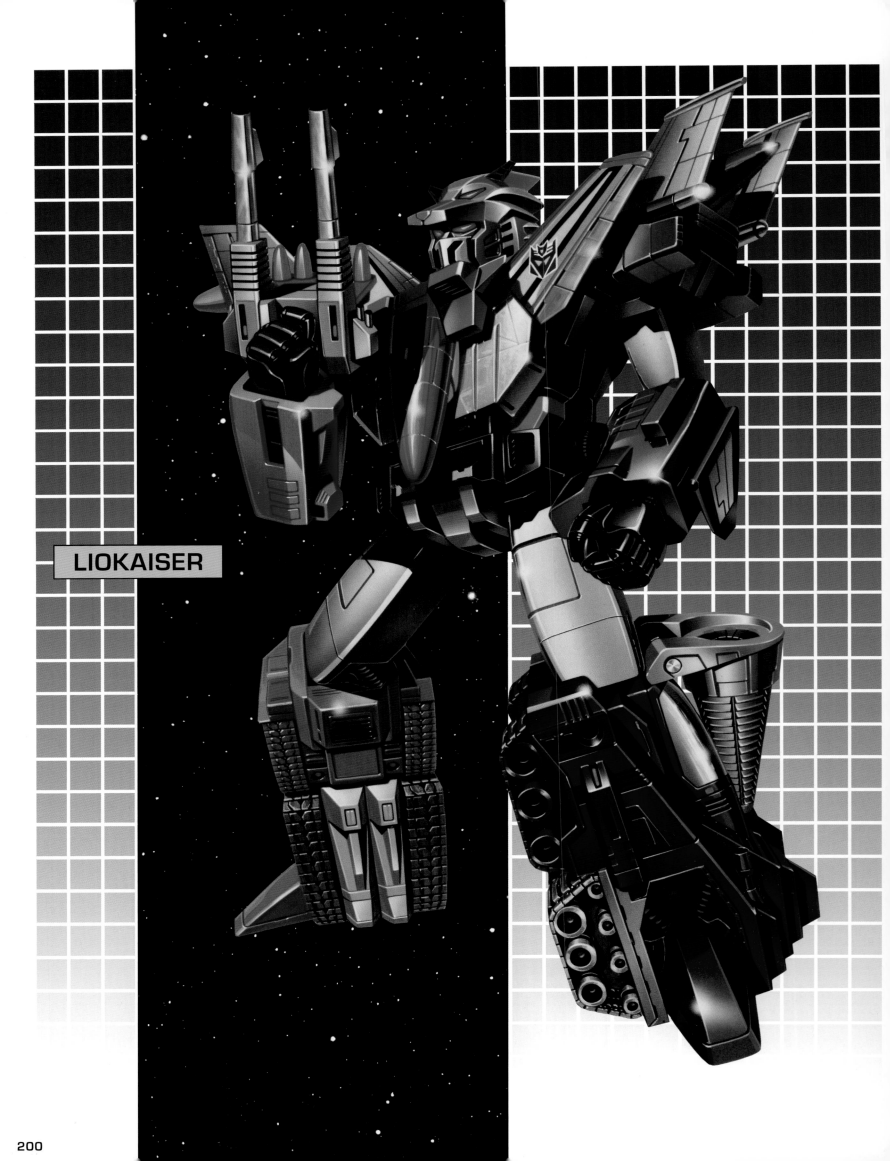

LIOKAISER

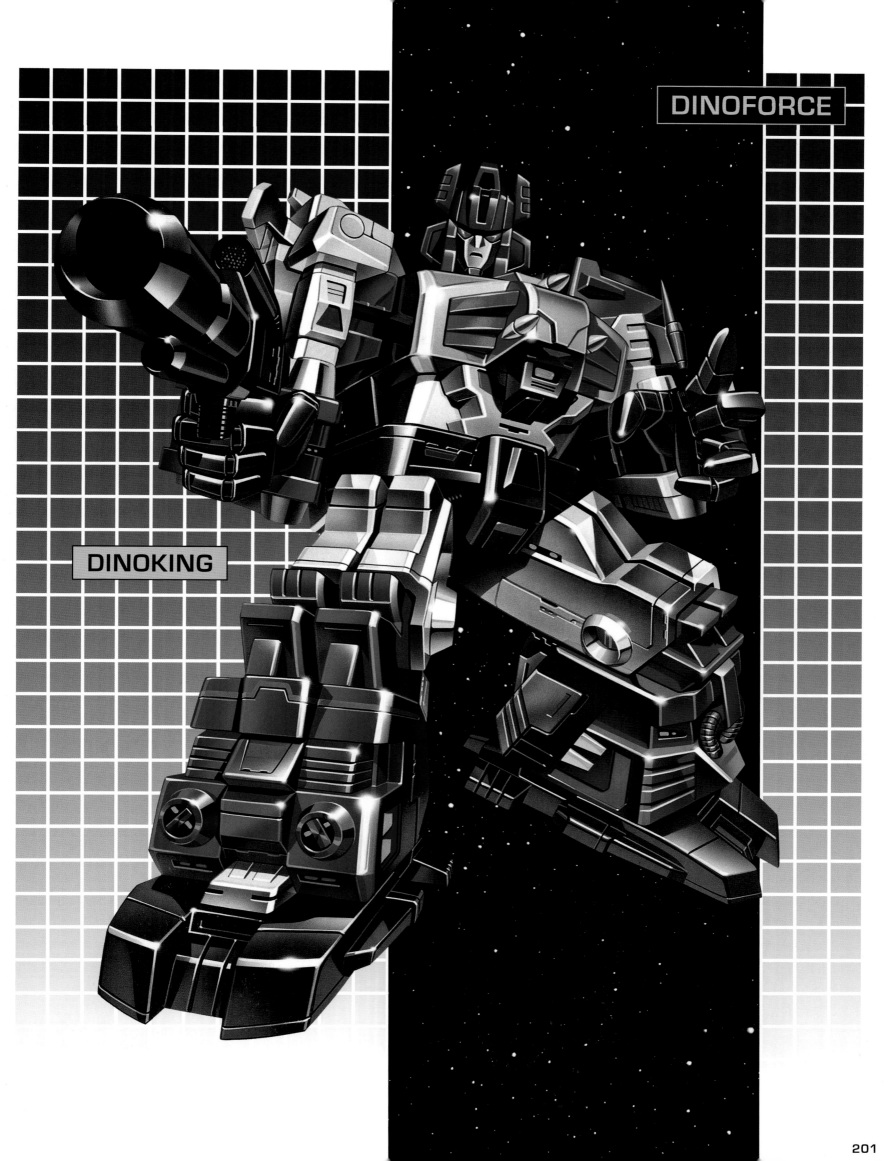

DINOFORCE

DINOKING

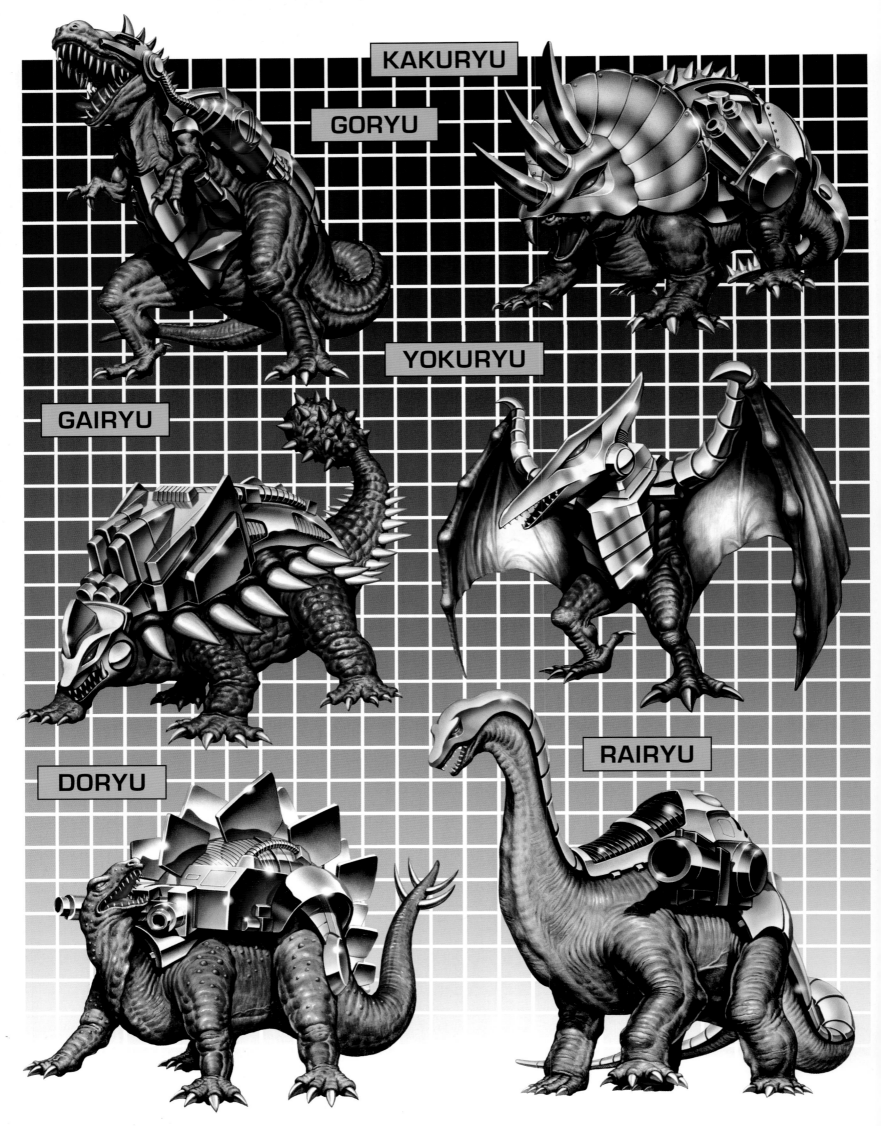

KAKURYU

GORYU

YOKURYU

GAIRYU

DORYU

RAIRYU

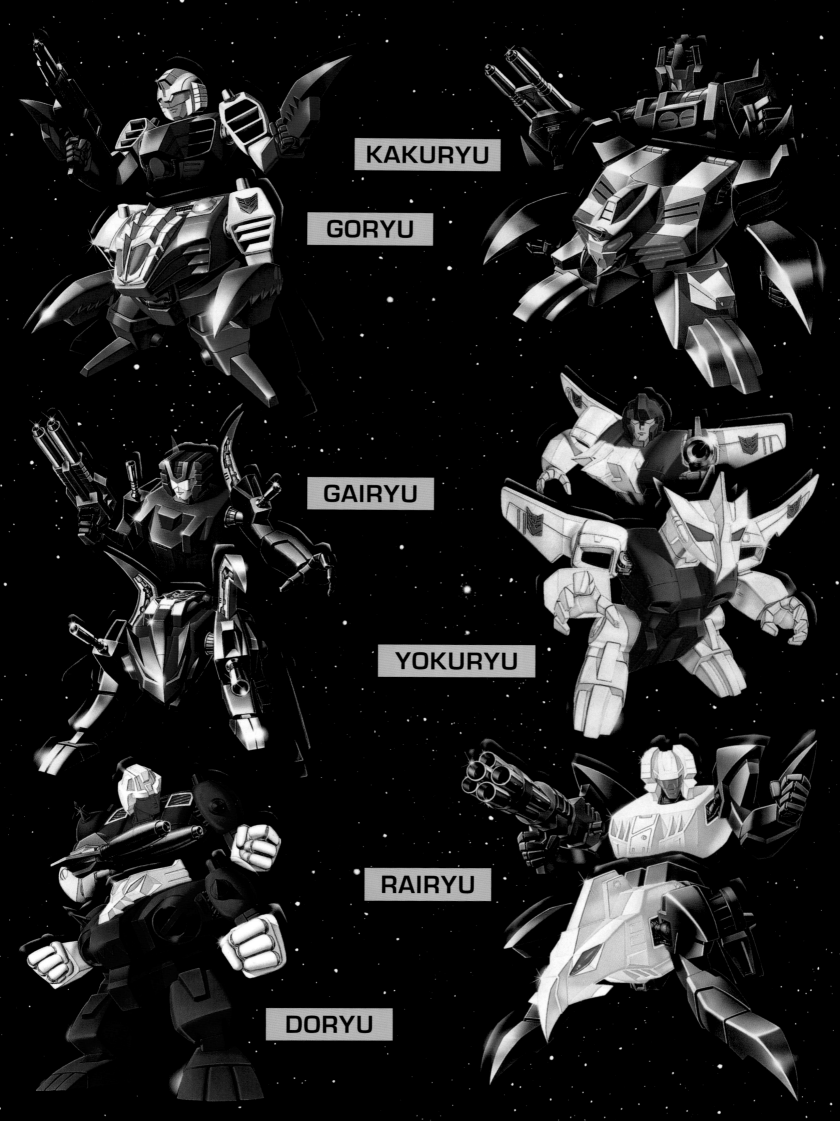

KAKURYU

GORYU

GAIRYU

YOKURYU

RAIRYU

DORYU

BLUE BACCHUS

BLACK SHADOW

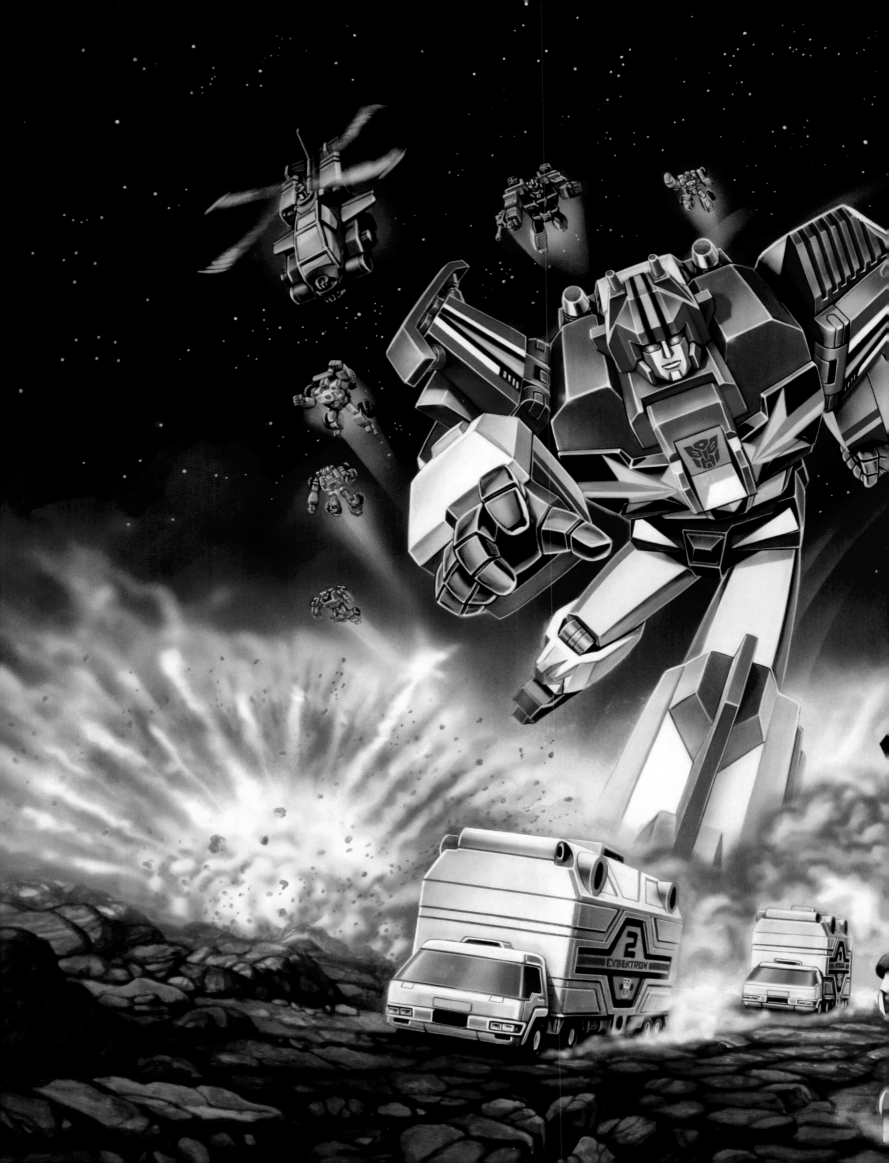

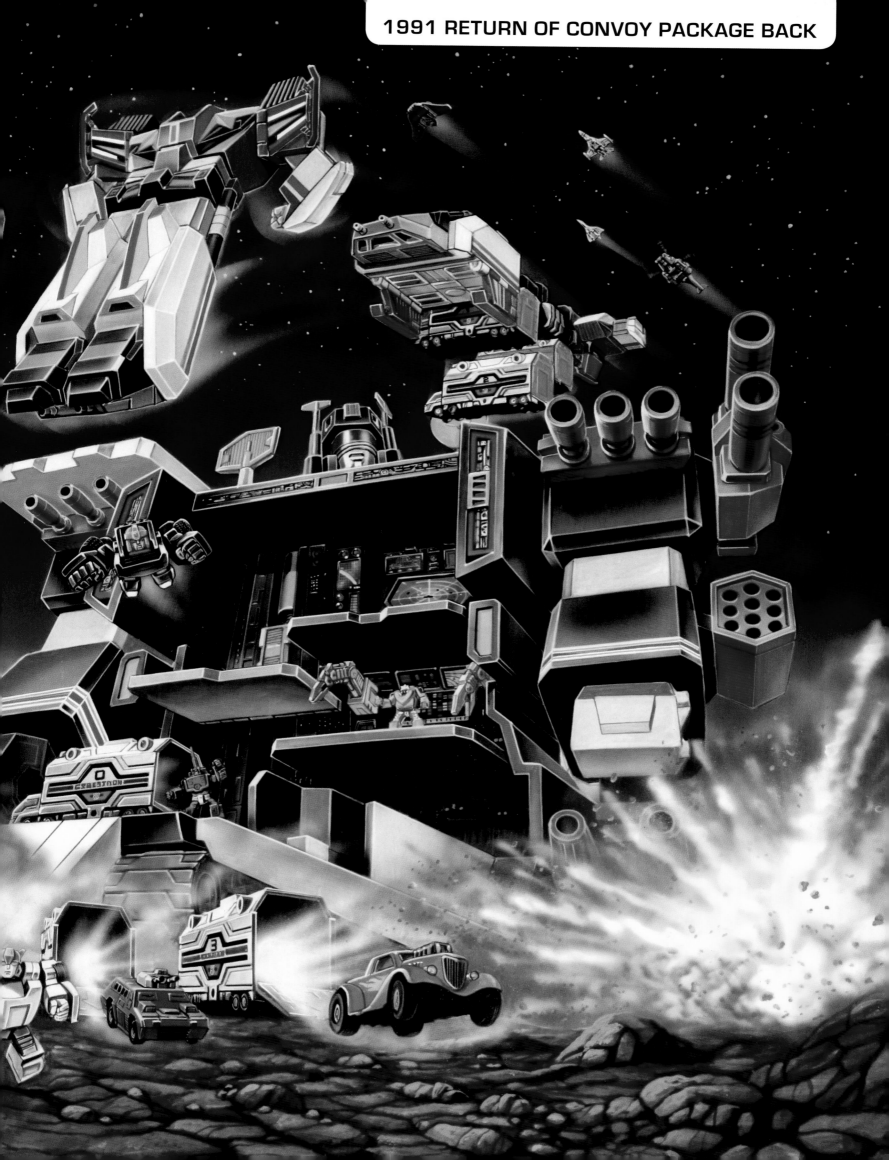

Classic Decepticon Logo with technicals

EVIL DECEPTICON

PANTONE YELLOW 100%

PANTONE 56% M 56% C

G2 Decepticon Sigil with Pantone

DECEPTICON®

1990 Nameplate

THE TRANSFORMERS® PRETENDERS™

Pretenders and Micromaster Logos

MICRO TRANSFORMERS

Decepticon Sigil
1988-1989

Decepticon Sigil
1990

Decepticon Logo,
1988-1990

TRANS FORMERS®

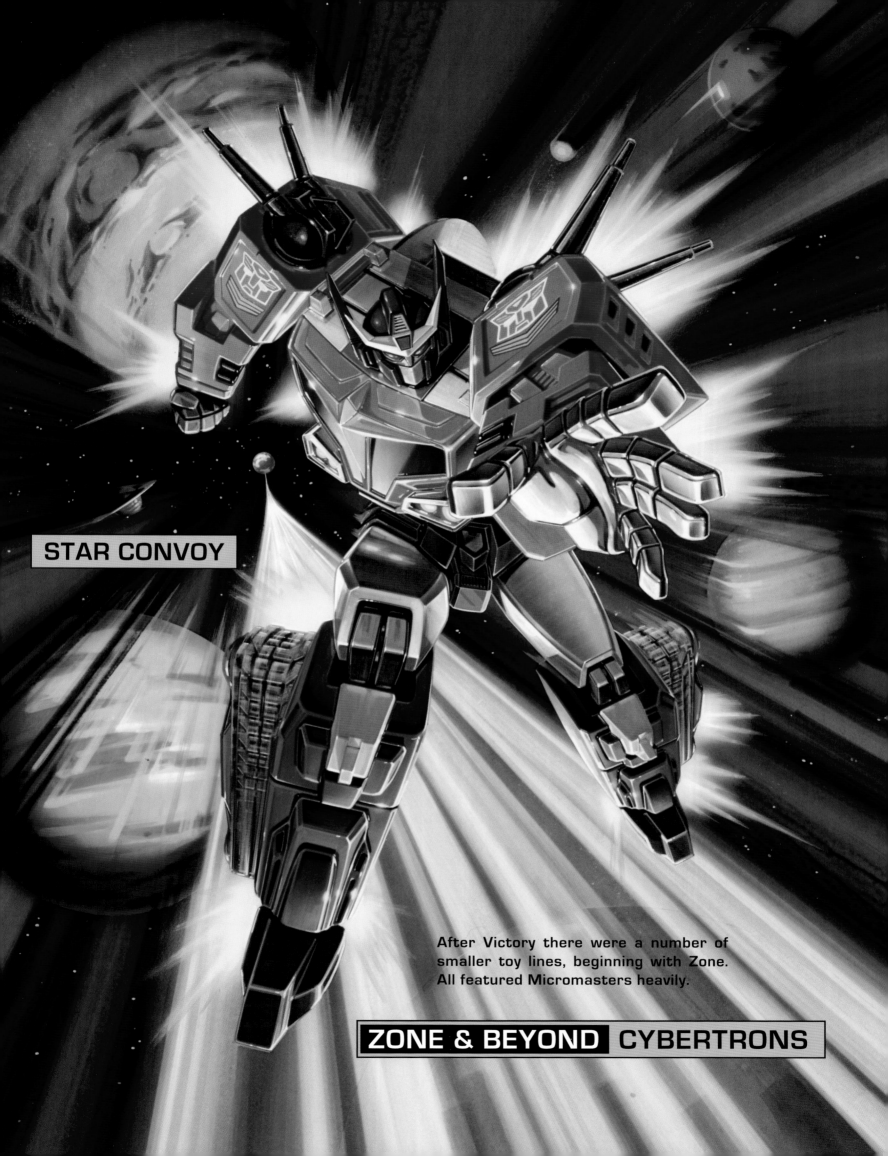

STAR CONVOY

After Victory there were a number of
smaller toy lines, beginning with Zone.
All featured Micromasters heavily.

ZONE & BEYOND CYBERTRONS

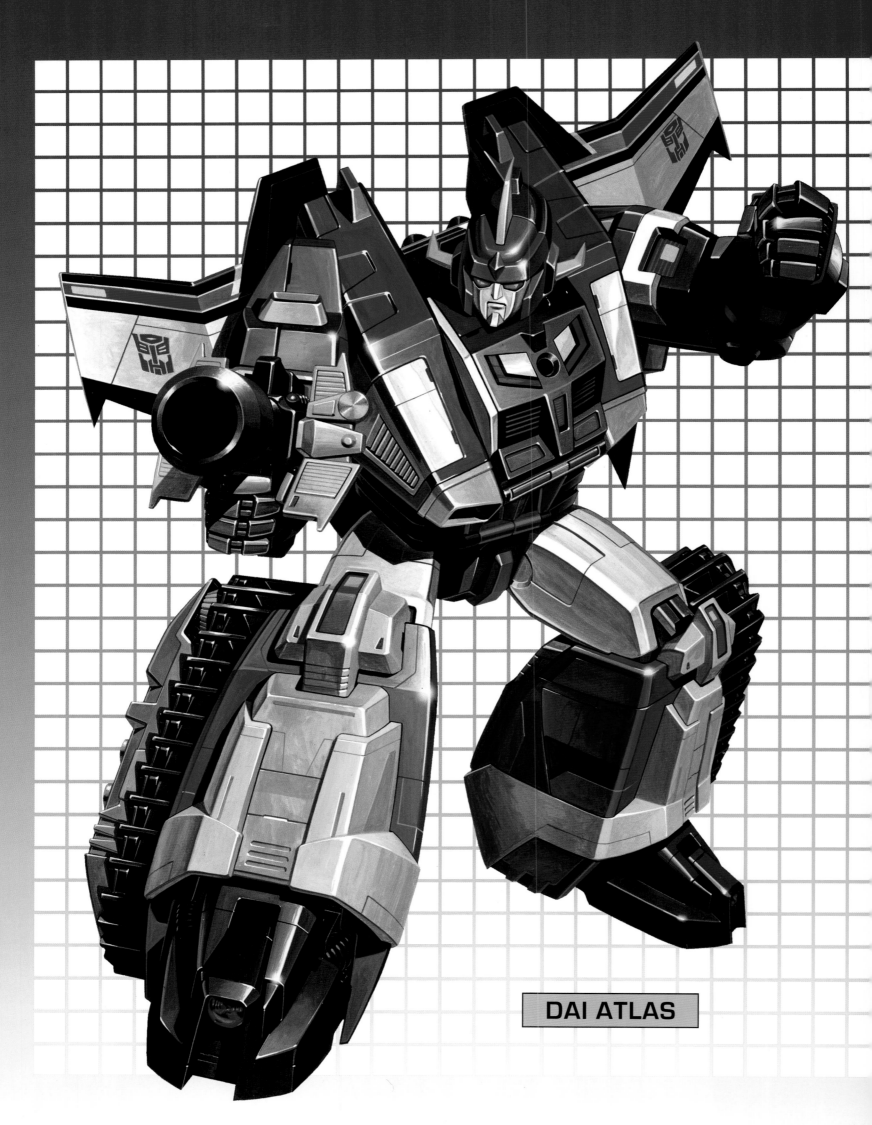

DAI ATLAS

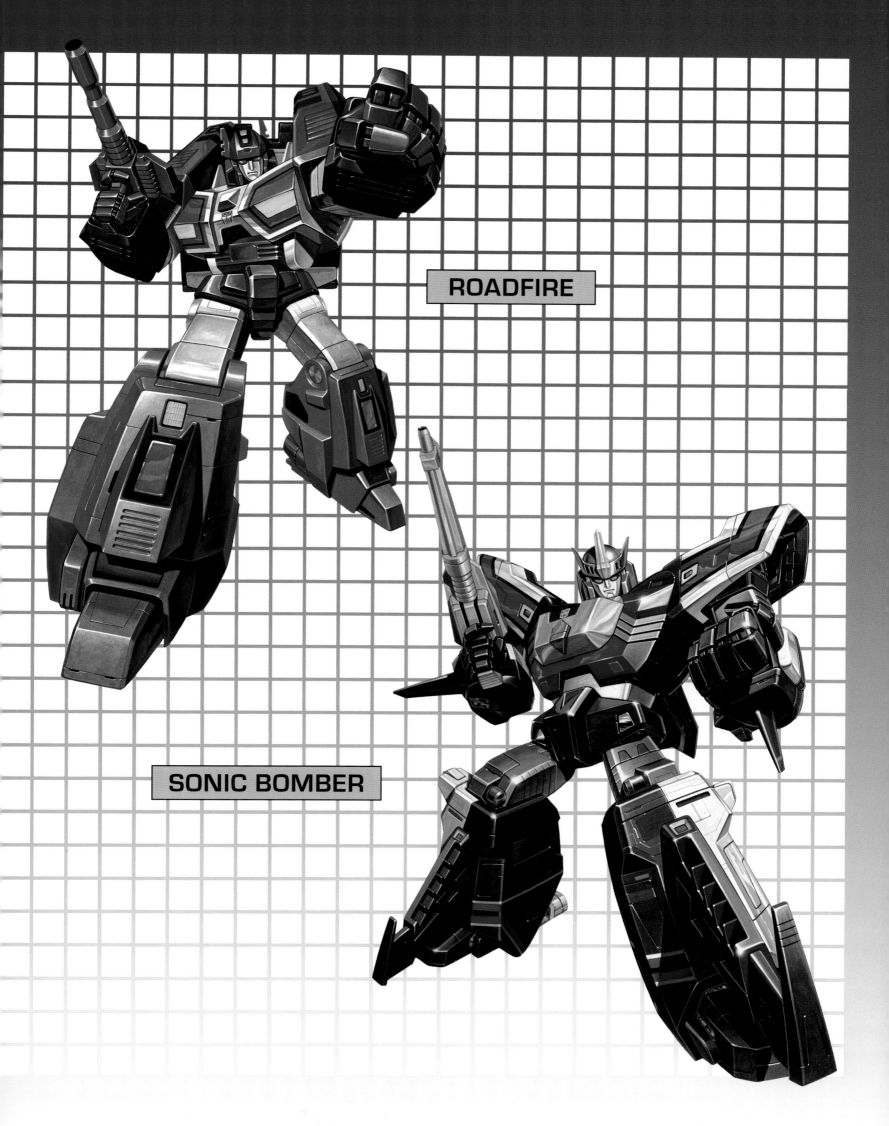

ROADFIRE

SONIC BOMBER

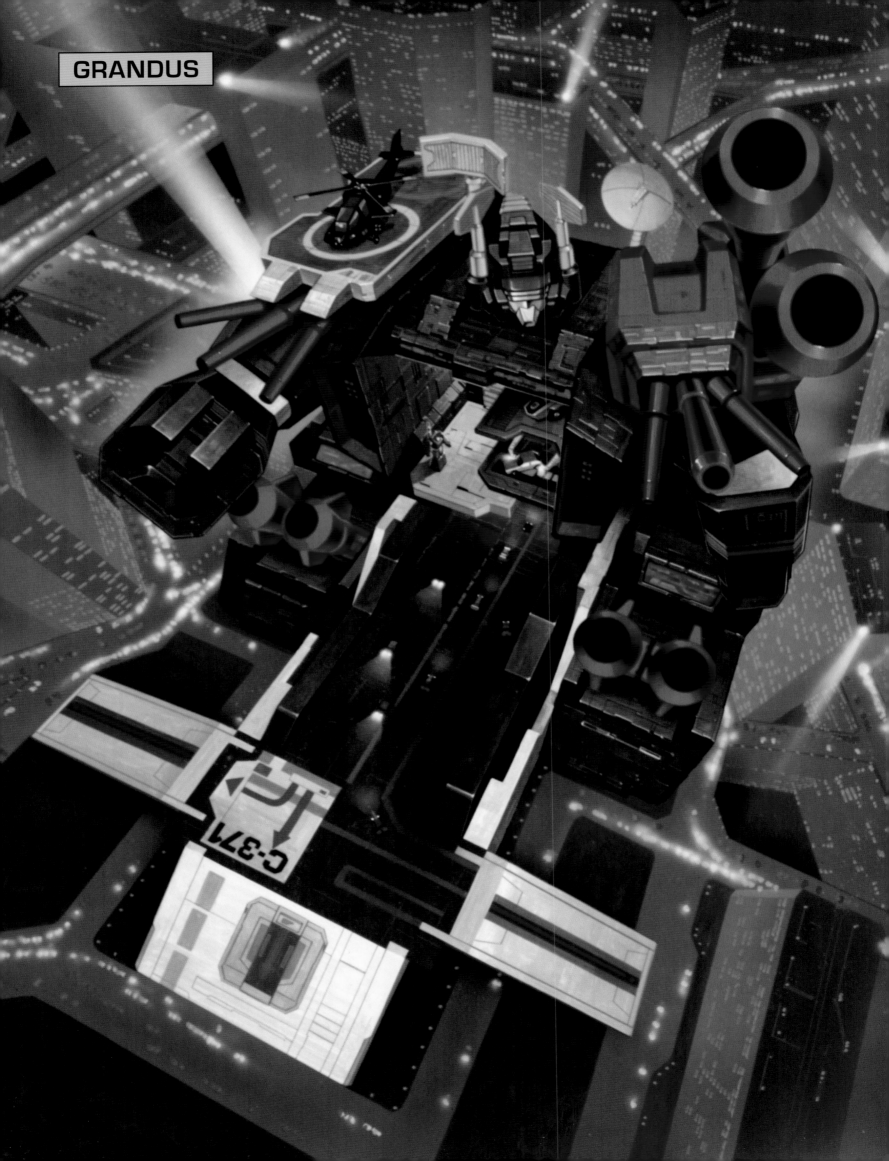

GRANDUS

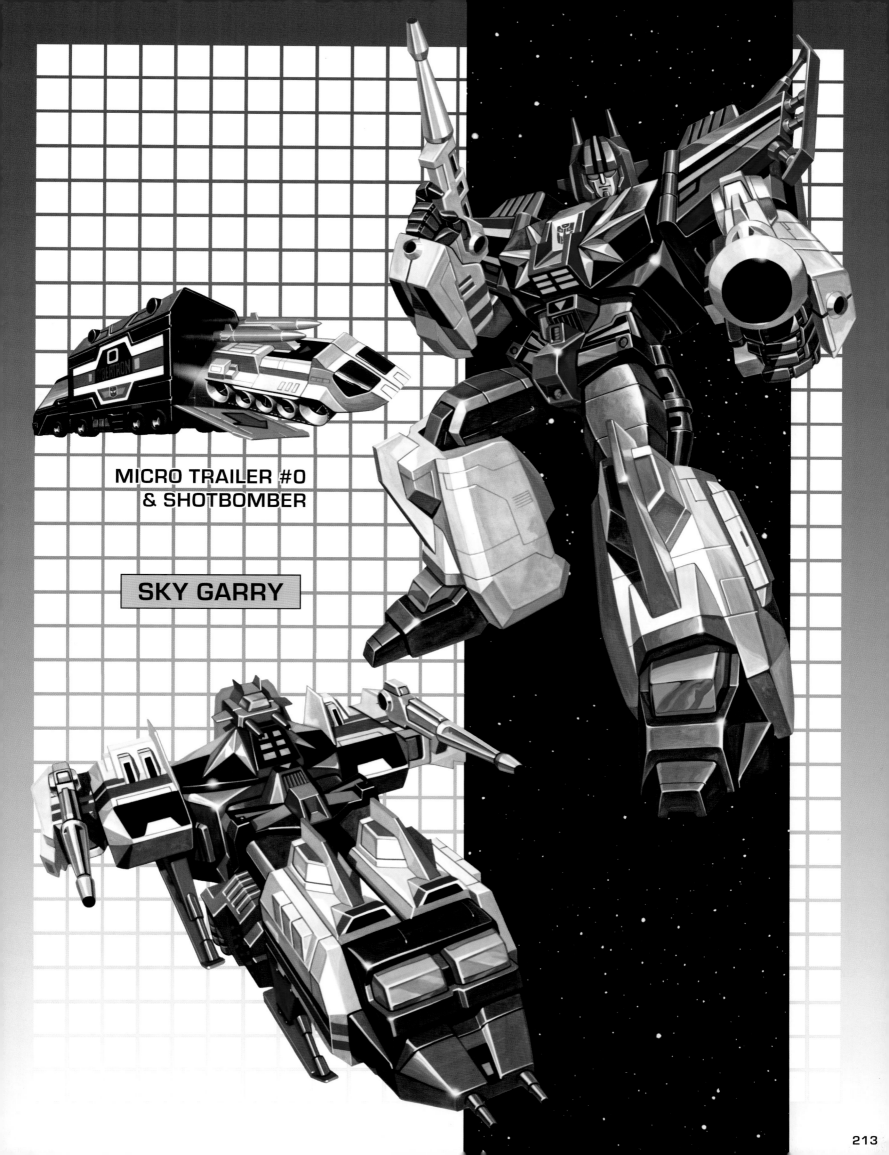

MICRO TRAILER #0
& SHOTBOMBER

SKY GARRY

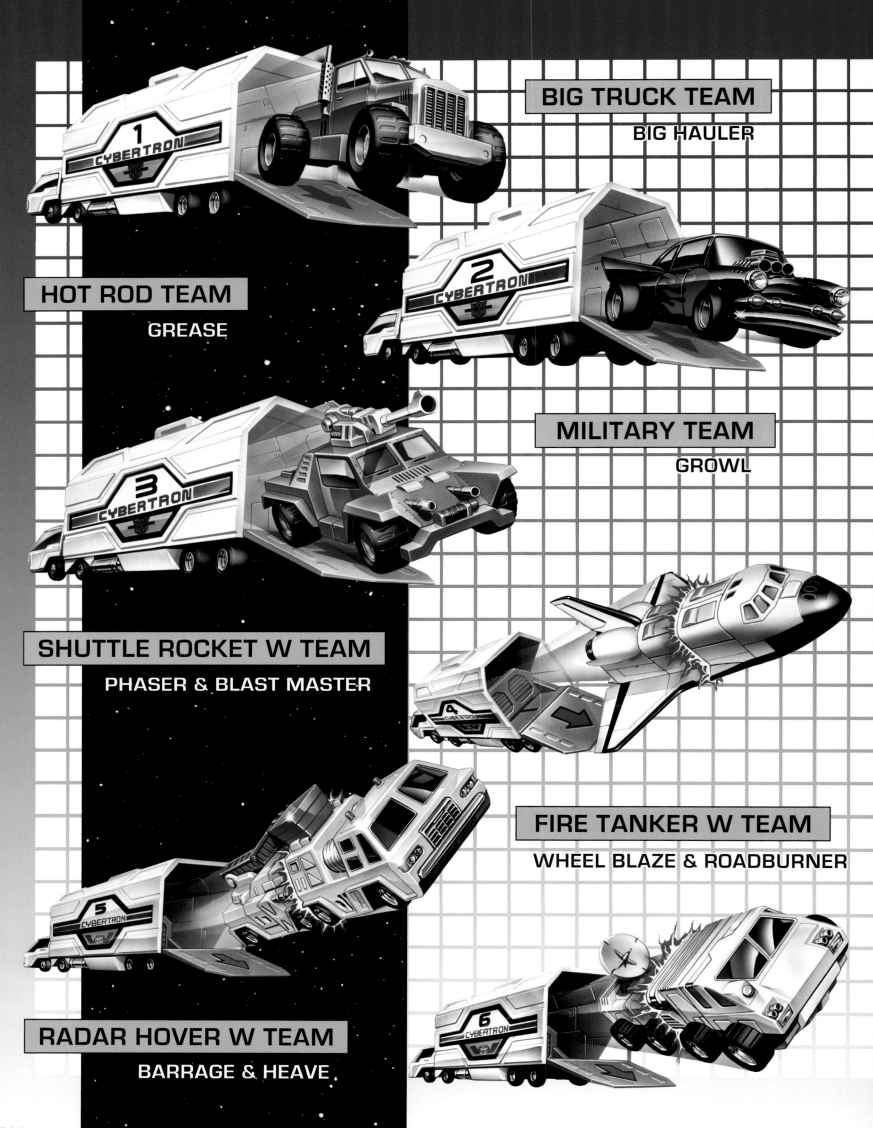

BIG TRUCK TEAM

BIG HAULER

HOT ROD TEAM

GREASE

MILITARY TEAM

GROWL

SHUTTLE ROCKET W TEAM

PHASER & BLAST MASTER

FIRE TANKER W TEAM

WHEEL BLAZE & ROADBURNER

RADAR HOVER W TEAM

BARRAGE & HEAVE

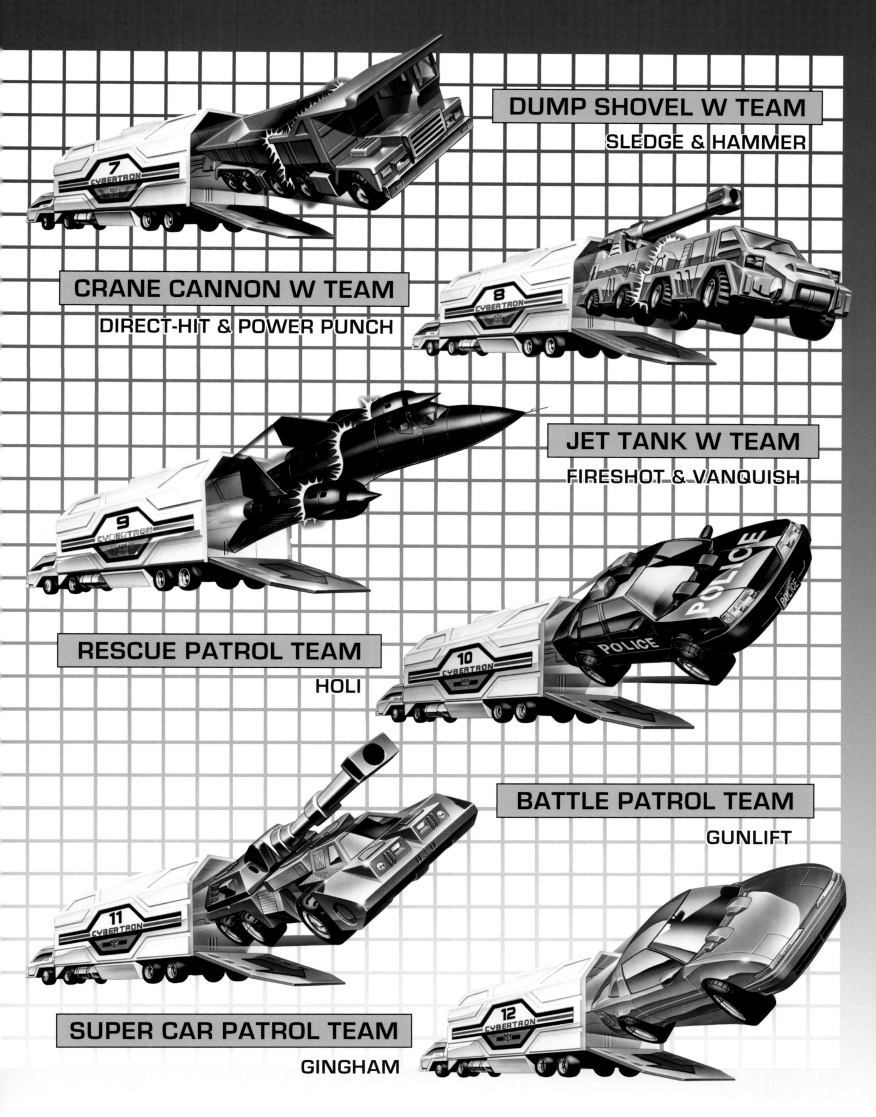

DUMP SHOVEL W TEAM

SLEDGE & HAMMER

CRANE CANNON W TEAM

DIRECT-HIT & POWER PUNCH

JET TANK W TEAM

FIRESHOT & VANQUISH

RESCUE PATROL TEAM

HOLI

BATTLE PATROL TEAM

GUNLIFT

SUPER CAR PATROL TEAM

GINGHAM

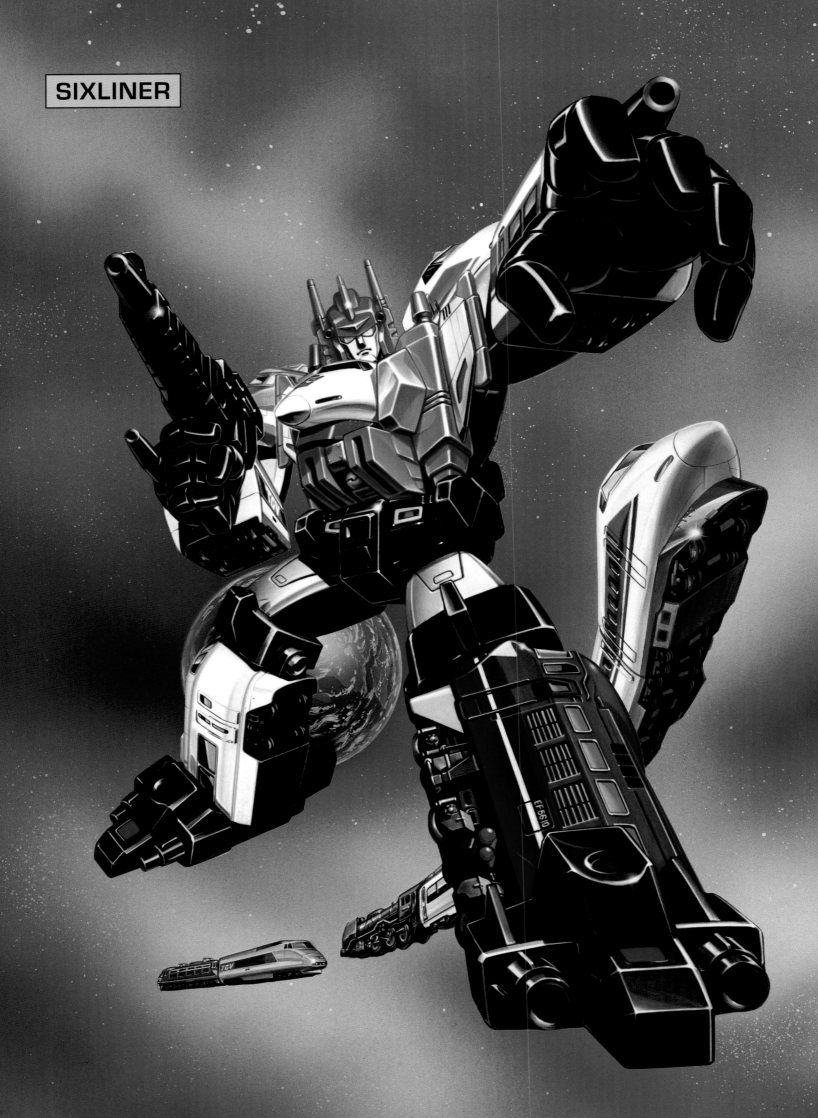

SIXLINER

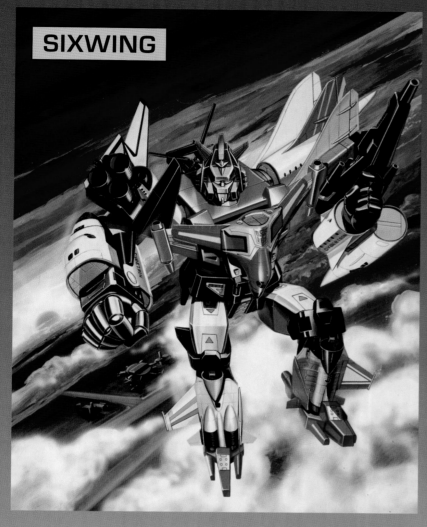

SIXWING

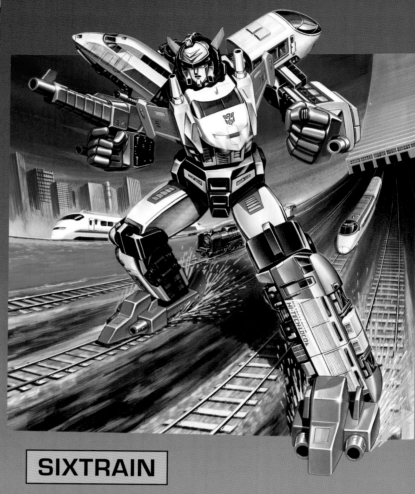

SIXTRAIN

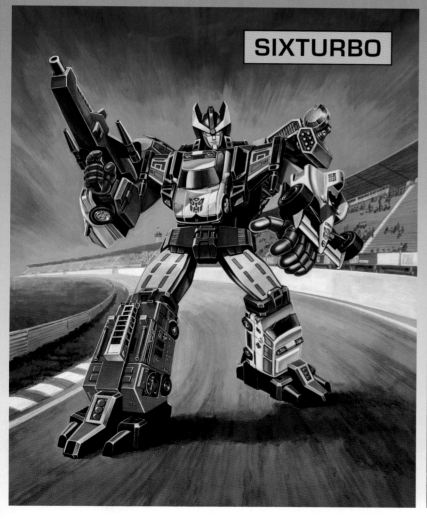

SIXTURBO

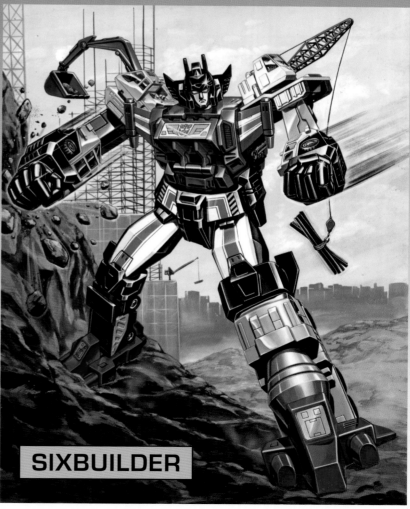

SIXBUILDER

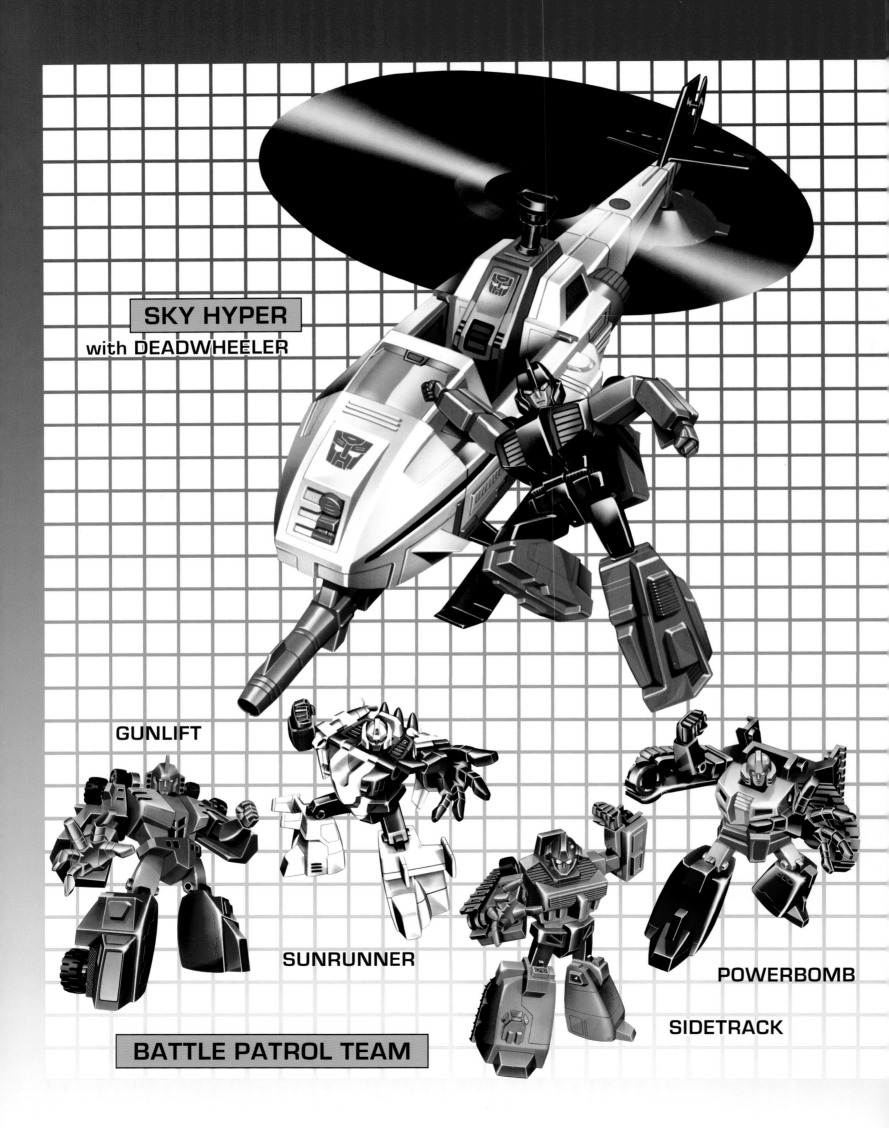

SKY HYPER
with DEADWHEELER

GUNLIFT

SUNRUNNER

POWERBOMB

SIDETRACK

BATTLE PATROL TEAM

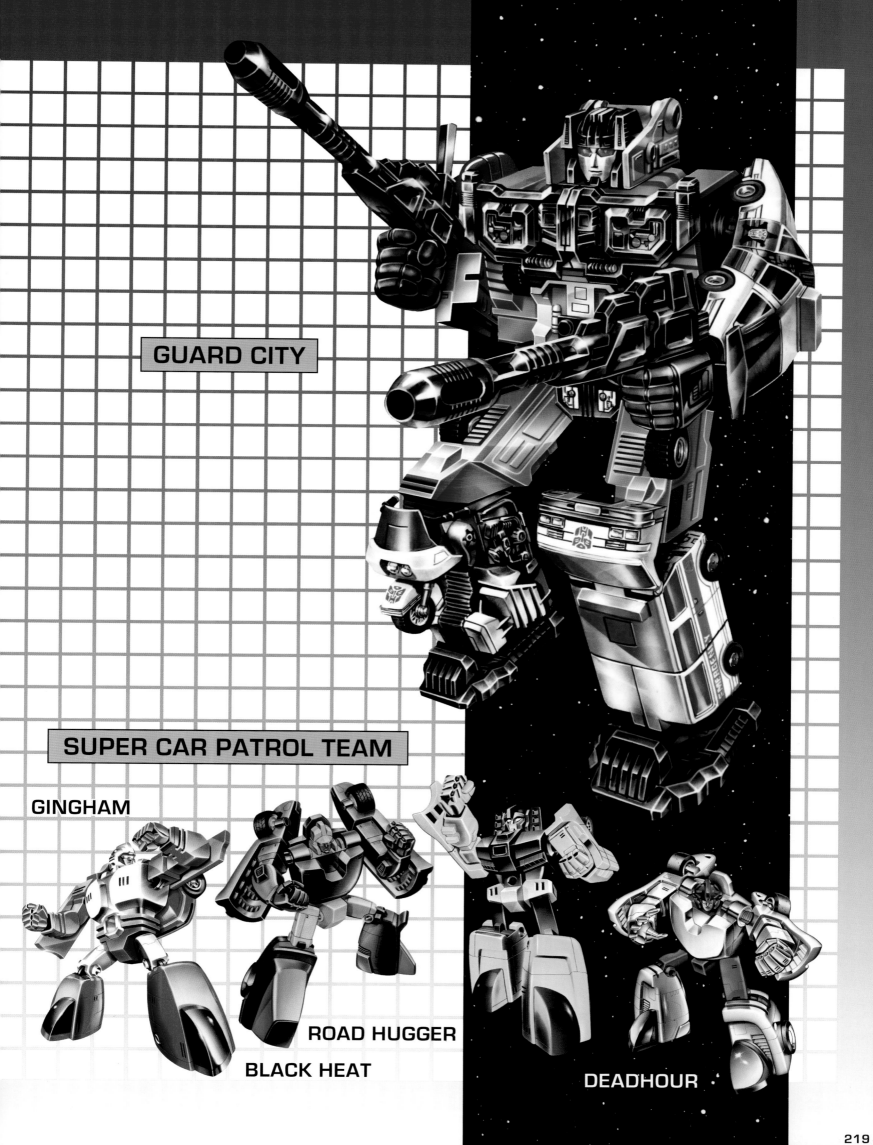

GUARD CITY

SUPER CAR PATROL TEAM

GINGHAM

ROAD HUGGER

BLACK HEAT

DEADHOUR

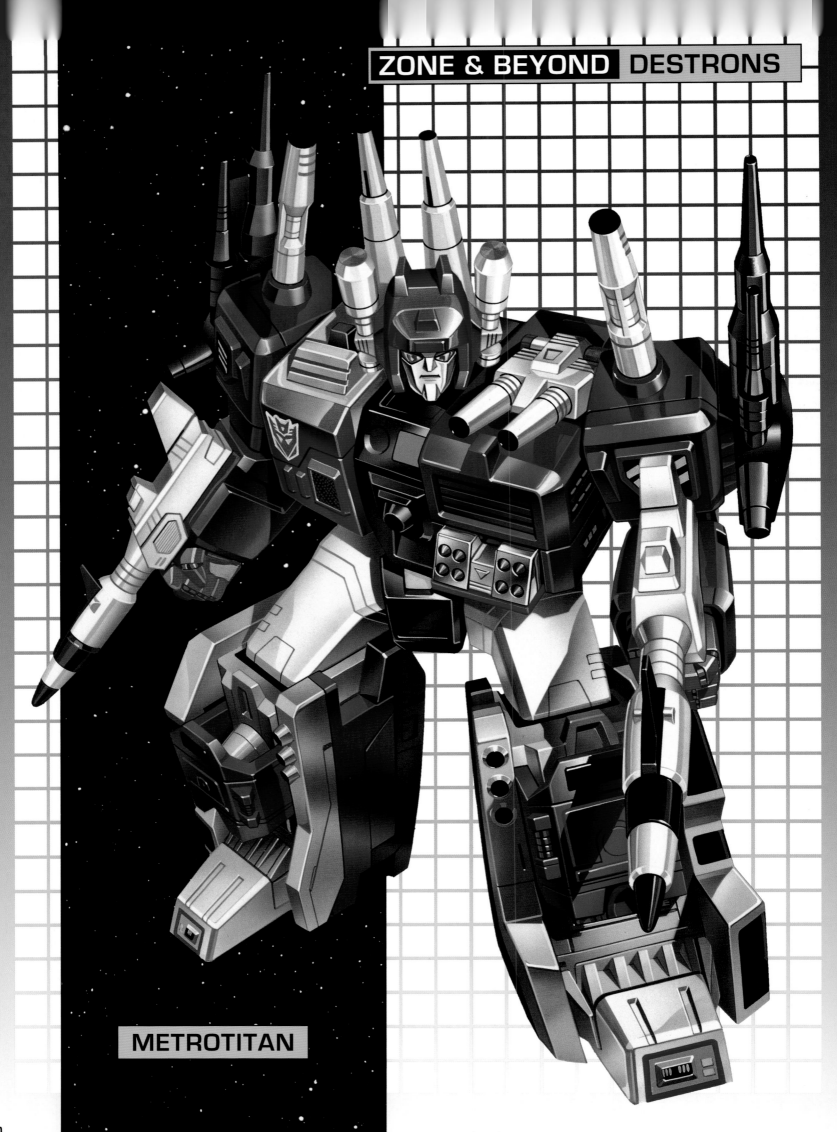

METROTITAN

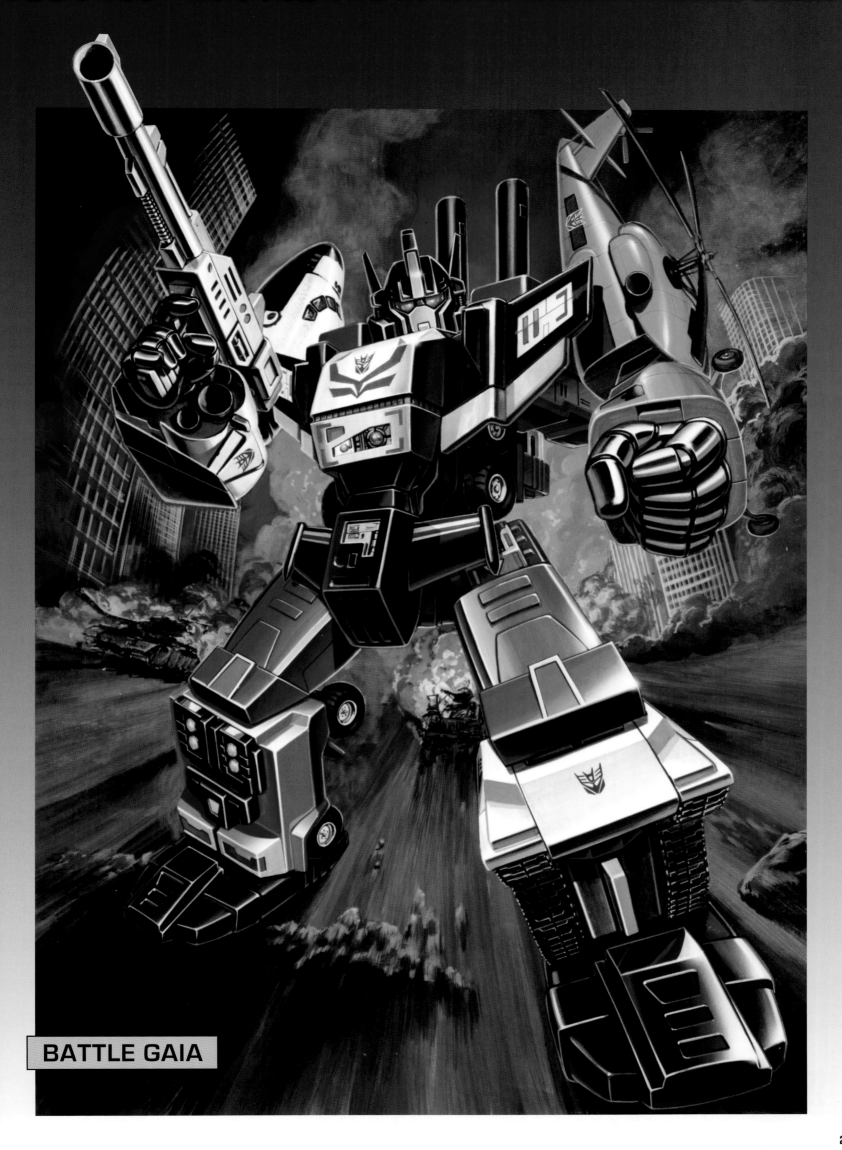

BATTLE GAIA

While The Transformers went on hiatus in the United States in 1991, it returned in 1993 as Generation 2. The backgrounds were modernized but the core art remained as it had been. Indeed, as much of the early Generation 2 line consisted of repaints of early Generation 1 toys, the artwork was often only a slight modification of the earlier illustrations. It was not until Beast Wars came along, in 1996, that the core artistic style in the US would undergo a drastic shift. (Japanese aesthetics diverged from the US in 1995, when they launched their version of Generation 2 with computer-generated visuals. While these are out of scope for this volume, you can get a hint of them by looking at the two-page spread that introduces our chapter on Generation 2 on page 224.)

Chapter Twelve covers all of Generation 2, though we are missing a few repaints from the tail end of the line. G2, which ran from 1993-1995, launched with a series of redecoed versions of classic toys but quickly expanded to include new characters and features, many of which would inform future design choices for years to come. Toys had a greater range of articulation thanks to an increased use of ball-and-socket joints. Weapons could usually be stowed somewhere in vehicle modes, and light-piping made eyes appear to glow in direct sunlight.

Disappointing sales resulted in the cancellation of the 1996 line of Generation 2 in favor of a radically revamped line, the Beast Wars. This move would prove incredibly fortuitous for the brand, proving that the core concept was robust enough to cover a vastly different style of toy. This naturally required a different artistic style, and thus provides a logical stopping point for this book. (Heck, it's already almost 300 pages!)

However, we're not quite done. Chapter Thirteen covers unused art, much of which came from toys developed for but unproduced in Generation 2. We were fortunate enough to uncover some new artwork from Generation 1 as well, providing insight into toys considered but ultimately rejected by Hasbro. It's incredible to think of the toys that might have been, or even just to contemplate that at one point someone like Quickswitch was slated to be a Decepticon.

We conclude with Chapter Fourteen: oddities. There was much artwork produced in the airbrushed style that simply didn't fit into our organizational scheme. We provide a sampling of some of the Diaclone and Micro Change artwork that inspired the aesthetic of Transformers packaging artwork. We look at modern uses of this style. We touch on the use of this style in the United Kingdom from 1991-1995. We include some catalog art and some back-of-the-package spreads. It's fascinating how much artwork exists in this style, and we had fun covering a few of the more unusual instances of it.

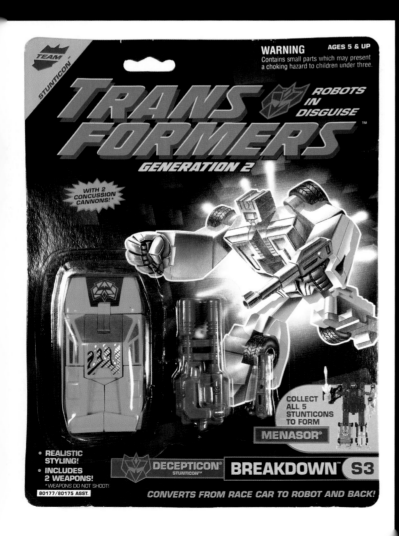

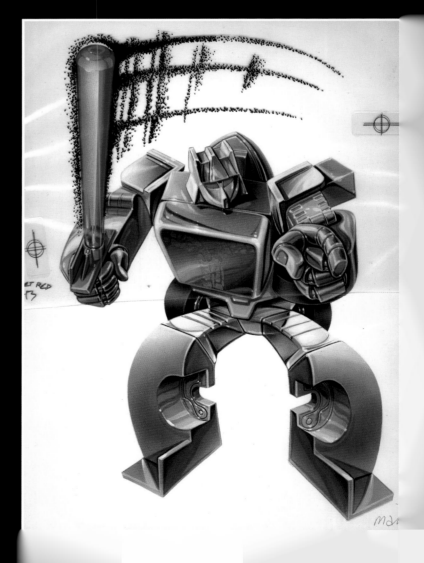

G2 Megatron Sketch

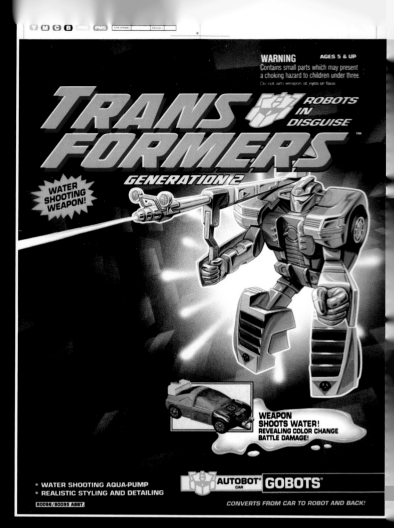

TRANS FORMERS™ ROBOTS IN DISGUISE

GENERATION 2

WATER SHOOTING WEAPON!

WEAPON SHOOTS WATER!
REVEALING COLOR CHANGE BATTLE DAMAGE!

• WATER SHOOTING AQUA-PUMP
• REALISTIC STYLING AND DETAILING

80086/80095 ASST.

AUTOBOT CAR GOBOTS®

CONVERTS FROM CAR TO ROBOT AND BACK!

Generation 2 Gobots Production Proof Card

DIE CAST CARS

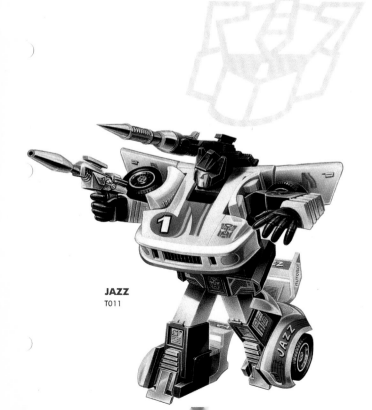

JAZZ
T011

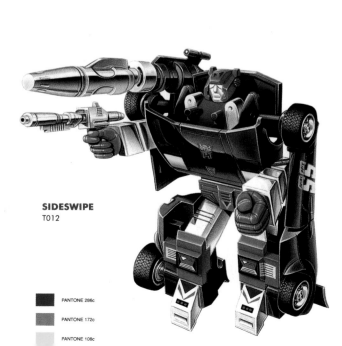

SIDESWIPE
T012

PANTONE 286c

PANTONE 172c

PANTONE 108c

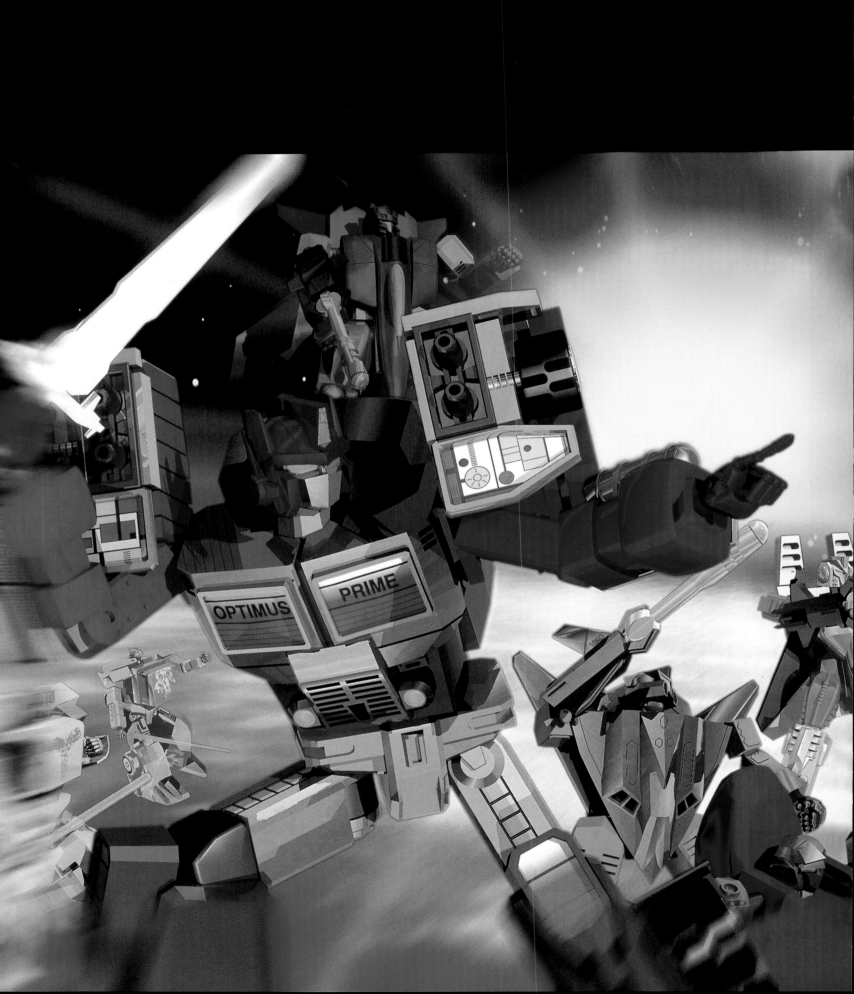

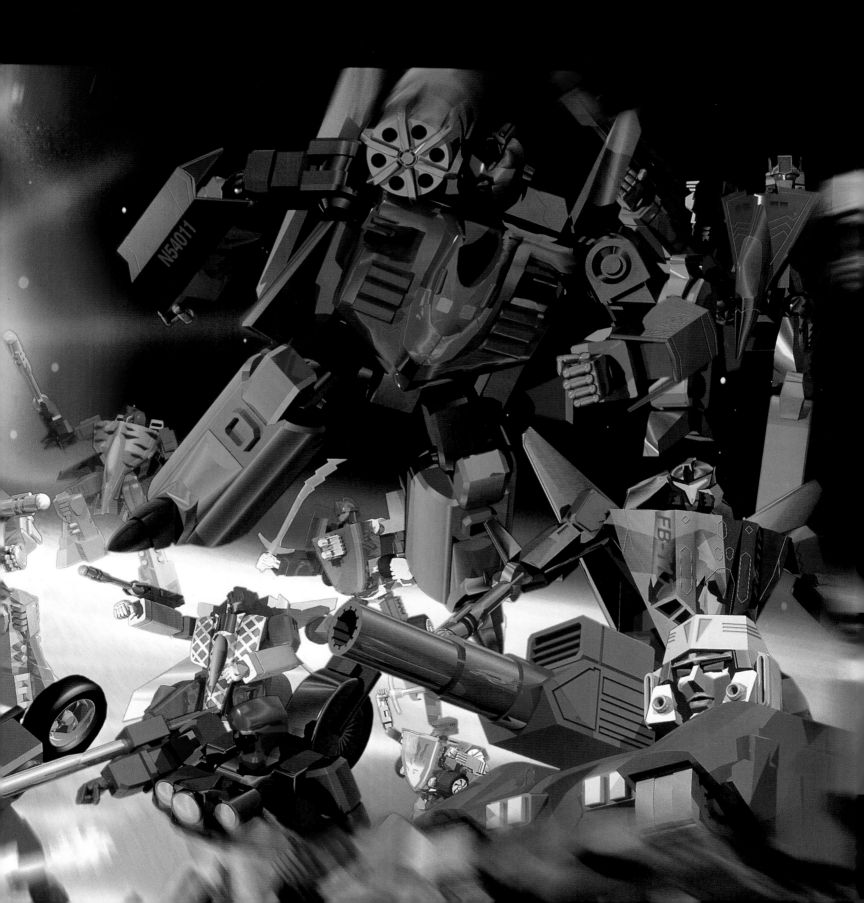

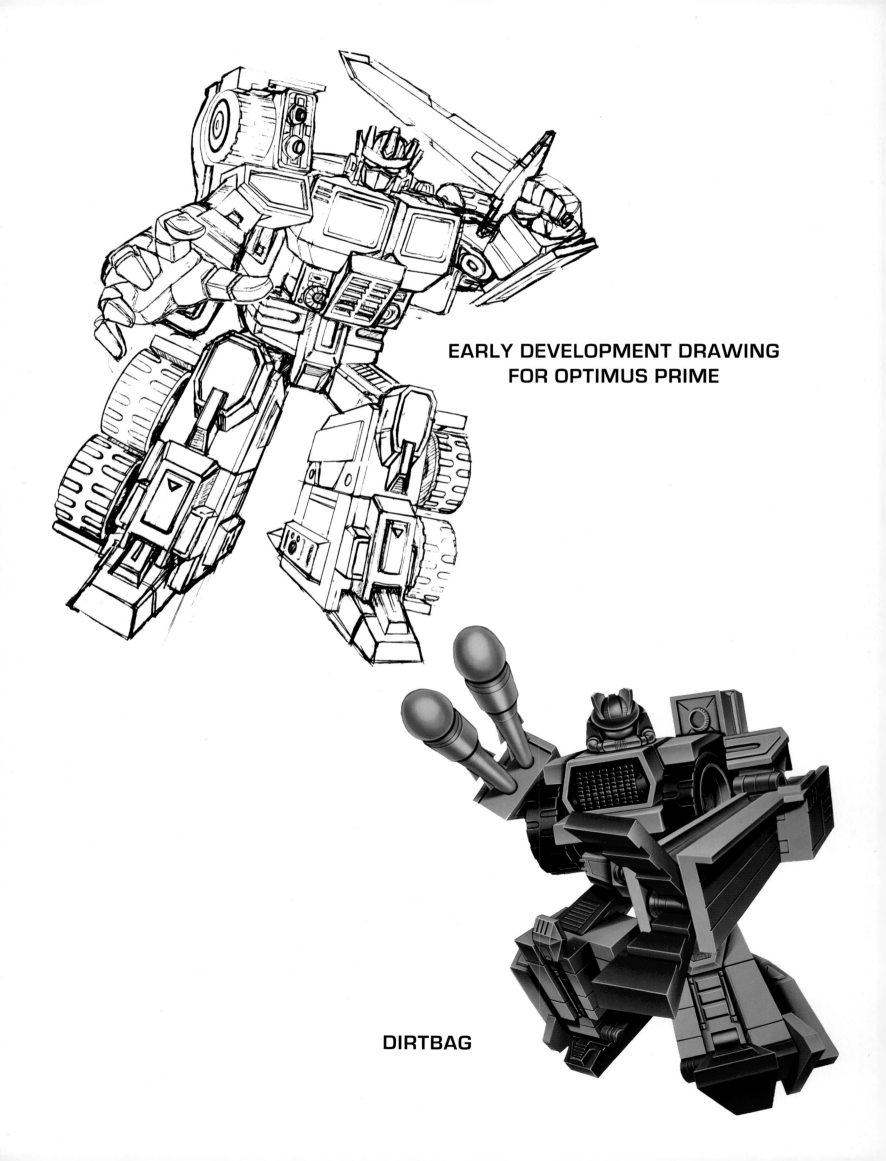

EARLY DEVELOPMENT DRAWING
FOR OPTIMUS PRIME

DIRTBAG

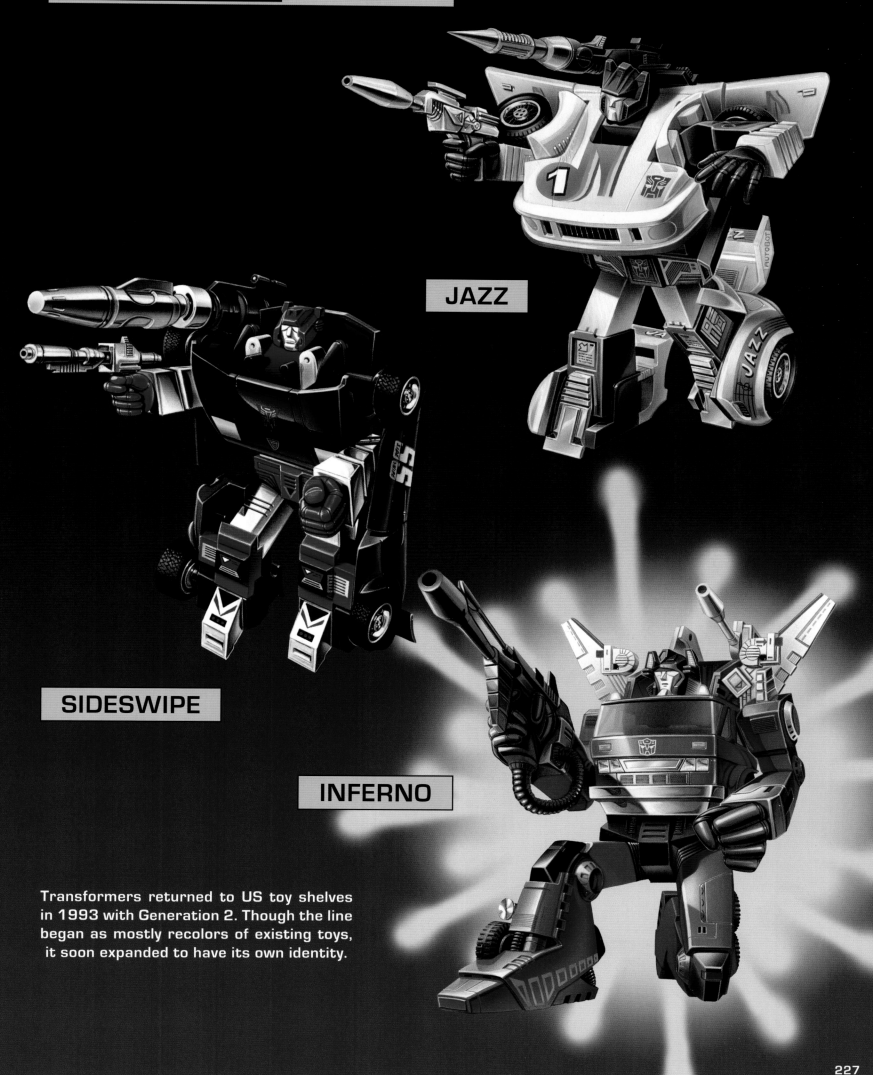

JAZZ

SIDESWIPE

INFERNO

Transformers returned to US toy shelves in 1993 with Generation 2. Though the line began as mostly recolors of existing toys, it soon expanded to have its own identity.

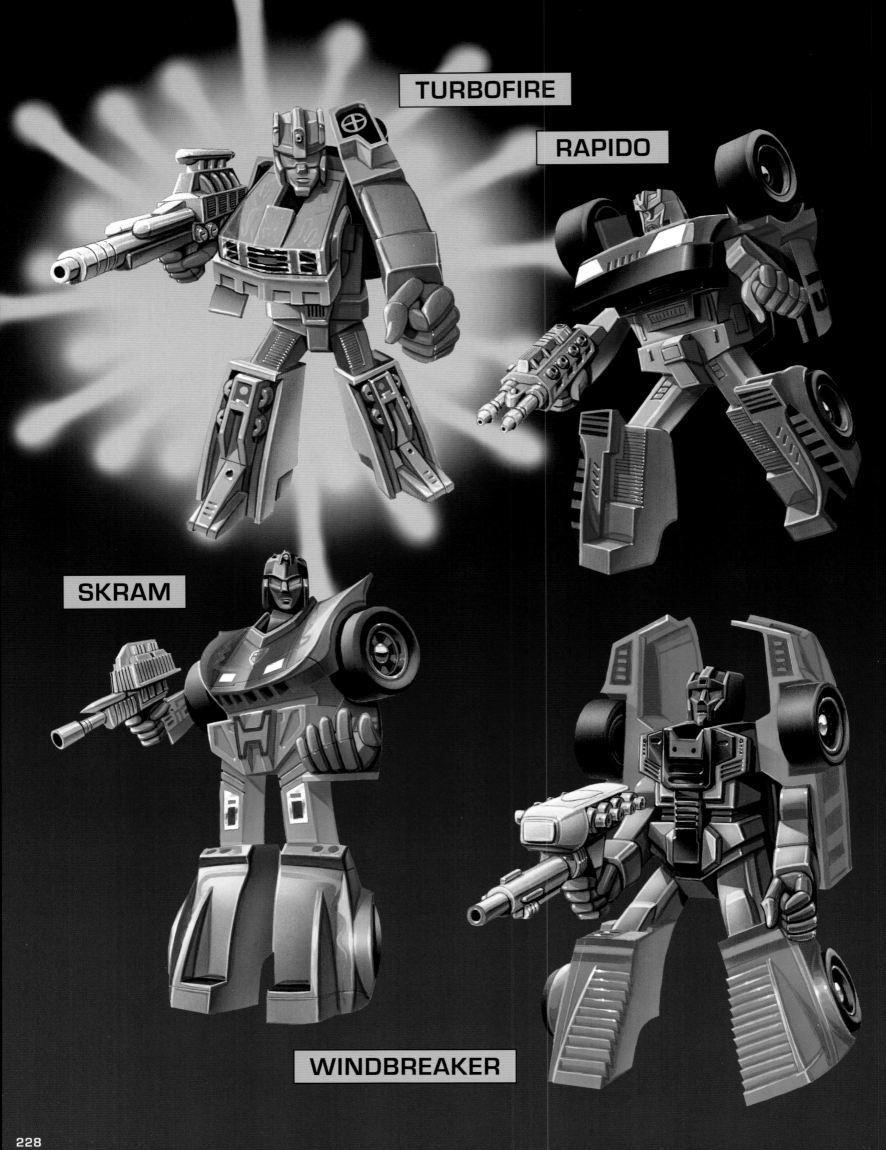

TURBOFIRE

RAPIDO

SKRAM

WINDBREAKER

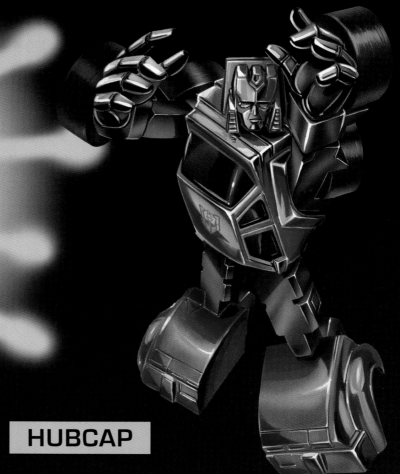

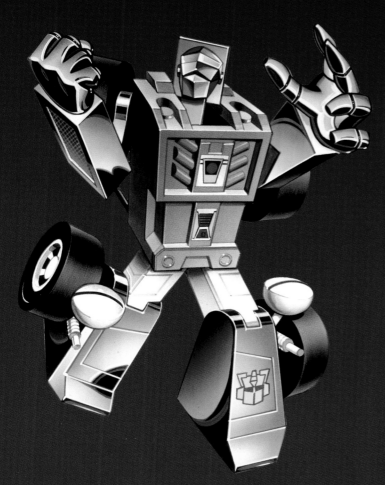

BUMBLEBEE

HUBCAP

SEASPRAY

BEACHCOMBER

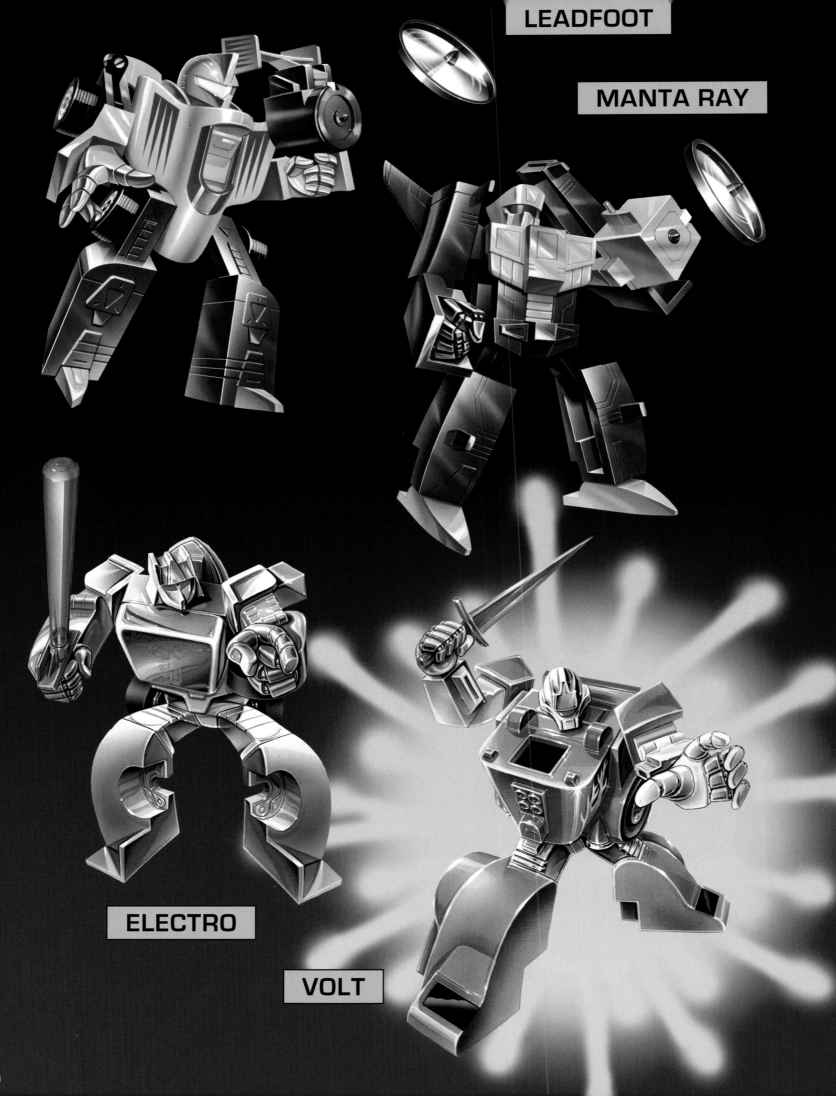

LEADFOOT

MANTA RAY

ELECTRO

VOLT

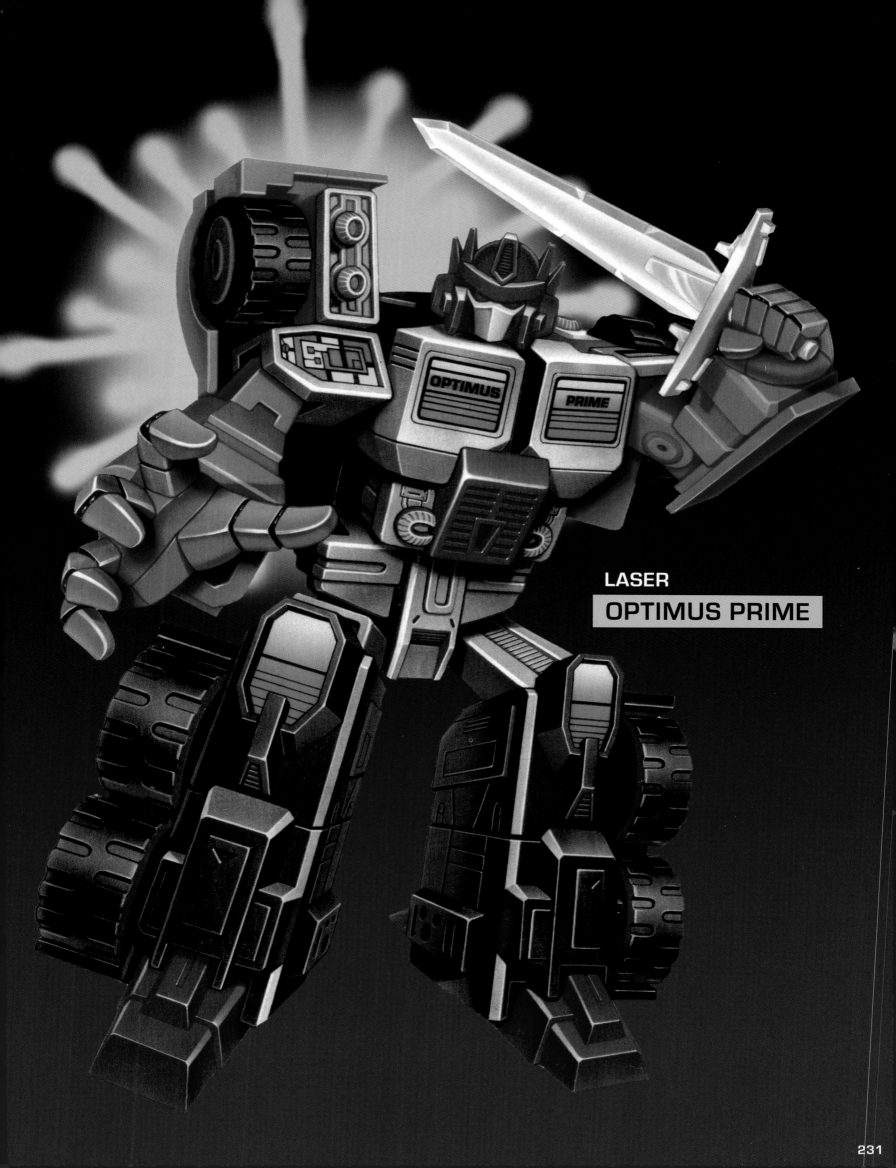

LASER
OPTIMUS PRIME

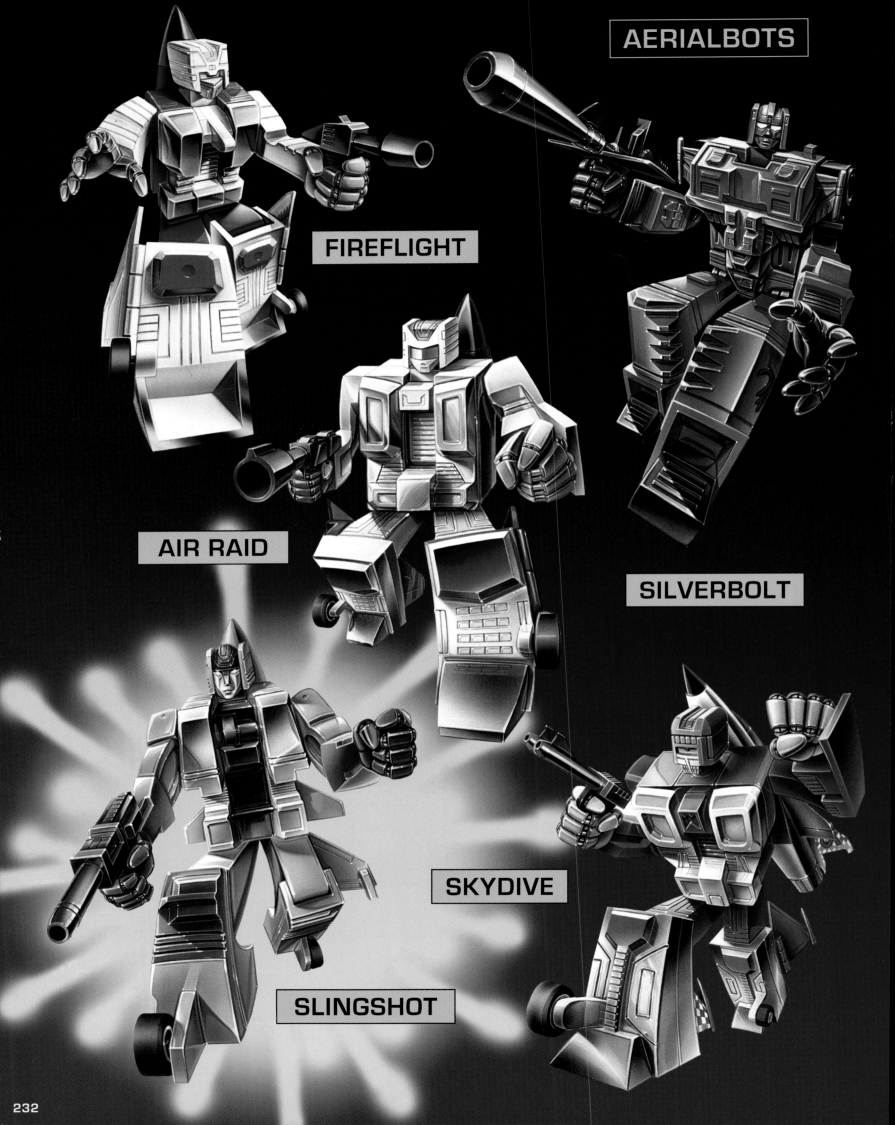

AERIALBOTS

FIREFLIGHT

AIR RAID

SILVERBOLT

SKYDIVE

SLINGSHOT

HIGH BEAM

FIRECRACKER

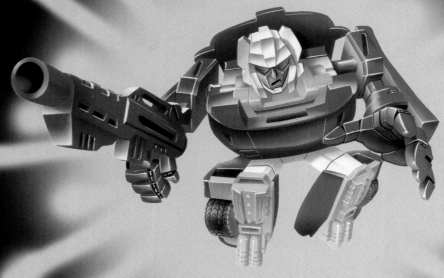

MOTORMOUTH

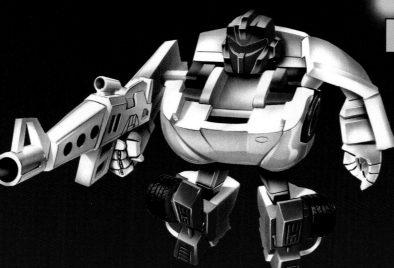

BLOWOUT

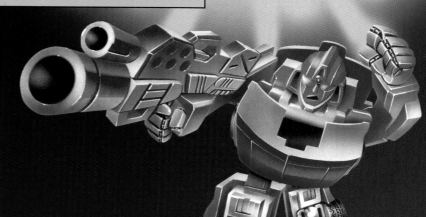

GEARHEAD

DOUBLE CLUTCH

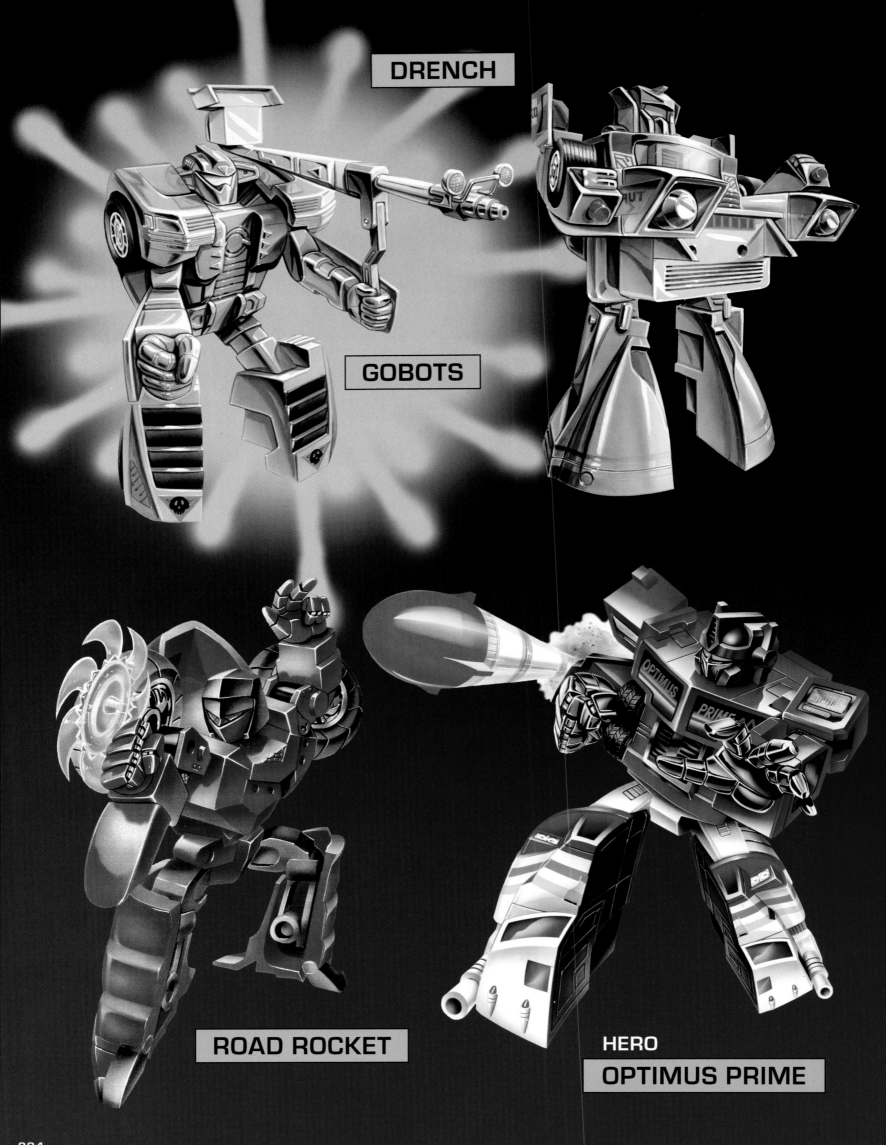

DRENCH

GOBOTS

ROAD ROCKET

HERO
OPTIMUS PRIME

234

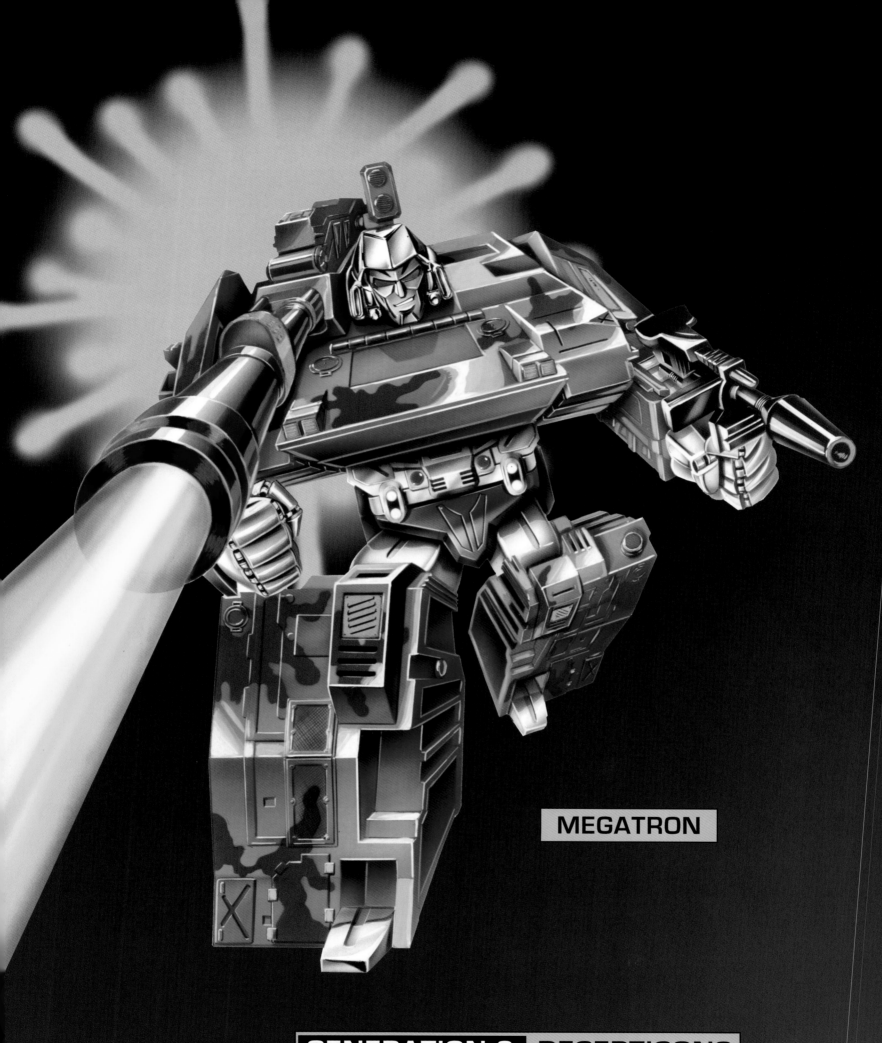

MEGATRON

GENERATION 2 DECEPTICONS

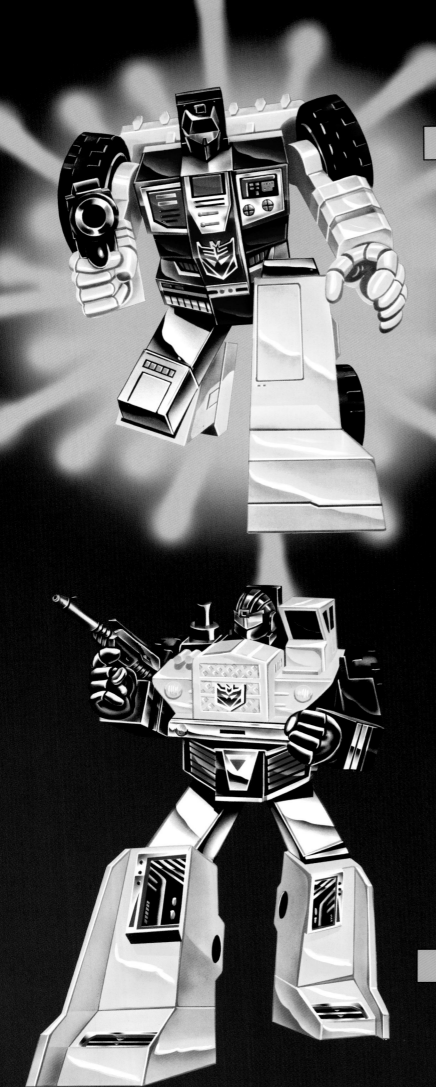

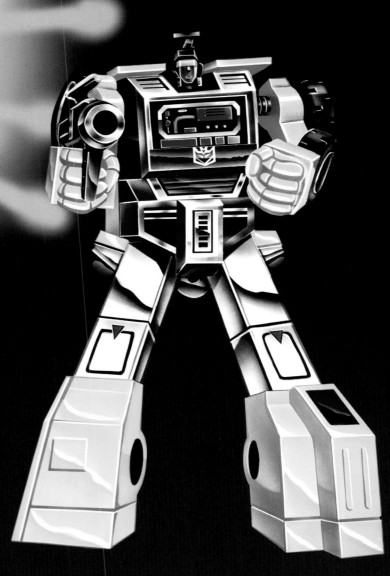

SCRAPPER

HOOK

LONG HAUL

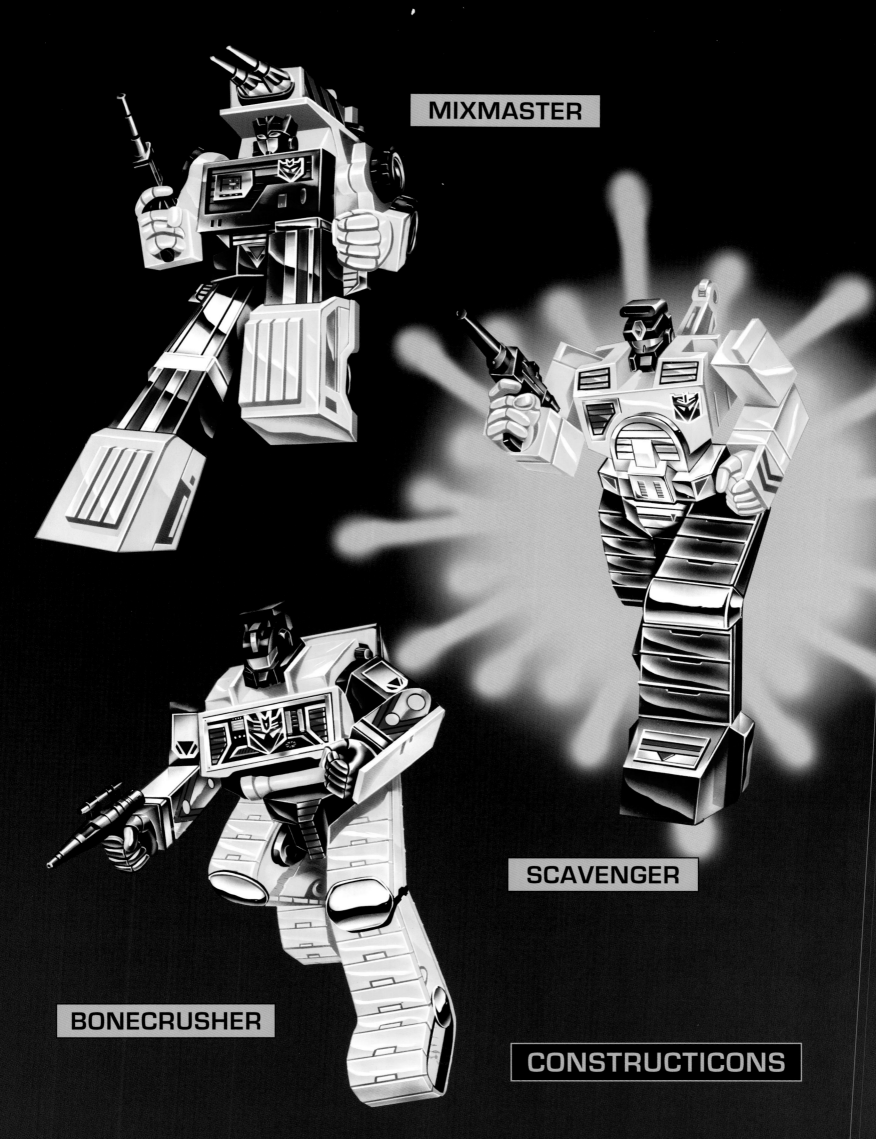

MIXMASTER

SCAVENGER

BONECRUSHER

CONSTRUCTICONS

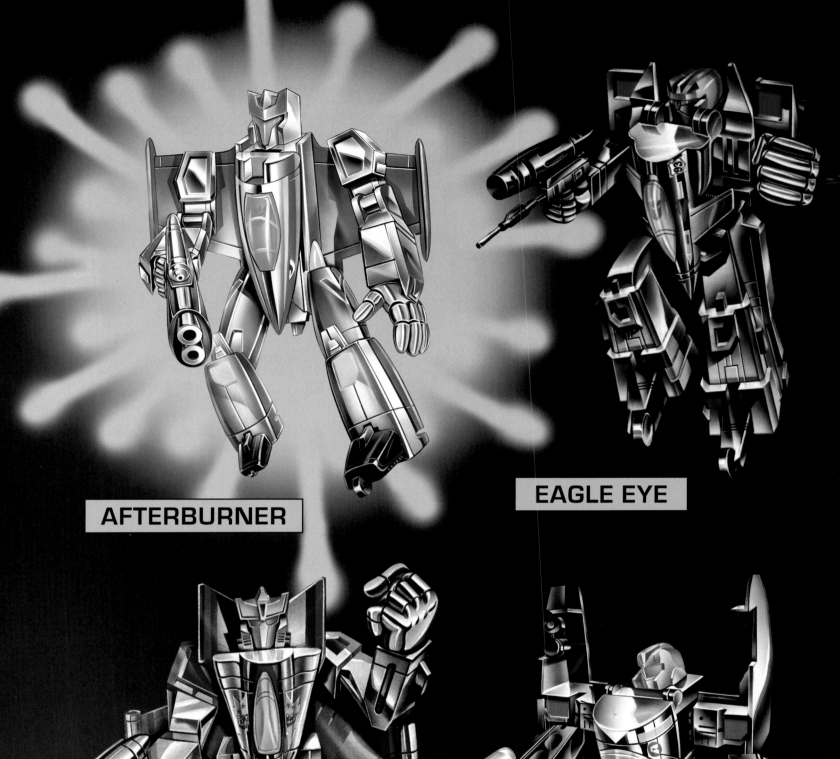

AFTERBURNER

EAGLE EYE

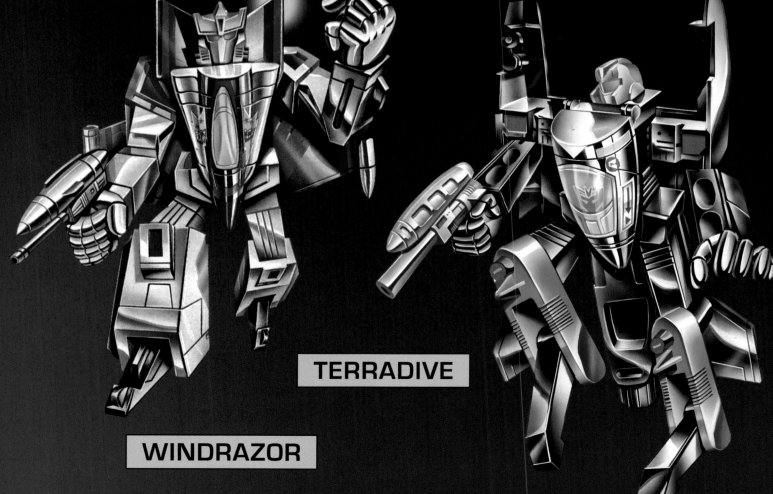

TERRADIVE

WINDRAZOR

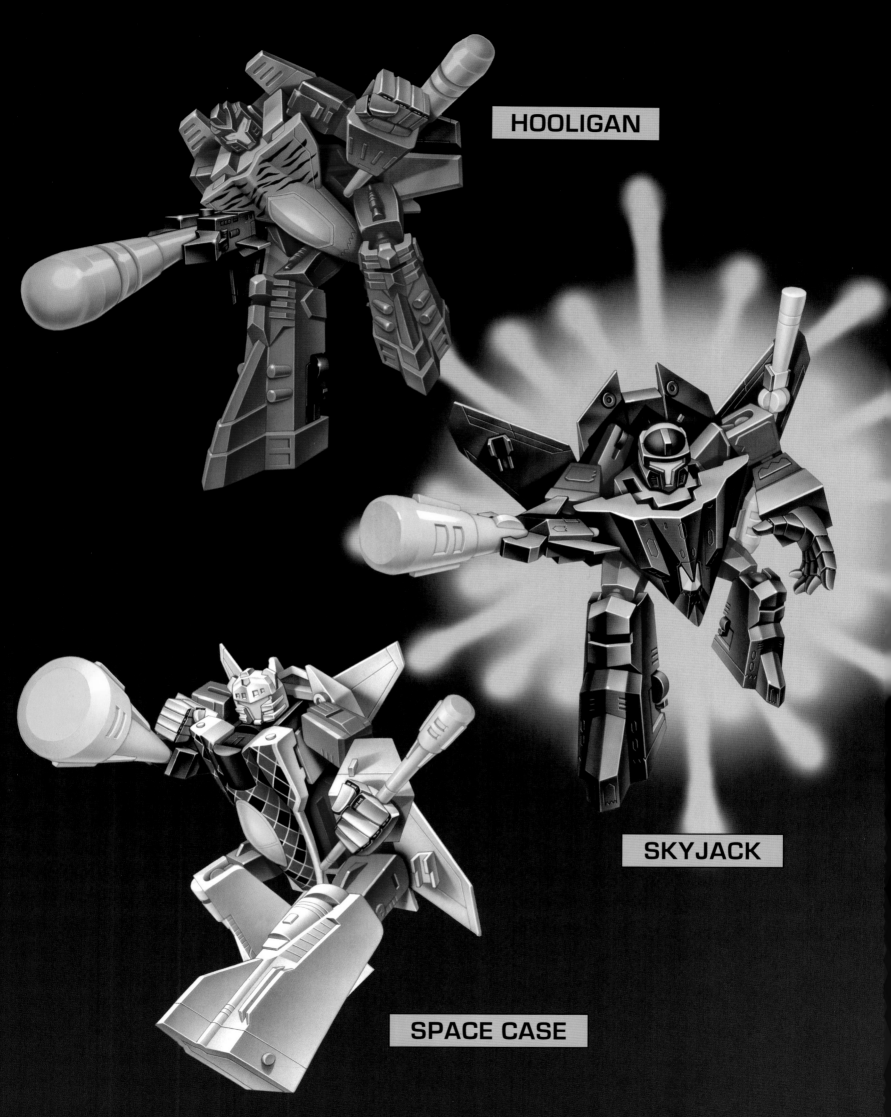

HOOLIGAN

SKYJACK

SPACE CASE

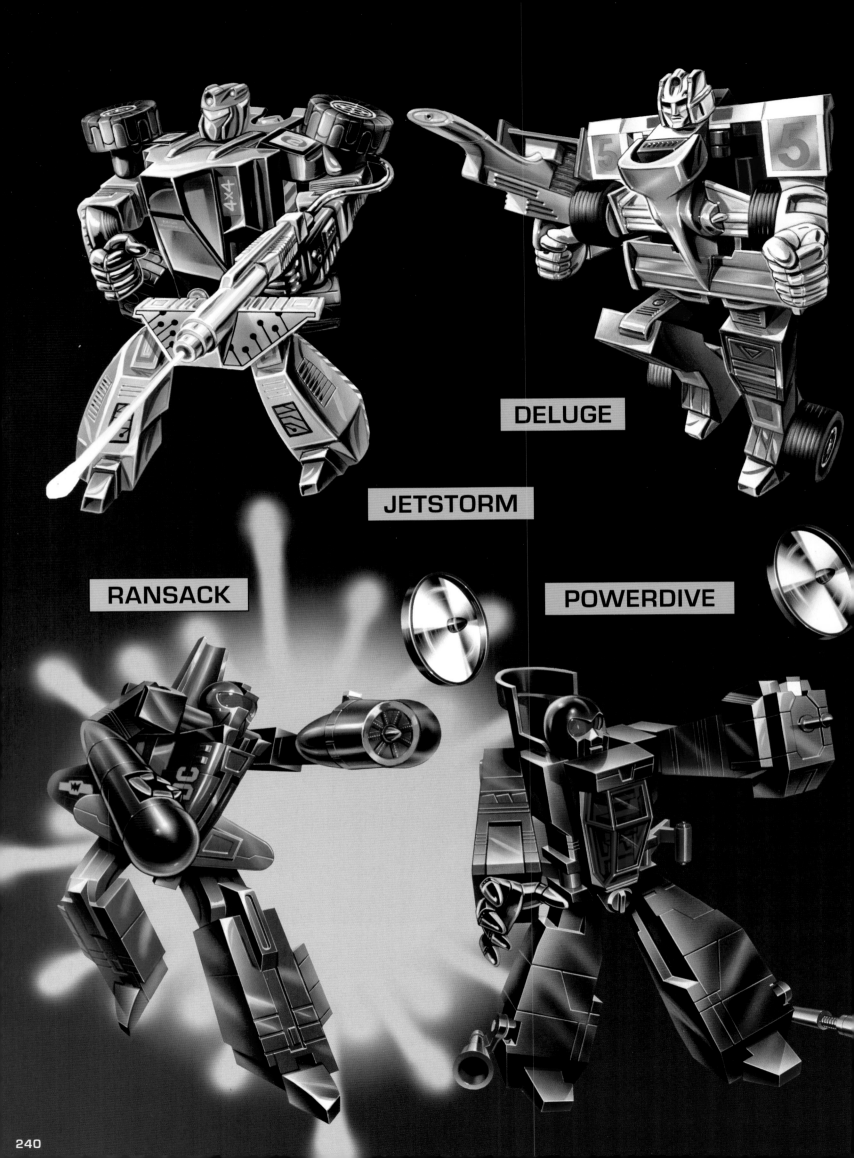

JETSTORM

DELUGE

RANSACK

POWERDIVE

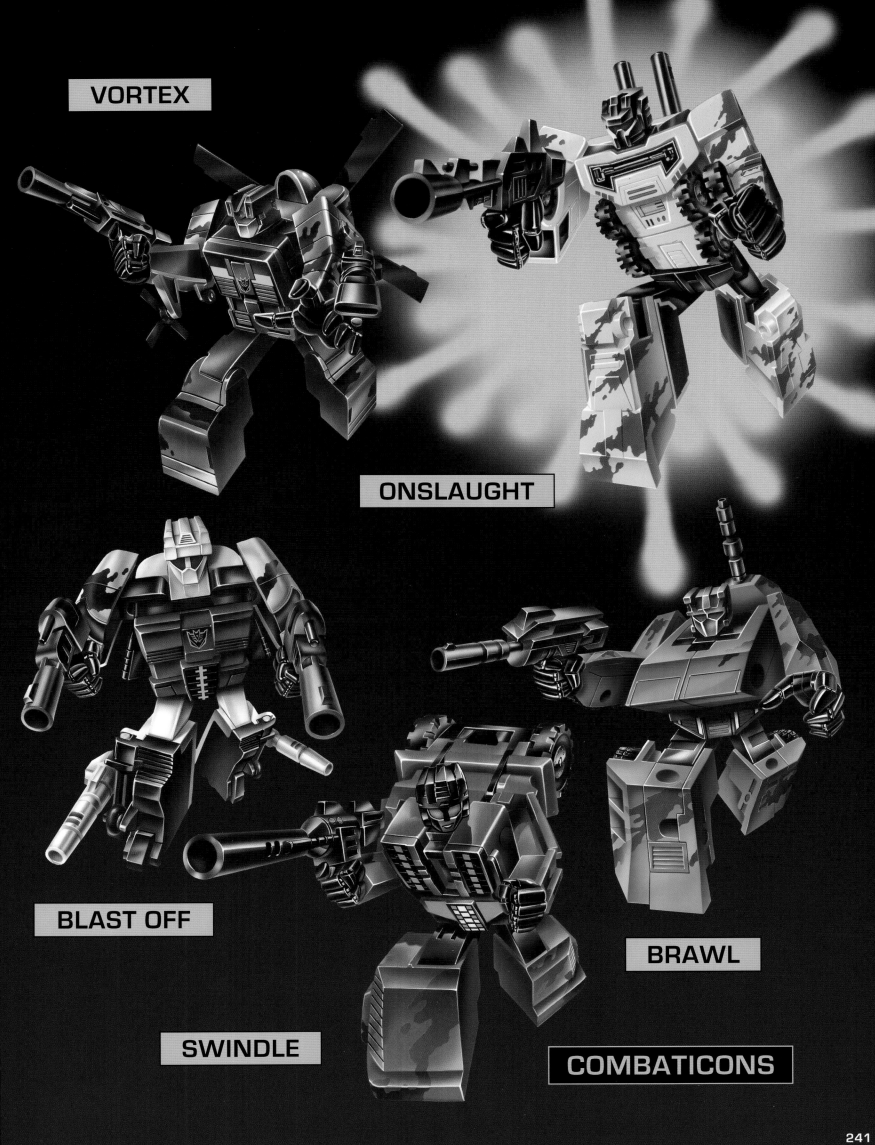

VORTEX

ONSLAUGHT

BLAST OFF

SWINDLE

BRAWL

COMBATICONS

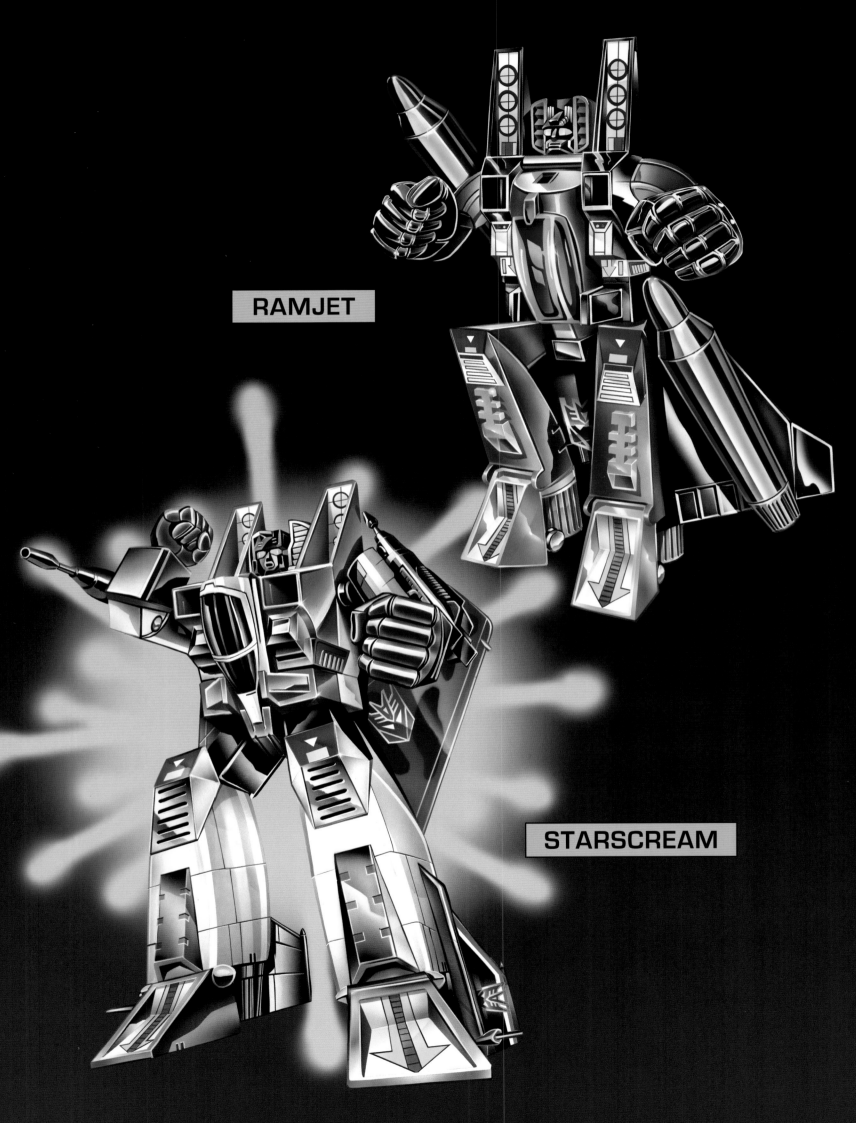

RAMJET

STARSCREAM

242

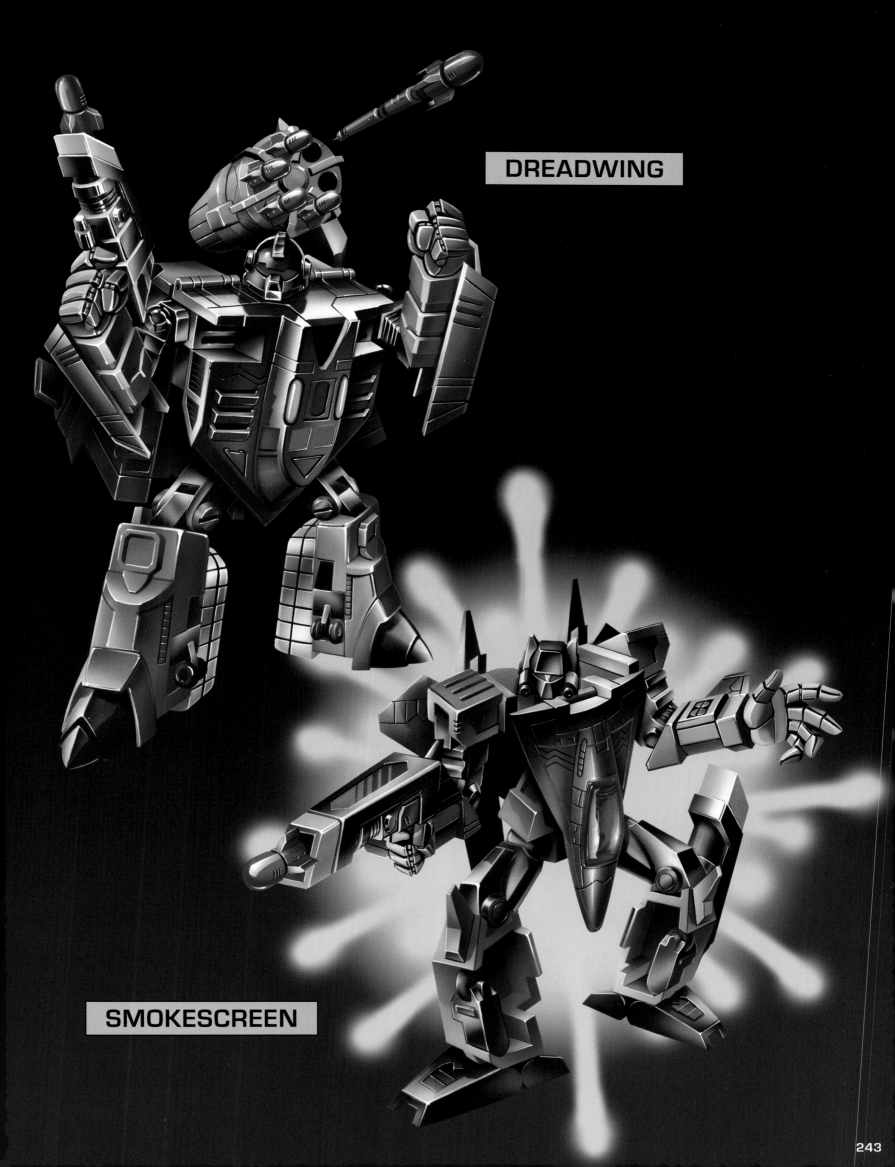

DREADWING

SMOKESCREEN

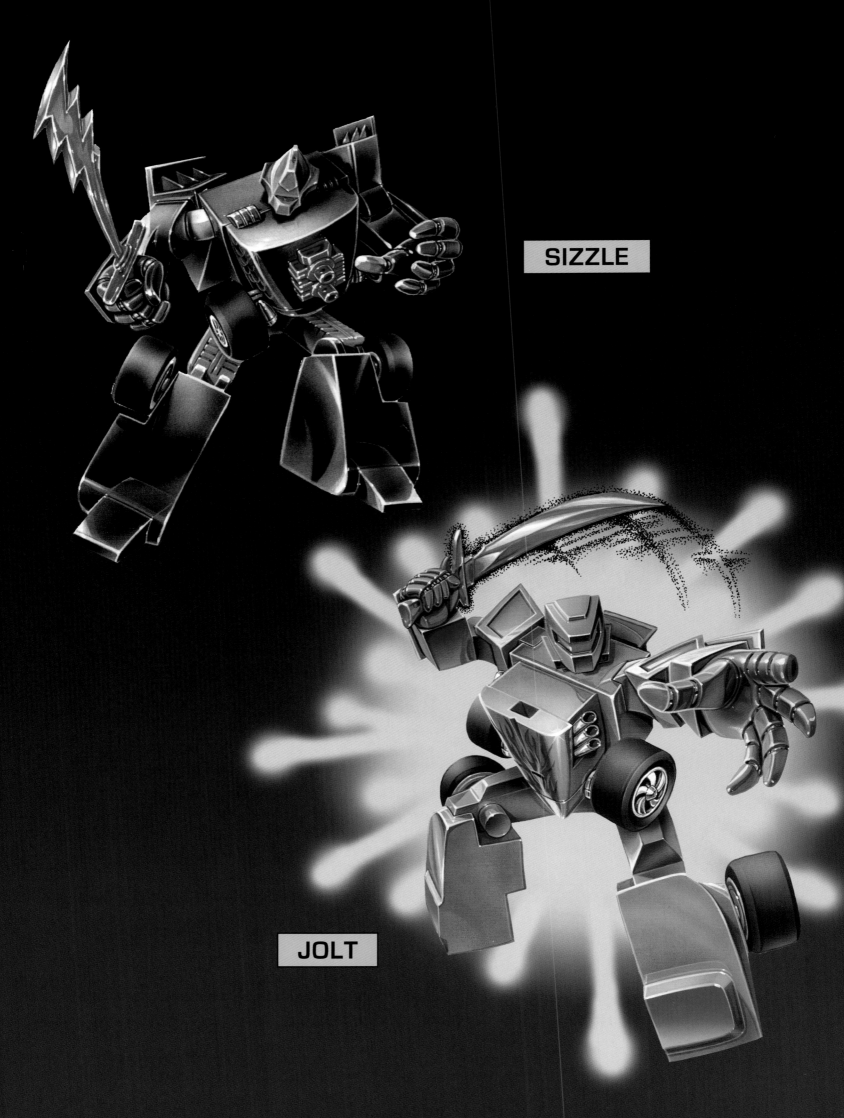

SIZZLE

JOLT

244

HERO
MEGATRON

ROAD PIG

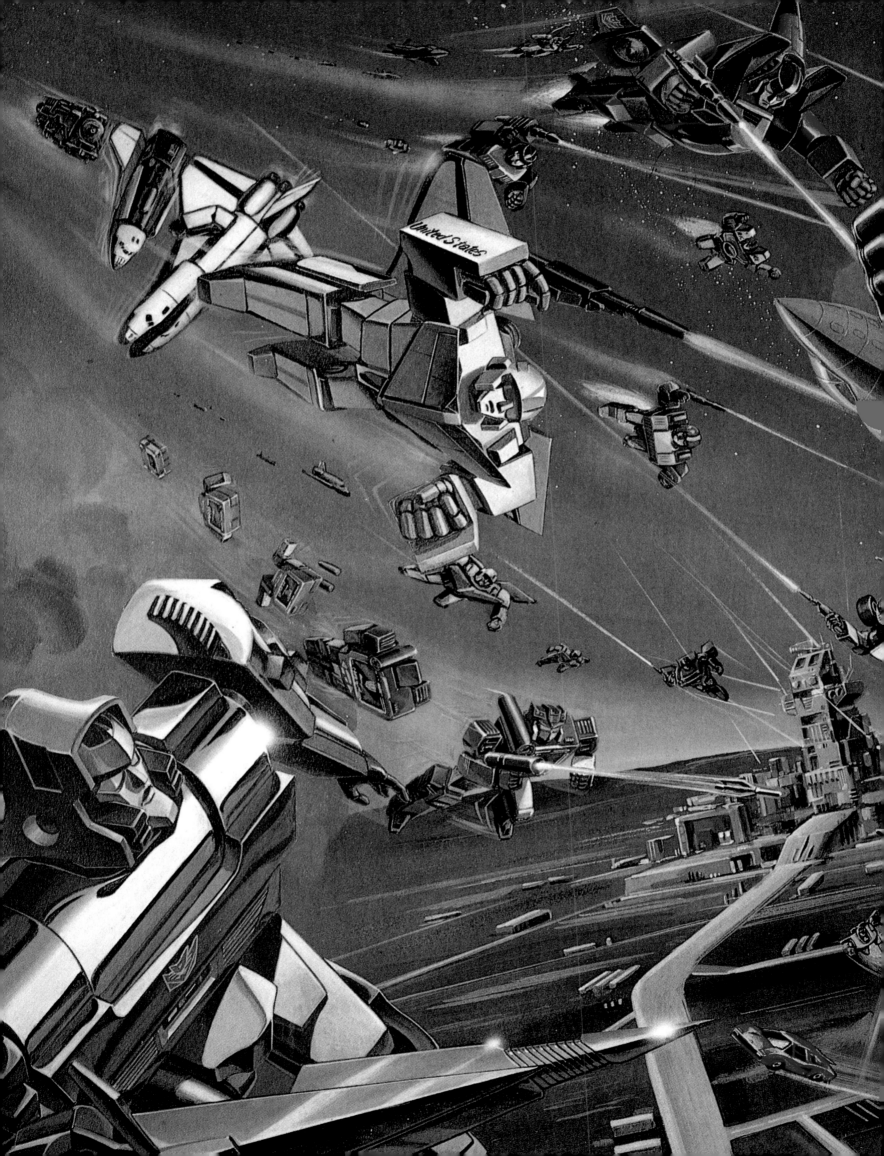

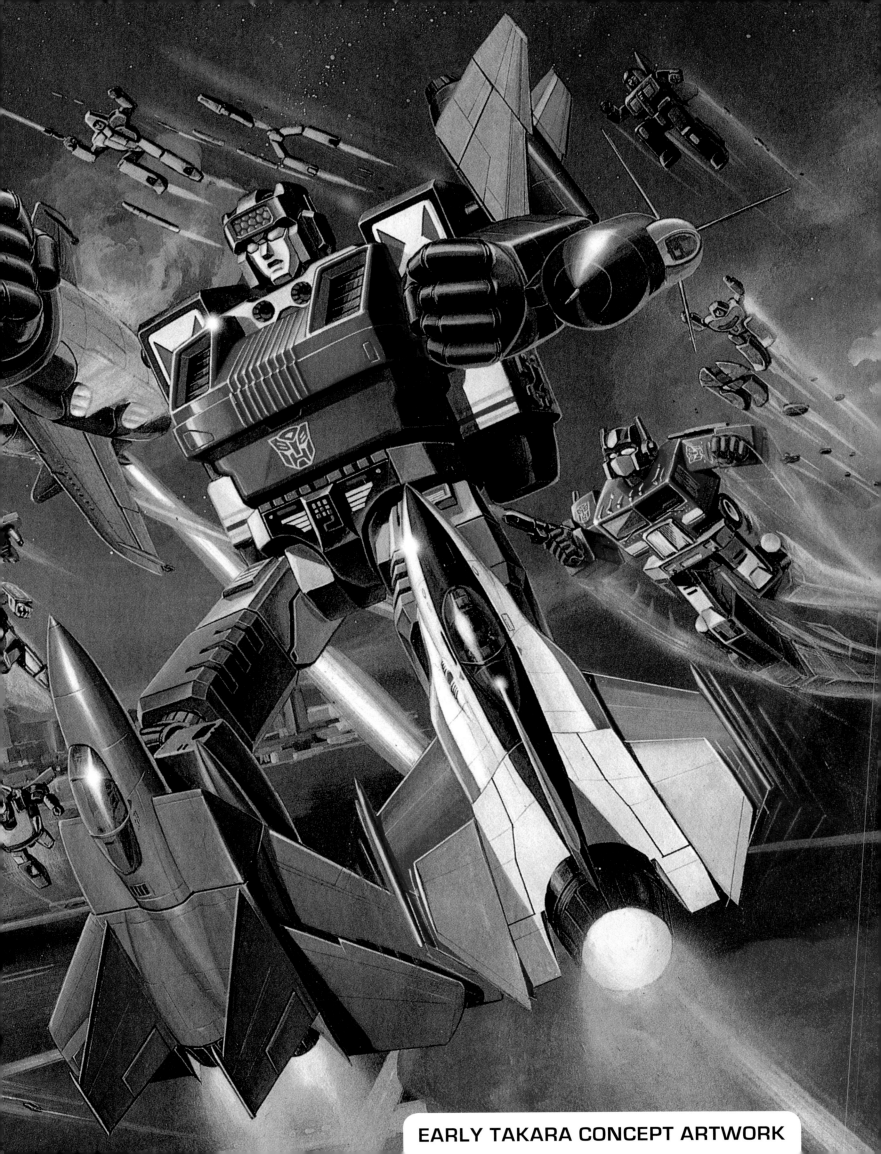

EARLY TAKARA CONCEPT ARTWORK

UNUSED TRANSFORMERS LOGOS

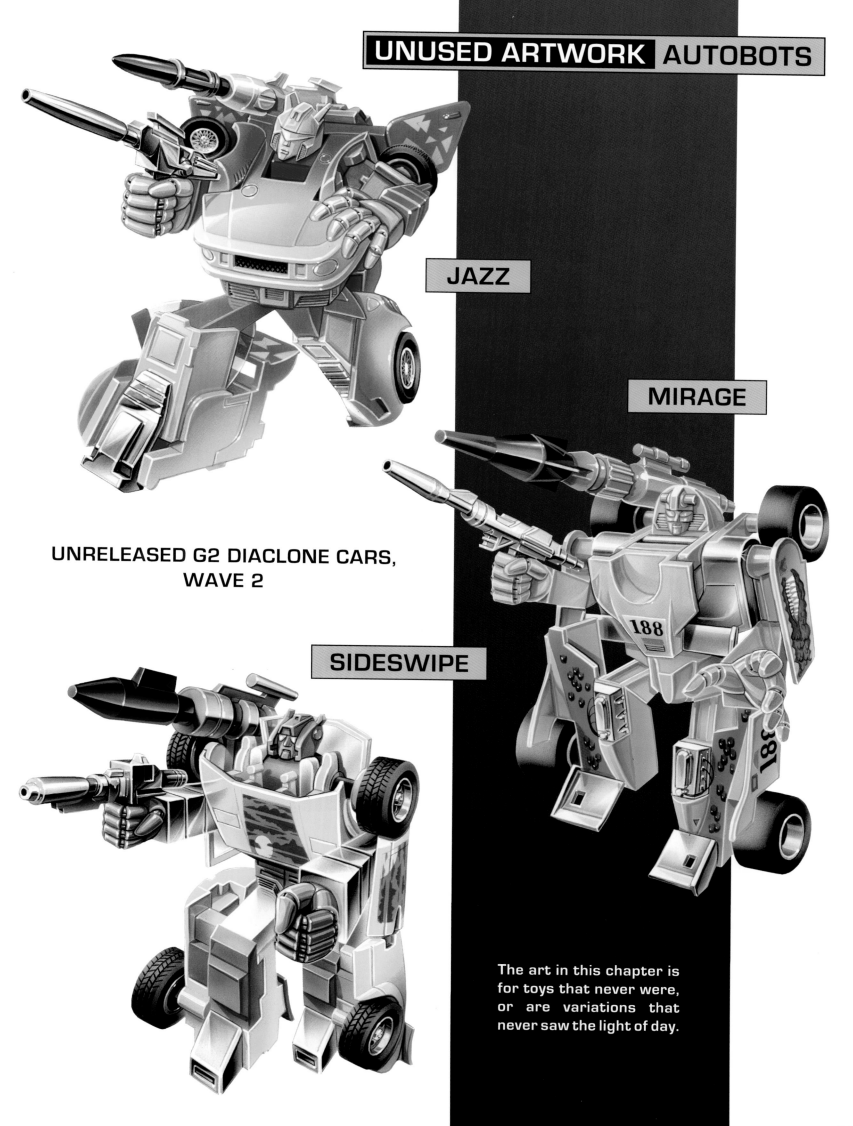

JAZZ

MIRAGE

UNRELEASED G2 DIACLONE CARS,
WAVE 2

SIDESWIPE

The art in this chapter is for toys that never were, or are variations that never saw the light of day.

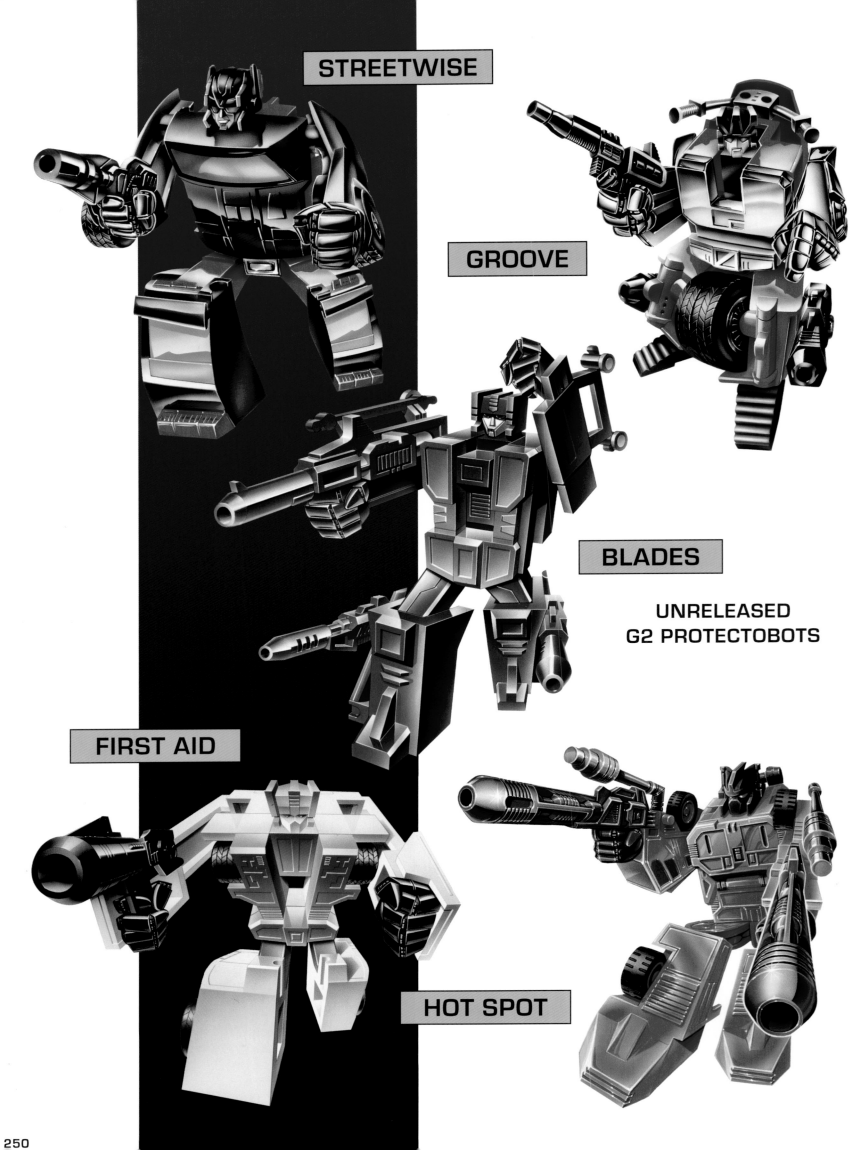

STREETWISE

GROOVE

BLADES

UNRELEASED
G2 PROTECTOBOTS

FIRST AID

HOT SPOT

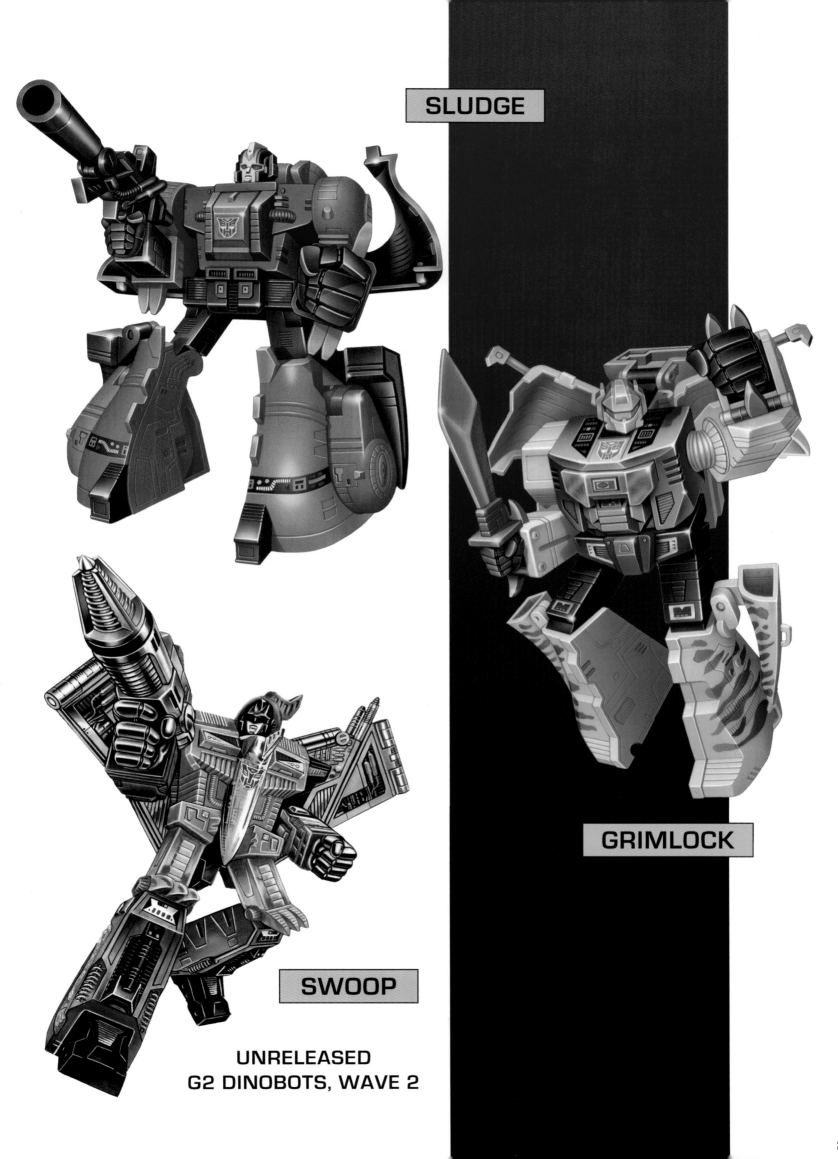

SLUDGE

GRIMLOCK

SWOOP

UNRELEASED
G2 DINOBOTS, WAVE 2

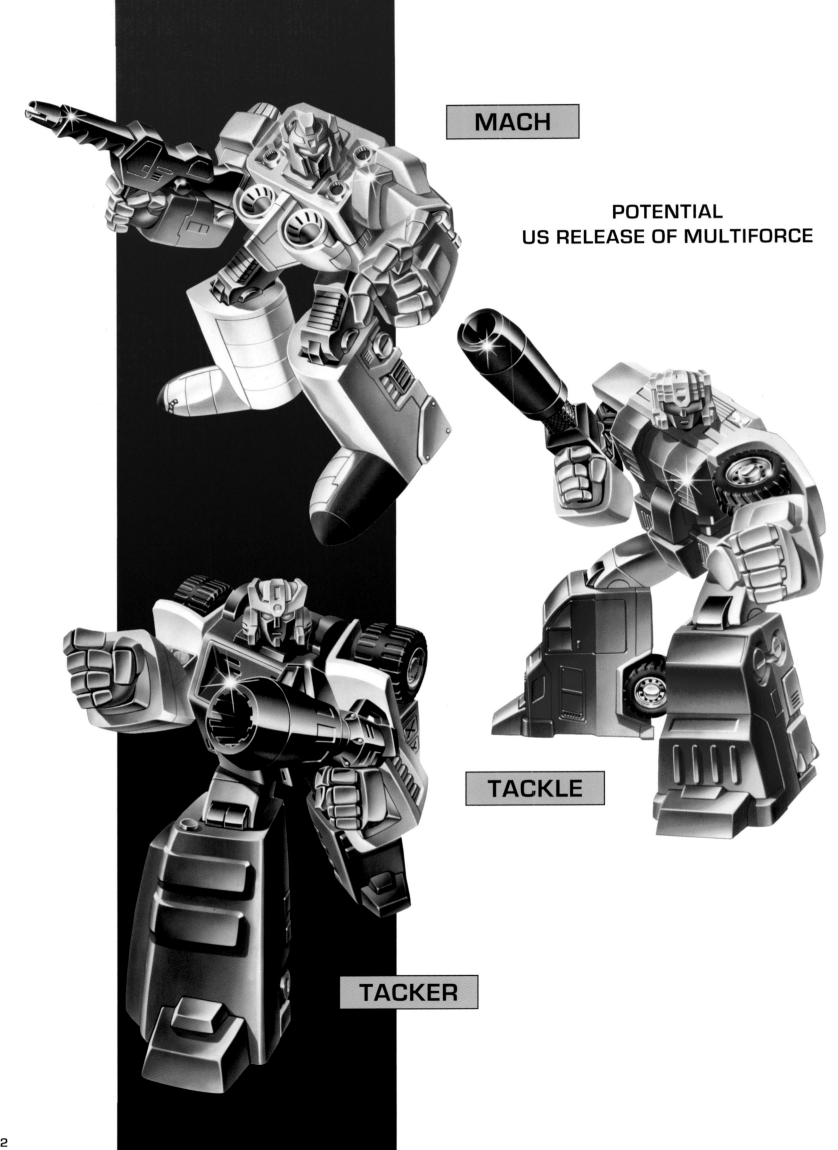

MACH

POTENTIAL
US RELEASE OF MULTIFORCE

TACKLE

TACKER

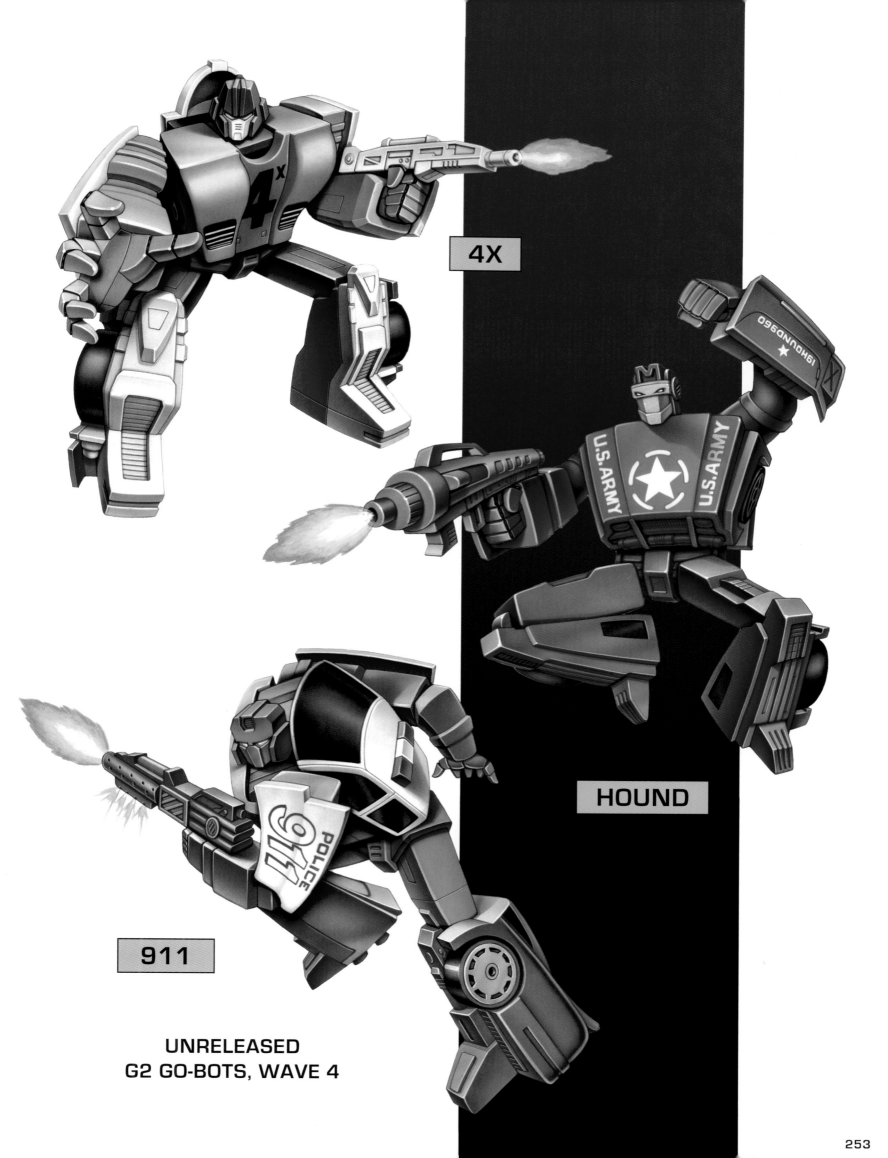

4X

HOUND

911

UNRELEASED
G2 GO-BOTS, WAVE 4

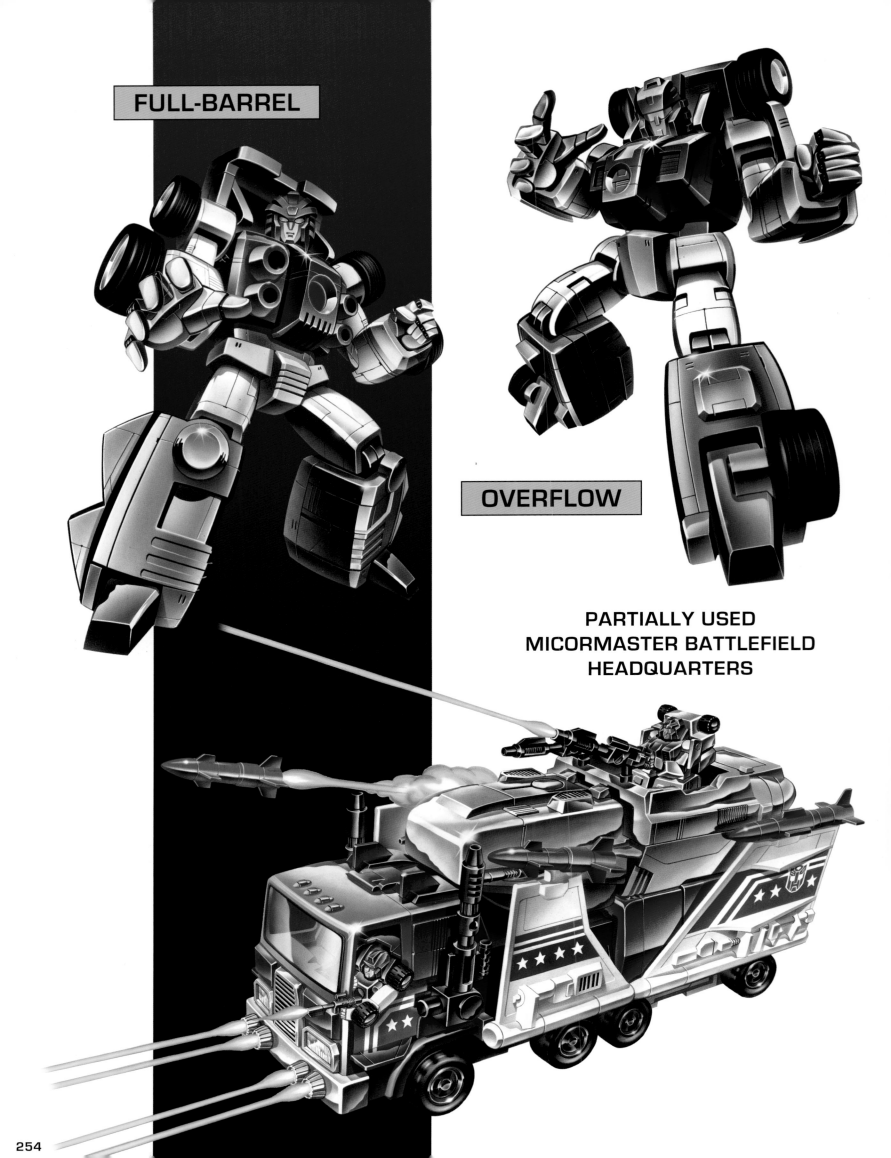

FULL-BARREL

OVERFLOW

**PARTIALLY USED
MICORMASTER BATTLEFIELD
HEADQUARTERS**

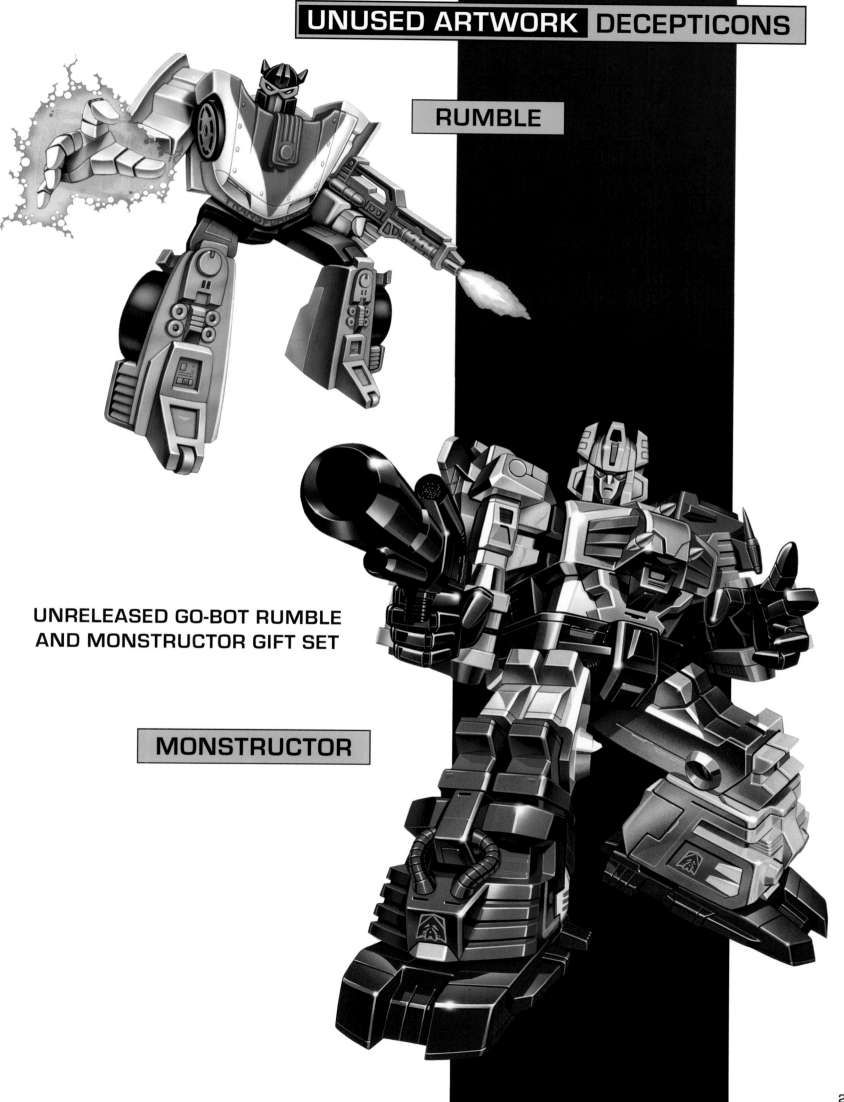

RUMBLE

UNRELEASED GO-BOT RUMBLE
AND MONSTRUCTOR GIFT SET

MONSTRUCTOR

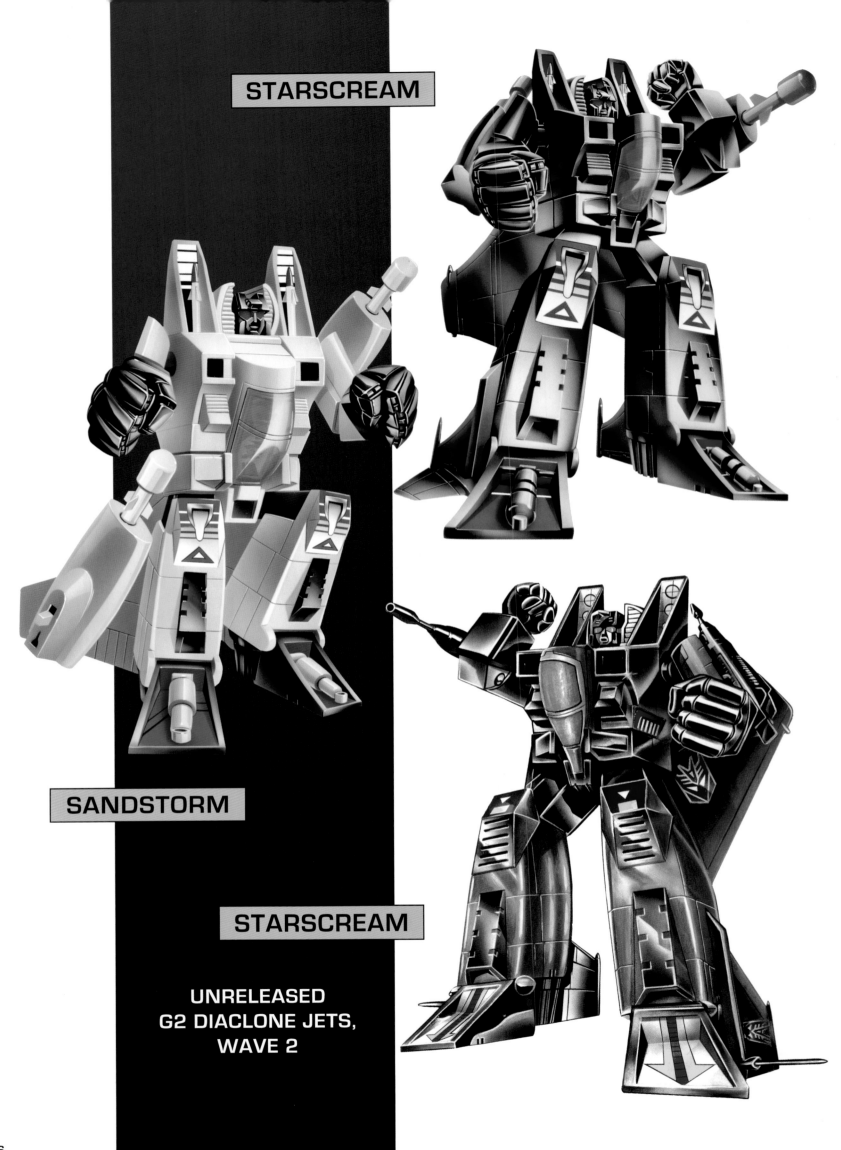

STARSCREAM

SANDSTORM

STARSCREAM

UNRELEASED
G2 DIACLONE JETS,
WAVE 2

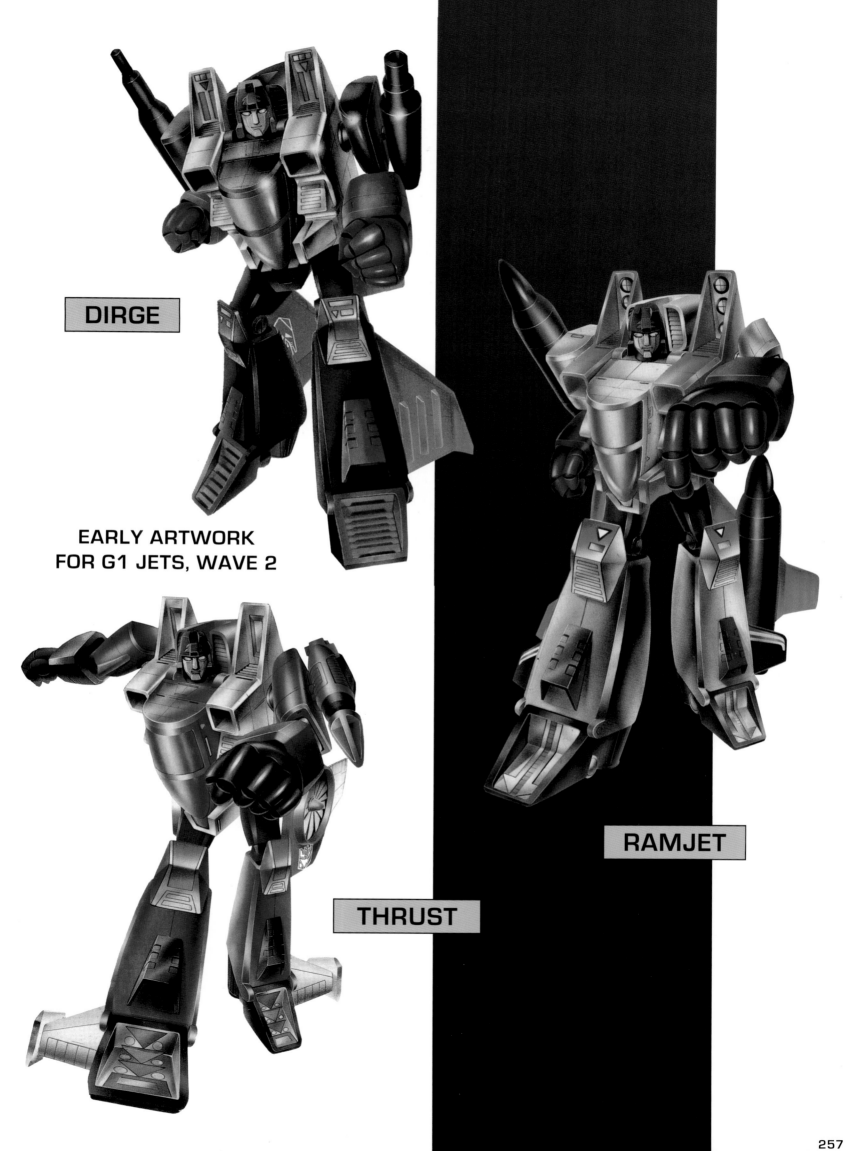

DIRGE

EARLY ARTWORK
FOR G1 JETS, WAVE 2

THRUST

RAMJET

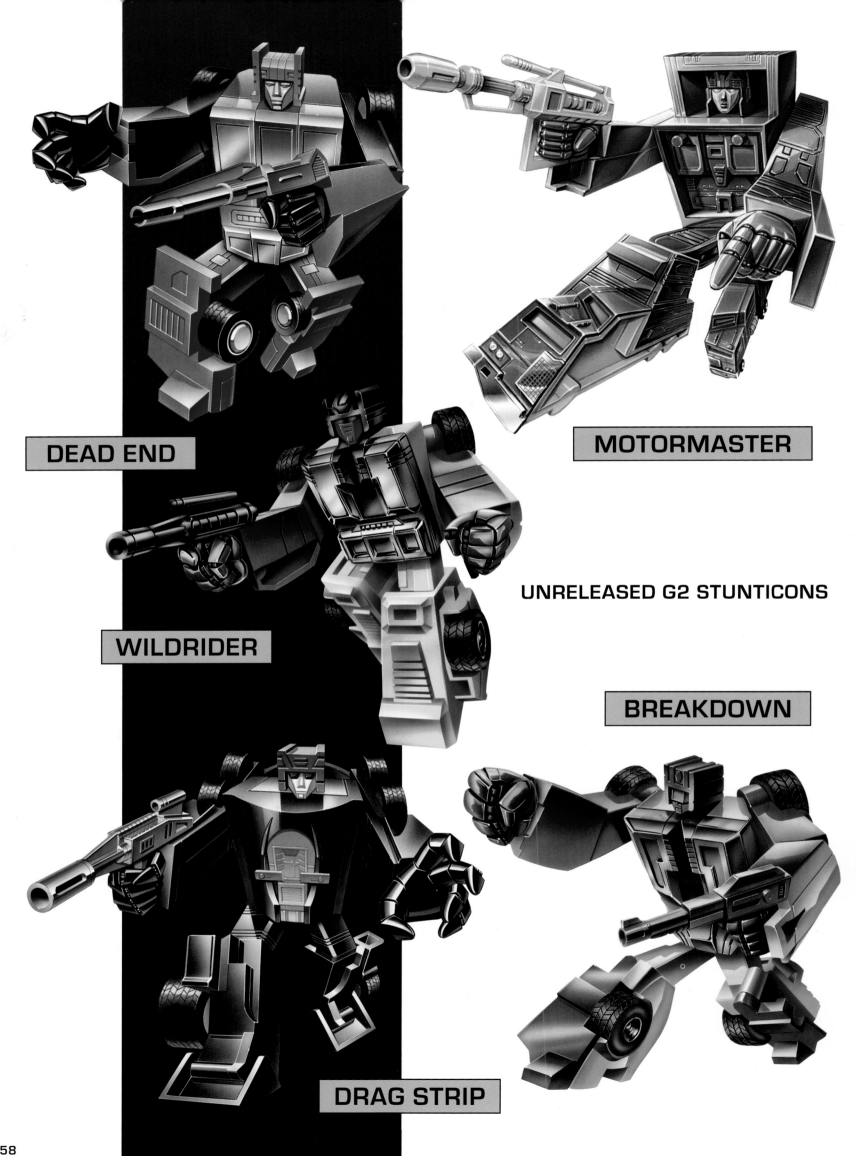

DEAD END

WILDRIDER

DRAG STRIP

MOTORMASTER

UNRELEASED G2 STUNTICONS

BREAKDOWN

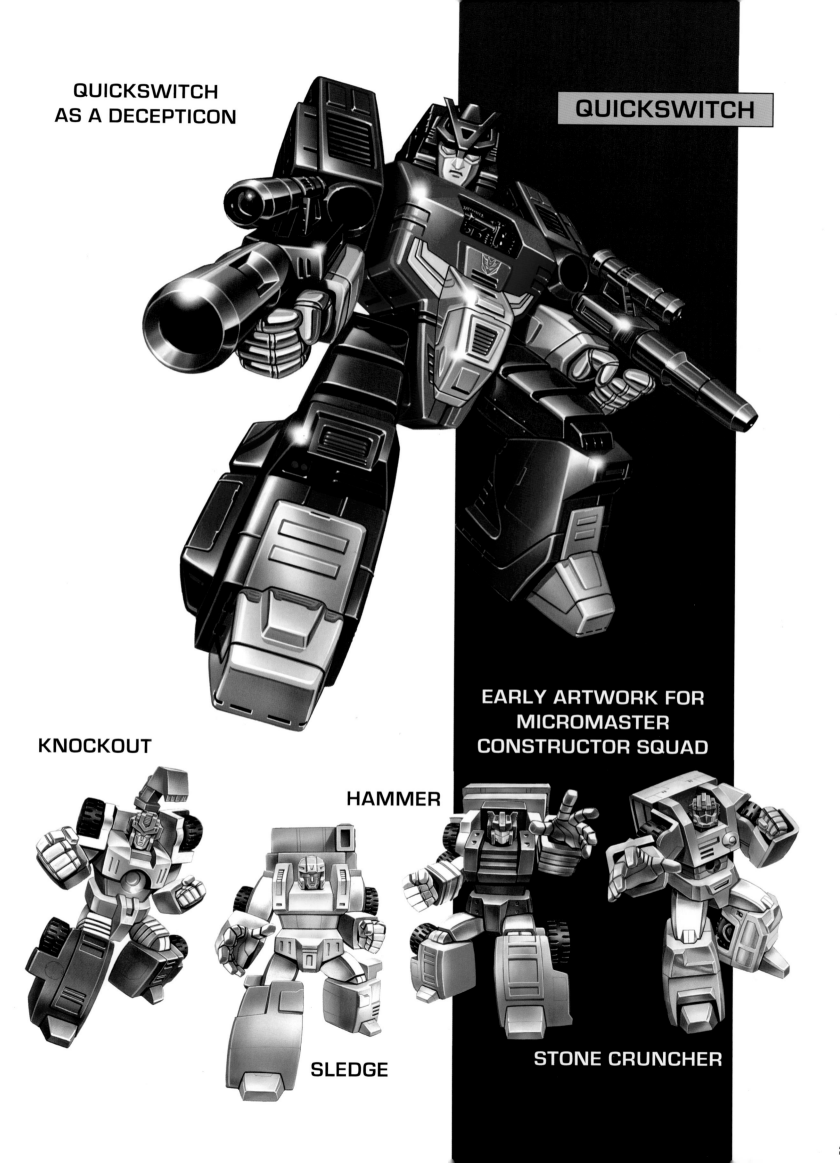

QUICKSWITCH
AS A DECEPTICON

QUICKSWITCH

EARLY ARTWORK FOR
MICROMASTER
CONSTRUCTOR SQUAD

KNOCKOUT

HAMMER

SLEDGE

STONE CRUNCHER

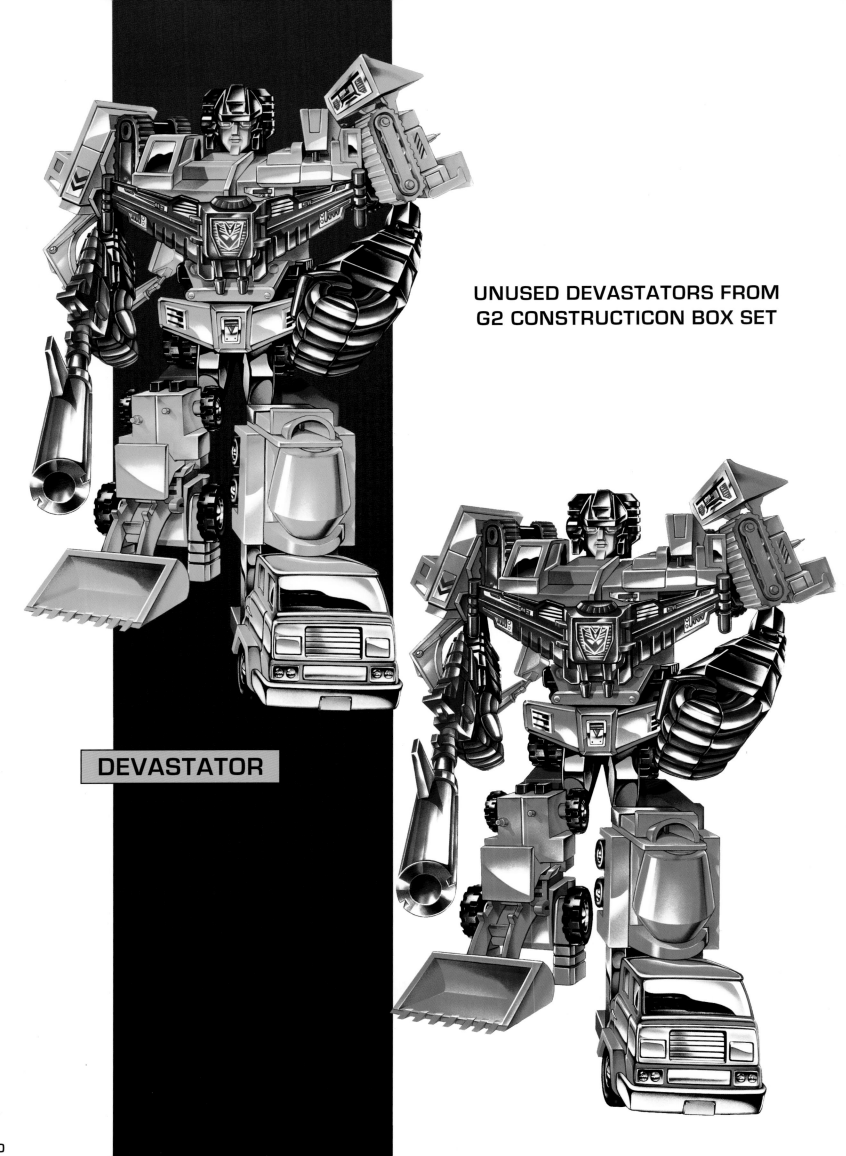

UNUSED DEVASTATORS FROM
G2 CONSTRUCTICON BOX SET

DEVASTATOR

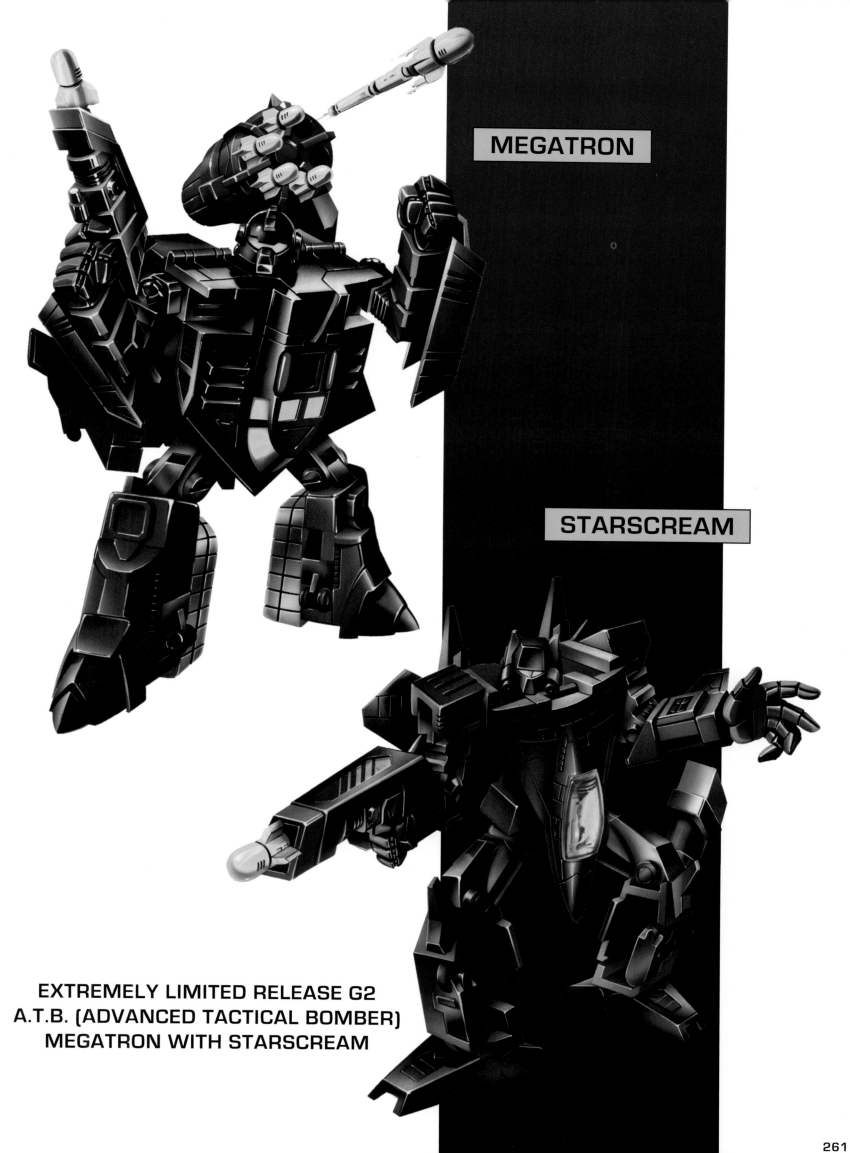

MEGATRON

STARSCREAM

EXTREMELY LIMITED RELEASE G2
A.T.B. (ADVANCED TACTICAL BOMBER)
MEGATRON WITH STARSCREAM

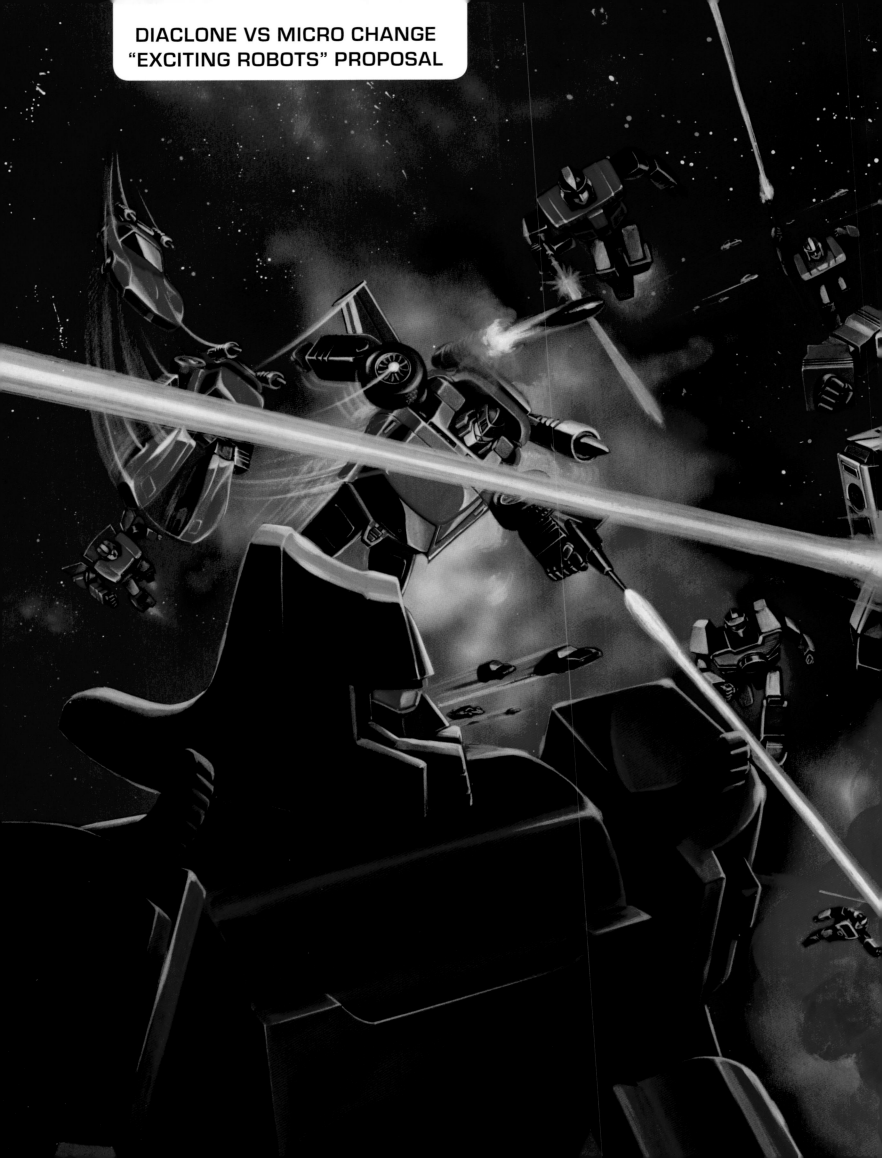

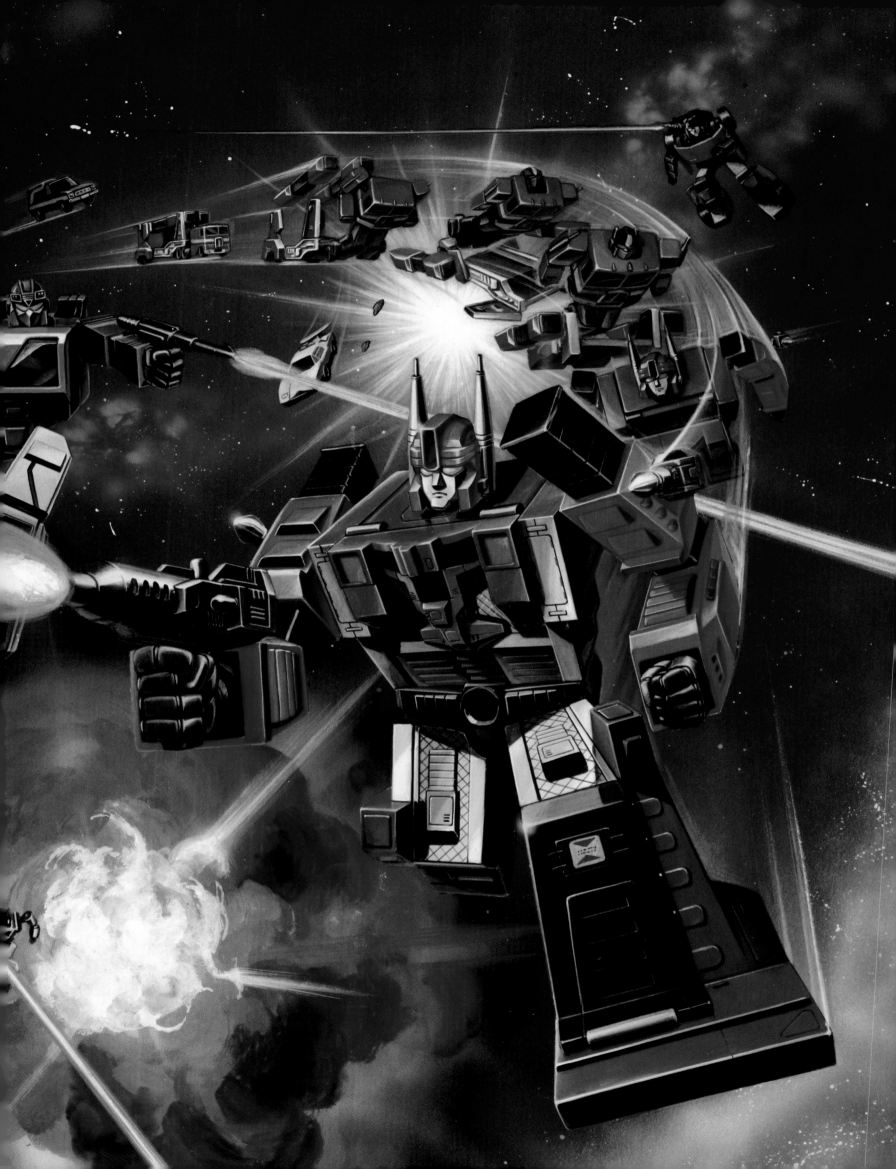

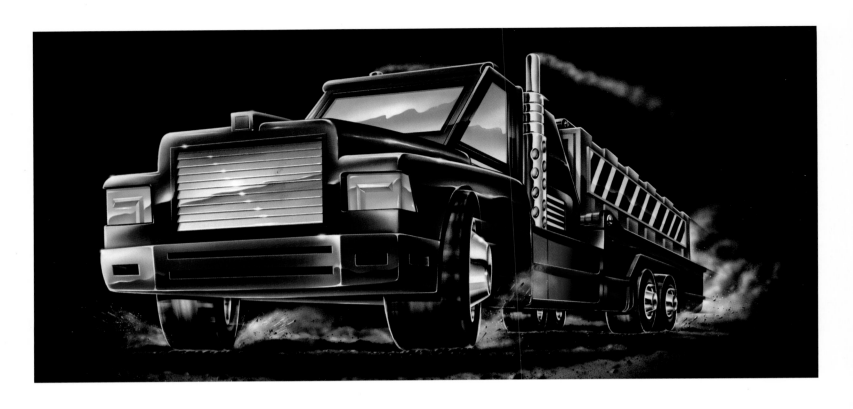

UNUSED ART FOR UK EXCLUSIVES
CLENCH & PYRO

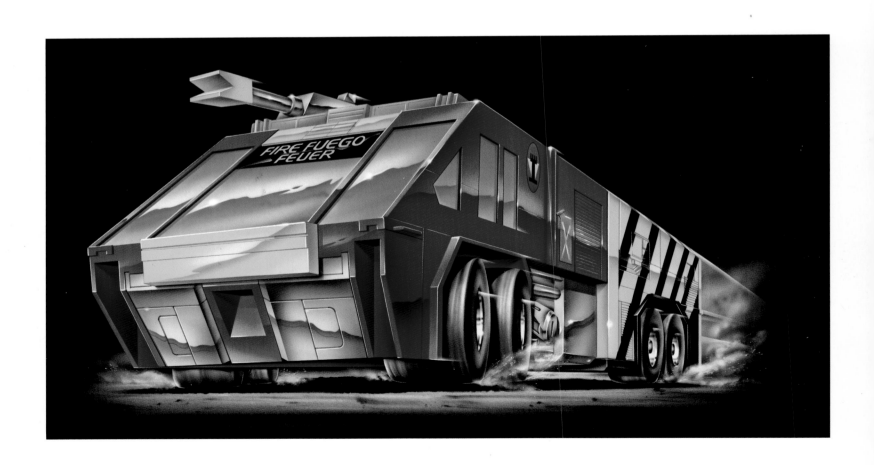

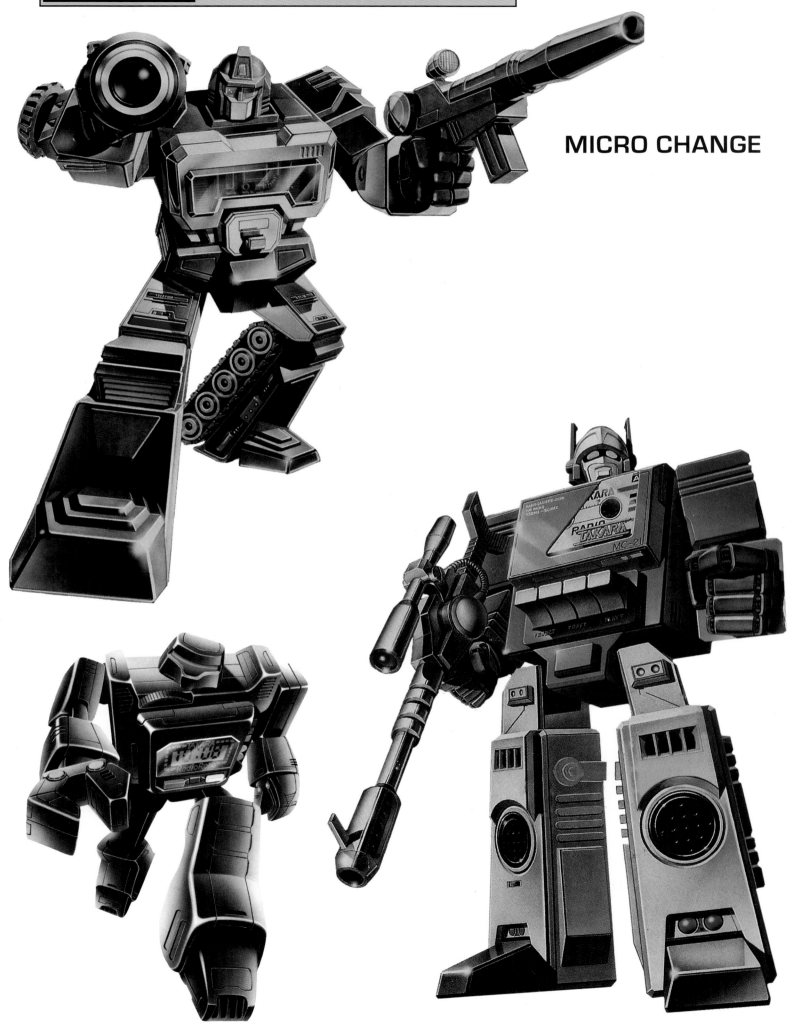

MICRO CHANGE

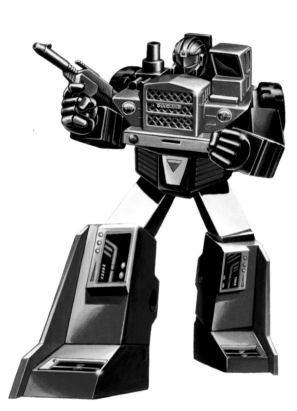

DIACLONE

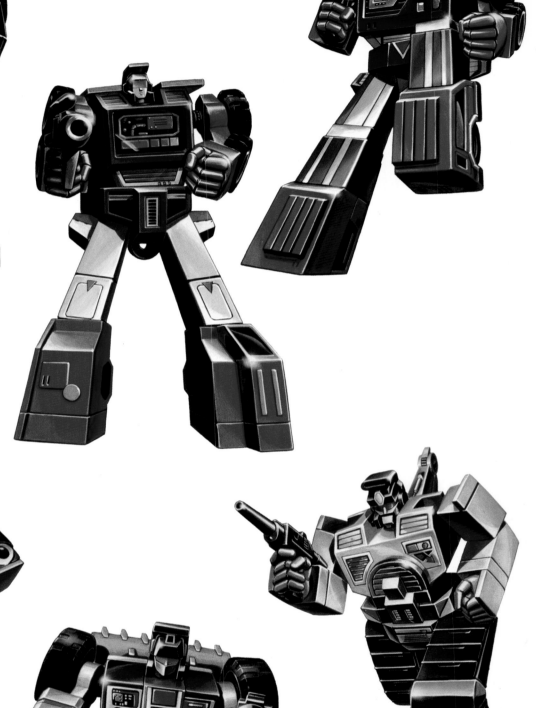

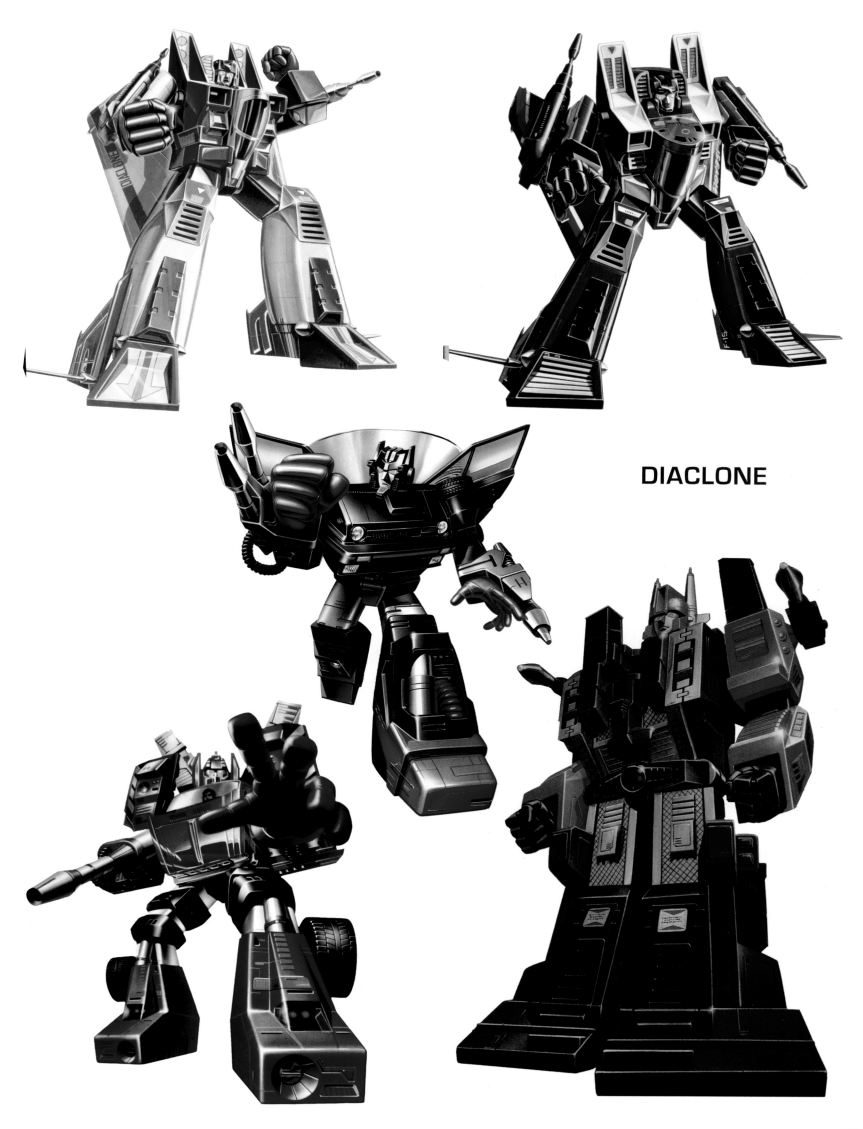

DIACLONE

BEET-ZEGUNA

BEET-GUGAL

BEET-VADAM

BEET-GADOL

ARMORED INSECT BATTALION BEETRAS

ODDITIES 1989 PACKAGE BATTLE SCENES

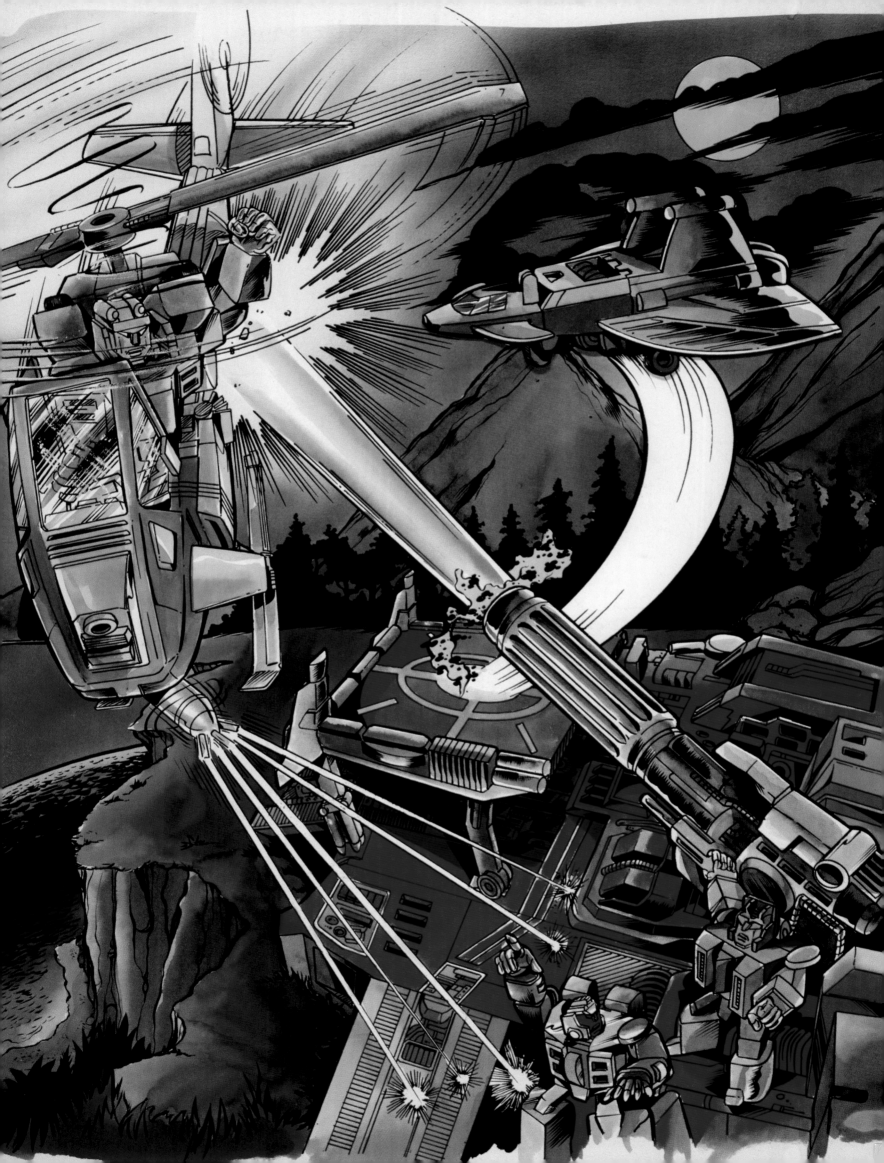

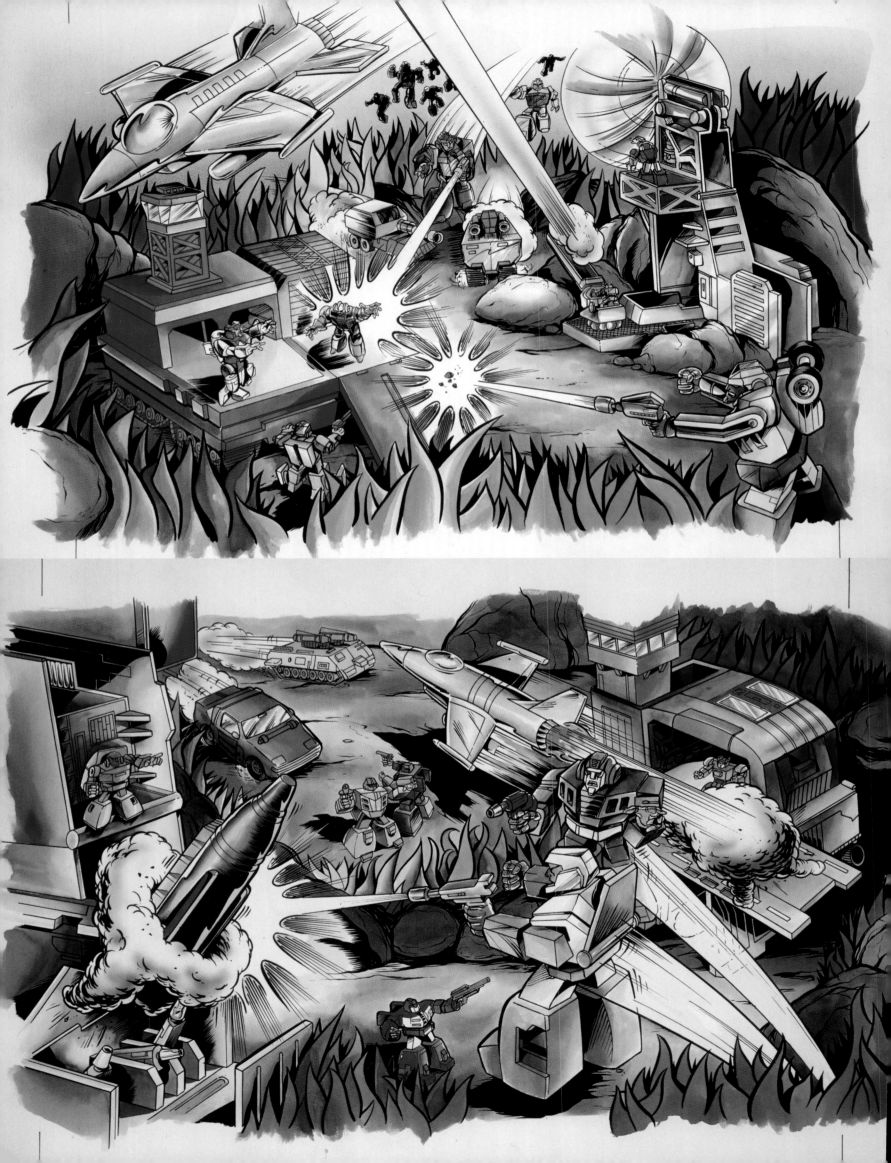

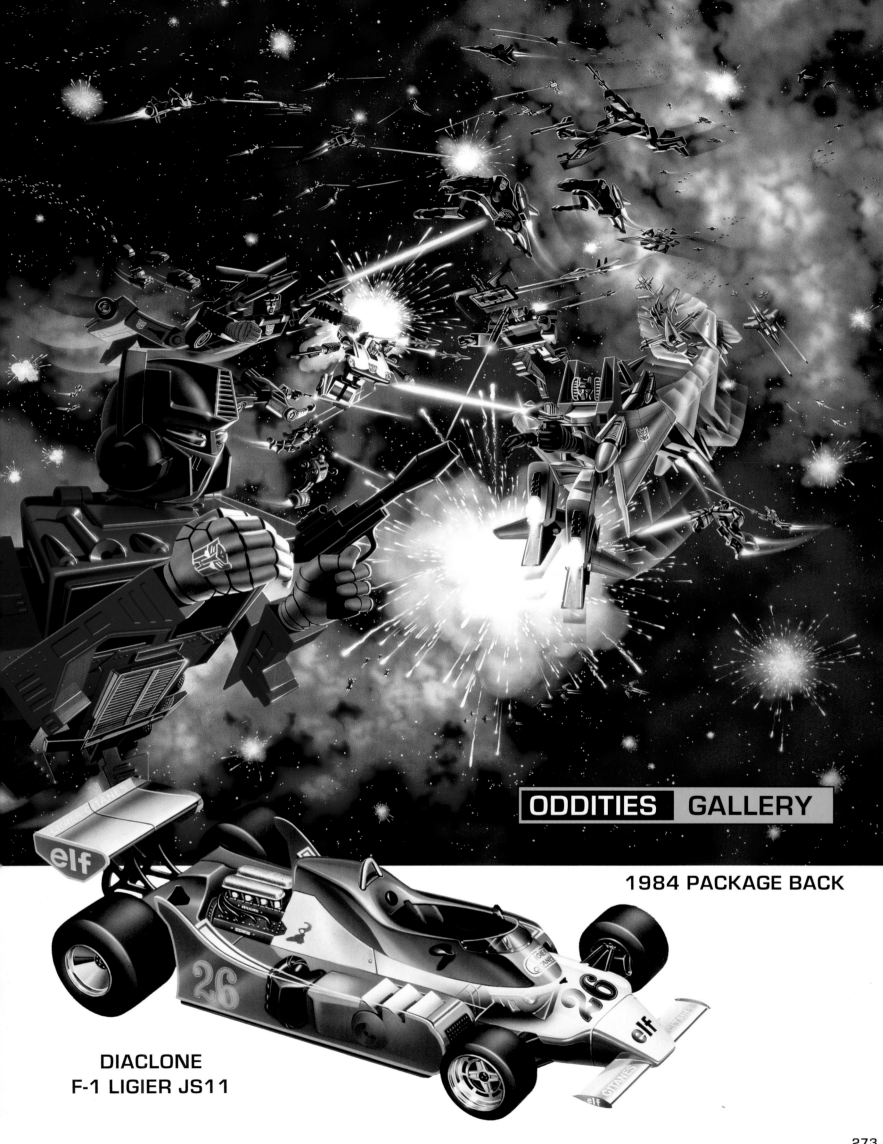

ODDITIES GALLERY

1984 PACKAGE BACK

DIACLONE
F-1 LIGIER JS11

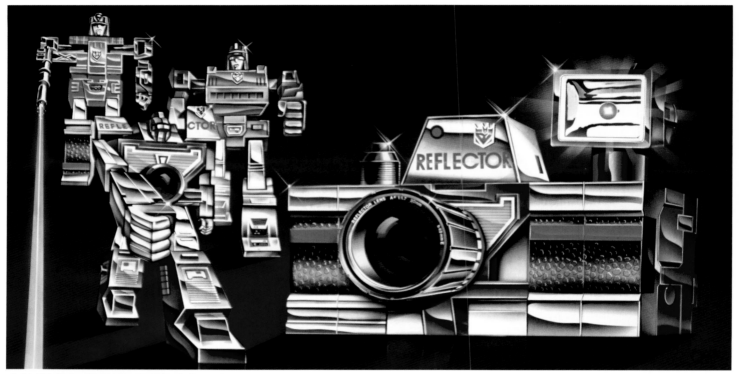

ABOVE: REFLECTOR (CATALOG)

BELOW: 1985 PACKAGE BACK

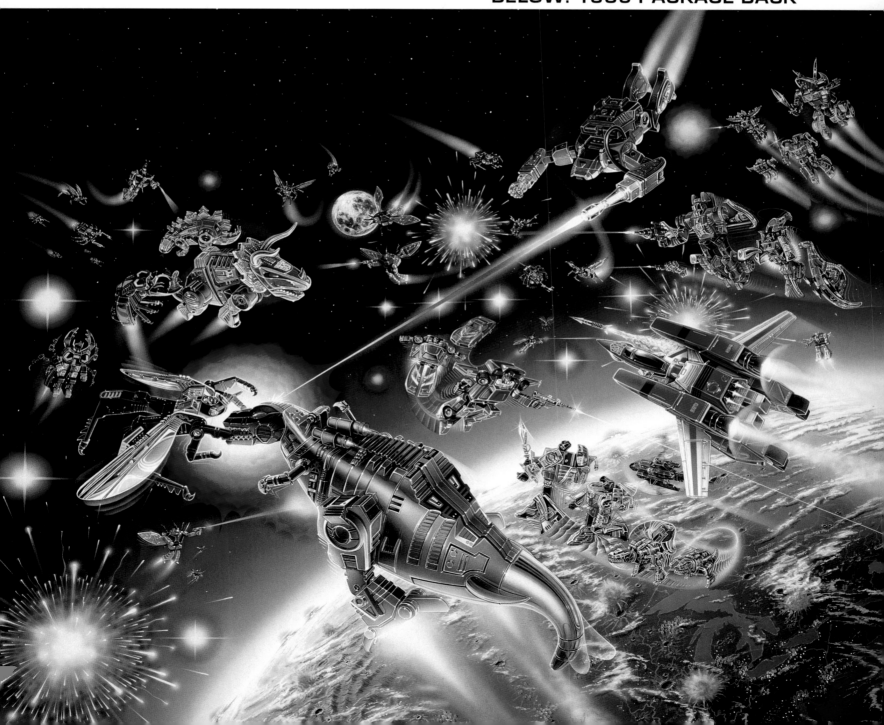

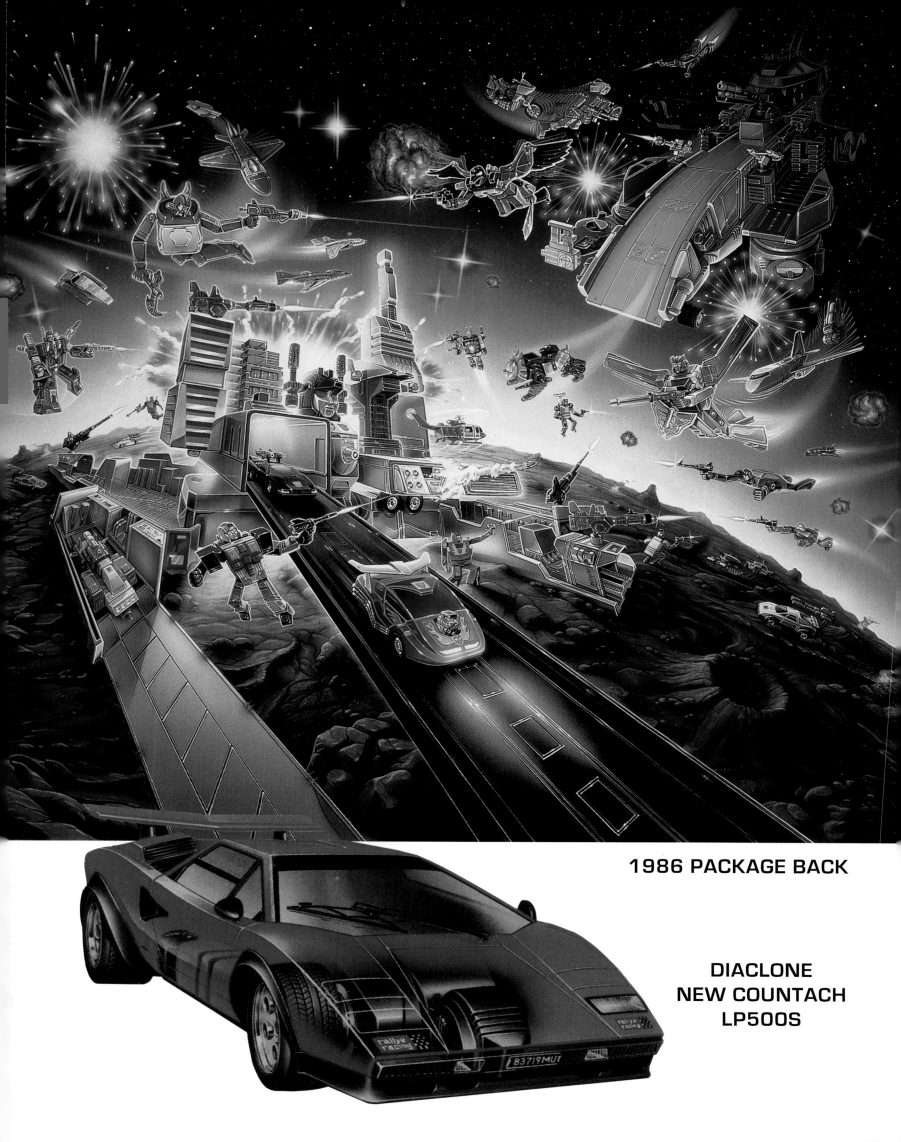

1986 PACKAGE BACK

**DIACLONE
NEW COUNTACH
LP500S**

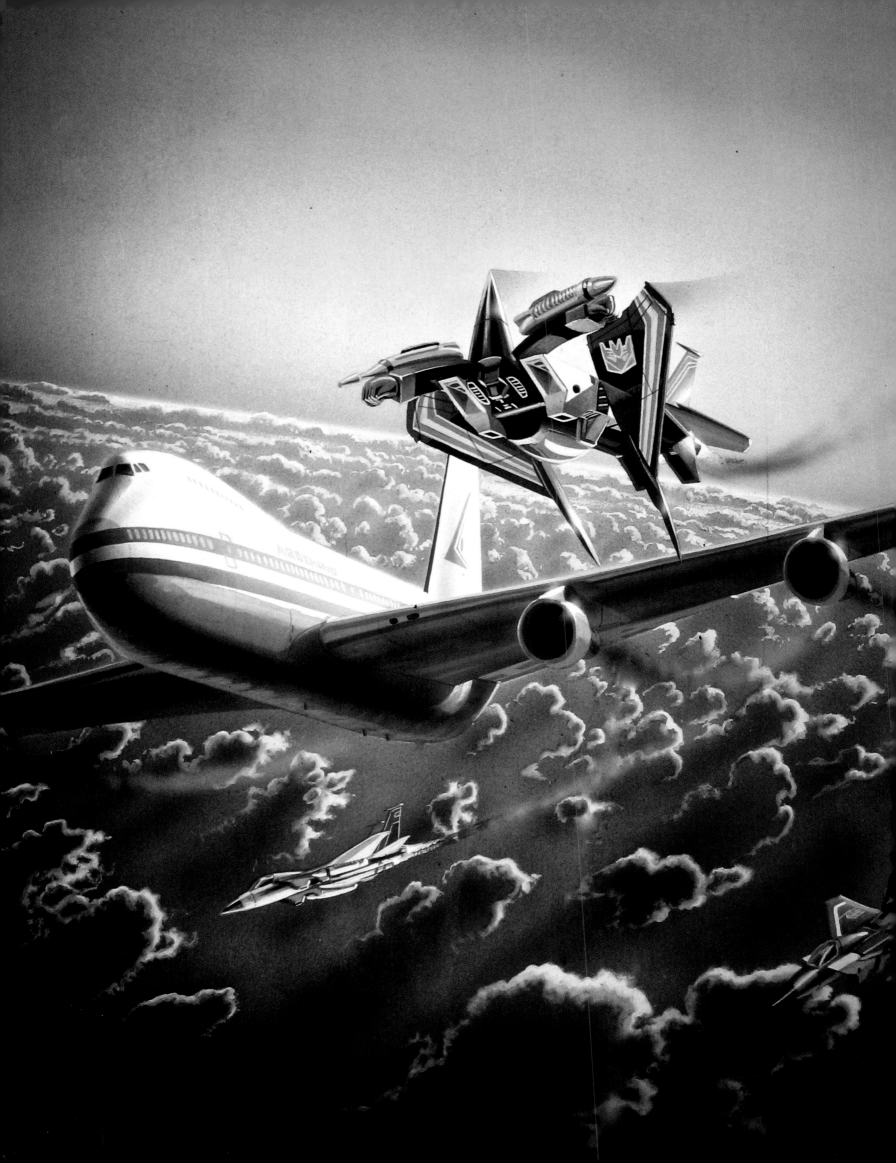

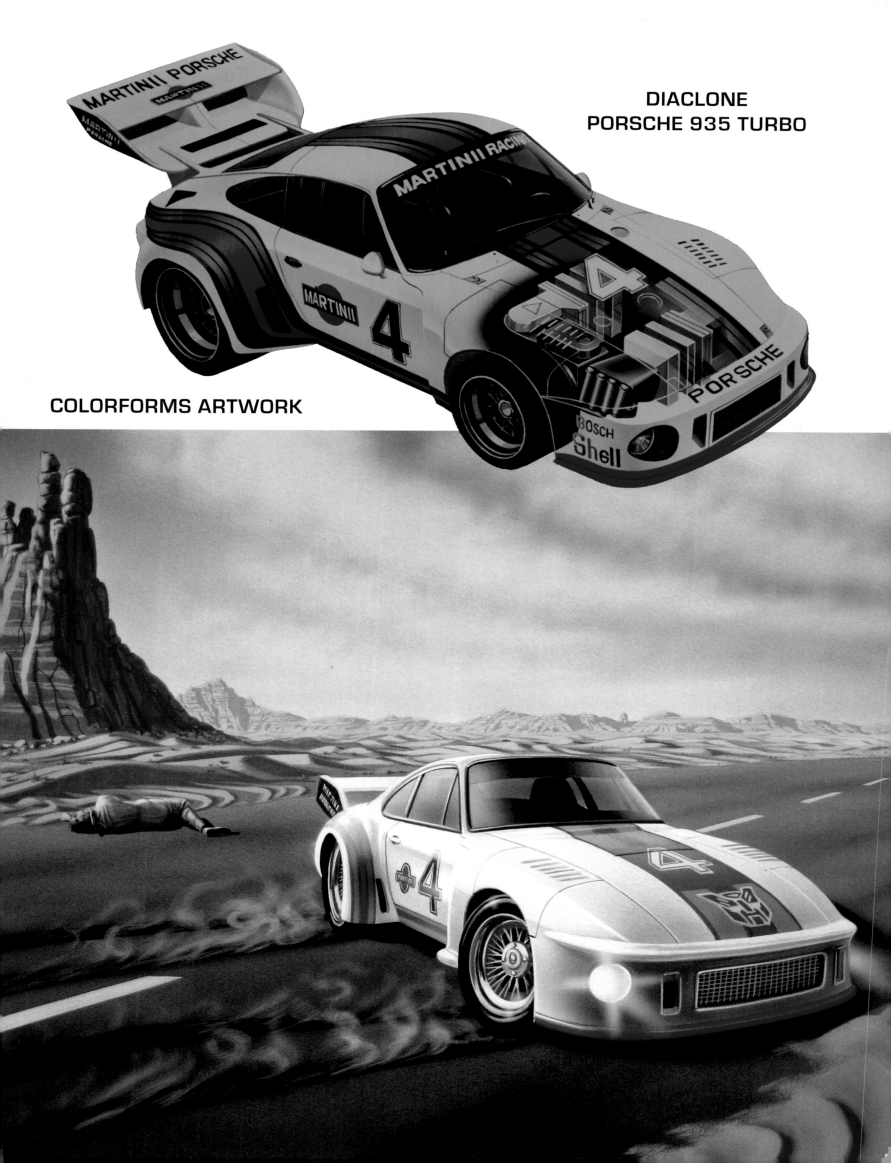

DIACLONE
PORSCHE 935 TURBO

COLORFORMS ARTWORK

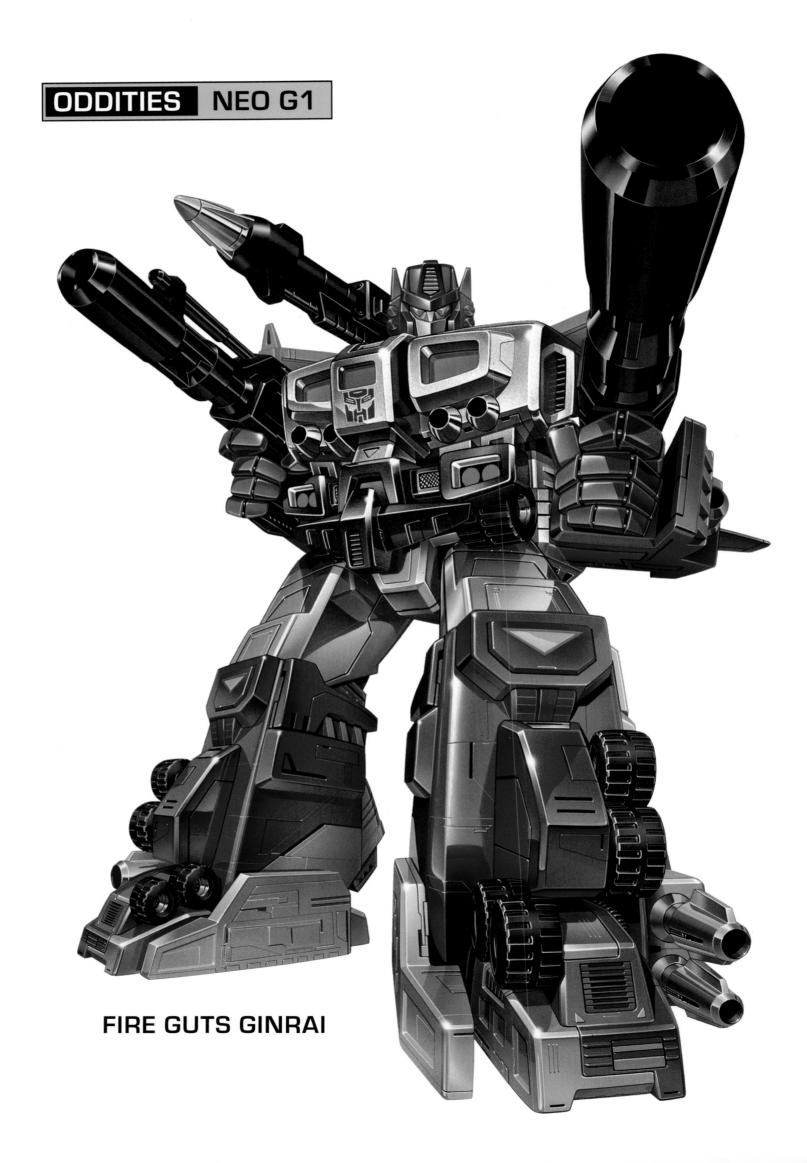

FIRE GUTS GINRAI

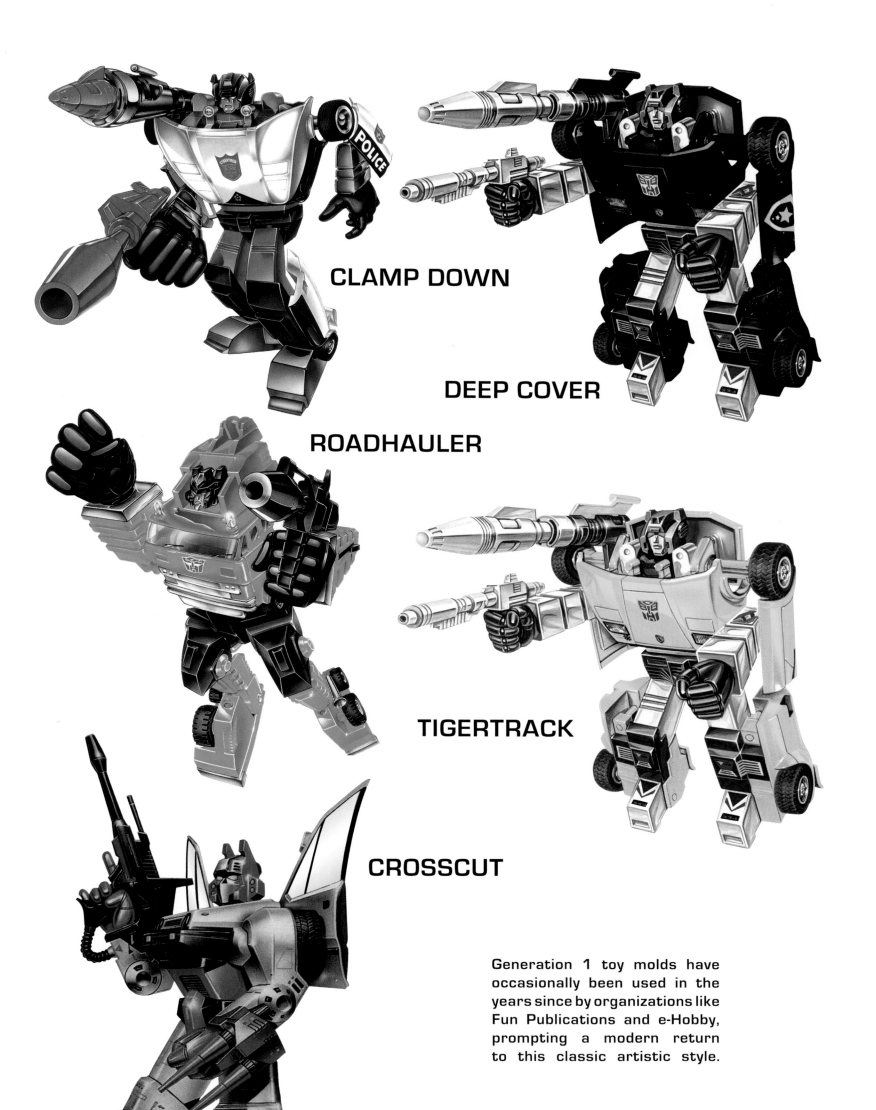

CLAMP DOWN

DEEP COVER

ROADHAULER

TIGERTRACK

CROSSCUT

Generation 1 toy molds have occasionally been used in the years since by organizations like Fun Publications and e-Hobby, prompting a modern return to this classic artistic style.

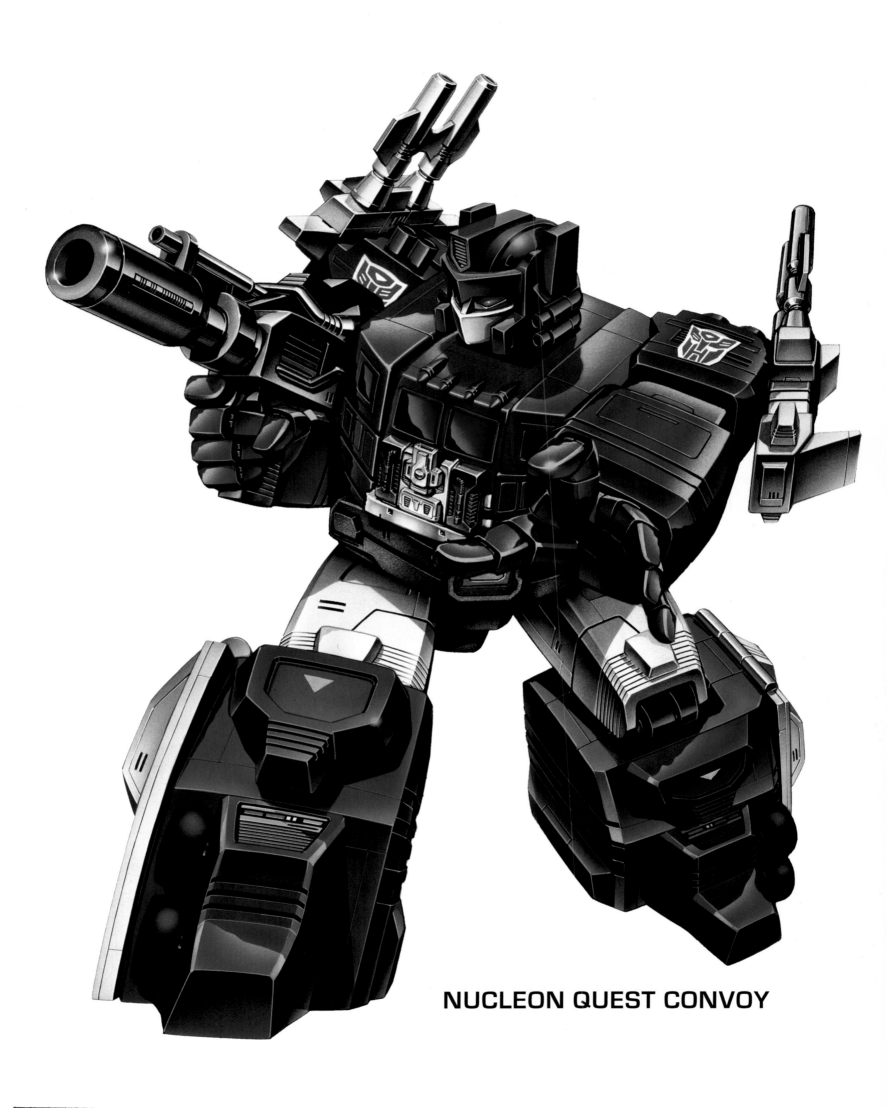

NUCLEON QUEST CONVOY

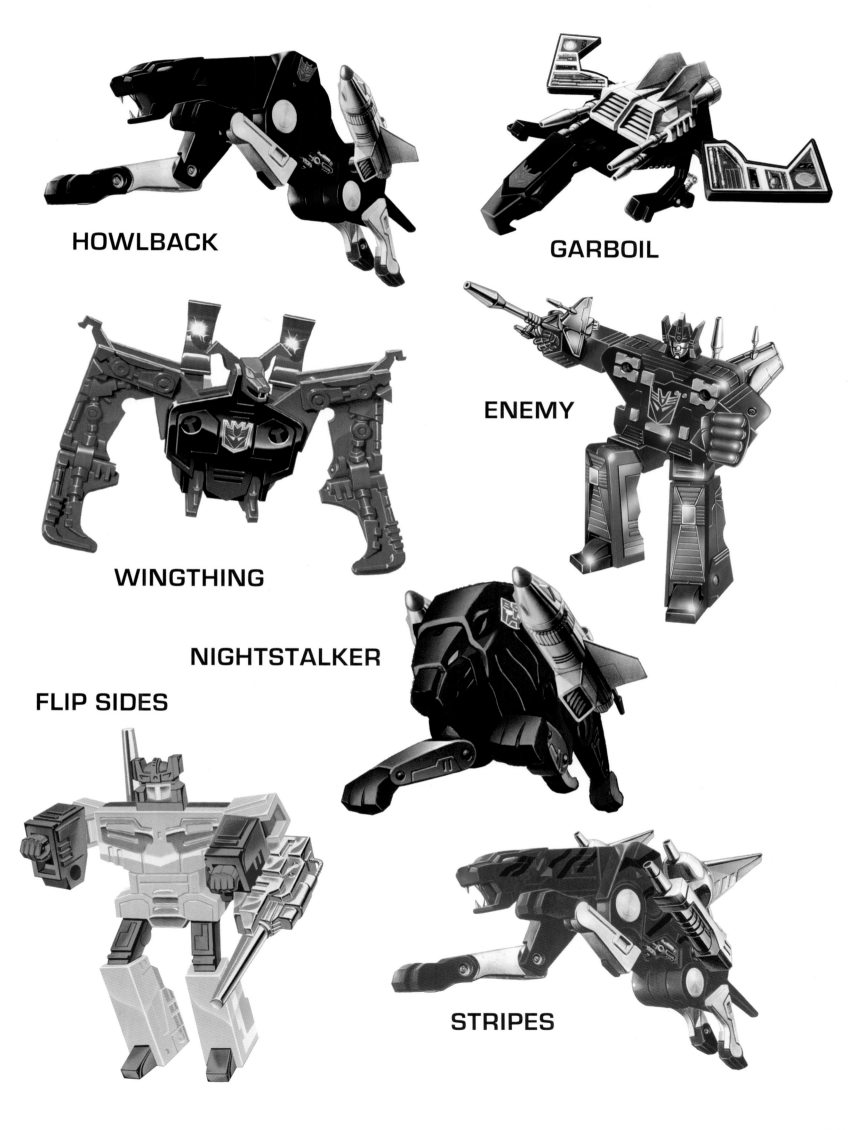

HOWLBACK

GARBOIL

WINGTHING

ENEMY

NIGHTSTALKER

FLIP SIDES

STRIPES

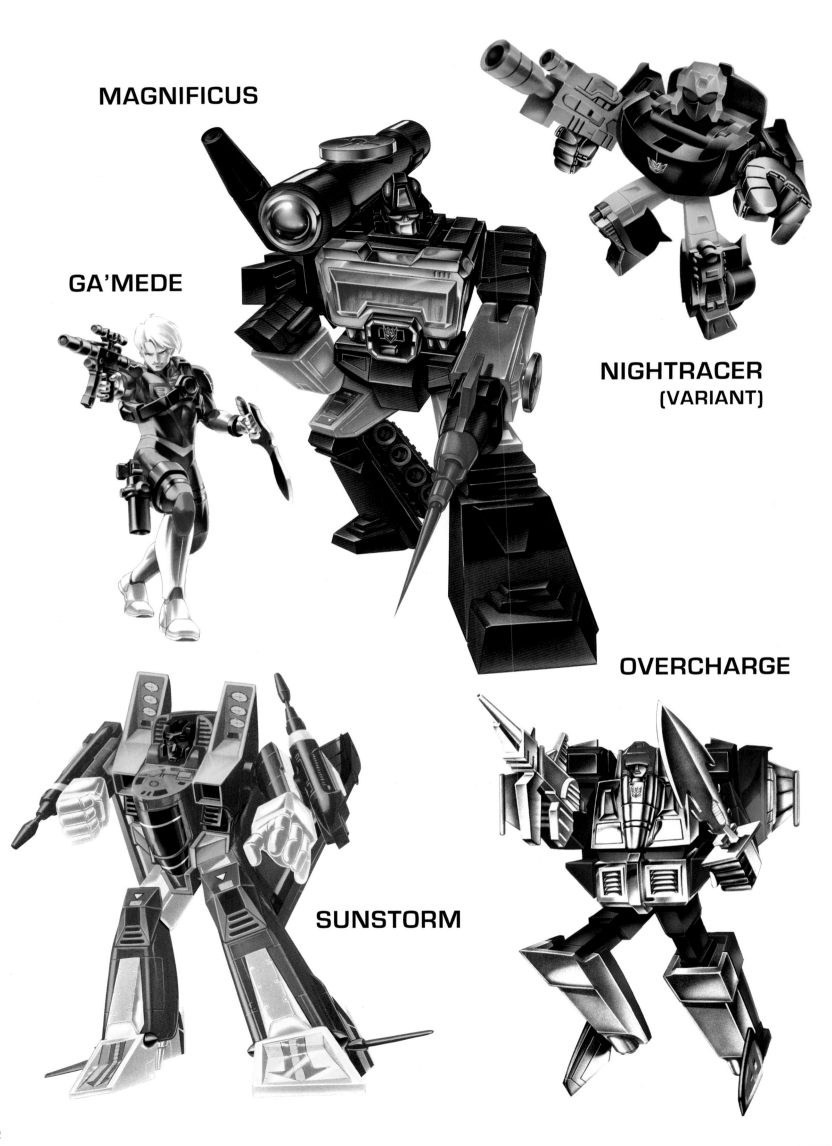

MAGNIFICUS

GA'MEDE

NIGHTRACER
(VARIANT)

OVERCHARGE

SUNSTORM

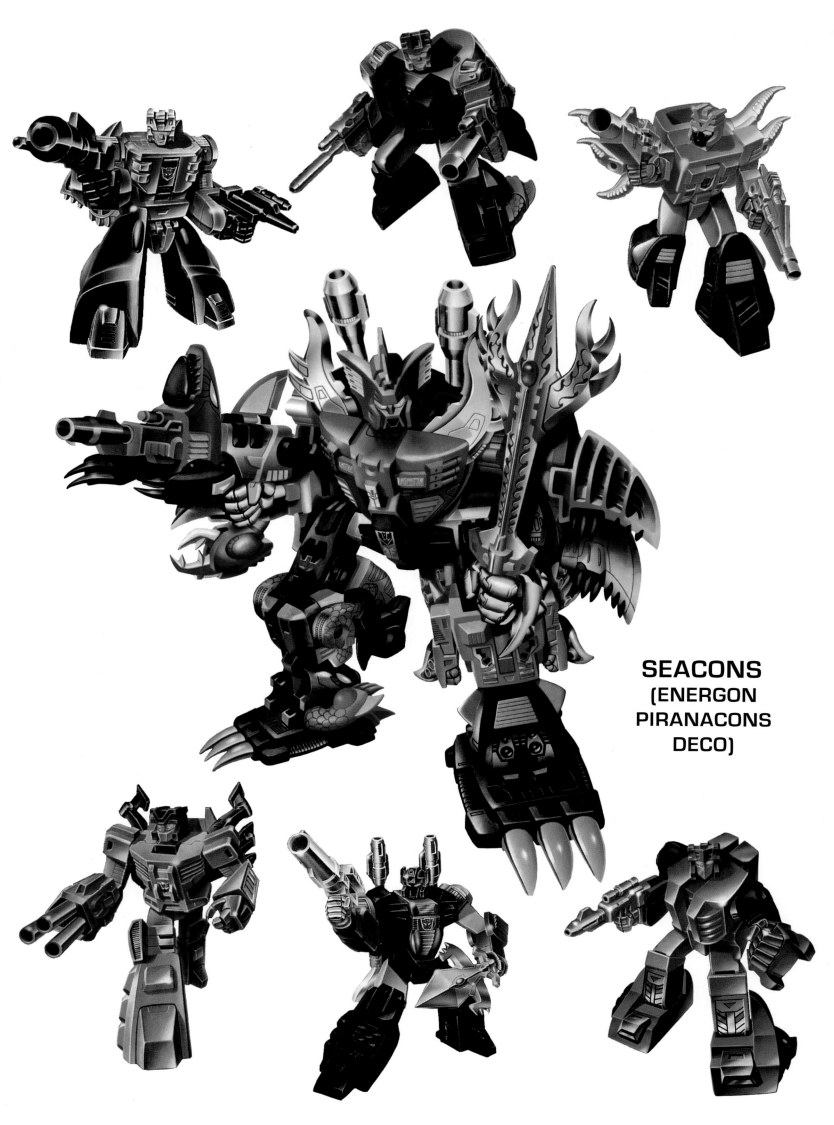

SEACONS
(ENERGON
PIRANACONS
DECO)

RETURN OF CONVOY
PACKAGE BACK (ALTERNATE)

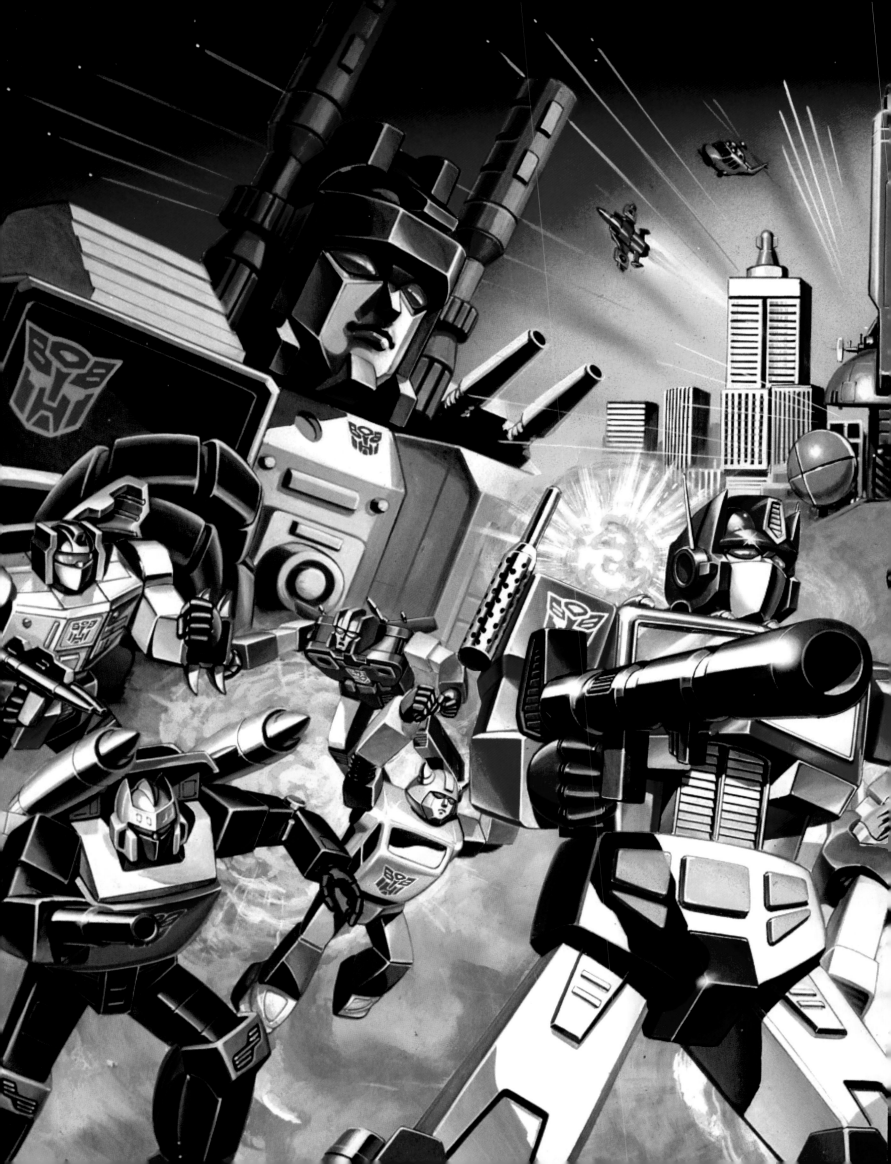

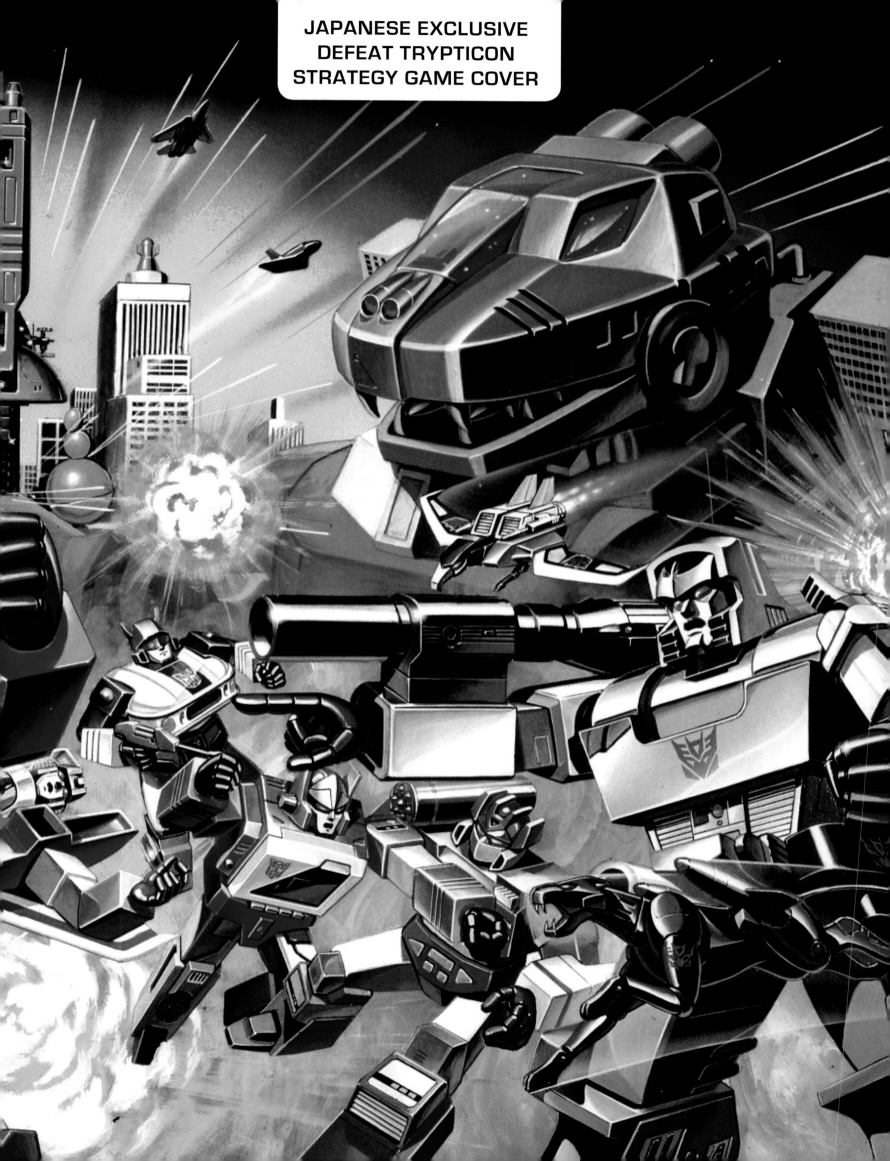

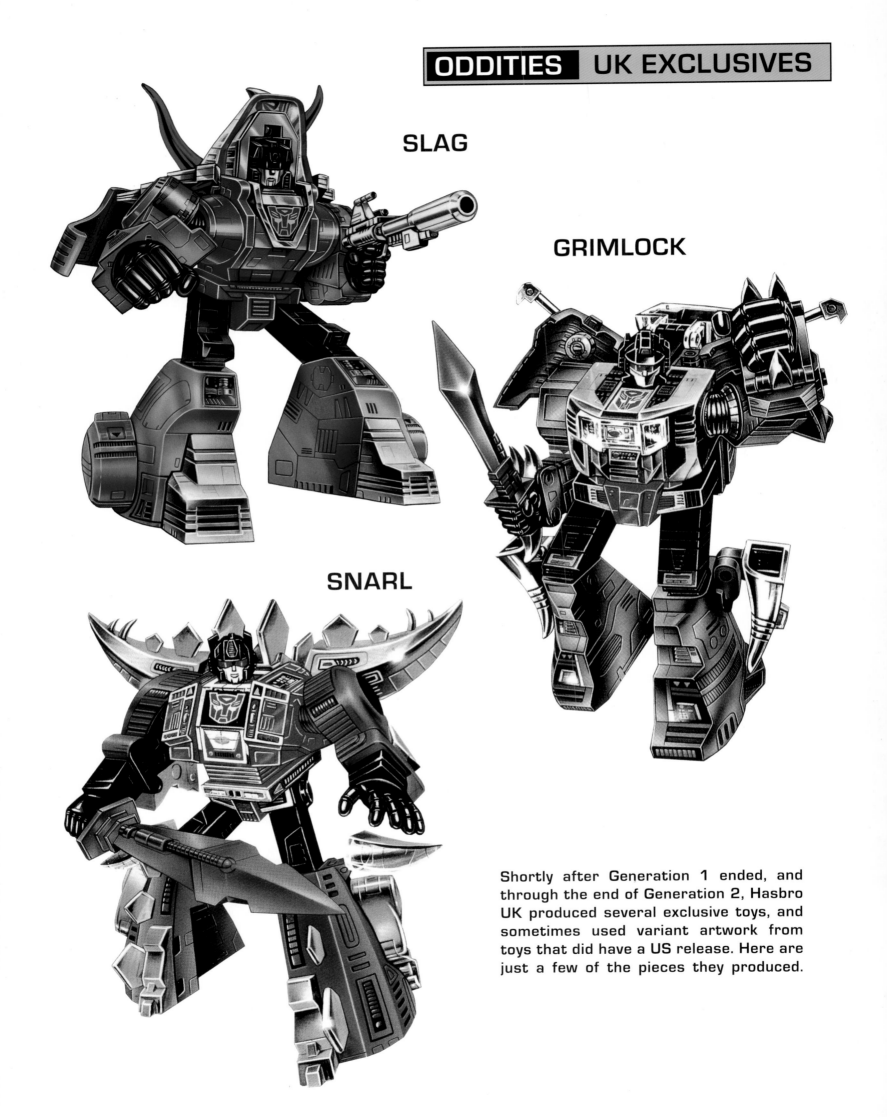

SLAG

GRIMLOCK

SNARL

Shortly after Generation 1 ended, and through the end of Generation 2, Hasbro UK produced several exclusive toys, and sometimes used variant artwork from toys that did have a US release. Here are just a few of the pieces they produced.

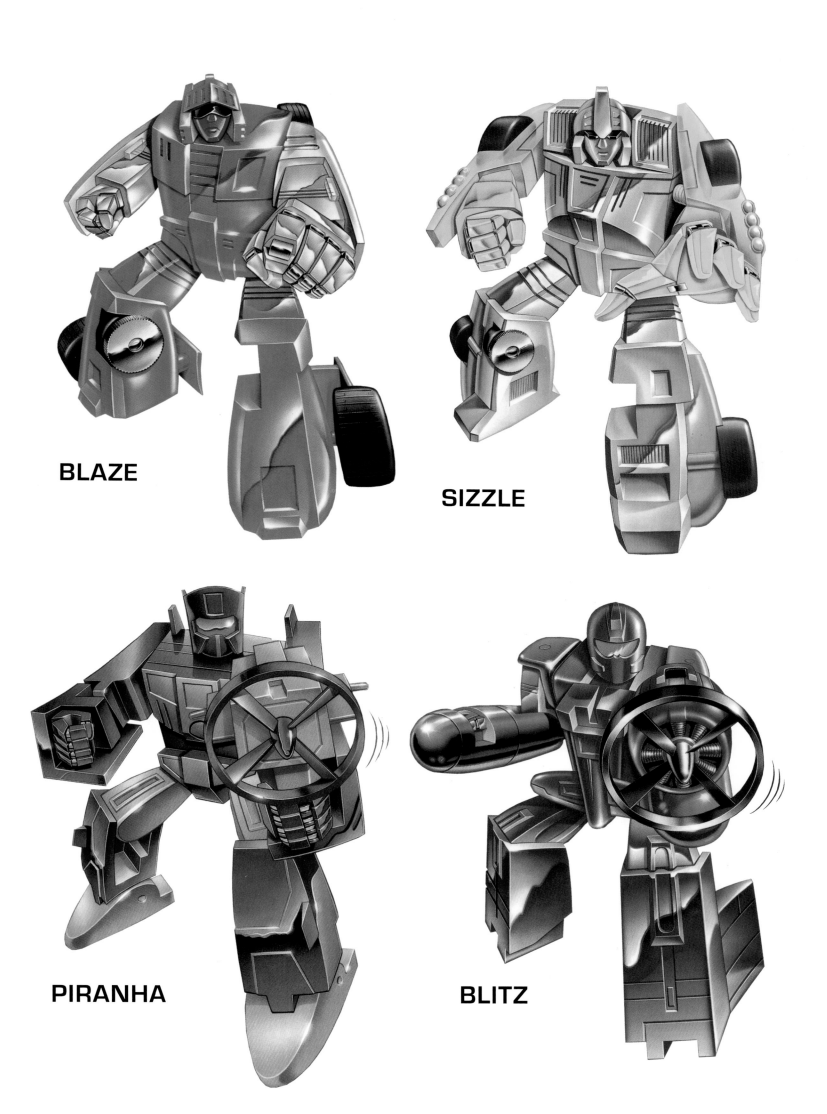

BLAZE

SIZZLE

PIRANHA

BLITZ

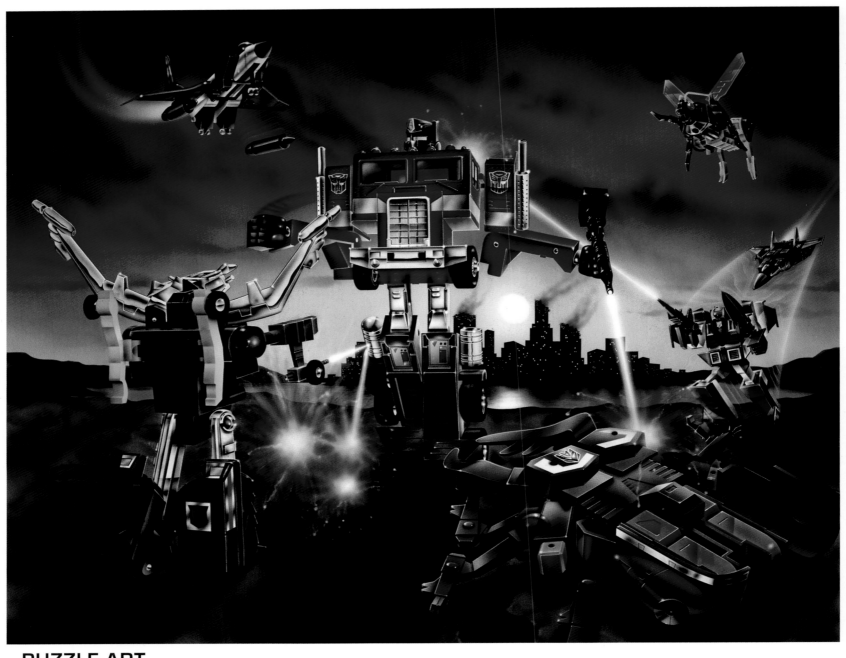

PUZZLE ART

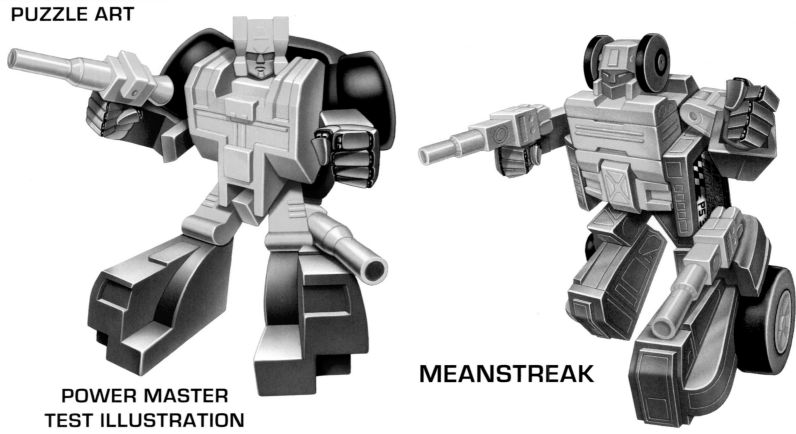

**POWER MASTER
TEST ILLUSTRATION**

MEANSTREAK

BULLET BIKE

IRONHIDE

PUZZLE ART

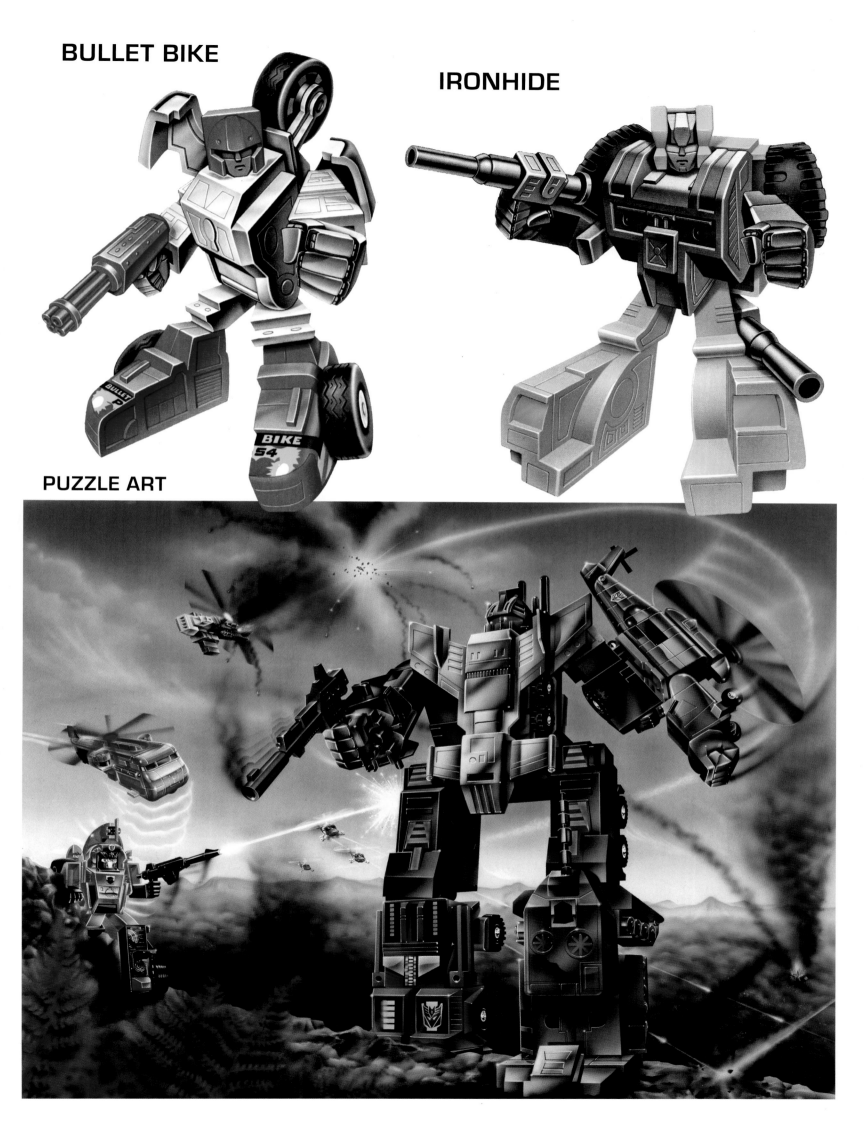

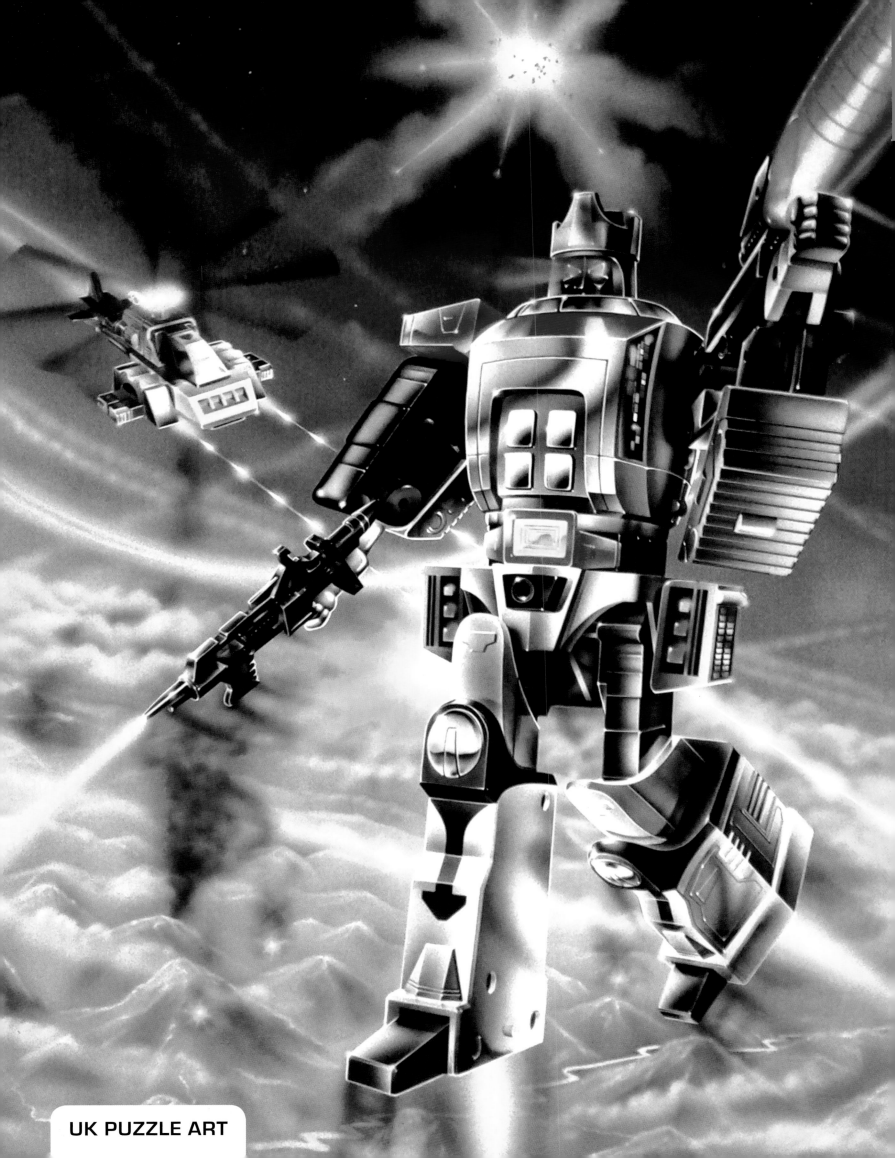

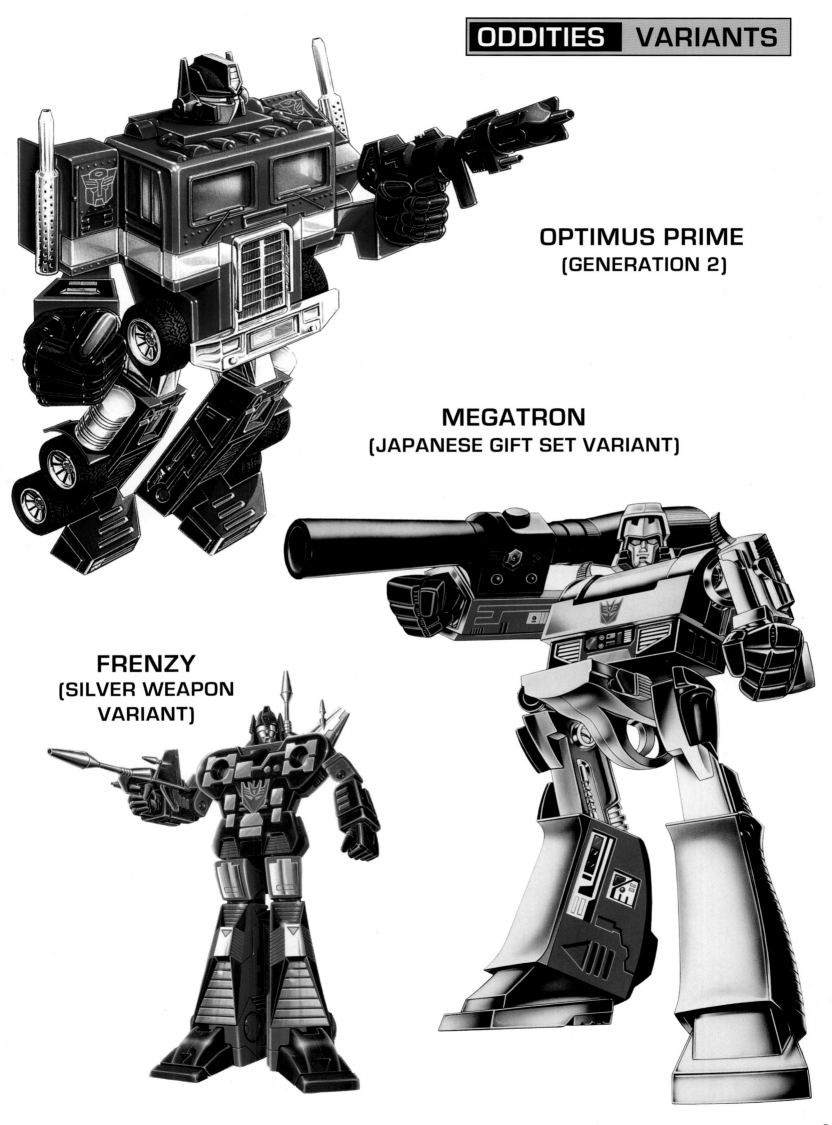

OPTIMUS PRIME
(GENERATION 2)

MEGATRON
(JAPANESE GIFT SET VARIANT)

FRENZY
(SILVER WEAPON VARIANT)

BUZZSAW

AFTERWORD

When thinking about our favorite Autobots and Decepticons from yesteryear, most fans probably think of their cartoon appearance. It's understandable: the cartoon was what gripped us every day after school, giving voice and personality to these characters, even if the animation models tended to greatly simplify or discard the intricate details of the toys upon which they were based.

But not me: I think of their box art.

Before the cartoon hit the airwaves, I remember first encountering the Transformers in the toy section of local department stores. I could see the toy beneath the clear plastic, of course, but it was the character art beside it that immediately caught my young eye: the promise of what this car or jet or cassette could become.

Unlike the cartoon, the package art was extremely faithful to the toy. The precisely-drafted linework, the faithful airbrushed colors and the respectful attention to detail made each piece something special, a companion to the toy that imparted a sense of urgency to otherwise inanimate plastic and metal. Every warlike mouthplate and visor, every latent wing and wheel, every little piece of post-transform kibble was maintained. The package art seemed to offer the promise that these alien robots could be real.

I can even credit the box art with getting me back into Transformers many years later. Like many kids, when I discovered the opposite sex and MTV, toys lost their interest. Carefully packed into a cardboard box and hidden in the basement, the Transformers were largely forgotten during my high school and college years. It was in my early 20s, killing time at a temp job in Manhattan, that I started surfing this new thing called "the internet." Eventually I happened to search for "transformers" and quickly came upon a picture of Megatron's iconic box art. Staring at his brandished fusion cannon, his iconic icy colors, and his self-assured "peace through tyranny" expression and posture, I immediately experienced that same sensation I had as a boy when I first saw this art. I saved it and every other box art image I could find to floppy disc, made a mental note to fetch that cardboard box from my mother's basement and... well, today that collection of Transformers has grown from a few dozen to hundreds. All thanks to the box art.

These days the Transformers are seemingly more popular than ever. Between the movies and the continuing success of the toy franchise, I doubt there are any children of the '80s who need reminding that the Transformers exist. Still, I suspect that there are at least a few lapsed fans who will see this book, flip through the pages, and re-experience that same rush of nostalgia that they had when they first stared through young eyes at a wall of Robots in Disguise and the box art that accompanied them.

- Adam Alexander, aka "Botch the Crab"

ACKNOWLEDGMENTS

This book, perhaps more than any other we've worked on in the past, would not have been possible without the help of a great many dedicated professionals and fans.

To each of the artists who created the many lavish illustrations in this book, a massive thank-you. We would especially like to thank those who took the time to share their recollections with the authors of this book, namely Allison Boisselle, Doug Hart, Bob Lavoie, Jeff Mangiat, Richard Marcej, Andy Perlmutter, David Schleinkofer, Shin Ueda, and Mark Watts.

Vast swaths of this book were made possible by the care and expertise of Rik Alvarez and Part One's Andrew Hall. They scoured through their personal archives for this project and shared many fascinating pieces.

Even their enormous contributions would have resulted in a book of only about half the size of the volume in your hands without the contribution of dedicated fans. Tracking down originals or first generation professional copies takes an enormous amount of time, effort, energy, and money. Nevertheless, each of the following fans shared their collections and knowledge with us, and by extension the world. To Alex Bickmore, Rasmus Hardiker, Paul Hitchens, Vance McLennan, and Maziar Shahsafdari, thank you for sharing.

Additional contributions and assistance came to us from a large number of fans and pros. Each and every one of them made this book just that much more complete, just that much more special. To Adam Alexander, Aaron Archer, Mark Baker-Wright, Colin Betts, David Bishop, Seamus Brown, Dave Edwards, Matteo Entreri, Tim Finn, Jamie Harris, Dan Klingensmith Jr, John Kent, Gina Kensek, Joshua Kluger, Steve Kushnir, Lanny Lanthem, Marco van Leeuwen, Martin Lund, Immo de Maar, Dave and Steve Mapes, Marc Patten, Joe Peterson, Jon Goode, Colin Pringle, Dallas Roderick, Pete Sinclair, Nancy Sorenson, James Tamoush, David Tree, and Jesse Wittenrich, hats off to you.

And finally, we'd like to once again thank the fans for their continued support. We do this for you. If you have any feedback we'd love to hear from you at transformerstheark@yahoo.com.

Bill & Jim

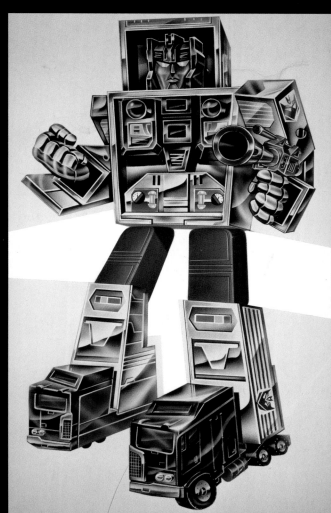

MOTORMASTER
with Japanese Alterations